Creative Elements

LANDSCAPE PHOTOGRAPHY—DARKROOM TECHNIQUES

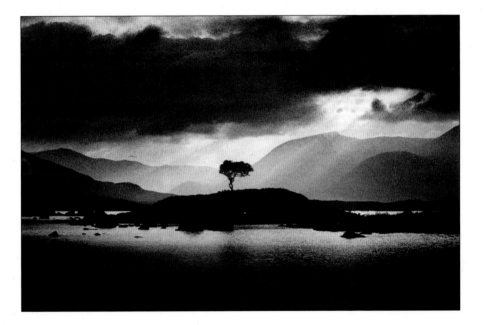

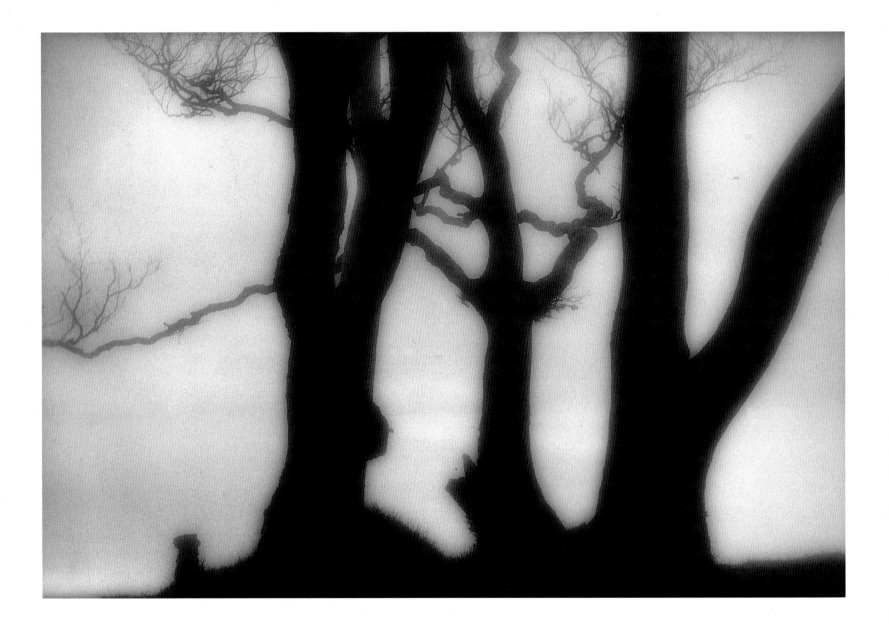

Creative Elements

LANDSCAPE PHOTOGRAPHY—DARKROOM TECHNIQUES

TEXT AND PHOTOGRAPHS BY

Eddie Ephraums

FOUNTAIN PRESS

Published by
FOUNTAIN PRESS
Newpro UK Limited
Old Sawmills Road
Faringdon
Oxfordshire SN7 7DS

Text & Photographs
EDDIE EPHRAUMS

Printing in
Hong Kong by
Regent Publishing
Services Ltd

First published in Great Britain
in 1993 by
21st Century Publishing Ltd

Special thanks to ILFORD
for their support in this project.

ISBN 0 86343 397 9

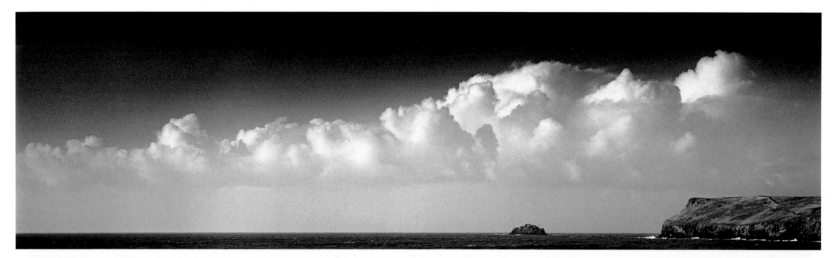

Contents

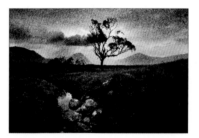
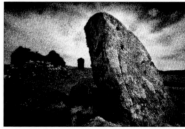

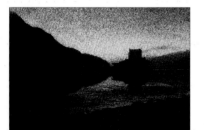

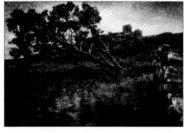

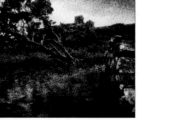
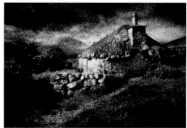

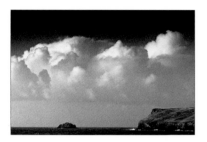

Pentire Point **page 60**

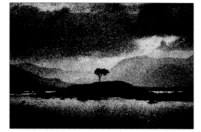

Black Mount **page 76**

Technical section

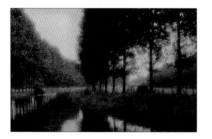

River Authie **page 64**

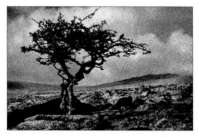

Mis Tor **page 80**

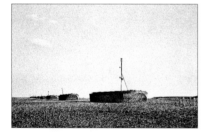

Bradwell Barges **page 68**

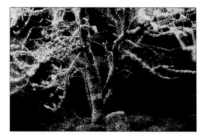

Fernworthy Forest **page 84**

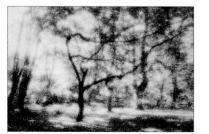

Epping Forest **page72**

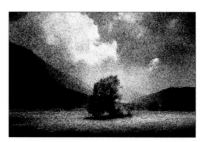

Route Napoleon **page 88**

Introduction to the photographs

The landscape photographs I have chosen for this book are not intended to represent a selection of my favourite images or my 'best' prints. Instead, they have been selected to illustrate the numerous technical points I wish to discuss, and also to demonstrate as many techniques and processes as possible.

If the subject matter of these photographs occasionally appears similar, this is to show different ways of tackling the same type of scene. For example, compare — then contrast — **Wistman's Wood** and **Fernworthy Forest** with **Rannoch Moor** and **Mis Tor**: all very similar subject matter, photographed in a like manner, yet each is the subject of one of a diverse range of darkroom photography techniques, employed for deliberate and pre-visualised effect. Look also at the two **Bradwell Barges** photographs on pages 69 and 70: each is of the same scene, yet both have been photographed and printed in totally contrasting styles. In every case I have tried to explain my techniques, and give reasons for their use.

In some cases the darkroom methods I have used to make these landscape images may — initially — appear complex. This isn't to elevate their technical status. It is intended to simplify the look of the print and therefore to clarify the meaning of the photograph. Such techniques show just how far beyond the point of camera exposure the black and white photographic process can go, if we want it to.

In other cases, by demonstrating these techniques, I hope to show how to work with difficult negatives, or cope with scenes that lack the intrinsic ingredients necessary for success. As an example, a straight exposure print of **River Authie** yields an imperfect photograph, but manipulation of the print overcomes this problem. Similarly, straight prints of **Route Napoleon** and **Black Mount** yield images that speak of detail rather than communicate drama. In both these cases print manipulation produces a simpler image and a clearer — more effective — photograph.

In fact, many of my landscapes are intentionally simple: they don't rely on fancy equipment (all but two have been made with very basic 35mm camera equipment) and, what's more, they don't depend on far-away exotic locations for purely alluring, visual effect. Instead they rely on the accessible, or the commonplace: **Epping Forest** in North London, for example, or the silhouetted trees of **King's Tor** car park on Dartmoor. And, of course, they rely on camera and (what may initially appear complicated) creative darkroom techniques, but — given time and practice — even these processes will appear simple and become second nature.

The difficulty of landscape photography is deciding what to photograph and understanding what it is we want to say about our chosen subject. I hope this will always remain so — a challenge to be enjoyed.

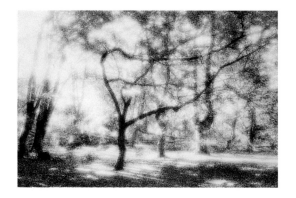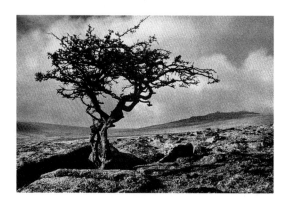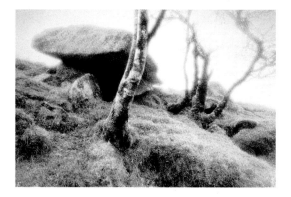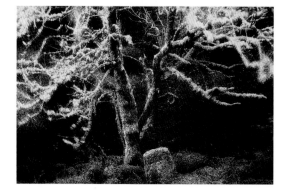

Chapelle Gratemoine

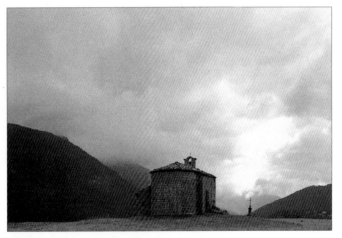

Above: full-frame straight exposure print.
Opposite: the final, thiocarbamide-toned print.

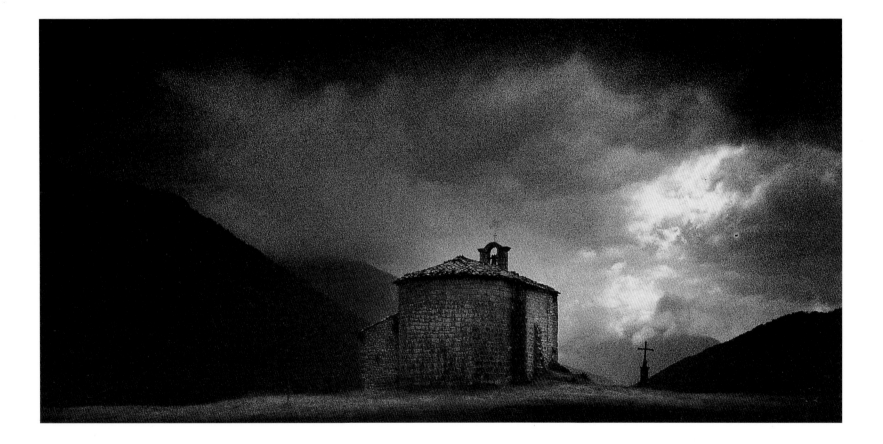

Image notes

A rich, cool, purple-brown tone seemed appropriate for this rather sombre, moodier image, I could not imagine the print with the kind of warm, summery, split-toned highlights of **Epping Forest** or **Rannoch Moor**, even though it was photographed in midsummer and at midday.

A few months after I made the photograph, I met up with a photographer friend of mine who had recently been to France. Much to my surprise he had photographed the same, quite remote location — but with colour transparency film. Even more surprisingly, both our images were made from almost exactly the same camera position and yet they could hardly have differed more in their personal viewpoint: his was brighter and full of summer colour. The difference didn't end there.

Like all good colour transparency photographers, he had waited for the right light, so that he could make his image without the use of heavy, and often inappropriate camera filtration. By comparison, my image relied almost entirely on darkroom techniques. And, whereas his colour transparency image made excellent use of the natural colour contrast of the scene — between the orange pantiled roof, the green foliage and a blue sky — my black and white print relied on more artifical means of illumination: a hard grade of paper, dodging, burning-in and local bleaching.

At the moment of camera exposure, the forked cloud was barely visible, whilst the building, foreground and surrounding landscape were all highly detailed, yet poorly separated in tone when visualised in black and white. A year or so earlier in my black and white photographic 'career' I, too, would have waited for 'better' evening light to get something of the heavier feel that I was after, without realising that darkroom techniques could do the job just as well, if not better. Fortunately, I knew just enough about the potential of the darkroom to realise that the camera exposure could, and indeed should, be made then — when the unusual cloud formation was perfectly placed.

To get the light back into my image required a mixture of careful dodging and local bleaching work with Farmer's reducer (formula 38). Extensive dodging on its own would not have worked; it would have left the side of the building and the foreground without a good black, and without the local, eye-catching increase in contrast, brought about through selective bleaching.

Making the print was easier than anticipated, but still took a day to complete. Time is something I am prepared to spend on a print, provided the negative is suitable and the image has potential.

1. The final image is so dependent on the right cloud formation. Even careful printing would not make a good picture from this negative.

2. No longer a landscape, but an architectural photograph and a bad one at that — requiring stronger, more directional, light to give shape and form to the building.

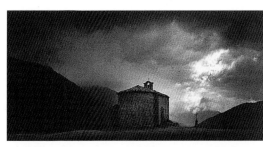

3. Toned, but without any local bleaching, the print looks really flat. Bleaching after thiocarbamide or sodium sulphide sepia toning does not work very well — it changes image colour.

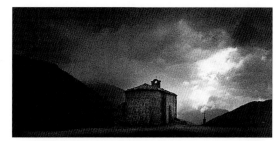

4. Locally bleached in the building and clouds, but with less detail in the forked cloud than for the previous image — the result of less burning-in at grade $^1/_2$. To make the final print overleaf, I also bleached the foreground, viewing the print in a mirror to check its balance.

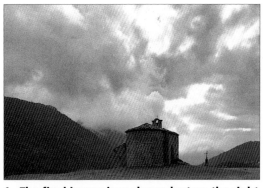

5. This is how the print looked just prior to toning. To maintain strong blacks, I didn't bleach it all the way back in the toner bleach (formula 46). After bleaching, the print was washed for about ten minutes in water at 20°C, until all the residual yellow stain had cleared, as shown here.

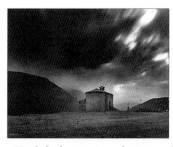

6. A 5" x 4" pinhole camera photograph. The 5-second camera exposure time for the TMax ISO400 film shows the speed at which the clouds were moving.

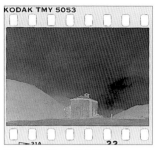
Kodak TMax ISO400

TECHNICAL DATA

The basic print exposure was made at grade 3¹/₂, during which time I used a small dodger to lighten the side of the building and the foreground — just a little — prior to their bleaching in Farmer's reducer.

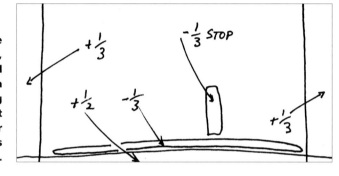

I used grade 4¹/₂ to burn in the sky, enhancing the tonal separation of the clouds. I doubled this exposure time in accordance with Ilford's VC paper filtration instructions.

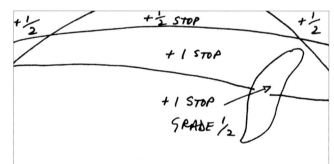

After fixing and briefly washing the print, I locally bleached the foreground and the building with a brush dampened with Farmer's reducer. The clouds at the top of the print were similarly bleached, but with a cotton wool swab for a more diffused effect.

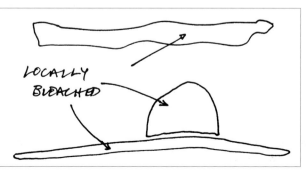

1. Subject:
Not the most promising of locations. In fact, it was only after I made a return visit to the place — approaching it from the opposite direction — that I realised the potential of the scene. Fortunately, this return trip coincided with a very changeable period of weather so I decided to stay for a while. Actually I only had to wait about half an hour before I saw the forked cloud formation develop, at which point it was simply a matter of waiting to see whether its rapidly changing shape would hold until it was in the right position. Fortunately, it did.

2. Camerawork:
35mm Nikon FM2 camera, with a 50mm lens set at f.11 and at ¹/₁₂₅ second. I used an orange filter, worried that red would be so strong as to leave potentially insufficient, printable — and dodgeable — detail in the shadows of the negative. With the clouds moving so quickly I had little time to establish the best viewpoint, but in hopeful anticipation, I erected the tripod, metered the scene with the centre-weighted meter and focused on the building. At f.11 I knew there would be little depth of field problem. The film was Kodak TMax 400, rated at ISO320.

3. Film processing:
I like experimenting with different developers and altering the method of development to see if negative quality can be improved. I chose Agfa Rodinal, diluted at 1+50, used at 20°C, with agitation for the first 10 seconds and for 10 seconds each minute. It worked very well, but only because I had rated the film at ISO320. TMax developer might have given full ISO400 film speed with better shadow detail.

4. Print exposure:
I only had one negative in which the rapidly moving clouds looked just right. I cropped this frame both top and bottom to match the same 1:2 format as the rest of a series of prints I was making, whose shape was anticipated prior to camera exposure. Once I had the right grade setting I made a couple of extra straight exposure prints at +¹/₂ and +1 stops, to determine burning-in times for the sky and foreground. For the same reason I also made a grade ¹/₂ test-strip of the forked cloud area, at +1 stop. I exposed the print for the mid tones, dodging the relevant shadow areas.

5. Print processing:
At the time I was trying out Champion Suprol paper developer, which gives very slightly warmer tones than normal. A more neutral tone developer might have resulted in a cooler, purple-brown, thiocarbamide tone, although I do like the final image colour. Development time was 3 minutes, followed by an acid stop and two-bath fix of Ilford Hypam. After a 5-minute wash, I locally bleached the dodged areas of the print with weak Farmer's reducer, taking care not to overdo it in case of local image colour change after toning — as with the Walkam Valley prints. The toner ratio was 5 parts activator to 1 part thiocarbamide.

6. And finally:
After some deliberation I decided to retouch the iron cross. As you can see from the picture opposite, it was broken. I think this final touch helped — perhaps not? I try to avoid 'religious' subject matter — although the photograph has sold well, its appeal is not as universal as a generic landscape.

Walkham Valley

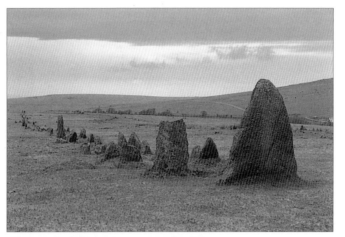

Above: straight exposure proof print.
Opposite: the final, thiocarbamide and gold-toned print.

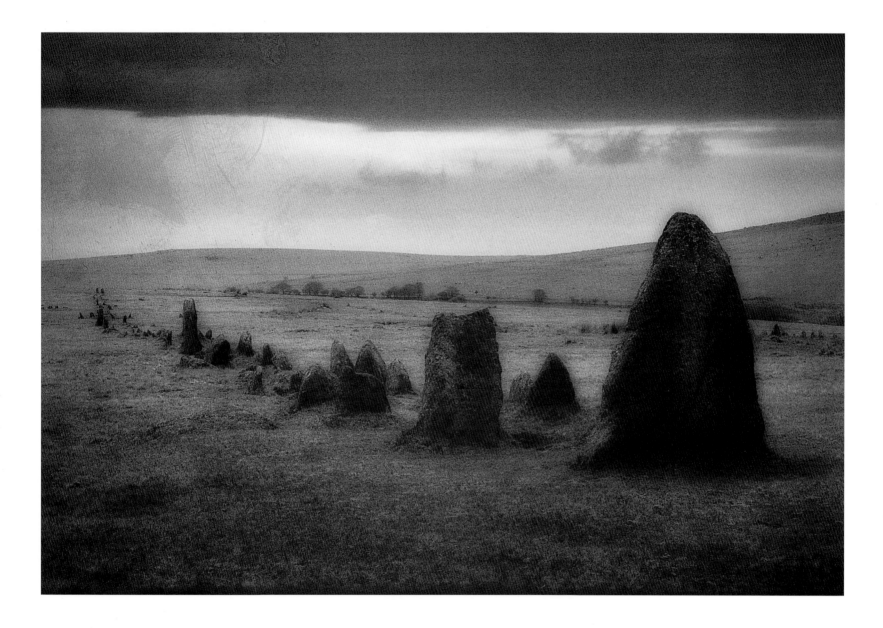

Image notes

There are prints you make to learn about photography, and there are those you make to see how far you've progressed in the medium. I'd say this print falls into both categories. First, it taught me that I can't locally bleach a print with Farmer's reducer if it is then going to be both thiocarbamide and gold toned for a very warm-orange effect. Second, it showed me I haven't progressed very far or, at least, how easily I can forget what I have often so painstakingly learned.

What I'm specifically talking about here is the fact that I concentrated too much on the quality of light that I saw at the moment of camera exposure, rather than the way the film and print would have recorded and registered it. The result was that, whilst I liked the image, it would take considerable effort at the printing exposure stage to achieve the feeling of light that I had experienced.

I have encountered this sort of problem before, with **River Authie** for example. There, it was a case of trying to flatten off the light, by fogging the print, to create a softer, mistier effect. Here, I wanted to maintain contrast and not just in the highlights, but also in the shadows around the stones. My first solution was to print for the highlights and bleach around the stones with Farmer's reducer. In black and white it worked, when it was thiocarbamide toned it still worked, but when it was subsequently gold toned the bleached area stood out like a bald patch in the grass. The result was very disappointing, especially as the best-balanced print of that session was one that had received this treatment.

I should have known better. Just because the process worked well on the thiocarbamide-toned print of **Route Napoleon**, I shouldn't have automatically assumed it would work equally as well for the multiple gold-toned print here. With the benefit of hindsight, it is fairly easy to understand that the more finely divided silver that the Farmer's-bleach attacks first is also the same finely divided silver that the gold toner works on to produce an even warmer tone than thiocarbamide used alone.

As for the final print, I like the back-lighting and the amount of depth I feel I managed to hang onto in what was actually a very dim, but contrasty, scene. Either way, it is interesting to compare this image with the Standing Stones photograph in TONING. There, the quality of light is quite different, in fact almost the exact opposite. What is more, thinking about that image has prompted me to remember that I dodged and bleached the stones on the right to lighten them — and it worked.

1. An alternative view of the scene, photographed earlier in the day. From this angle, the main stone is less well defined and the light too diffused to give any sense of shape or form to the others.

4. When burning in the top of the sky, I was careful to keep the card moving to grade in the extra density being given to the cloud. Not burning-in the cloud would have left the bottom of the print much too heavy.

2. Burning in the lower foreground and later the top of the sky adds depth to the scene, drawing the eye into the photograph and then along the line of stones.

5. Burning in the right-hand side, then the left, has helped to grade in, more gently, the framing effect of the black borders. It also balances the top and bottom burning-in effect.

3. By flexing a sheet of card, so that its shape follows the skyline, it is possible to burn in the sky without accidentally darkening the top of the hill. Moving the card grades-in the effect.

6. A bright patch of sky to the top-left kept taking my eye out of the picture, rather than along the stones and towards the central light-source. Here, it is being burned in.

Ilford Delta ISO400.

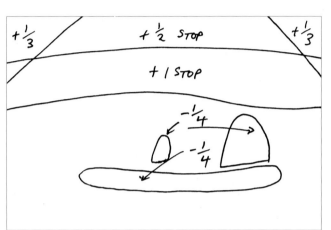

I very lightly dodged the stones, but for just a ¼ stop and no more. Diffusing a print makes the blacks weaker in tone, so dodging must not be overdone.

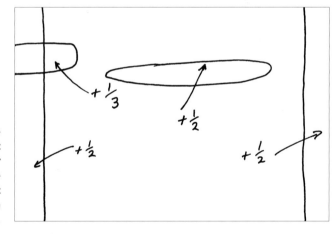

Unlike Black Mount, all the burning-in of this print was made at one VC filter setting, grade 3. I felt the tonal range of the print didn't want too much over-emphasis.

I locally bleached the foreground in a couple of versions of this print, but that changed the colour when it was gold toned. I resorted to dodging the final print, as shown in the top diagram.

1. Subject:
I found this location on Dartmoor, after scouring the Ordnance Survey maps of the area. The words "Stone Row" were printed next to what looked like a quite promising, lengthy, man-made feature. A preliminary visit to area, mid- afternoon, indicated that early evening might be best for a backlit photograph, with the line of stones leading westwards towards a setting sun. Such preparation is fine, provided all the variables are taken into consideration. In this case I failed to visualise how the scene would look if the sunlight wasn't direct enough and if there were no shadows. The outcome was that I got the sunset I wanted, but the foreground was flatly lit, with little separation of tone, creating a negative that was hard to print.

2. Camerawork:
35mm Nikon FM2 camera, a 50mm lens, Ilford Delta ISO400 and an orange filter. I focused on a point beyond the main stone and stopped the lens down to f.16 (one stop further than I would normally like to go) to get maximum depth of field. In the enlarged 20" x 16" print, everything appears relatively sharp, as suggested by the camera's depth of field preview. Just as with Wistman's Wood, I had problems with my tripod, because, as at Trumpan, the stones are actually quite small. To get a view of them that looked up at the light necessitated a low viewpoint.

3. Film processing:
Ilford LC29, diluted 1+29, agitated for the first ten seconds and ten seconds a minute thereafter. 12 minutes development produced negatives, exposed at ISO400, that were of the right density for me.

4. Print exposure:
Diffusing the stones during enlargement has helped to enhance their presence, whilst cutting back the amount of unwanted, detailed background information, including a road and a pub. The latter is just visible to the right of the scene in the proof print and has been retouched out of the final version along with the road. The diffuser I used was an anti-Newton glass from a 6 x 6 cm transparency mount. It was held in a VC paper filter holder, under the lens, for the duration of the entire print exposure — including the burning-in of the sky. As with King's Tor, I decided to use an oversize negative carrier to print in black borders. I was worried that without this the bright band of sky, that runs through the middle of the print, might distractingly lead the eye out of the image. The paper was Multigrade matt.

5. Print processing:
Standard development, stop and fix, followed by a rinse and hypo-clear. The prints were then washed for a further hour before being bleached in formula 46 with double the amount of potassium bromide for added warmth. After a 10 minute wash, to clear the bleach's stain, I thiocarbamide toned the print in formula 50, made up at the weakest activator dilution for the warmest tones. Further to another 30 minutes wash, I partially gold toned the print, taking it a little further than appeared correct, simply because I knew the colour would flatten off as the print dried down.

6. And finally:
Ideally, I would have preferred more directional light to give the stones added form, but this might have made the print look too busy.

Ardmore Point

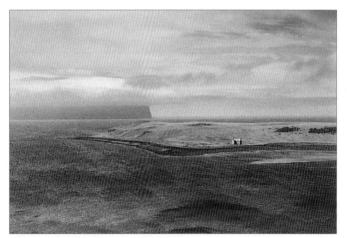

Above: an alternative viewpoint.
Opposite: the final, selenium-toned print.

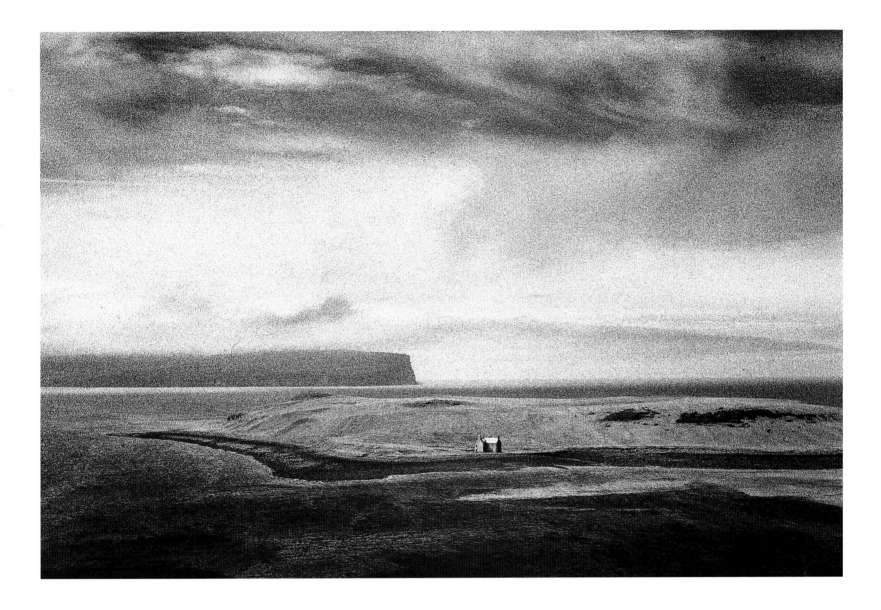

Image notes

Not the most startling of compositions, but to place the building anywhere else within the frame, and attract the same attention (as the photograph on page 21), might have required cropping of the negative, or a longer focal-length camera lens.

When I visualised the image, before the moment of camera exposure, I was particularly interested in keeping the foreground fairly uniform in tone. I didn't want any bright, distracting highlights on the water that might take the eye away from the small and potentially indistinct structure of the building. However, I did want to enhance the subtle cloud pattern of what might otherwise have been a large, very dull, area of sky. To this effect — although it may look as if the lighting was quite harsh — I had to use a red filter on the camera, and then a grade 5 VC paper setting, to get the contrast and tonal separation that I wanted. The effect of the midday haze was much stronger than appeared to the eye.

In comparison, the main **Bradwell Barges** photograph relies quite heavily on a uniform tone of sky to provide little information, or clue, as to the whereabouts of the boats. In that picture, because the barges were larger and bolder than the building here, the possibilities regarding composition were more numerous.

When making the print of **Ardmore Point**, I was particularly concerned about balancing the overall tonal values of the image so that the building and distant headland would be able to compete with each other, rather than with the rest of the print. So, once I had made the basic exposure, during which I briefly dodged the building, I carefully burned in the print from the horizon upwards, using a straight-edged piece of card. The white upper surface of this card enabled me accurately to locate the projected line of the horizon when the enlarger was switched on. Holding the card quite close to the print easel, and moving it up and down very slightly while burning in, permitted me carefully to darken the headland. This precise exposure work also meant I could retain the lovely area of subtle lighting, just below the horizon, towards the left-hand side of the print.

The headland burned in, it just remained further to expose and darken the sky, grading in this exposure by moving the card up and down in gentle sweeps. After that, I darkened the bottom-left and upper-left corners of the print in the same manner and then both sides of the image to hold them in. Finally, some extra local exposure, at grade $^1/_2$, darkened a potentially distracting cloud in the upper-left corner.

1. The building is just visible to the left of the photograph. Adopting a higher viewpoint and placing the subject centrally in the frame, as in the final print, makes an enormous difference.

4. I used a straight-edged card to burn in the sky. In the past I might have tried to carry out this type of precise burning-in work using my hands — usually without success.

2. Dodging had to be precise to lighten the building slightly, whilst leaving the surrounding headland looking realistically darker.

5. Two cards, simply held at right angles to each other, formed the required shape for burning in the top left of the sky.

3. Burning in the sea to the bottom-left was uncomplicated, but nevertheless, it merited the use of a 'burning-in card' (as for photograph 5) for a predictable, smooth gradation of tone.

6. Bright, distracting areas are quick to show themselves in the print, but are often hard to locate when trying to burn them in. A white-backed card makes this exposure work easier.

Kodak TMax ISO400.

TECHNICAL DATA

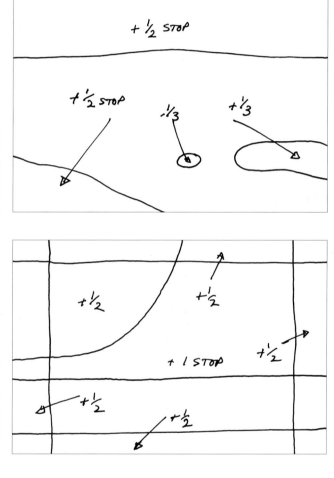

+ ½ STOP

+ ½ STOP -⅓ + ⅓

The print was made at grade 5. The very limited exposure latitude of this harder grade required precise dodging and burning-in.

+ ½ + ½

+ 1 STOP + ½

+ ½

+ ½

I almost always burn in all the edges of my prints. Sometimes the effect I want is quite subtle, as here. King's Tor and Walkham Valley required more edge-exposure.

+ ½ GRADE 1

VC papers really come into their own when bright, distracting areas need to be toned down using softer grade setting. Flashing or fogging is the only alternative for a graded paper.

1. Subject:
Ardmore Point is situated in the remote NW corner of the Isle of Skye, off the west coast of Scotland. Although I had marked it on the map, my main preoccupation when visiting the area was the 'Trial Stone' at Trumpan, just a few hundred yards away from where this photograph was made. Only when I was photographing Trumpan and waiting for the light to change — so that it would fall on the face of the stone — did I take in the potential of the scene that lay behind my camera position. After a brief wander around, to ascertain the best vantage point, I made various exposures of the Point, of slightly differing composition, with Dunvegan headland in the distance and without even having to wait for the light to change. The shadows falling on the house were just right.

2. Camerawork:
35mm Nikon FM2 camera, with a 50mm lens set at f.11 and at $1/60$ second with a red filter. I did wonder at the time if the tiny building would be lost in the vast expanse of openness, particularly as I was using TMax ISO 400, faster — always inherently grainier — film. In fact, a longer focal length lens was not needed, although the building did disappear in some exposures I made with a wider-angle 35mm lens. Careful dodging of the building, and selective burning-in elsewhere, has maintained its understated prominence within the scene.

3. Film processing:
Agfa Rodinal, diluted 1+50, 13 minutes development at 20°C. A finer-grain developer, like Kodak TMax might have clarified the house a little, but would it have made the image any more effective?

4. Print exposure:
I had at least half a roll of negatives to choose from, but only one in which the sea in the foreground wasn't visibly ruffled by the wind. Although I had used a red camera filter, a grade 5, VC filter setting was necessary, combined with a condenser (contrastier) lightsource. Both of these enhanced the graininess of the print, which required spot-on focusing of the negative prior to print exposure, made with a 50mm El Nikkor lens, at f.8. I made the print on Ilford Multigrade FB matt. Using a gloss surface would have given me more contrast, were it needed.
Fortunately, Multigrade FB is the most contrasty of the FB, VC papers I have tested. Other (FB, VC) papers may not have provided adequate contrast.

5. Print processing:
I very slightly underexposed the print, and then developed it for a factor of 7 to get maximum print contrast. To reduce the risk of fogging during processing, I switched off all but one of the safelights. The print was stopped in 2% acetic acid and two-bath fixed in Hypam at 1+9. After washing and hypo-clearing, I bleached and redeveloped the print using the blue-black image colour combination (formula 57 + 58). After a fifteen minute wash, I selenium toned the print with Kodak Rapid Selenium toner, at 1+5 for 3 minutes, to pick up the blacks and to enhance the subtle blue tone. The finished matt print has a lovely, almost velvet-like quality, sadly lost here as with any photo-mechanical reproduction printing.

6. And finally:
I'd like to go back! Scotland possesses such a wealth of photographic opportunities.

Eileen Donan

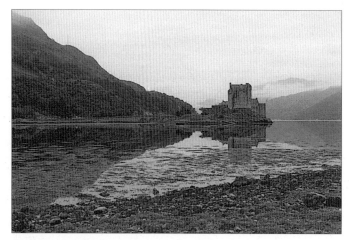

Above: straight exposure proof print.
Opposite: the final, overexposed and bleached print.

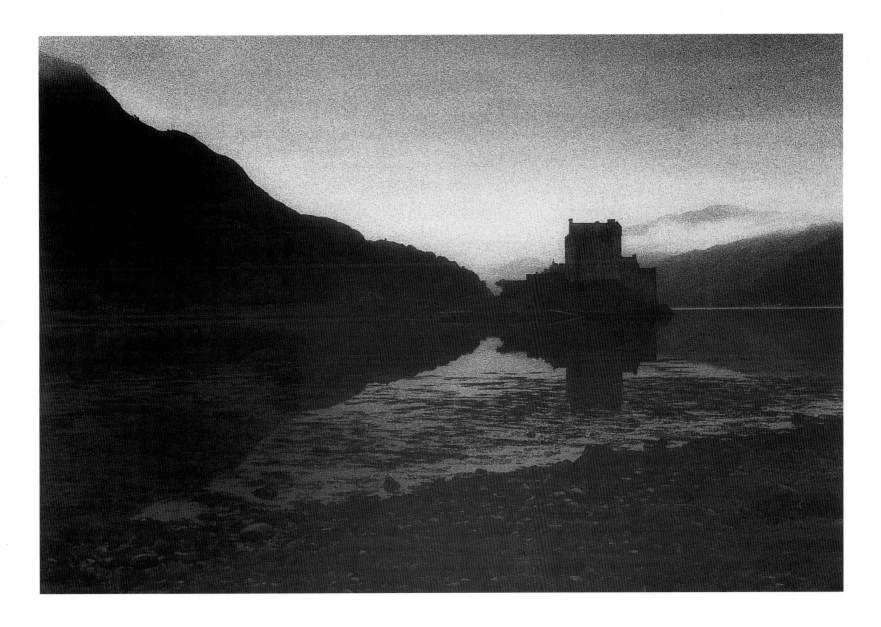

Image notes

This was one of the few occasions when I have opted to photograph a well-known and already overly photographed location. Why? Quite simply, I was curious to see what I could do with the subject. Almost all the photographs of it that I had seen were very traditional in their approach, made from a higher viewpoint (on the hill to the left), overlooking the castle and taking in the Isle of Skye — behind my camera position.

I decided upon a less familiar angle and one that looked inland. I also opted for a partially silhouetted, less obvious approach, that would, I hoped, be more subtle. I didn't want to rely too heavily on the viewer's ability to recognise the scene as a way of making the image work. To this effect, I made the photograph early in the morning. In Scotland, mid-June — the summer solstice — brings with it very long hours of daylight, so that by four a.m. it was already almost too light! However, one of the advantages of being up so early was that the place was totally deserted, the other was that on this occasion I was fortunate enough to watch an otter casually feeding, just a few yards out from where I was working.

For the type of partially detailed silhouette that I wanted, I decided that a correct, rather than an underexposed camera exposure would be best. I reckoned that this would give me the option to dodge or burn in any part of the negative later in the darkroom, if needs be. In fact, I dodged the castle a little, but only enough to separate it tonally from the rocks on which it sits.

I overexposed the print by one stop and a half, so that I could bleach it back later in Farmer's reducer. This 'lifted' the cloud detail behind the castle, without letting the darker image areas become too light — making the silhouetted effect more pronounced. However, to retain some detail in the foreground, I used a grade softer paper than normal, so that when holding the unbleached print up against a strong light, I could see some detail waiting to be made — just — visible by the bleach.

After I had worked out the basic exposure time, the print wasn't too complicated to expose: some burning-in of the general, triangular-shaped reflection on the water was necessary, (I will almost always burn in a reflection if I am going to burn in the sky) and an adjacent area that was also too light. I also slightly darkened the bottom-right corner of the print and then gently burned in the sky, grading it in using a flexed — curved — sheet of card which I moved back and forth with a gentle sweeping motion. And, to be on the safe side, I made at least three final prints for bleaching.

1. An alternative, poorly balanced view. The reflections are more harmonious in the final version, leading the eye into the photograph.

4. Bleached back too far, the print now lacks adequate contrast and density. This cannot be replaced as the work of Farmer's is permanent.

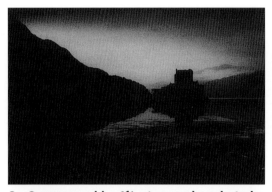

2. Overexposed by 1¹/₂ stops and ready to be bleached back in a dish of Farmer's reducer. The print only needs to be briefly washed before this processing stage.

5. At the bottom-left of the image was an overly bright reflection of the hillside. If not dealt with, this area would have gained prominence after bleaching. I burned it in.

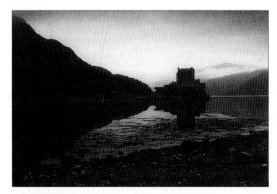

3. Partially bleached back in Farmer's. The print lacks subtlety and balance. Further bleaching is required, which can take a total of 10 minutes or more.

6. Burning in the sky using a card, as described in IMAGE NOTES. If print exposure times that are too short there is a risk of lines appearing where such printing tools are moved slowly.

TECHNICAL DATA

Kodak TMax ISO400.

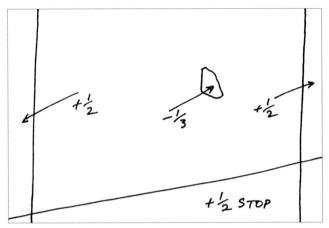

The print was made on grade 3¹/₂. I dodged the castle very briefly, trying not to lighten the rock on which it sits.

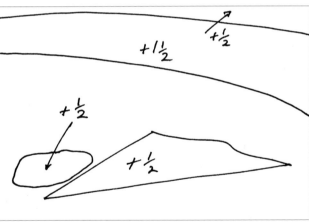

Compared with some of my other images, this print was not complicated to expose. The triangular reflection was burned in with a card, like that used for Loch Ainort.

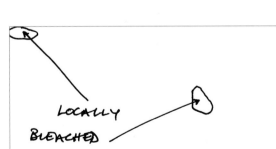

The whole print was bleached in Farmer's reducer. Some additional, local bleaching work helped to lift the cloud at the upper-left and to enhance the building.

1. Subject:

If it's the atmosphere of a place you want to convey, then Scotland is ideal. The landscape is suitably uncluttered and the climatic conditions usefully varied. Generally speaking, it is a country I prefer to photograph when the weather is less pleasant: foreboding cloud cover, interspersed with the odd patch of sunlight, seems a more fitting backdrop than a clear, bright-blue sky. Whether this would be true for colour photography, I don't know. I often find it hard to remember the colours of a place after I have been photographing it and visualising it in black and white. A healthy sign.

2. Camerawork:

35mm Nikon FM2 camera with 35mm PC lens. In this instance I didn't need to use the perspective control facility of the lens, as discussed in Epping Forest (CAMERA-WORK). I opted for a yellow filter. Anything stronger might have penetrated the misty haze too much, losing valuable atmospheric effect. I set the lens at f.11 and focused just beyond the shoreline, in the middle of the image. With the camera mounted on its tripod, and the wind virtually non-existent, I was happy to expose the film at the necessarily slow shutter speed of ¹/₂ second. The light level was very low indeed.

3. Film processing:

I didn't keep processing notes for this film. I'm not too sure exactly why, but judging by the crispness of the grain I would suggest the negatives were developed in Agfa Rodinal, an old favourite of mine. It is amazing to think that this popular developer recently celebrated its 100th anniversary.

4. Print exposure:

A straight print from this negative produces too much detail and a sky that is too light. Printing the picture darker and burning in the sky doesn't help much — it still looks too photographically alive. But printing on matt FB compressed the tones nicely, producing a less abrasive result. More often than not, I don't like prints that jump off the paper at me, preferring instead the sort that invites the viewer to look into the image. Printing this photograph on glossy paper really does create an image whose composition and pattern of shapes, are far too bold. In my view, these shapes are merely the frame upon which to hang the atmospheric, misty effect. The print was made on Multigrade FB matt and exposed with a very old, cheap diffuser enlarger. Yet, in the final print, the grain is very sharp across the whole image.

5. Print processing:

If a print is to be bleached back then it must be developed evenly, or else the bleach will accentuate any processing tide marks, rather like the bleached, but untoned, test prints in TONING. With this in mind, I will develop such prints to completion. In this case the print was developed for 3 minutes at 20°C, after which it was stopped and fixed normally, prior to a 10-minute wash. It was bleached in formula 38 i, but with four times the amount of water added to slow down the process. At this dilution, the solution will need to be changed after each print.

And finally:

Photographic prints are best seen firsthand. I fear the subtlety of this print may be lost in its reproduced form here.

King's Tor

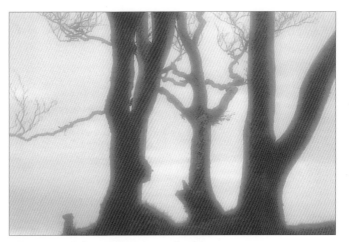

Above: straight exposure proof print.
Opposite: the final, thiocarbamide-toned print.

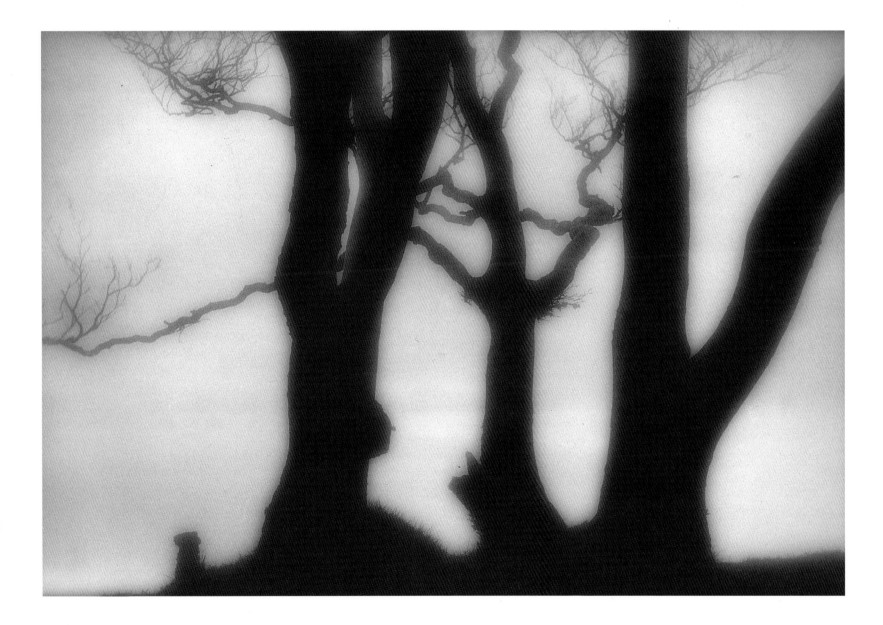

Image notes

I discovered these trees quite by accident, after I parked my car right next to them. I was preparing to investigate the stone row of **Walkham Valley**, a few hundred yards away. It was mid-afternoon and the trees barely caught my eye, but when I returned to the car later, they were transformed. The heavy rain of that afternoon had left their trunks blackened in effect and an idea was sewn.

Viewing them then, with the 35mm camera's 50mm lens stopped right down, I tried to visualise how they would look totally in silhouette, against an evening sky. The first thought that came to mind was that I needed a longer lens, of about 70mm focal length. I didn't have one. If I stuck with the 50mm, I knew I would get an image that was too three-dimensional in effect — and that wasn't what I had in mind.

Having established a good viewpoint and worked out that the evening would be best, I decided to go in search of a suitable lens. Several phone calls later, and a drive to south Devon, produced a Nikon zoom lens, courtesy of an old friend. I was set, and a couple of days later, when the weather forecast sounded promising, I returned to the location, but first to photograph **Walkham Valley**. The trees could afford to wait till later in the evening.

I made various exposures of the scene as the light changed. I wanted a fairly plain backdrop of cloud, but for most of the time it was broken and the setting sun was clearly visible in the viewfinder. It was eventually quite late, when my camera meter could barely make a reading, that I got the backdrop I wanted. Even then, it was still a little broken up, but I knew that fogging the print later could take care of that.

When I first visualised the photograph, I had a clear idea of what I wanted, but it would require using a method that was totally new to me. I had thought of diffusing the image in camera, to soften the smaller branches and to make the backlighting diffuse into the main tree trunks. I also had the idea that I wanted to diffuse the same image under the enlarger, to get the trunks to bleed out slightly, and also to make the black print border, that I thought was necessary, bleed into the image. But would it work?

To be on the safe side, I made a number of different camera exposures, both with and without diffusers, from a variety of slightly different camera viewpoints, and at slightly differing focal length settings. But time was not on my side. My camera exposures were running into three minutes and more, and the light was fading fast.

1. This uninspiring overview is how I first saw the scene. The trees of the final print are just visible to the left of this photograph.

2. Almost there, but not quite. If worked on, this negative could produce a good print but not a particularly interesting photograph.

3. Sunset. I'm still not sure of this viewpoint. For a start, the trees don't fill the frame, whilst the low camera angle perhaps unrealistically makes the sun look a little low in the sky.

4. The basic print exposure made, I then added a series of fogging exposures, pencil-marking the edge of each for identification later.

5. The left-hand branch, rather distractingly, doesn't appear to connect with the black print border. A small, but important detail.

6. The problem of the branch could be solved by cropping the photograph, but that would lose the black border. Simpler, I decided, to retouch it using an artist's 000 size brush.

Ilford Delta ISO400.

1. Subject:
A car park on Dartmoor hardly sounds like a promising location, but that is where these trees are situated. Stumbling across subjects, such as this, rekindles one's desire to look for the unexpected in everything. For example, as I walk towards a location, I occasionally look behind me to see if I am missing out on a better, perhaps unplanned, viewpoint. In this case, the location covered such a small geographical area that I was able to walk around it, and view it, from every conceivable angle in a very short space of time. And the best view turned out to be from a less obvious angle.

2. Camerawork:
35mm Nikon FM2 camera with zoom lens set at 70mm. Trying to get the required depth of field meant f.16, which caused a problem with the rapidly failing light. My bracketed exposures ran from 15 seconds to 3 minutes, and more. I was trying to think how much reciprocity failure would affect the image, knowing that it could affect the shadows and make the highlights of the negative relatively too dense if I didn't alter the film development time. Unfortunately, there were other images on the same roll, so any alteration to film development was out. Fortunately, the film (Ilford Delta ISO400) coped well.

3. Film processing:
Ilford LC29, diluted 1+29, produced a negative of good printable quality from the longest-exposed frame. It contained just enough diffusion of light into the dark bodies of the tree trunks. Shorter development, at a dilution of 1+19, might have produced a negative with more, perhaps useful, shadow detail.

4. Print exposure:
I made several experimental prints to see how the print would look both with and without a black border. I also tried several types of border: thick, thin, diffused and undiffused. The undiffused border version, in TONING, looked as if it was separate to the image, whilst another that was diffused, but without a sharply defined outer edge, looked far too heavy and actually drew the eye out of the photograph. The idea of the border was to unify the picture and to connect all those branches that touched the edge of the frame. As you can see in photograph 5, the thin left-hand branch didn't quite have the boldness of tone at its outer edge, so a little judicious retouching was needed to complete the picture. The print was made on Multigrade FB matt, 20" x 16".

5. Print processing:
For toning work I will usually standardise my developer type, its dilution and development time. Changing any of these can introduce unforeseen variables into the toning process, so for this print I used a standard developer: Ilford Multigrade, diluted at the recommended 1+9 ratio, in which the print was developed for 3 minutes at 20°C. The latter is my standard development time for 20" x 16", FB prints. After processing, the print was partially bleached in formula 46, then thiocarbamide toned in formula 50, after which it was briefly gold toned (rather like Walkham Valley), although the thiocarbamide bleach and tone were somewhat briefer.

6. And finally:
I made a number of prints of different balance, but the burned-in outer edges of this print make it work the best.

It was necessary to dodge between the left-hand tree trunks, then between these and the left-hand branch. Enlarger diffusion made them blend into each other. The print was made on grade 3.

Burning in all the print edges, for ¹/₂ stop, reduced the contrast between the sides of the print and the black borders.

Some brighter areas of sky required additional fogging. A mask wasn't necessary. These areas were larger and easier to work on than those of River Authie.

Rannoch Moor

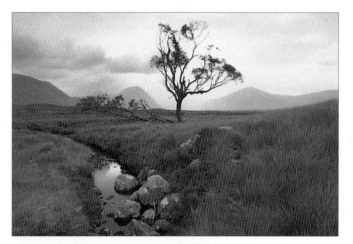

Above: straight exposure proof print.
Opposite: the final, thiocarbamide-toned print.

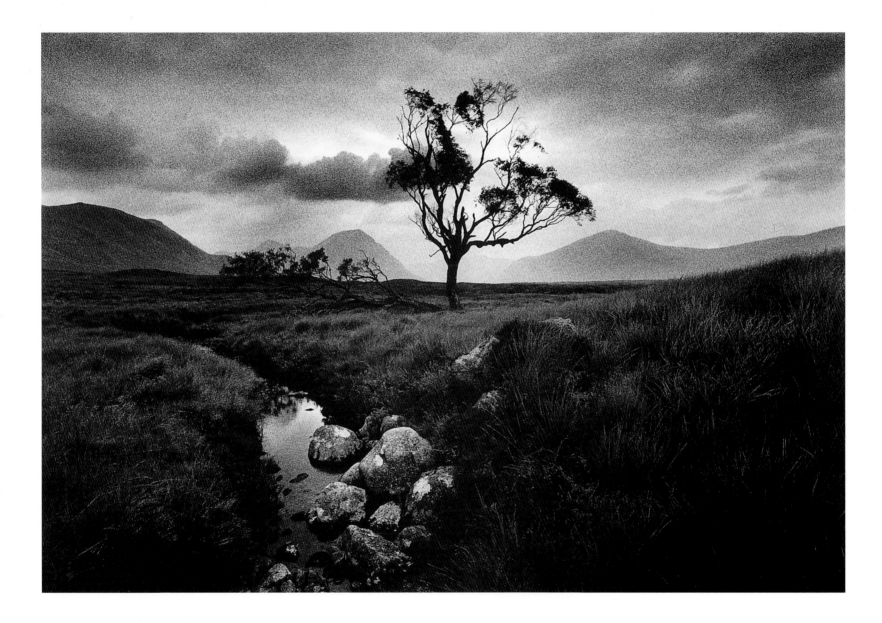

Image notes

There can often be just a minimal difference in time between what is judged to be the right, or wrong, moment of camera exposure. Literally a few seconds earlier, the highlighted cloud was sitting too far to the left, a few moments later it was obscured by the tree. More often than not, such decisions have to be made too quickly, perhaps whilst the light is also fading fast, as at **King's Tor**.

Compare this often hurried process of decision making with that of fine-print making. For me, there is no better way of making an exhibition-quality print than to build up to it slowly, by making a series of test-strips and afterwards to line these up along a wall, out of the darkroom, and to view them whilst sitting in a comfortable chair! In this way, all the prints can be carefully studied in a relaxed, unhurried manner, to assess their contrast, density and balance. It is a great way of being able to focus all one's thoughts and energies into a photograph, without the natural elements taking any sort of control.

So, whilst I envy colour transparency photographers for the relative speed, and mechanisation, of their process, I don't envy them for what they miss by not having to spend time over their images in the darkroom. With rapid processes, like E6, it is possible to be thinking of making the next completed image before the previous one is dry, let alone processed.

Time spent in the darkroom, working on black and white prints, isn't time wasted. It is one of the best ways of seeing mistakes, and successes, in camerawork gradually unfold in front of one's eyes. For example, **Rannoch Moor** looked good in camera, and as a straight print, and even better with the sky and foreground burned in. However, time spent looking at various other exposure permutations, especially viewing them upside down, revealed that the image needed further print exposure work to achieve a harmonious sense of balance.

In particular, the hill to the left merited some attention. I hadn't noticed it at the moment of camera exposure, but altering its density dramatically improves the print. Too heavy, and it pulls the image of balance, too light and its detail becomes unnecessarily obvious.

And of the time spent working on this particular photograph in the darkroom? It has contributed towards a feeling of greater affinity between my camera and darkroom work. The upshot is that on location I am finding it progressively easier to deal with rapidly changing scenes, such as this, which require carefully timed exposures.

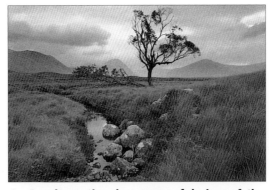

1. An alternative, less successful view of the scene, made from the same camera position, but simply at a different moment in time.

4. Burning in the bottom-right corner of the print plays down some unwanted detail, as shown by the photograph in PRINT FINISHING.

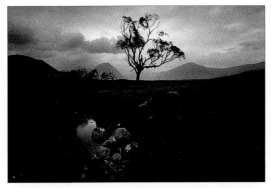

2. My first attempt at printing this negative was made on too soft a grade of paper. Although the print has a full range of tones, it looks too flat.

5. Burning in the main cloud at a harder grade setting enhances its role in the print. It also ensures against possible loss of contrast with the yellow thiocarbamide tone.

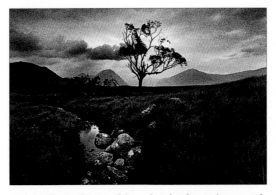

3. At first glance this print looks quite good, but comparing it with the final version reveals some subtle changes in balance, most noticeably the hill on the left is too dark here.

6. Burning in around the tree with a softer grade setting adds much needed density and directs the eye towards the main cloud, which is the intended highlight.

TECHNICAL DATA

Kodak TMax ISO400.

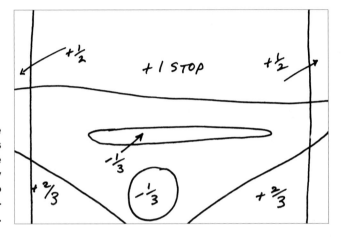

The basic print exposure (and some burning-in) was was made at grade 3. The extra exposure for the sky was carefully graded-in, to stop the top of the left-hand hill going too dark.

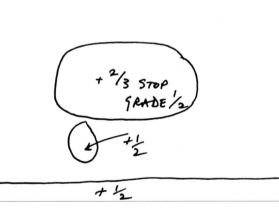

The bright middle-distance area, around the tree, was burned in at a softer, grade ½ setting. This maintained the lower contrast impression of haze.

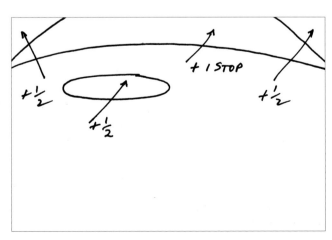

Finally, I changed the setting to grade 4, to build up the top of the print and the cloud, otherwise both would have been lowered in contrast by the warm-yellow tone.

1. Subject:
It proved much easier to photograph Rannoch Moor than Wistman's Wood. There was less subject matter to choose from: a single isolated tree as opposed to a densely packed woodland. Besides, the wonderful quality of evening light, and the obvious presence of the cloud, helped to determine the nature and composition of this photograph. (The same cannot be said of Wistman's Wood). Unlike Black Mount, I opted to keep the main light fairly central to the print, rather like Route Napoleon in fact. Also, a more adventurous composition, such as Wistman's Wood, might have produced a more eye-catching photograph, but here, as with Route Napoleon, I was concerned with letting the natural elements have their say. All that I wanted to contribute to the photograph was carefully judged print exposure and toning work, so that the print would look as natural as possible. More often than not, this simple approach actually involves rather a lot of work.

2. Camerawork:
35mm Nikon FM2, with a 20mm lens set at f.11. With little time for bracketing, I opted for an orange filter, believing that yellow would be too subtle and red too harsh. Besides, the contrast-increasing effects of the latter would almost certainly draw unwanted attention to the foreground grass.

3. Film processing:
With several other scenes of different subject brightness-range all on this one roll, it was not possible to alter the development time. So, I used Rodinal for its compensating quality, although now, for similar backlit subjects, I would probably opt for a two-bath developer.

4. Print exposure:
My first toned print of this negative (photograph 2) proved simple to expose – It would. I used too low a paper contrast setting. Dissatisfied with the result, I opted for a harder grade setting for the basic exposure and for much of the burning-in of the foreground, then an even harder grade setting for burning in the very top of the print and for the cloud. Thiocarbamide split-toning my first effort reduced print contrast in that area, so that just the sky became a subtle yellow-brown tone – hence the harder grade setting.
Trying to cater for such changes in print contrast can be difficult. The final, untoned black and white print of this scene looked top-heavy until it was toned. Deciding what toner is going to be used should therefore be a decision that is made prior to print exposure. (Although the contrast-altering effects of some toners can be usefully employed to salvage certain poorly balanced prints.) The final print was made on Multigrade FB matt, with an old diffuser enlarger and under-the-lens VC filters.

5. Print processing:
Normal development to completion, coupled to my standard use of a 2% acetic acid stopbath and two-bath Hypam fixer, ensured a predictable outcome to thiocarbamide toning. Making the print on the bromo-chloride, neutral tone Multigrade also gave a predictably subtler, less vibrant, yellow tone than that of a warmer-tone chloro-bromide paper, arguably better suited to this image.

6. And finally:
Retouching the print (see PRINT FINISHING) lets the eye to wander, uninterrupted, over the scene.

Glen Coe

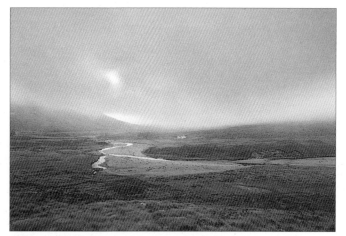

Above: a straight exposure proof print.
Opposite: the final, thiocarbamide-toned print

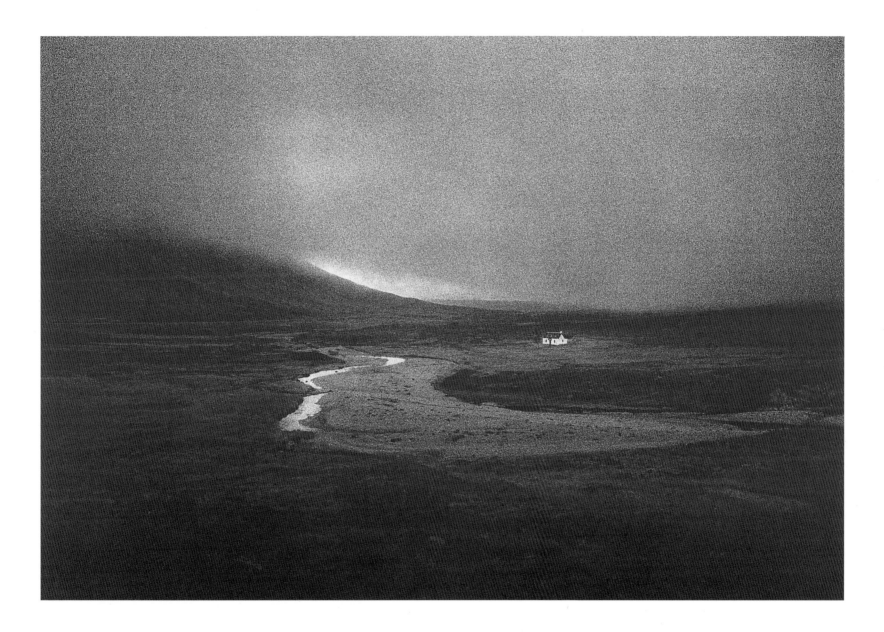

Image notes

Compare this photograph with **Ardmore Point**. They both contain the same subject matter: a small, isolated building in a large, open landscape, but there, I would suggest, the similarity ends.

For a start, they have been printed in contrasting styles to create an individual, distinctive sense of place. For example, the print of **Ardmore Point** is more open, providing the viewer with information about the landscape. In that photograph the function of the building is to lead the eye into the view. From there it is free to wander around the scene, taking in various shapes and patterns of tone. It is as much a photograph about the expansive scenery of the western isles of Scotland as an image of an ordinary looking but isolated building.

On the other hand, **Glen Coe** is almost totally devoid of all information about the landscape. All that is visible is the building, the stream and the break in the clouds. Its content is minimal and the approach quite abstract. My intention was to make an image that spoke of a presumably precarious balance between man and the natural elements.

With this in mind, a cold, thiocarbamide tone seemed most appropriate for **Glen Coe**. I didn't want a colour, like that of **Rannoch Moor**, which would inappropriately liven up the view. In the latter case, the feeling is that sunlight is about to break through from behind the cloud, in **Glen Coe** it is the reverse. The sun seems about to be shrouded in low-lying mist — and it was.

I made various prints of differing balance and tone. It was remarkable how much these altered the atmosphere of the photograph. For example, I experimented by printing the sky a heavier tone. It produced a rather unsatisfactory, solid, and static weight of cloud, that bore down too heavily and overdramatically on the print. Keeping the cloud a little lighter in tone, as in the final print, but darkening its edges, has given it a greater sense of volume and dimension. Looking at the top of the print on page 37, I like to think the cloud is actually moving forward, towards the viewer, whilst in contrast the line of the stream is taking the eye in the opposite direction, towards the light. In between sits the building, not just as the focal point of the photograph, but as a fulcrum around which this activity is taking place.

When I print certain negatives, such as this, I like to visualise a point within the final print upon which I could balance the image. In **Ardmore Point** it lies between the building and the distant headland. If I look at a finished print and find it hard to identify such a place, then, more often than not, I know my printing is at fault.

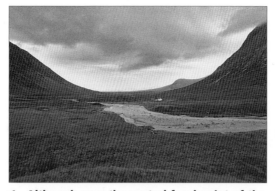

1. Although near the central focal point of the photograph, the building is lost from view. There is too much going on in the scene for it to compete.

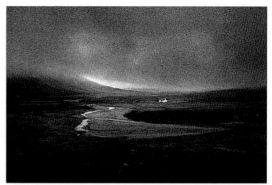

4. I made innumerable versions of this print, some with more detail in the foreground, others with less. The building simply can't compete with the former.

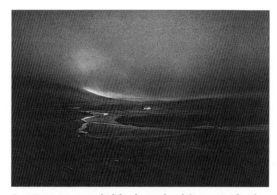

2. A very rough black and white proof. The burning-in is too heavy-handed, to the point where the image lacks any kind of subtlety.

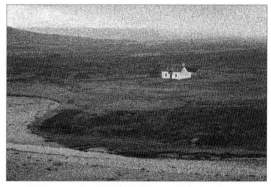

5. The unretouched house blends into the background all too easily, so I knifed the ridge-line of the roof (see PRINT FINISHING).

3. The colour of this toned version seems inappropriate. The balance of the print is similarly undecided, taking the image neither one way of the other.

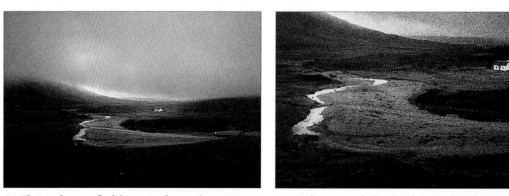

6. A close-up of the final, toned and retouched print. Retouching took almost as long as printing, but it was worth the effort. Even viewed from a distance, this print works.

Kodak TMax ISO400.

I used a ½" diameter black card dodger to lighten the stream, and then one of 1½" diameter for the house and surrounding area. A fifteen-second basic exposure gave enough time for both jobs.

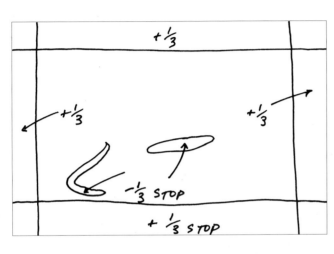

The print was made at grade 4, with the exception of a small bright area of cloud. It was burned in at a softer, grade 2 setting, to avoid a dark halo effect.

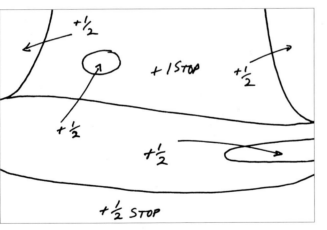

Bleaching these dodged areas with a medium point artist's brush has lightened their highlights but left their blacks intact. Dodging alone could not achieve this effect.

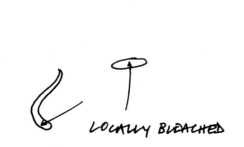

1. Subject:

Landscape photography is not a passive process. Although some subjects immediately catch the eye, and are easily recorded on film with little if any creative input, others may remain lost from sight, unless we are prepared to look for them and to work at them. Just as we can learn to visualise scenes in black and white (as depicted in the photographs in CAMERAWORK), we can also develop the ability to see the potential of a location, even if the weather conditions, or the angle of view from which we first view the scene, are not in our favour. And so it was here. My first view of the scene left me unimpressed, until I tried to visualise what the location could look like, given the right weather conditions and an alternative viewpoint. Previous visits to Scotland gave me an idea of the type of misty conditions I could expect, and told me that first light would be the most likely time of day to capture this effect. It paid off.

2. Camerawork:

35mm Nikon FM2 camera, with a 50mm lens set at f.8. In my haste to expose the film, in between brief periods of good visibility, I suspect I forgot to check the camera focus, having composed the scene with the lens set at infinity. Fortunately, for a scene like this, where there is very little near foreground included in the frame, and what there is of it is printed dark, there was little likelihood of the print looking unsharp, except through camera shake or poor printing.

3. Film processing:

The Rodinal processed negative was fine, with good tonal separation and very crisp grain clearly visible even in the 10" x 8" proof prints.

4. Print exposure:

Even a good negative, with a full tonal range, plenty of shadow detail and easily printable highlights, won't necessarily be simple to print. View it on a light-table and, yes, it is easy to identify those areas that may benefit from burning-in or dodging, but enlarge the same negative, up to, say, 20" x 16" in size, and it can be very difficult to identify the same areas under the dimmer light of the enlarger. In this case, the border between the ground and the sky (which I wanted to burn in) is quite well defined in the negative, but virtually impossible to detect during print exposure. So, I stuck some white masking tape to the black blades of the easel, to act as a clearly visible burning-in markers. When it came to burning in the sky, I simply aligned the burning-in card with these, markers and then slightly moved it up and down this invisible line for the appropriate period of time. The print has been made on Multigrade FB matt.

5. Print processing:

After very much standard processing, I briefly rinsed the print, and then, with the darkroom viewing light on, I locally bleached the line of the stream with Farmer's reducer, using a medium point brush for the more delicate detail. I also applied a little bleach to the house, but not so much as to reduce the density of the building back to paper white. In my estimation that would look too overstated and very contrived.

6. And finally:

I had a few seconds to expose this scene before it was again shrouded in mist. The composition of the proof shows how slow I was to react.

Monkstadt House

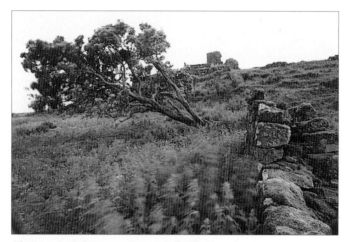

Above: straight exposure proof print.
Opposite: the final, thiocarbamide-toned print.

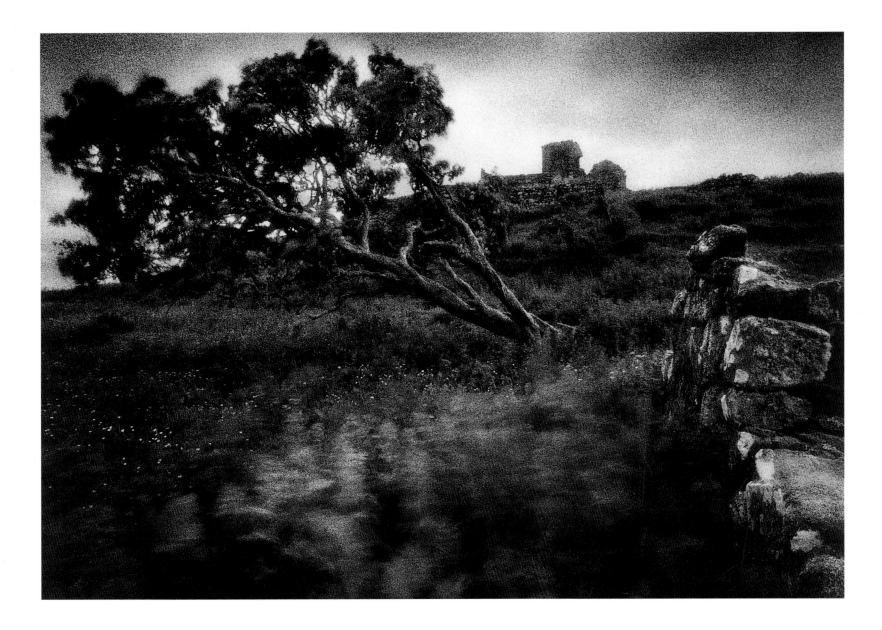

Image notes

How should a black and white photograph be exposed when the light is unsuitably flat and overcast? It shouldn't! A return visit is a much better idea. Yet, perhaps rather foolishly, I opted to expose this image. I decided I could change the quality of light later, through various darkroom methods and techniques.

Making the print was worth the effort, if only to see how far the black and white darkroom process can be pushed. In fact, the end result matches, quite well, the quality of light I would have wanted, had conditions been more in my favour.

For example, the photograph was actually exposed around midday. Evening light, I figured, would have been better; I wanted the light to strike the scene from the right, in the same way that I played the Farmer's reducer over the tree trunks. Photographing the scene later in the day would also have made the sky darker, avoiding the use of a printing mask for that particular area. In fact, because the scene was backlit, I also flashed the sky during printing. This helped darken it enough to balance the print and allow attention to be drawn to the aforementioned trees and to the moving foliage in the foreground.

In all, I took a whole day to make the final print, not counting the time I spent making proofs in the preceding weeks. During that intervening period I looked at the proofs, tying in my pre-visualised print of the scene with what was actually there on the negative, trying to decide whether or not I was being realistic in my expectations.

For a start there was a derelict car to the left of the scene, clearly visible in all the proofs, which would need to be retouched. What's more, in some of the negatives the edge of the lens hood had intruded into the frame. It had been raining a little at the time and I used the hood to keep the front element of the lens dry. An umbrella would have been a better idea, but — typically — that was in the car, a mile away. I should have realised that by using a neutral density (ND) and a coloured glass filter, the lens hood would intrude too far into the camera's view. But I was so intent on using a slow shutter speed, to accentuate the movement of the foliage, that I overlooked the problem of the extra ND filter. Had I looked into the corners of the viewfinder, whilst using the depth of field preview, the hood would have been brought much more noticeably into focus and the problem avoided.

Still, if everything had gone in my favour, there would be little to write about here, and I wouldn't have learnt quite as much as I did! That said, I think I'll wait for better light next time.

1. The wall and tree in the final print make little impact on this view of the scene, which was photographed from the opposite direction.

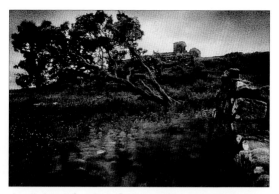

4. A toned print that needs retouching and which would have benefited from the local application of Farmer's bleach, as for the final print on page 41.

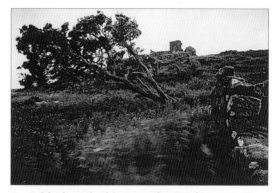

2. A black and white proof print from another negative, which was undiffused in camera. The main elements of the image appear indistinct.

5. Burning in the sky with an accurately cut-out printing mask was easier than it might at first appear.

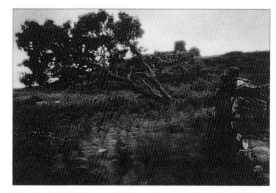

3. I opted for a diffused negative, realising that if I used a printing mask, it would make the grading-in of the burned-in sky look more natural.

6. A little extra exposure to the top-left of the sky prevented the darker tone of the tree from dominating that corner of the print. A mask was not necessary for this less precise job.

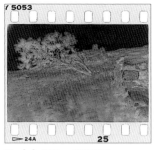

Kodak TMax ISO400.

TECHNICAL DATA

Three separate dodging manoeuvres, totalling almost the entire duration of the basic exposure time, required some quick-handed work.

+1/2 STOP

-1/4

-1/3 STOP

-1/3

The use of an enlarger timer footswitch left both hands free to work the burning-in mask for the sky.

+1 STOP

+1/2

+1/2 STOP

+1/3

+1/3

+1/2

I flashed the top half of the print, grading in the exposure using a flexed card that was moved for the entire duration of the flash.

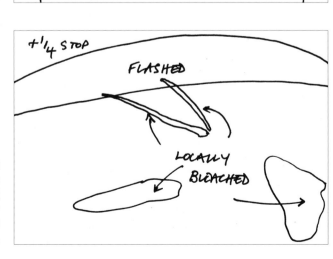

+1/4 STOP

FLASHED

LOCALLY BLEACHED

1. Subject:
It was the derelict house that first drew my attention to this location, then the tree, after which I thought the inclusion of a third element, such as the wall, would add more depth to the image. Including the wall in the photograph, so that it leads the eye up towards the building, also helps to offset the line of the inclined tree, which would otherwise draw the eye out to the top left of the print. Balancing all these elements of composition proved harder than I thought.

2. Camerawork:
Nikon F2 with a 20mm lens set at f.11. Using a wide-angle 20mm lens meant that any minor alterations to the camera's position, which was on very unstable and rocky ground, totally altered the balance of the image. This problem was made worse by my use of a neutral (ND) and coloured filter. Their combined light-stopping effect made any passing changes in the cloud formation, and the movement of the foreground foliage, hard to detect and difficult to time. Of the fifteen or so exposures I made, the movement seemed right in only one. The others looked fine, until compared with this frame. With only one ND filter to choose from, and the lens set at its best (f.11) aperture, there was not much scope for altering shutter speed (to vary the degree of movement), except by changing the coloured filter.

3. Film processing:
In retropsect, constantly wanting highly magnified 35mm negatives to look as sharp as possible, hasn't always lead to the 'best' choice of developer. A two-bath developer would be my choice, now, for this type of backlit scene.

4. Print exposure:
With so much going on in the image: foliage movement, opposing shapes and complimentary textures, I knew that it would be hard to balance the photograph. For example, simply standing back from the print and viewing it up-side down, or back to front, would not provide adequate print refinement guidelines. More positive action would be needed. So I decided to complicate the print still further! Bleaching the tree, to create a natural, more balancing effect of light, has helped. I think it 'normalises' the landscape, at least, in a similar way to that achieved through the use of the printing mask. For the latter I tried to use a long exposure, giving adequate time for very gradual movement of the mask, thereby avoiding any unsightly exposure edge effect. By using the mask in the same visual plane above the baseboard as that in which it was drawn from a projected image of the negative, a good fit has been ensured, with no overlapping, incorrectly exposed edges. The print was made on Multigrade FB matt, with an old diffuser enlarger and 50mm El Nikkor at f.8 (the best aperture for this lens).

5. Print processing:
Normal, full development, followed by a standard stop-bath and fix. After this I rinsed the print before bleaching the tree trunks with a cotton wool bud, just dampened with Farmer's reducer. I rinsed the print with cold water in between each gradual application of bleach, using an angled light to detect the extent of the wet, bleach-covered area.

And finally:
Why not multiple tone this print like Fernworthy Forest?

The Rance Estuary

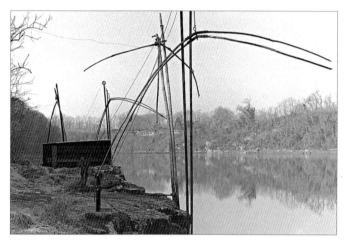

Above: an alternative viewpoint.
Opposite: the final, selenium-toned lith print.

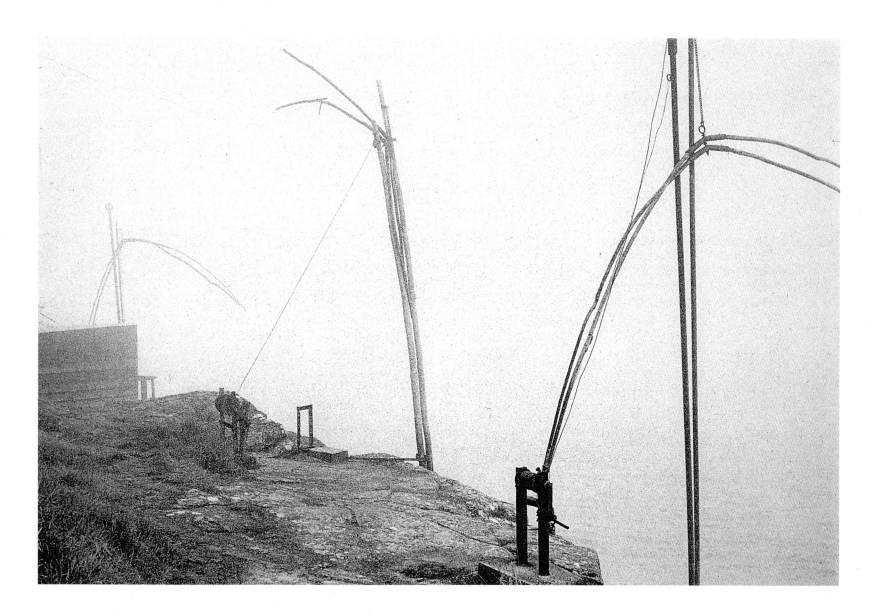

Image notes

I chose the lith process, in this instance, because of its contrast-increasing effect on darker print values, and for its tone-compressing effect on lighter highlights: I wanted to enhance the bold shape of the winch and to accentuate the subtle effect of the mist.

To make a lith processed print, I first check my print expose time is correct by exposing and developing a sheet of paper in the normal way, using a conventional paper developer. If this print looks good, I'll expose another sheet, but for an extra two stops of exposure, e.g. a 10-second print exposure time will become 40 seconds. This (over-exposed) print is then developed in heavily diluted (restrained) lith developer to create the lith print.

Lith development (at the right dilution) is initially very slow. The image may take as long as a minute and a half to emerge, with the print showing little contrast and density. Then, after about 4-5 minutes, the shadow density suddenly builds up as the process of infectious development takes place.

The skill is to judge when to take the print out of the developer: under our red or orange safelight filter, the image's complimentary warm, orange-brown colour makes the print look brighter than it really is. I took the print out of the developer just as the winch started building up a good amount of density, giving it time to reach the required depth during the five second developer drain time, prior to the stopbath.

After the stop and fixing baths, and following a half-hour wash, I selenium toned the print:
i) to neutralise the characteristically very warm image tone of the lith print,which I felt was inappropriate for this 'cold' image,
ii) to increase print Dmax, i.e. to darken the winch for added contrast — increasing effect, and
iii) to process the print archivally and to improve its permanence

Selenium toning a lith print is no different from working with any other warm-tone, chloro-bromide paper. After a couple of minutes in the toner, the image colour starts to cool-off and the blacks begin to increase in density. I took the image out at this point. Were the image toned for longer it would gradually turn warmer in colour again, but with stronger, peachy-red highlights. To stop the toning process, I simply immerse the print in cold wash water just before it looks right. To judge the progress of the selenium toner, and to see its colour changing effect, I employ two separate types of darkroom viewing light, one is fitted with an artist's daylight simulating (5400°K) tungsten bulb, the other with a more conventional, warmer (3600°K) tungsten bulb.

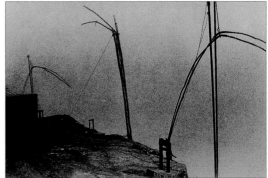

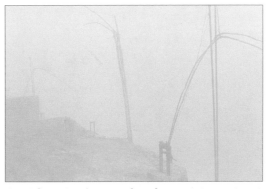

1. The lith print after 1 minute 30 seconds development. The image has emerged, but lacks contrast and density.

4. Fifteen seconds more development and the midtones are already too dark. Without good agitation, the print may develop unevenly.

2. After 4 minutes development, contrast begins to build up more rapidly in the shadow areas of the print.

5. After six minutes the print is developed to completion. The two stops of extra exposure have produced a print that is almost black.

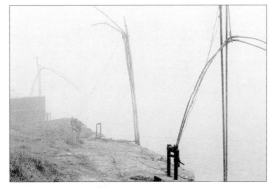

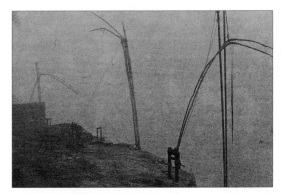

3. After 5 minutes development the print is judged to be ready: the shadows now have the right amount of density, whilst the highlights still have a light, peachy-brown tone.

6. Extended development will not produce sufficient density or contrast in an exhausted lith developer. In their highly diluted state, these developers may only last one hour in the dish.

Fuji Neopan ISO400.

TECHNICAL DATA

Having established a basic exposure time (of 120 seconds!) for my 20" x 16" print, I burned in the image according to the printing plan I made for my original 10" x 8" proof.

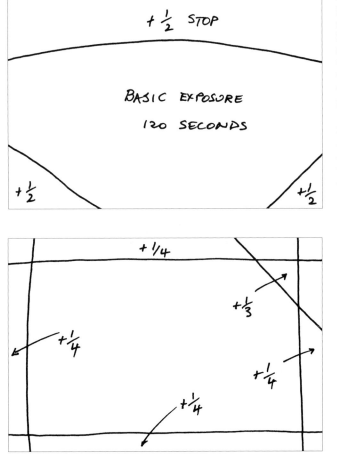

+ ½ STOP

BASIC EXPOSURE
120 SECONDS

+ ½

+ ½

At the new print size of 20" x 16", some refinement of burning-in times was necessary, to balance the more open feel of the larger, exhibition print.

+ ¼

+ ⅓

+ ¼

+ ¼

+ ¼

I modify my print exposure times, and record their details, in f.stops — using the f.stop table at the back of the book. (This diagram simply shows these changes in seconds of exposure.)

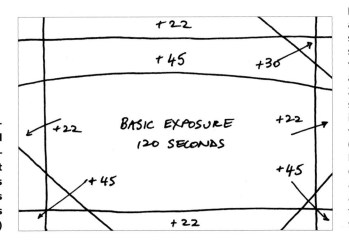

+22

+45 +30

+22 +22

BASIC EXPOSURE
120 SECONDS

+45

+22 +45

+22

1. Subject:
A small estuary in Northern Brittany in late winter. Previous visits showed that early morning, about an hour after sunrise, would produce the densest and most appropriate amount of mist. The wooden poles are the remains of a small, by-gone, local fishing industry. Very early examples of the net's cantilever design were first recorded in China, then India and presumably they were introduced to Europe from there.

2. Camerawork:
35mm FM2 camera, with a 28mm lens at f8 and at $1/60$ second with no filter. Having established the right viewpoint, I then set up the camera on the tripod. To meter the scene more accurately, I pointed the camera down a little so that its centre-weighted meter would read more of the darker foreground detail. I focused just beyond the nearest winch, checking depth of field with the camera's preview facility. The film was Fuji Neopan ISO 400, rated at the same speed.

3. Film processing:
I had a few problems loading the film into a presumably damp spiral - it stuck several times whilst being wound on. The film was developed for 12 minutes at 20°C in Agfa Rodinal, diluted 1+50, with agitation for the first 15 seconds and then for ten seconds each minute thereafter. The stop bath was a 2% acetic acid solution at 20°C, in which the film was stopped for 30 seconds with intermittent agitation. Fixing was for longer than usual: 3 (as opposed to 2) minutes in Ilford Hypam fixer at 20°C diluted 1+4, with constant agitation. This extended, agitated sequence was used to clear all the dye sensitisers from this modern film.

4. Print exposure:
Only one negative to choose from: no bracketed or alternative viewpoint exposures — it was too early in the morning for me! I printed the negative full-frame, using a diffuser enlarger with an Ilford Multigrade head, set at grade 4 to give a blueish light for this graded paper. 50mm El Nikkor lens. Even set at f5.6, the basic print exposure time was 2 minutes (with no dodging for a change). The print was made on Process-Lith FB paper.

5. Print processing:
Champion Novolith developer, 1 part A, 1 part B and 24 parts water. At 20°C the image emerged after 1minute 30 seconds. Development, with constant agitation, was 5 minutes — a factor of x3+. A 2% acid stop for 30 seconds, then a two-bath alkali fix (formula 26) for 4 minutes in each bath. The print was washed for half hour, selenium toned at a 1+9 dilution, until the warm colour (of photograph 3) was neutralised. Print was rinsed, hypo-cleared and then washed for one hour.

6. And finally:
I flattened the print for 20 seconds, gently, between two sheets of pre-heated (thoroughly dried) museum board, in a dry mounting press set at 90°C. Once cooled, I retouched the image with a 000 artist's brush and pigment; I wanted to remove a few dust marks and also some lighter, distracting areas of foreground detail. With hindsight, I should have bracketed the camera exposures. Although my meter reading and film processing times proved correct, I was lucky, several other negatives on the roll had loading and processing marks. It was my first time with a new film.

Wistman's Wood

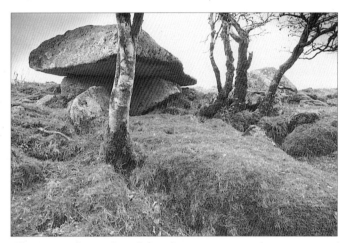

Above: an alternative viewpoint.
Opposite: the final, blue-toned print.

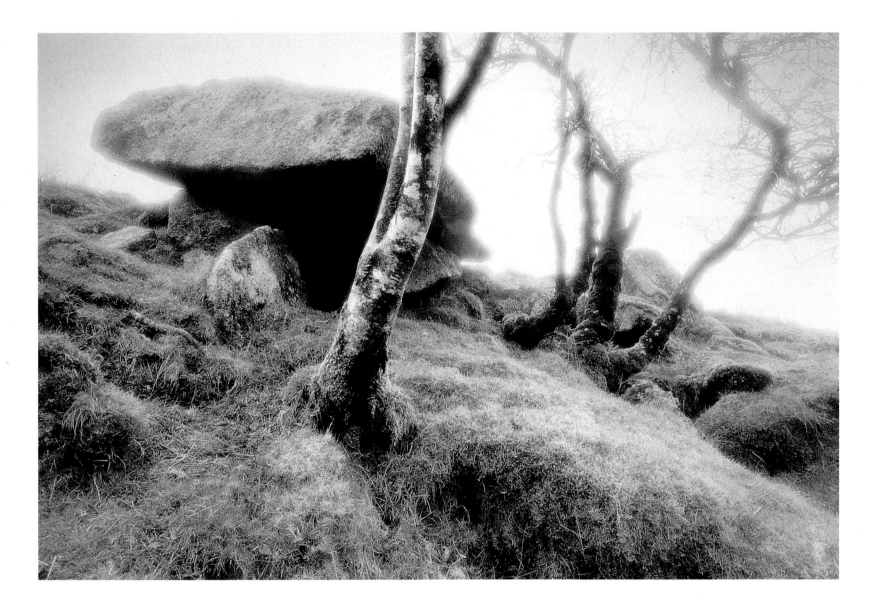

Image notes

I liked the black and white proof of this image (photo 4) so much that I was quite hesitant to tone the final print. That said, the end result — quite subtle in tone — more than offset any initial hesitation that I experienced. In fact, once toned, using formula 51, the light-blue colour looked more than appropriate and far removed from the vivid, garish blue results of some toners that are currently on the market.

It's often quite hard trying to decide whether to use a toner, or not, especially in this case when the colour of the trees (see SUBJECT opposite) was so powerful an influence at the time of camera exposure. Their almost dazzling light-green tone might have suggested the use of something chemically similar for the print, but for me that would have simply said "woodland" rather than the implied, slightly mystical effect I was after. I was influenced by all the literature I had read about the location; it spoke of ancient history rather than of natural colour.

This is one photograph where perseverance at camerawork really paid off. After my first visit I thought I had a good photograph of the scene, until I realised that the image I had in my mind's eye was not the image that was recorded on film (see alternative view, previous page). Since I had no means to process the film, to check where I had gone wrong, I decided to return to the location a few days later and start again. Only, this time, I wanted to be there early in the morning before there was any chance of the cloud cover breaking. I needn't have worried, it was pouring with rain, in fact so heavily that I almost — but not quite — gave up on the idea of the return visit.

When I arrived at the scene I immediately recognised what I was looking for — a tilted horizon. In my opinion, changing the camera angle has made all the difference to the final print. What's more, if you view the image in reverse with a mirror, you'll see it works equally well. More often than not this a healthy sign, that image composition and print balance are in harmony with each other.

Unfortunately, I had little time to make any other exposures of alternative views of the wood. However, the slight sense of loss one feels at having found a good location and under-utilised its potential was more than offset by having an image that I knew I was happy with — even before I looked at the contact prints. This satisfaction was almost a little premature. Other photographs I made of Dartmoor were damaged, not by rainwater getting into the camera, but by the continuous, extremely high level of humidity that caused one roll to stick together in camera.

1. The scene looked promising, provided an alternative, less cluttered, and clearer viewpoint could be established.

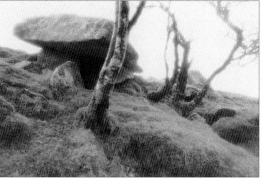

4. A straight proof print of the negative. The image is clearly out of balance, at least requiring some burning-in, or flashing of the sky.

2. My tripod was unsuitable for this low angle of view. I have now rectified this problem with a clip-on bracket that attaches the tripod head to one of it's legs.

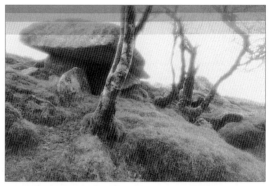

3. Here the camera is still positioned a little too high, the right-hand tip of the stone rather distractingly cuts through the skyline.

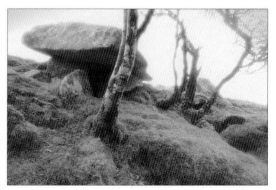

5. I decided to fog the sky, rather than burn or flash it in. A fogging test-strip enabled me to calculate, rather than guess, the right fogging exposure time.

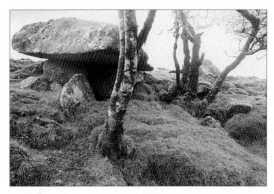

6. The final proof print with the sky fogged-in. The print still needs to be locally bleached — in the tree — and then blue toned.

Ilford XP2 ISO400.

+1/3

+1/3

+1/3 STOP

+1/3

A grade 3 print. Had this image been exposed onto a conventional film, and developed in a standard developer, I know the printing diagrams here would look more complicated than they are.

+ 1/4 STOP

+1/4

FOGGED

+1/4

UNFOGGED

Fogging the sky compressed the highlight tones, giving them a lovely mystical quality. It also covered up a film processing air bell in the upper-left of the sky.

LOCALLY
BLEACHED

I confined the bleaching work to the tree trunk. I wanted this to stand out clearly, but not too obtrusively, against the darker, fogged-in sky.

1. Subject:
Wistman's Wood is a small, ancient oakwood, set in the heart of Dartmoor. Local literature speaks of its contorted trees, sculptured by the wind, and stunted by the cold, harsh, local conditions. A promising location I thought, until I visited the place. Initially it turned out to be very hard to photograph. Although some of the trees were wonderfully contorted, their close proximity to each other made them ill-defined. Studying them, I thought how good the location would look in colour! The light-green branches, covered in moss and lichen and set against a drab, monotone, Dartmoor sky, would have made a wonderful abstract colour study of nature. It was one time I was — almost — tempted into using transparency film.

2. Camerawork:
35mm Nikon F2 camera, with a 20mm lens set at f.11 and at $^1/_{30}$th second. I opted for my less valuable back-up F2 camera because of the extremely heavy rain, visible against the dark shadow of the rock in print 2. I made a number of exposures with different filters, finally settling upon a negative made with a yellow-green, that both lightened the foliage and darkened the sky slightly. Composing the image wasn't easy. Bending down to ground level, and holding an umbrella at the same time, is not a camera technique I have read of in any other book — so far!

3. Film Processing:
What can I say? The XP2 film was C41 processed at Boots the chemist. Apart from the negatives coming back in short strips of four their quality was excellent, even if the one frame I used did have an air bell mark.

4. Print exposure:
I shall certainly be using more XP2 in the future: it is so much easier printing backlit subjects with a film that has good exposure latitude. The print has been made full-frame, without any cropping — the F2 camera giving an almost complete view of the framed image. The print was made on Ilford Multigrade FB matt, using their Multigrade head on a De Vere 504, but with a medium format light-box fitted. The 35mm box makes exposure times unbelievably fast, in fact too fast for me. My original 10" x 8" proof was made at grade $1^1/_2$, but at 20" x 16" the final print needed grade 3. This harder setting, with its more limited exposure latitude, required some modification of dodging and burning-in.

5. Print processing:
Multigrade developer, diluted 1+9, produced a good neutral tone print, which I developed to completion for absolute evenness of tone, failings in which would have been exacerbated by the contrast-increasing blue toner. The image was stopped in 2% acetic acid and two-bath fixed in Hypam at 1+9. After a five minute rinse, I lightly bleached the main tree trunk with a dilute solution of Farmer's reducer, applied with a swab of cotton wool. I was careful not to overdo this, in view of previous experiences, e.g. the Walkham Valley locally bleached and toned prints. The print was briefly blue toned with formula 51, diluted with 1 part water for a more controllable effect.

6. And finally:
I made five prints off this negative, only one of which was good! The others I overwashed, after toning, losing detail in their highlights.

Trumpan Stone

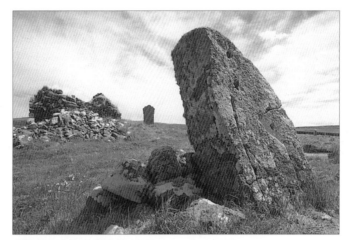

Above: a very slightly different viewpoint.
Opposite: the final, thiocarbamide-toned print.

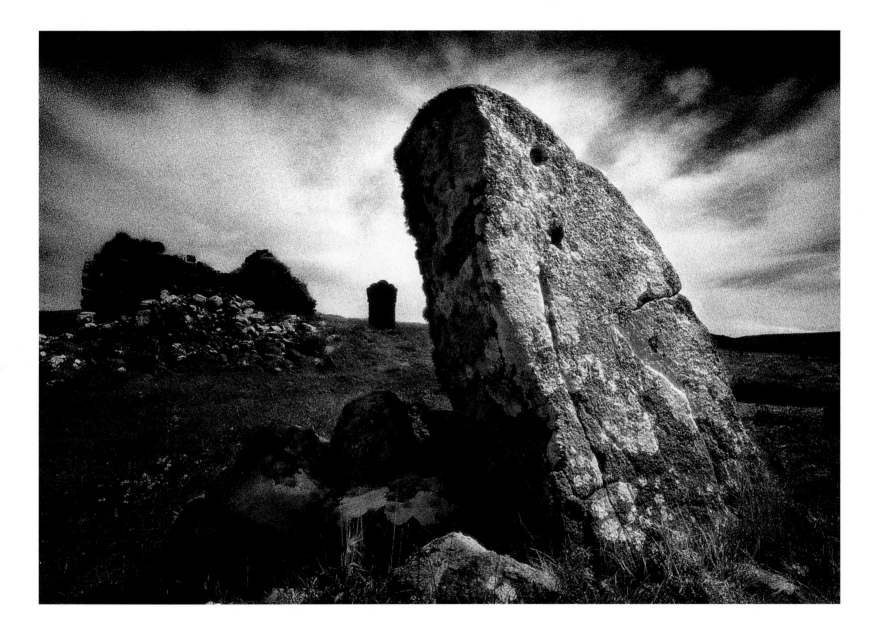

Image notes

Looking at the final print, you would be forgiven for thinking the stone is megalithic in proportion. Reading the local literature, prior to visiting the scene, I thought so too. But, when I arrived, the stone was so small it took me some time to identify it as the subject of much local history.

Having had my expectations built up in this way, I was determined not to leave empty handed.

So by means of a very low camera viewpoint and a 20mm wide angle lens, I figured I could perpetuate this little distortion of the truth.

Unprepared for what angle of view would be best, I had decided upon a midday visit to reconnoitre the scene. In fact, once I had found the stone I soon realised that midday was the right time to photograph it, if I wanted the light to fall on its face. Illuminated in this way, the hole at the top of the stone (that gives it its proper historical title of 'The Trial Stone') is made clearly visible.

The guidebooks spoke of how any person, deemed to have committed some crime or other, would be brought to the stone, blindfolded, then spun around and told to point to the position of the hole. From this, I surmised that if the accused correctly guessed the spot they were innocent, and if not, then presumably they went to an early grave. Hence my inclusion of a headstone in the image, which is also there for another very good reason. It is an easily recognisable feature of commonly known proportions, and has added a useful sense of scale to the photograph.

Although the direction of the light was appropriate, the stone was still darker in tone than the sky behind it. Using a red camera filter has helped to iron out this imbalance, but, like **Monkstadt House**, it was still necessary to make a printing mask to help burn in the top of the print. As in the aforementioned location, there was also a distracting body of man-made tone to one side of the image, only here it was a bright patch of gravel footpath, rather than a derelict car. Rather than retouch it, I decided to burn it in, using a much softer grade setting to make it less noticeable.

Rather as with **Monkstadt House**, it was quite hard trying to decide upon the right composition for the image. In both cases a straight print exposure fails to achieve the right balance and only by playing with the light, through dodging, local bleaching and burning-in, was I able to get what I wanted. I don't know how I would photograph the same locations in colour, without such tools. Perhaps the inherent colour contrast of each scene would do the job for me.

3. **A test-print like this, with strips of different enlarger exposures, clearly indicates how much extra exposure is needed to burn in the sky.**

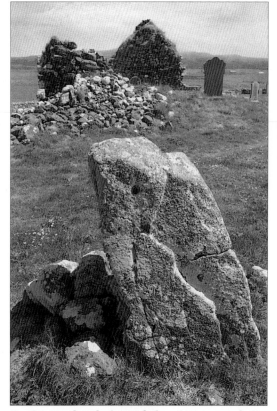

1. **An eye-level view of the stone reveals its quite diminutive proportions.**

4. **Arguably, a black and white, untoned print might best suit this type of subject matter. It would certainly be preferable to the warmer tone of this version of the scene.**

2. **Even the use of a red camera filter couldn't darken the sky sufficiently. This wouldn't have been a problem had there been less cloud cover and a bluer sky.**

5. **The bright footpath to the right of the stone was best burnt-in using a card with a similarly shaped hole. The photographs in ENLARGING demonstrate the need for such cards.**

Kodak TMax ISO400.

The print was made at grade 3¹/₂. I dodged the stone with a custom-shaped dodger, the use of which is illustrated in ENLARGING.

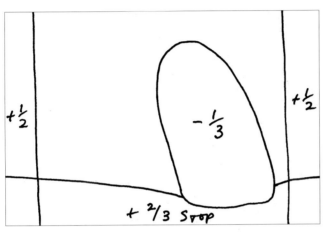

I burned in the whole sky at grade 3¹/₂ then, using a printing mask as for Monkstadt House, burned in the top part at grade 4¹/₂.

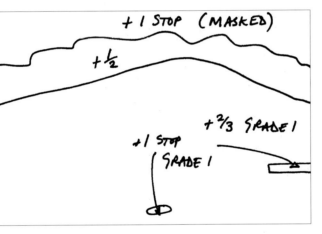

Local bleaching of the stone, with Farmer's reducer, had to be carefully controlled to retain highlight detail. I only bleached the face of the stone, not the side, to give depth to the print.

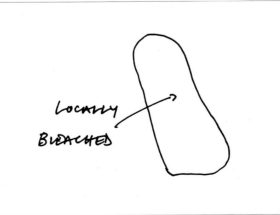

1. Subject:
It is very easy to get locked into a conflict of interest with any type, or style, of photographic work. For example, how 'honest' should our pictures be? Like the best photo-reportage work, the most memorable (and arguably the most influential) photographs are those which depict a reaction to an event, rather than the event itself. So, for example, whilst I had no qualms about distorting the physical proportions of the truth in this photograph, I was some-what hesitant about painting the crofter's cottage of Loch Ainort in too idyllic a light. Perhaps we don't need to concern ourselves with such self-imposed problems. Surely, by virtue of its colour, a toned landscape is sufficiently removed from the truth that we can simply enjoy it for what it is? Besides, every untoned black and white reportage photograph is merely one person's abstraction of the truth.

2. Camerawork:
Nikon FM2 camera, with a 20mm lens set at f.11. Trying to get sufficient depth of field with this type of very close-up subject is less of a problem with the smaller format 35mm. Especially when a wide-angle lens is used. I find not having to worry about such potential problems makes landscape photography less of a technical exercise and more free-flowing. This image was photographed with a red and a diffuser filter. I quite often use the diffuser if I want to depict atmosphere rather than detail.

3. Film processing:
This negative was on the same roll as Ardmore Point. They both required different development. A limitation of 35mm photography.

4. Print exposure:
Making a small proof print from this negative is quite easy: the smaller the print the inherently contrastier it looks and the softer the grade that can be used to print it. In practice, this cuts down the amount of dodging and burning-in that is required. But, enlarged up to 20" x 16" in size, the print requires all sorts of exposure changes. For example, the face of the stone needed to be dodged, as depicted in the photograph in ENLARGING. It also benefited from some local bleaching work with Farmer's reducer, but that was a decision based on my printing the picture quite heavily, by slightly overexposing it. Similarly, detail such as cloud patterns often becomes less apparent when the image is opened up, as a consequence of greater enlargement. This worked to my advantage here. The sky looked too busy in the smaller proof print.

5. Print processing:
As for most of my landscapes, I processed the Multigrade FB matt paper in Ilford's purpose-made developer, diluted 1+9, and developed it to completion. One of the joys of thiocarbamide toning a print such as this, (also Black Mount and Glen Coe) is that the richest, purple-brown tones, can be achieved with little, if any, loss of density or contrast in the final image. This makes assessment of the black and white print that much easier, since enlarger exposure modifications are rarely needed. After toning, the print was washed for one hour and then air dried — without wiping off any surplus water — as usual.

6. And finally:
Creative printing can often rectify images like this that appear off-balance in camera.

Loch Ainort

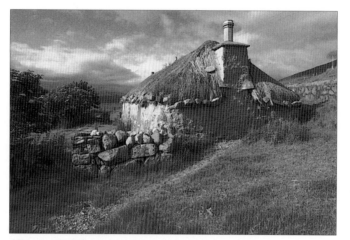

Above: straight exposure proof print.
Opposite: the final, thiocarbamide toned print.

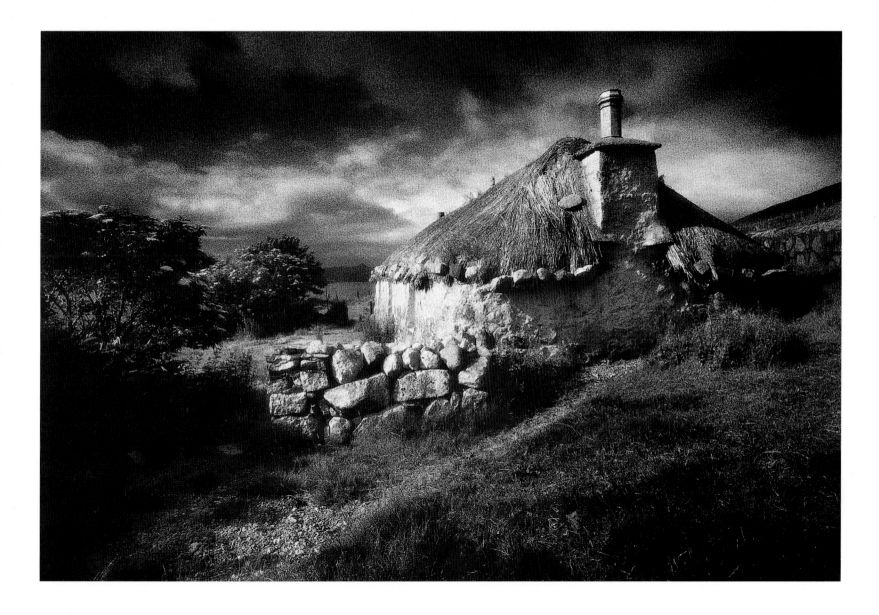

Image notes

Printing this image for the first time really brought home the spoiling effects of dry-down. Reprinting it taught me how I could overcome the problem, and, in particular, by less conventional, more experimental means.

Tradition has it that black and white prints should be made on a grade of paper whose contrast range 'fits' that of the negative. If I had followed that approach I would have made the final 20" x 16" print on grade $1^1/_2$, not grade $3^1/_2$ as printed on page 57. The result would have been a print that was dull and lifeless, and as low in perceived contrast as the proof print of the scene.

The toned version in PRINT ASSESSMENT was my first attempt at printing the negative to supposed exhibition quality. It was made on grade $2^1/_2$, and, in an attempt to hold in the highlights of the front wall, I slightly overexposed the print. I thought that although most of the shadow detail would be lost as a consequence, the inherent contrast and luminosity of the scene would shine through! I couldn't have been more wrong.

Studying this print when it was dry, recalling how good it looked when wet, I became aware of two completely different photographs. The wet print, as I remembered it, had looked right. But was this change all the result of dry-down? The answer became apparent when I took the finished print back into the darkroom. The print viewing light was too bright. It made the dry print look good again. Too good, obviously.

My answer to this problem was to change the type of print viewing light and to lower the wattage. As I have described in the technical section, if the print looks good under this light it will look good anywhere. So, when I reprinted it a few days later, viewing it under the new illumination system, I discovered that it wasn't until I printed it even harder, on grade $3^1/_2$, that the print really began to work. And, to get the best out of the negative, it was necessary to use a basic exposure time that was correct for the midtones, not the highlights or the shadows. But, surely, this would leave the highlights too bright and the shadows too dark? Yes, but only if they weren't burned in or dodged.

However, as we all know, there is a limit to how much a print can be dodged even if the negative is tonally well separated before the blacks visibly start to lose their density. So, a little local bleaching work with Farmer's reducer gave these dodged, partially lightened shadows all the lift they needed. The effect was to produce a print with depth, despite the harder grade of paper.

1. Dodging the shadow to the bottom left, to give more depth to the print. A black card dodger provided accurate control over exactly which areas to lighten.

2. Dodging the same general area with a sheet of card, or with a hand, does not provide the same degree of precise control.

3. The use of a flexed card helps when burning in a larger, general area of tone, but the darkened chimney required bleaching later. In fact, this also gave it more of lift than dodging it.

4. With the sky burned in, there still remained a bright patch of cloud that needed further exposure if it wasn't to compete with the front of the building.

5. The side of the chimney was too bright. I used a couple of burning-in cards to tackle this area, the same way as in photograph 4, above.

6. The wall looked fine in the black and white proof, but after toning I suspected its yellow colour might look too bright (as it may do in reproduced form here). I burned it in.

TECHNICAL DATA

Kodak TMax ISO400.

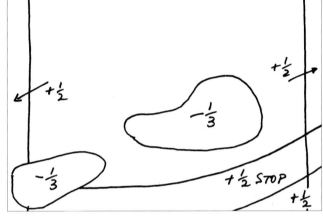

I used a 2" diameter, black card dodger to lighten both the marked areas. Moving it feather-ed-in the edges of both localities.

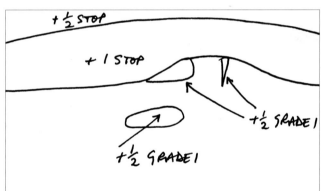

The sky was burned in at grade 3¹/₂, then several bright highlights were toned down at grade 1, as depicted in the photographs opposite.

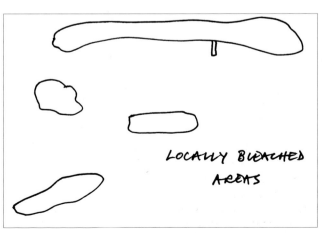

LOCALLY BLEACHED AREAS

This may look like a lot of local bleaching work, but it didn't take longer than 15 minutes. Bleaching the whole print, in a dish of Farmer's reducer, would have lightened the burned-in highlights.

1. Subject:
Anyone who is familiar with the history of the west coast of Scotland will know that life for the crofters was not as rosy as this picture might suggest. A more sombre colour of tone, and a less optimistic feeling of light, might have been more appropriate had I wanted to make a documentary photograph and an historical statement. But then, should photography always depict such places in a style that reveals exactly how they were? Is it necessary to fossilise them? Surely, a good photograph should leave something to the viewer's imagination? But how much? The main Bradwell Barges photograph, in its black and white state, may appear quite documentary in style but, by leaving out the key element of the sea, does the picture become untruthful? No, it becomes more interesting. It causes us to think, to ask ourselves how the scene really is, or, perhaps in this case, what it was really like to live in such a cottage.

2. Camerawork:
In CAMERAWORK I have included an overview photograph of the scene: including late C20th fencing, telegraph pole and wires. It is interesting to compare this with the final, print, but beyond that the picture has little appeal. It is too dry and too factual. A 50mm standard lens was used and a 20mm wide-angle for the final print. The camera was an FM2, with an orange filter for both photographs.

3. Film processing:
Another film developed in Rodinal. Would a stronger compensating developer have helped to cut down the amount of burning-in? If so, would the print still look as luminous?

4. Print exposure:
I rather surprised myself with this photograph. Once I had worked out the revised grade setting, and calculated the new basic exposure time for the final version of the print, it actually became surprisingly easy to make, despite the number and variety of different dodging and burning-in exposures. By drawing several printing diagrams, with the different stages of exposure listed in order, producing the print simply became a matter of working by numbers. In this way I was able to make five good, locally bleached and toned final prints in one day's printing session. And, when they were dry they still looked good! The lessons I learnt from making this print have stuck with me. See the photographs in PRINT ASSESSMENT. All the prints were all made with a very old diffuser enlarger and under the lens VC filters.

5. Print processing:
A low-wattage viewing light bulb might help to assess print dry-down, but a stronger lightsource is better for local bleaching and toning work. I find a directional spotlight is best for high lighting the locally bleach dampened area, to check whether or not the bleach has strayed into an adjacent area. This migration of solution is more commonplace with 'non-absorbent' RC papers. I bleached the chimney pot with a medium-point, lightly dampened (more controllable) brush. On the foreground and sky I used a more heavily dampened, cotton wool swab, to give a more general effect.

6. And finally:
Given the choice, how would you photograph and then print this scene — if at all?

Pentire Point

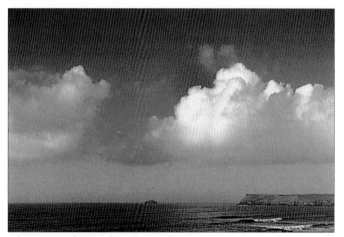

Above: an alternative viewpoint.
Opposite: the final, blue-toned print.

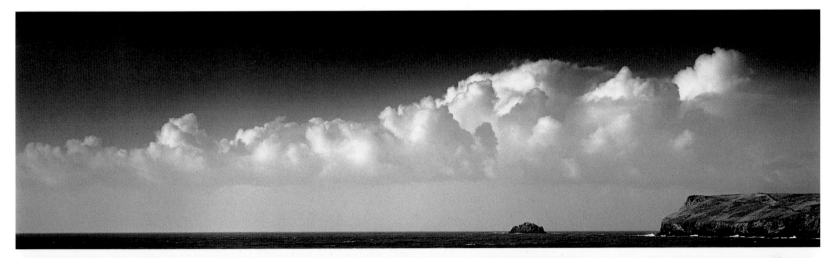

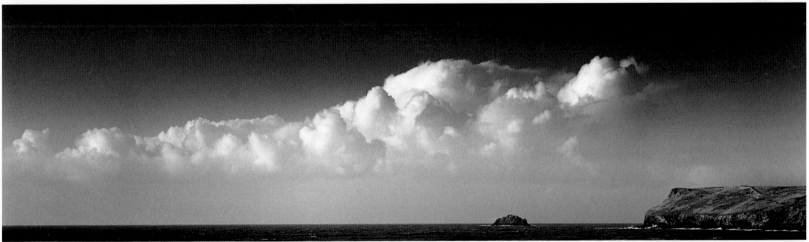

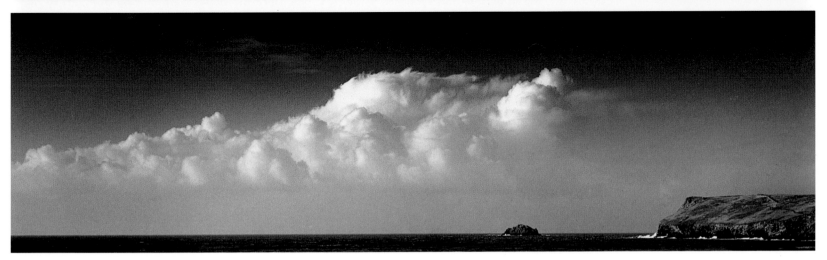

Image notes

Early morning and dusk are my preferred times for getting what is usually the best of the light. The rest of the day I'll leave free for location finding and catching up on much needed sleep. But not in this case.

When it comes to photographing coastal cloud-scapes, the afternoon should produce the best cloud formations — as colder sea air is drawn up and over a warmed land mass. Basic schoolroom geography (or is it physics?) tells us that as it rises above the coast, moisture-laden sea air will cool and condense, forming clouds and, in this case, a quite spectacular cumulus formation.

This scene started as a thin wisp of a cloud, which then took about twenty minutes to develop fully. During this period I had plenty of time to take up what I hoped would be a good vantage point and to begin exposing a sequence of photographs, of which the triptych is just three frames from nearly two, 36-exposure rolls.

Unfortunately, this vantage point was exposed to the full force of the wind and I only had a rather lightweight tripod. After I had weighted it down with my camera-bag it was a little more stable, but not adequately so for the fine-grain, high-resolution Kodak Technical Pan film that I was using. From previous experience with this film, I knew any camera shake would show up on the 20" x 16" enlargements I hoped to make. With this in mind, I tried to time my exposures to any brief respites in the wind, but — typically — these usually coincided with the breaking of a crest of a large wave, and my intention was to keep the clouds as the main highlights in the photographs. So any such occurrences were not welcome, although I only retouched one small wave in one of the prints.

Unlike the photograph of **Wistman's Wood**, I had absolutely no hesitation in toning these photographs, nor did I have any hesitation in using a blue toner. The colour looks natural for a seascape, whereas for **Wistman's Wood**, the (albeit lighter) blue was meant to impart a slightly mystical air, or sense of unreality.

Despite feeling a sense of satisfaction with the triptych, I have to confess I haven't tried anything similar since. It was such a hard job trying to get all the prints to match, both in density and balance, before they were toned, that I stuck all three to a sheet of plastic. In this way they could all be toned and washed together for an identical blue tone. I wasn't prepared to take any chances at all, and it paid off. I managed to make two good sets of this triptych in one printing session. Not bad, I guess, for a first — and possibly last — time.

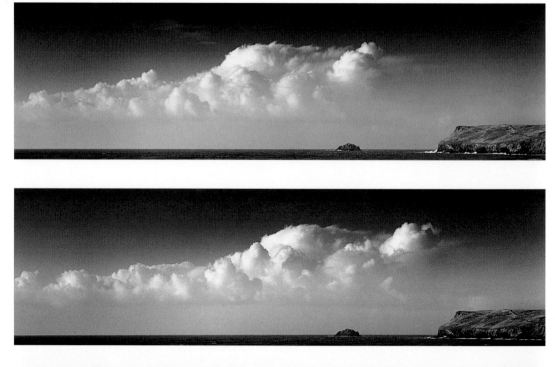

1-3. The same prints as on page 61, but viewed in reverse order. In fact, if we read a page from top to bottom, this sequence is the right one, since the clouds were moving from left to right. However, this motion leads the eye less favourably down to the bottom of the page, rather than lifting it up, with the movement of the clouds, to the top right. Viewing either sequence in a mirror creates a very disturbing effect: the clouds almost seem to be moving against the wind.

4. Not me, but a friend composing an alternative view. This photograph was made after the triptych, by which stage the cloud formation has been lost to a larger, less defined cumulus.

5. A full-frame proof print, showing more of both the sea and the sky. The extra weight of sky merely makes the clouds top-heavy, whilst the sea is too broken up and fussy.

 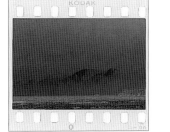 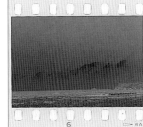

Kodak Technical Pan ISO25.

TECHNICAL DATA

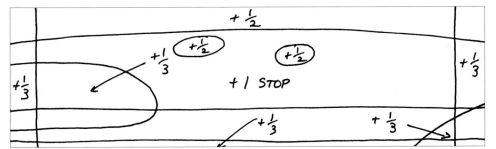

All three negatives, although identically exposed, required different basic print exposure times, to compensate for differences in development in too large a tank.

1. Subject:
I went to the north Cornish coastline more prepared for a holiday than for serious photography. In fact, now, I never combine the two — when it comes to relaxation, photography is too much like hard work! Besides, taking it seriously usually requires working alone which, by definition, is rather antisocial. That said, there is always something wonderful about the intersection between land and water. But, as I said in THE INTRODUCTION TO THE PHOTOGRAPHS, trying to translate this certain something into a good print is photography's perpetual challenge. So, more often than not, I'll simply opt to enjoy the moment for what it is, rather than for what I can make of it, which often turns out to be a poor photographic imitation.

2. Camerawork:
35mm Nikon F2 camera, with a 50mm lens set at f.5.6 and at $1/_{60}$. Not really a fast enough shutter speed to guarantee negatives free of camera shake with the camera on a lightweight tripod. I opted for a yellow filter: orange or red would have produced too stark an image, largely because of the extended red sensitivity of Kodak Technical Pan film. Not placing the horizon too near the bottom of the frame, as in the final print, has kept it free of any camera lens distortion.

3. Film processing:
Agfa Rodinal, diluted 1+200 and developed for 10 minutes with agitation for the first 10 seconds, then every minute. More frequent agitation might have created developer flow marks with this inherently sensitive film. Also, it might easily have created too much contrast.

4. Print exposure:
There are prints that are fun to make and, well, there are others...! Although all the negatives were identically exposed, they all needed different exposure times, for reasons explained in FILM PROCESSING. Also, as the cloud formation changed, its highlights moved from one place to another. In the top print on page 61, the brightest highlight sits within a burned-in area of the sky, so I had to be careful not to darken it too much. The prints were made with a diffuser enlarger and printed on Multigrade FB matt. Knowing how blue toners can increase print contrast (see TONING test prints), I was sure to make these about $1/_2$ grade softer and to make certain they all balanced perfectly.

5. Print processing:
Multigrade developer, diluted 1+9. All the prints were developed individually and for $3^1/_2$ minutes , i.e. to completion, so that they would all have similar density and contrast when toned. They were all stopped in 2% acetic acid, then two-bath fixed in Ilford Hypam. Hypo-clearing followed a brief rinse and the prints were then thoroughly washed for three hours to remove every last harmful vestige of fixer; I didn't want to lose any of the delicate highlights to the ferricyanide bleach in the blue toner.

6. And finally:
The next time I produce a triptych, I'll be sure to make up fresh print developer before I begin. On this occasion I started with some part-used developer which began to die by the third print. Only by extending print development time, using the FACTORAL DEVELOPMENT CHART, was I able to maintain the same density for the third print.

River Authie

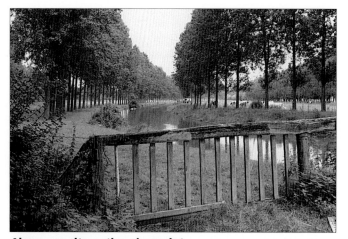

Above: an alternative viewpoint.
Opposite: the final, thiocarbamide and blue-toned print.

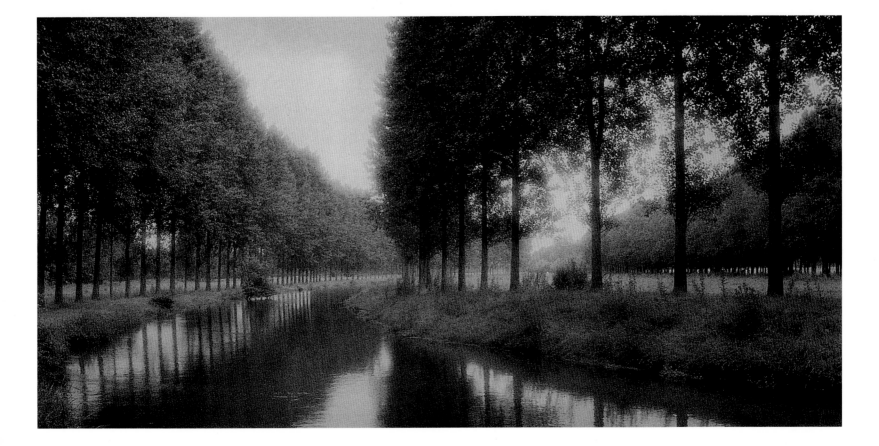

Image notes

Sometimes all I want to show of a particular landscape is the sense of atmosphere, or the feeling of place, that I experienced leading up to the moment of camera exposure. Nothing else.

Trying to capture this quality involves more than just pointing a camera at the scene and 'taking' a photograph of it. The camera will show the scene, warts and all. It will record what it sees, rather than what we perceive. Whilst you or I, the photographer, might be able to identify this perceived quality in the print, the viewer most certainly will not.

This is where darkroom creativity really comes into play.

Toning might seem the most obvious way of achieving this 'mood', but unless the print has been carefully exposed, and thoughtfully balanced, the use of a toner will appear superficial, rather than integral, to the image.

For example, a straight proof print of the **River Authie** produces a documentary-style photograph, i.e. an impartial, factual image largely devoid of personal comment. But, cropping the image top and bottom, selectively dodging and burning it in, fogging it, and then toning it, have combined to make the image speak, in a way that I hope is now clearly understood.

This may sound an overly complicated way of getting the print to work in the way that I wanted, but what is the alternative? There is no halfway house. To leave out any of the above stages of the process used to make this photograph, for example the fogging of the print, would result in an unsatisfactory image. Just look at the poorly fogged, but carefully dodged, burned and toned versions in TONING. They look too hard and too matter-of-fact.

Returning to the scene, when conditions were more appropriate, perhaps when it was mistier, or when the light was fading, certainly would have contributed to the sense of atmosphere of the photograph, but by no means completely. Some creative input would still have been required, for example deciding whether to multiple tone the print, first using a thiocarbamide and then a blue toner, or to tone it more simply and more quickly in a one-bath, proprietary, green toner solution.

Automation, of cameras and darkroom equipment, presumably aims to relieve us of much of this thought process and processing work, but to what end? Ultimately, will it benefit our work? If so, I am all for it, but as yet I remain to be convinced. Time spent working on a photograph cannot be replaced by money spent on it.

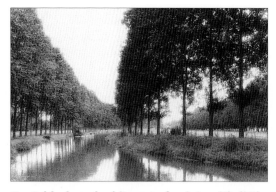

1. A black and white proof print, with little dodging and burning in, produces a photograph with very little sense of place and hardly any atmosphere.

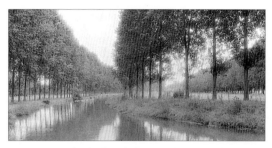

2. Cropped, dodged, burned-in and fogged. This print looks better, but still needs more fogging to tone down the highlights.

3. Although I later fogged the entire print, I still burned in part of the sky, to add some detail to what would otherwise have been a large, perhaps distracting, monotone area.

4. The bright horizontal patch of grass to the right of the print really caught my eye. Burning it in at a softer grade also prevented the tree trunks from becoming locally too dark.

5. Yet another bright distracting area of tone. Like that at the foot of Trumpan Stone (see ENLARGING), it is too small to burn in 'by hand'. Better to use a sheet of card with an appropriately shaped hole.

6. After I fogged the whole print, I made a further exposure, using a mask, to tone down certain areas, such as the bright patch of sky in the upper-right of the print.

Kodak TMax ISO400.

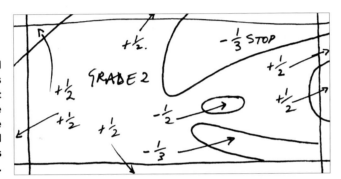

Dodging the shadowed trees and river bank has lightened areas that might have been lost to the contrast-increasing blue toner. Dodging a small area between the trees has created a focal point.

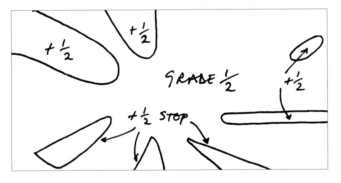

Burning in the reflections, each corner and the bright patch of grass, 'systematically' improved this image.

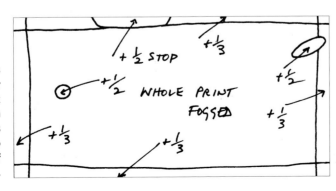

First, the whole print was fogged, then several other areas, using the mask (illustrated in photograph 6). All the print edges were slightly fogged, to enhance the brightness of the dodged focal point.

1. Subject:

I first saw this location early in the morning, when conditions were similar to that of Rance Estuary. Shrouded in mist the scene looked atmospheric, but it lacked depth. I wanted to be able to see more and to show it. A return visit later in the day revealed a wonderfully shaped, tree-lined, river. This gave the location the sense of place that I originally felt was missing. Unlike the fishing poles of the (albeit French) Rance Estuary, the trees said "France", and I wanted to show them all, but in a less abstract way. However, at this later stage in the day, the mist had cleared, and the atmosphere with it. So, to get around this problem, I decided to diffuse the scene in camera slightly, and then to fog the print. Like the mist, this fogging compressed the highlights of the scene, but without causing detail (the distant trees for example) to disappear from view.

2. Camerawork:

35mm Nikon FM2 camera, with a 35mm, PC lens. I wanted to include more of the trees to the top of the picture, but without pointing the camera upwards, causing them to converge. The perspective-control facility of this lens gets around such problems, although tilting the enlarger baseboard would (less conveniently) achieve the same effect. I tried a number of filters, including yellow, orange, yellow-green and green. The yellow-green worked best, maintaining detail in the foliage and sky.

3. Film processing:

Knowing the print was going to be fogged, almost any developer could have been used for this essentially back-lit scene. I opted for my usual Agfa Rodinal.

4. Print exposure:

It is hard to define what gives a print its quality. Certainly, the photograph should look as if it was simple to make. In that way it will seem natural rather than appearing uncomfortably contrived. A good example would be to imagine how this print would have looked were it just diffused in camera, without subsequent paper fogging. The stark, contrasty midday light would have contradicted what the filter was trying to imply. For example, the top-right of the print looks unnaturally bright before overall and local fogging. The latter helps to reduce its relative contrast with that of the adjacent darker tone of the trees. More often than not, I find it is the attention paid to such detail which prevents the game from being given away. Looking at the finished print, it does give the impression of having been easy to make. In some ways it was. I knew how I wanted it to look. That always makes printing easier. But it did take time, innumerable exposures, different grade settings and a fogging mask, all with a very old, low-powered enlarger.

5. Print processing:

Normal processing was followed by the usual brief rinse, hypo-clearing bath and full wash. The print was then thiocarbamide toned (see TONING photographs), thoroughly washed and, finally, blue toned to produce a more duotone green than is given by a one-bath green toner. Without care, too much blue toning would have blocked up the shadows, creating an unrealistic, and to be avoided, extra amount of contrast.

6 And finally:

It is perceived depth, rather than actual contrast, that makes a print like this work.

Bradwell Barges

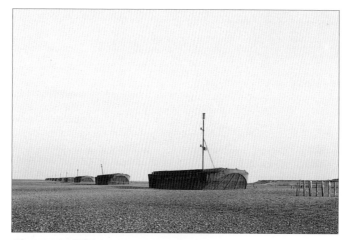

Above: straight exposure proof print.
Opposite: the final, gold-toned print.

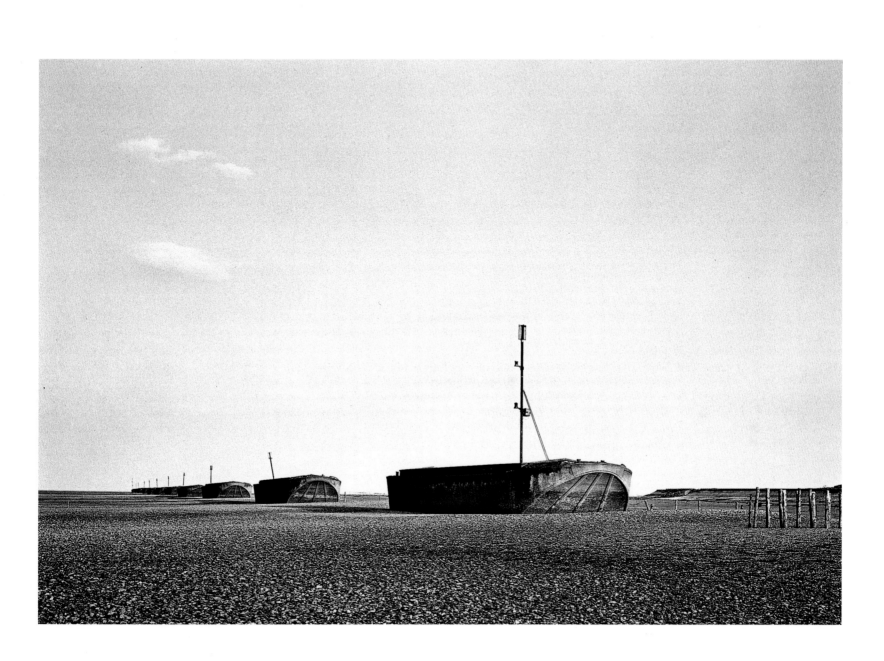

Image notes

1. A thiocarbamide-toned version of the same scene, but photographed from an alternative viewpoint, as the tide was coming in. The negative was the last on the roll and by the time I had replaced it the tide had already risen too far in front of the wooden groynes. The one negative I did have was a little underexposed, lacking some shadow detail in the two dark lines of stones to the right. However, a little dodging gave them sufficient life. Whilst burning in the sky at a harder grade setting with the variable contrast paper really gave a considerable lift to the clouds – simply not possible with conventional graded paper, except by slightly bleaching them.

Photographs that are instantly eye-catching often lack the subtlety required to hold the viewer's attention over a longer time-span. And so it is with the thiocarbamide-toned print of the barges opposite.

At the time of camera exposure, my immediate reaction was to favour this more panoramic format image. After all, almost all of the "intrinsic ingredients of success," of which I spoke in the INTRODUCTION TO THE PHOTOGRAPHS, were there. The cloud formation echoed the line of the barges, the waterline neatly touched the top of the groyne. Everything seemed to connect, and obviously so, to the point where I now ask myself, "what is left to the viewer's imagination?" Little, I would say. It's a pleasantly interesting landscape; not an enquiring one like the main image overleaf. I still find that print holds my attention. When I look at it, I ask myself, "what are all these barges doing in the middle of a landscape?" even though I know full well they are by the sea and what their function is. The success of the image, rather like that of the fishing poles of **Rance Estuary**, depends upon the fact that no tell-tale water is visible.

Perhaps I am judging the thiocarbamide-toned print on this page a little too harshly. After all, it is one of many pictorial images in the book. But then maybe it is one of the better ones, and therefore stands up better to criticism!

Apart from some burning-in with a harder grade to enhance the clouds, the thiocarbamide-toned print needed little else except some burning-in of the right hand side to compensate for the higher subject luminance values towards the sun.

Similarly, the main print required little manipulative printing work. Even so, the first time I printed the negative I did try cropping it to give a 1:2 ratio and a more panoramic feel. As in the print on this page, I was interested to see what linear, rather than dimensional, form could do. It didn't work. When I photographed the scene, I visualised a photograph that showed more than a line of barges. I wanted to show something of Essex, where the photograph was made. It is a wonderfully uncluttered, almost minimalist, very flat region, but with a big open sky. As such, it is one of the hardest areas I have tried to photograph, until I realised I was trying too hard to make photographs of the place, rather than letting it speak for itself. For me, the main print on page 69 says "Essex" (in a way I can't), so that by carefully composing the image in camera, waiting for the tide to go out and having the good fortune of an almost cloudless sky, the scene has done the rest for me.

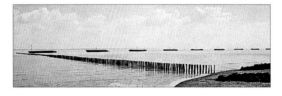

2. This black and white proof print has been fogged during processing. I deliberately developed it directly under my main safelight, and for too long, to show how easily the highlights can be degraded. Only bleaching-back the print in Farmer's reducer will produce an acceptable photograph.

5. A straight proof print, exposed for the shadows, that has left the highlights looking somewhat too light.

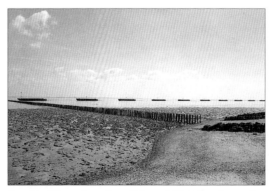

3. Waiting for the tide whilst hoping the clouds will form into a pattern that is complimentary to the line of barges. The tighter crop above is clearly much better than here.

6. Another straight proof print, but more generously exposed to see how much extra exposure is needed to burn in the sky by the right amount to balance the print.

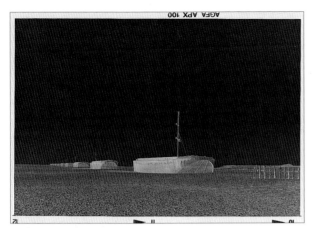

Agfapan APX ISO100.

The toned print, opposite, was made at grade 2, with the sky was burned in at grade 4.

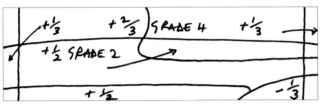

The main print, on page 69, was made at grade 3. The bow was dodged with a 1/2" diameter, black card dodger. All the burning in was at grade 3.

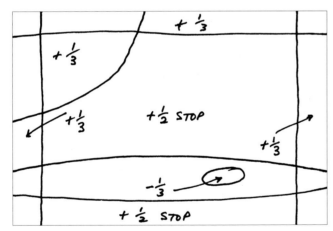

Dilute Farmer's reducer, applied over the bow with a fine brush, added that much needed final touch. Overbleaching would certainly have become noticeable, as a colour change after gold toning.

LOCALLY BLEACHED

1. Subject:
I was actually sailing further up the coast when I first saw these barges, just visible in the far-off distance. As we got closer I realised they were static, probably moored along the shoreline as a protection against coastal erosion, perhaps longshore drift. Several further visits to the area revealed that at low tide their hulls were completely high and dry, which prompted me to make the photograph on page 69. To this effect, I studied the local tide tables, looking for the first opportunity to photograph them when the tide would be out in the evening. At this time of day I figured the light would fall on the bows of the barges, leaving their starboard sides in shadow, whilst low tide would permit the angle I wanted and also keep my feet dry.

2. Camerawork:
6 x 9 cm Linhof Technica 70 camera with 105mm Nikon (standard focal length) lens and orange filter. Although it is a medium format camera it does have both front and back movements that permit control of depth of field even at large apertures. Since the light was fading fast, I could only manage f.8 at 1/2 second with the Agfapan APX 100, so I tilted the lens panel until I could see all the barges were sharp on the focusing screen. With the lens panel locked into place, I bracketed several exposures since I was new to working with this old view camera.

3. Film processing:
Agfa Rodinal diluted 1+50. Normally, for ISO100 (inherently contrastier) films, I would dilute the developer further, to 1+75, but the light was surprisingly flat and I didn't want to run the risk of too low contrast a negative.

4. Print exposure:
The negative I chose was ideal in shadow detail, highlight separation and over all contrast. Exposing the print was simple: a little dodging of the leading boat's bow, some burning-in of both the foreground and sky and no more. However, the sun was very low in the sky when I made the exposure and there wasn't sufficient light on the bows to make them stand out as I wanted. The choice was to dodge these for longer, but run the risk of them looking too weak in tone; or to print on harder paper and lose the subtle tonal range of the print; or to expose and dodge the print, as described, and then locally bleach the bow with Farmer's reducer. I opted for the latter method. The print was made on Multigrade FB matt, printed with a condenser enlarger to add a little sparkle, and lift, to the highlights. Gloss paper would have helped in this respect, but the extra effort of printing on matt was finally worth the effort. The final print has a lovely subtle feel to it.

5. Print processing:
I wanted maximum density and contrast in the shadows, so decided to try out a variety of developer formulas, including numbers 4 and 8 in the formulary. Eventually I settled for number 4, Ilford's Universal developer, preferring to get the extra contrast by making the print a half grade harder than normal and then burning in the sky a half grade softer. Development was to completion and after fixing, hypo clearing and washing, the print was briefly gold toned to cool it off and to archive it.

6. And finally:
I'd like to do more of this style of landscape imagery. It's easier to print!

Epping Forest

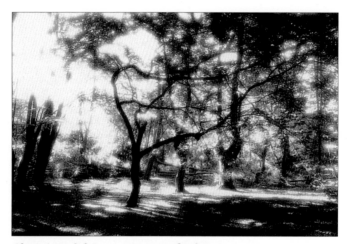

Above: straight exposure proof print.
Opposite: the final, thiocarbamide-toned print.

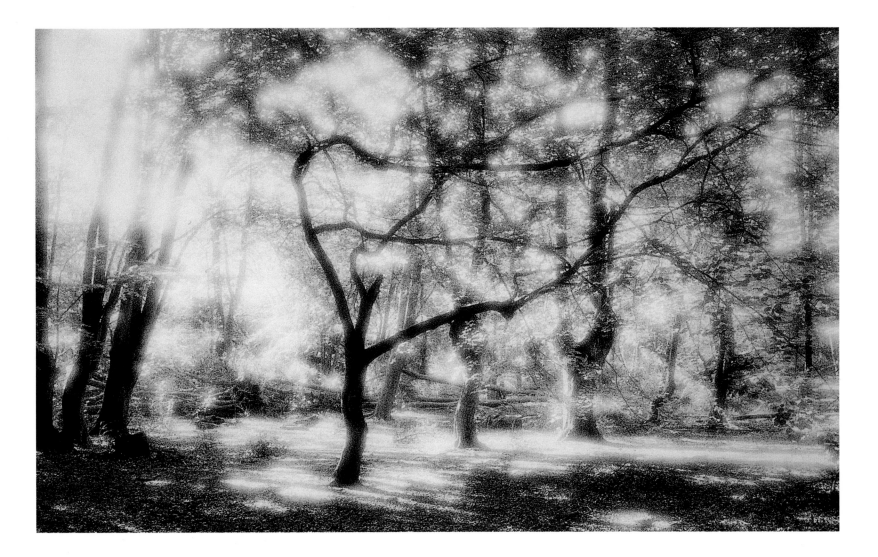

Image notes

I first came across this tree by chance, whilst out for a walk. Since then I have been back a countless number of times, during different seasons and at various times of the day, but only first light in the summer achieved the desired effect.

In particular, I wanted the base of the tree to be framed in shadow, with its body backlit by foliage-diffused sunlight. As you can see, from the photographs in CAMERAWORK and the other prints here, it is a location where both the right angle of view and the right conditions are imperative. The success of the print is also dependent on both camera and darkroom techniques achieving a more pronounced effect of diffusion and a stronger sense of light. Darkroom techniques have also helped to make the tree stand out more clearly. This effect has been brought about, in part, through the split-toned colour, and by making the basic exposure at a much harder grade setting.

The first time I printed the negative, much to my surprise, I got it 'right'. Unfortunately, I only made one print as time was short, and that image is no longer in my possession. And, in my haste to finish the print, I didn't keep any printing or toning notes. Since then I have made various attempts to get the same colour and delicacy of tone to the print's highlights, without success. Perhaps the chemistry I used was different, or maybe I used a more concentrated toner bleach but for a briefer duration. Given time, I'm sure tests will reveal where I have gone wrong and in the process, thanks to them, I'm constantly learning more.

All this most probably makes it sound as if I am not happy with the main print on page 73. In part, that is the truth. When the tone you get isn't exactly the tone you want there is always a slight sense of dissatisfaction with the print, even if it is a well-balanced image. And this print is well balanced when compared with my first, supposedly better, effort. Thinking about it now, that first print was a little too heavy in the foreground, to the point where that darker body of tone wasn't so much a base for the tree to stand on as a weight to pull the print out of balance.

Being constructively critical of one's work in this way is certainly very healthy, but, in my experience, black and white darkroom photography is a potentially very solitary experience which offers little scope for the counterbalancing effect of feedback from one's peers. But when I do get comment, very often it is more to do with the tone of the print than its form, or content. In future, perhaps, this calls for more untoned photographs like **Bradwell Barges**. Perhaps not?

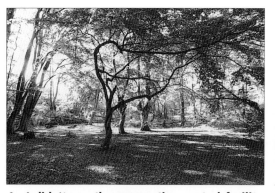

1. I didn't use the perspective control facility of my 35mm lens for this undiffused image. As a result the trees to the left lean in too much.

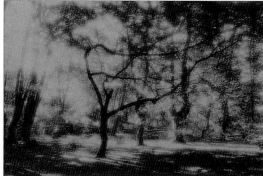

4. The fogged print. I also locally fogged the final print, on page 73, to improve its balance, as illustrated in the printing diagram opposite.

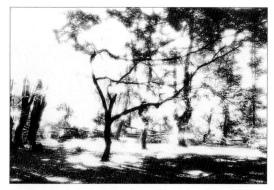

2. Printed on grade 4 and exposed to give a good black in the tree. This print is obviously too contrasty and needs to be flashed or fogged to tone it down.

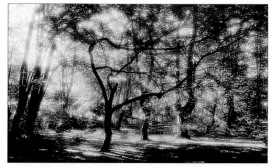

5. Too much basic grade 4 print exposure, and too much fogging, has created a photograph that is too heavy, whilst too little washing has left the lightest highlights bleached out after toning.

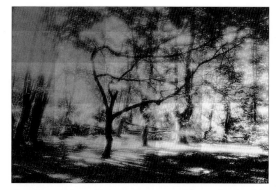

3. The same print exposure as above but with a series of flashing/fogging exposures to determine how much 'white light' exposure is needed to print in the highlights.

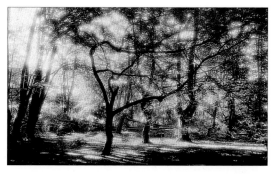

6. Another out of balance print. Epping Forest is one image that is quite easy to get right in black and white, but when it is toned the change in optical contrast radically alters image balance.

Kodak TMax ISO3200.

TECHNICAL DATA

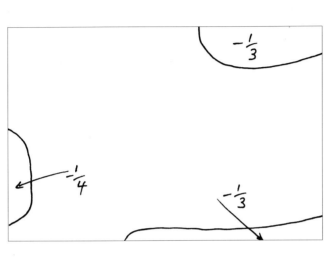

The top-right of the scene was much too dark and, until it was dodged, it pulled the print right off balance.

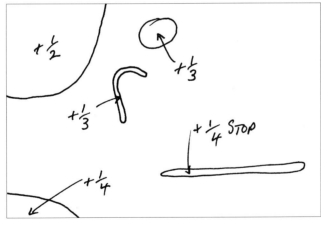

It was possible to burn in the top of the tree, moving a card with a small hole in it, over the line of the trunk.

The whole print was fogged, then locally fogged, to play down off-balancing areas. Unlike River Authie, I did not find it necessary to make a mask for these less precisely shaped areas.

1. Subject:

Epping Forest isn't as densely wooded as Wistman's Wood, but it is just as hard a place to photograph, and maybe more so, because at the back of one's mind, with the constant reminder of the sound of traffic, is the thought that one isn't out in the country, but in London — a different sort of jungle…! But, as I said in THE INTRODUCTION TO THE PHOTOGRAPHS, less visually alluring landscapes often make the most interesting subjects, rather like the barges at Bradwell. In fact, when it comes to more obvious locations, such as Eileen Donan castle, I am usually tempted to steer away from them rather than in their direction. Perhaps photography has shown us too much of the world and we've got to the point where we want to see more of our own views of it.

2. Camerawork:

35mm Nikon FM2 camera with 35mm perspective control lens, giving rising front lens movement, to lose some of the foreground without pointing the camera up and therefore distorting the view. In a couple of the proof prints, made without a PC lens, the tree to the left can be seen to lean too far inwards. It creates a distracting sense of movement that interrupts the flow, or rhythm, of the main tree. I used TMax ISO 3200 film, with orange and diffuser filters, to get an almost infra-red, but more controllable, effect. The film was rated at ISO1600 to give good printable shadow detail. In my experience, ISO 3200 is a little over-optimistic, but for others perhaps not.

3. Film processing:

Agfa Rodinal again! Diluted 1+50 and developed for 14 minutes for good contrast.

4. Print exposure:

Producing a conventional print does little for this subject: the tree blends in too much and the bright highlights are washed out. Increasing paper grade contrast separates the tree from the background, but it makes the highlights distractingly bright, rather than pleasantly luminous. The answer, I decided, was to print hard, with a short basic exposure time and then to fog the print. This would achieve two aims: first, the highlights would be printed in and, second, they could be toned. Judge for yourselves which you think is better. And whilst I may have spoken earlier of our need for feedback, this is one situation where I, as the photographer, don't doubt the reasons behind my choice of printing method. The print has been made on Multigrade FB matt, using a diffuser enlarger.

5. Print processing:

Normal development in Multigrade developer, diluted 1+9 and developed to a factor of 5, which in this case was 3 minutes at 20°C. The print was stopped in 2% acetic acid and two-bath fixed in Ilford Hypam. Because I avoid over-fixing my prints and don't de-velop any papers, except lith, in warm tone developers I do not normally find it necessary to use a plain or alkali fixer, for reasons outlined in PRINT PROCESSING. Once fixed and briefly rinsed, I hypo-cleared the print and then thoroughly washed it. Any residual fixer would permanently lighten the highlights as in the reject images in PRINT ASSESSMENT.

6. And finally:

There's another very contorted tree nearby. So far, I haven't produced any good photographs of it. Any ideas?

Black Mount

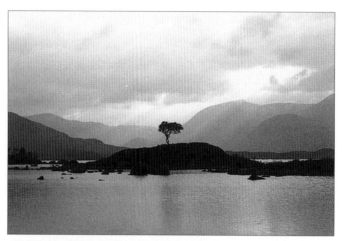

Above: straight exposure proof print.
Opposite: the final, thiocarbamide-toned print.

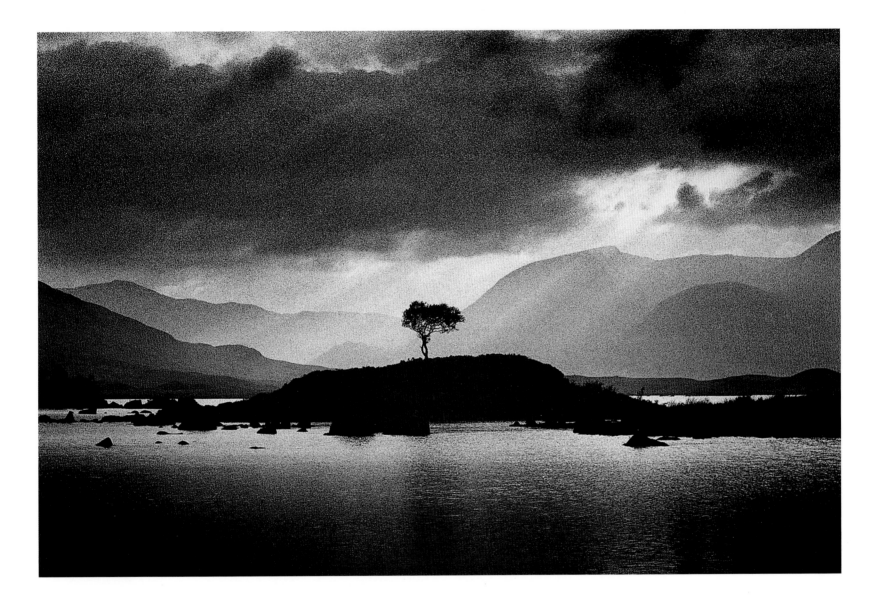

Image notes

Opportunities of dramatic light are there for the taking. Photographs incorporating them are rarely produced with such ease.

In PRINT ASSESSMENT I have shown how the various enlarger exposures for this print were worked out, so that, by using three different contrast filter settings, the quality of light I achieved in the print finally matched that which had drawn me to the scene in the first place.

In their unmanipulated form, black and white photographs rarely possess the sense of luminosity and light that comes more naturally to colour transparencies. In part this is because monochrome prints are viewed by reflected light and transparencies by transmitted light. Transparencies also benefit from the effect of colour contrast. This optically, rather than physically, enhances the liveliness of the image in the way that split-toning a print yellow-black, like **Rannoch Moor**, adds colour contrast to the picture.

When making a potentially difficult print, such as this, with hard to control but dramatic lighting, the logical solution might appear quite simple. Why not lith process it? It gives the print warm-tone highlights and strong, neutral-tone shadows for optical and physical contrast-increasing effect. And, by virtue of the fact that the lith process requires the print to be overexposed by two stops, the highlights are automatically burned-in.

In part, this is why the lith printing process has proved itself so popular. It isn't just a fashionable process, but a clever one. So why didn't I use it here?

First, the lith process doesn't work well with VC papers, such as Multigrade. Second, it tends to compress the highlight values of the print (see my notes accompanying the lith prints of the **Rance Estuary**).

Applying the lith process to **Black Mount** would have had a contrast-controlling effect. I wanted the opposite — to increase the contrast of the clouds, not compress them. Besides, I didn't want a warm, overstated, split-tone, lith print image colour, but a cooler, more guarded, monochromatic, purple-brown thiocarbamide tone. My reason being, that whilst the lighting of this scene was lively in nature, I actually wanted to play this down, in a way that would be fitting to the essentially understated nature of much of Scotland's scenery.

In my opinion, the Scottish landscape doesn't garishly catch the eye. It slowly draws it in, giving the viewer plenty of time to absorb what is there, whilst forming their own impression of the scene.

1. A black and white proof print, that has had some burning-in work. The balance of this print needs to be improved. But how? (See PRINT ASSESSMENT, pages 132-133.)

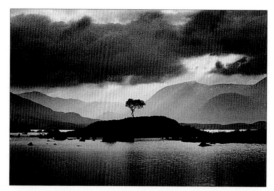

2. The sky is too dark and heavy in this toned version. Besides, the print lacks gradation of tone between the ground and the clouds, so the photograph looks unnatural.

3. Burning in the water seemed the natural thing to do if the sky was also to be burned in. A flexed, curve-shaped card, gradually moved up and down nicely blended in this work.

4. Burning in the top left-hand corner has brought out a highlighted cloud formation that helps to balance the fall of the light, which appears from the right.

5. Burning in the middle distance, at a softer grade setting, provides much needed, subtle tonality which is definitely lacking in photograph 2.

6. The final print has detail even in the 'light-source'. This area was locally burned-in, although in photo-mechanically reproduced form here I suspect this effect may be lost.

Kodak TMax ISO400.

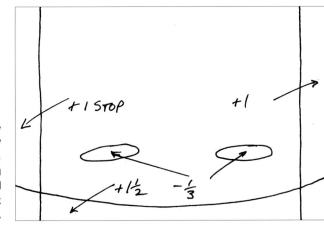

I printed the image quite dark, so that the shadow detail was lost. However, this required dodging either side of the island with a 1/2" diameter, black card dodger.

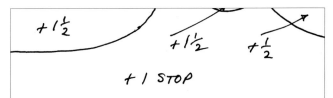

Burning in the sky, at a harder grade 4 setting, required careful exposure control. I didn't want the tops of the hills to become unnaturally dark.

Grade 1/2, with its greater exposure latitude, is much more forgiving of any burning-in errors. That said, it was still a juggling act trying to balance these exposures.

1. Subject:

Since I made this print I have seen several other photographs of the same scene, made by other photographers who, like me, had lodged some of their images in a photographic picture library. Access to an 'image bank' not only provides a wealth of ideas for photographing other locations, it also provides a useful insight into a wide variety of different photographic techniques. I saw Black Mount in colour, in different seasons and in different shades and hues of monochrome. Each image had its own style, although some were clearly derivative — inspired by the work of other photographers. My particular approach to this image was inspired by the name. I didn't want any detail to be visible in the island mount. Quite literally, it had to be black.

2. Camerawork:

35mm Nikon FM2 camera, with a 50 mm lens, set at f.8 and an orange filter. A red filter would have usefully darkened the foliage of the island. It would also have helped to enhance the separation of the clouds, which I later printed at a harder grade setting, to achieve the same effect. However, it would have penetrated the haze and that, more than anything, would have killed the image. Even with an orange filter on the camera I had to burn in the middle distance at very soft VC paper setting to maintain this atmospheric effect. Hand-held at $1/125$ second, the image is sharp.

3. Film processing:

All the dirt marks visible on the final print (see PRINT FINISHING) are from the glass negative carrier (I would say that!) and not from the final rinse of the film, which was made with deionised water.

4. Print exposure:

My first few efforts at this print were too dark and too soft. This fulfilled the overall objective for the print: to keep the island black and the highlights detailed and therefore suitably understated (for reasons explained in IMAGE NOTES). However, it did little for the tonal separation of the print. In effect, the print looked dead. Reprinting it, using three different grade settings, as illustrated and described in PRINT ASSESSMENT, completely altered this state of affairs. It so distorted the natural tonal range of the scene as to make it look more real! This technique works on the assumption that we perceive a scene using more subjective than objective criteria. For instance, some unfiltered colour transparencies I had seen of Black Mount appeared too clinical. My final print was made on matt Multigrade FB. I did try a gloss surface to enhance tonal separation but , for want of a better word, the print looked too slick.

5. Print processing:

A standard print developer, followed by 2% acetic acid stopbath and two-bath fix of Hypam, diluted 1+9, with the photograph fixed, as usual, for 1 minute in each. The print was rinsed, hypo-cleared and fully washed. I bleached the print about halfway back in the toner bleach, formula 46, to keep the island almost completely black in the final toned print. I was careful not to to touch the print during or after toning — as with any print.

6. And finally:

A little retouching work , as depicted in PRINT FINISHING, really helped to complete this essentially simple image, by removing distracting details and dirt marks.

Mis Tor

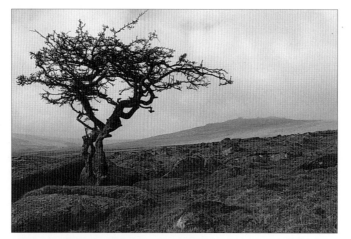

Above: a slightly different viewpoint.
Opposite: the final, selenium-toned print.

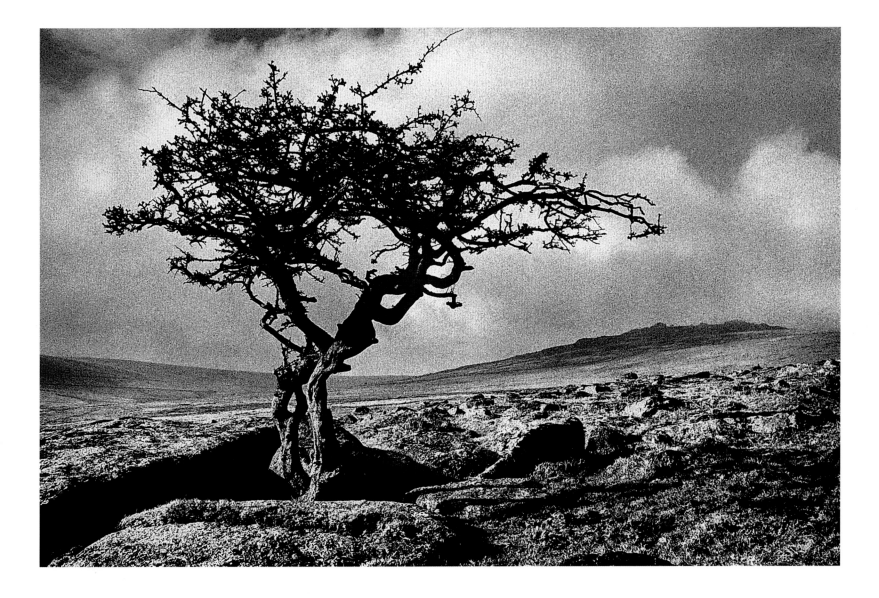

Image notes

Everybody has been influenced by the work of other photographers at one time, or another. For some, this was the force that motivated them to take up the medium of photography. For others, it remains a guiding light to their work, long after the flame was first kindled.

Much can be learned from looking at the work of others. For example I have always admired the landscapes of Bill Brandt. Yet, many of his prints appear quite crude in their making: stark images, usually heavily printed, often with the appearance of being hurriedly bleached. Some are so rough, they look as if they have been hewn out of black and white paper. Their effect is immediate and yet, for me, the reaction is still long lasting.

Arguably, it is with this imagery in mind that I photographed **Mis Tor**, although I have never consciously set out to copy, or to emulate, anyone else's work. In fact, if I want to produce untoned black and white prints, my preference is for a style like that of my own **Bradwell Barges**, on page 69. That print has also been locally bleached, but the evidence of handiwork is not visible. It is an attempt to produce a more understated image, allowing the viewer to form their own impression of the scene and to draw their own conclusion from it. As such, it is a more impartial, but hopefully not too impersonal, approach to the landscape. In comparison, some so-called "Fine Art" black and white photographs, that matter-of-factly state what is there, rarely capture my attention. They lack comment. A black and white print should be more than just a dialogue with its photographer.

The print of **Mis Tor** has been bleached, overall, in a dish. My intention was that this should add a greater sense of directional light to the scene. Briefly bleached, the process lightens just the highlights of the print first, rather as if directional sunlight has hit an overcast scene, whose heavy, dark-grey cloud-cover is unable to reflect light back into the (as yet unbleached) midtones and shadows.

If the bleaching process is arrested at this point, the print will remain unchanged in colour, but prolong the treatment, in particular in Farmer's reducer (formula 38), and the print will become slightly warmer in tone. The bleached prints of Hound Tor, in TONING, exemplify this effect.

Mis Tor isn't intended to be an echo from someone else's past. It is a personally inspired image, in which the echo is of shapes and form, within the print itself. The undulating line of the foreground shadow is meant to be seen, similarly repeated, in the right-hand branch of the tree and then again in the line of cloud to the farthest right of the print.

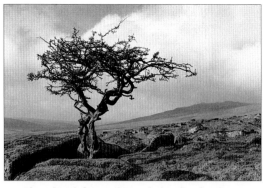

1. The cloud formation of the final print was just beginning to take shape when I made this exposure.

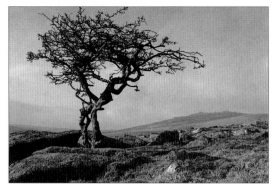

4. A lower camera angle has destroyed all sense of depth. The extra foreground shadow and cropped branches do little for the print.

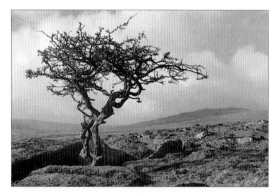

2. A closer camera position and a better crop. This exposure was made a few seconds before that of the final selenium-toned print. Note the small undodged dark area in the foreground.

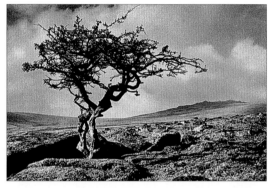

5. Bromo-chloride VC papers, such as Ilford Multigrade and Oriental Select, produce neutral-toned prints whose colour is not easily changed by development methods alone.

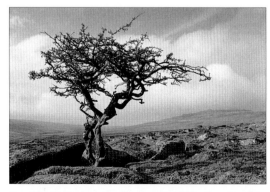

3. There is no shadow over Mis Tor in this print. Its disappearance noticeably affects the balance of the image. Without it, the right-hand side of the print appears empty.

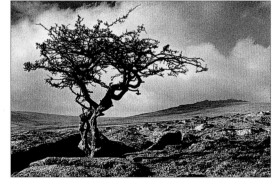

6. Gold or selenium toning, to completion, will change the colour of all papers, such as Bradwell Barges. A brief period of toning intensifies the image and archives it.

TECHNICAL DATA

Ilford Delta ISO400.

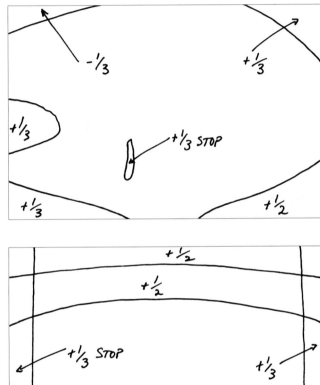

Although the bottom half of the tree trunk was naturally brighter than the top, which lay in shade, burning it in produced a more natural effect.

Overagitated, dish-bleached prints lose density at their edges where bleach solution turbulence is greatest. Burning in is an advisable, preventative measure.

Even a dish-bleached print may benefit from some additional local reduction work. Here, I thought the right-hand line of clouds needed accentuating.

1. Subject:
I had seen several documentary-style, black and white photographs of Mis Tor before I visited the location. All of these had been made with standard focal length lenses. From these prints one could deduce that the weathered granite, igneous intrusion was impressive — but only if viewed on location in 3D. In print it clearly lacked much needed dimensional form. The most obvious way to get around this problem would be to use a longer focal length lens. But, with the exception of the abstract photograph of King's Tor, I prefer to work with standard or wider angle lenses. I don't like the 'distancing' effect and the more detached feel, that longer lenses can sometimes give to a landscape. I want to be a participant of the landscape, not a passive, 'stand-offish' observer of it.

2. Camerawork:
Rather than make a photograph of the Tor by itself, to show its weathered rock formation, I decided to include the feature as part of a general landscape of Dartmoor. In this print I wanted to show some more transient patterns of nature: the shape of the foreground shadow, the lines of the tree and the cloud formations. The Tor is simply background information, but the shadow falling across it is vital. It adds a natural sense of depth to the picture. The photograph was made with a 35mm Nikon FM2 and 35mm PC lens, with an orange filter.

3. Film processing:
Ilford LC29, diluted 1+29 and developed for 12 minutes, with once a minute agitation, 2% acetic stopbath and fresh one-bath Hypam fixer diluted 1+4. Fixing time, to clear the dye sensitiser of the Delta ISO 400 film was 3 minutes.

4. Print exposure:
More often than not, bleaching a print back in Farmer's reducer enables it to be printed $1/2$-1 grade lower in contrast and overexposed by about $1/4$-$1/3$ stop. The effect of the bleach is then considerably to lift the contrast of the print by lightening just its highlight density. The joy of this process is that, printed softer, the image still retains good shadow detail, if it is required. I wanted to concentrate more on shadow form, so I used a harder grade. Knowing how the bleach exaggerates highlight separation, I knew that some areas of delicate tone might be lost. With this in mind, I tested a couple of quickly made 20" x 16" prints to see where, if at all, such problems might arise. Several areas did lighten too much and were burned in for longer in the final print. Although printed with a diffuser enlarger, the bleach accentuates the grain, making the print look as if a pointsource light was used.

5. Print processing:
Multigrade developer, diluted 1+9, with the development to completion. 2% acetic acid stopbath, then 2 bath Hypam fix. After a brief wash the FB print was laid in a dish and the bleach poured smoothly, but rapidly, over it for a uniform, mark-free coverage. Bleached for 1 minute, with Farmer's (formula 38) heavily diluted for a slower, controllable effect. The print was rinsed in cold water, to arrest the action, washed, selenium toned, hypo-cleared, washed and air-dried.

6. And finally:
Make sure all the print stays covered with bleach and don't overagitate the tray — the sides of the print, where there is greater solution turbulence, will bleach quicker.

Fernworthy Forest

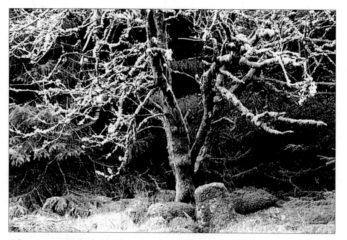

Above: a slightly different viewpoint.
Opposite: the final, thiocarbamide and blue-toned print.

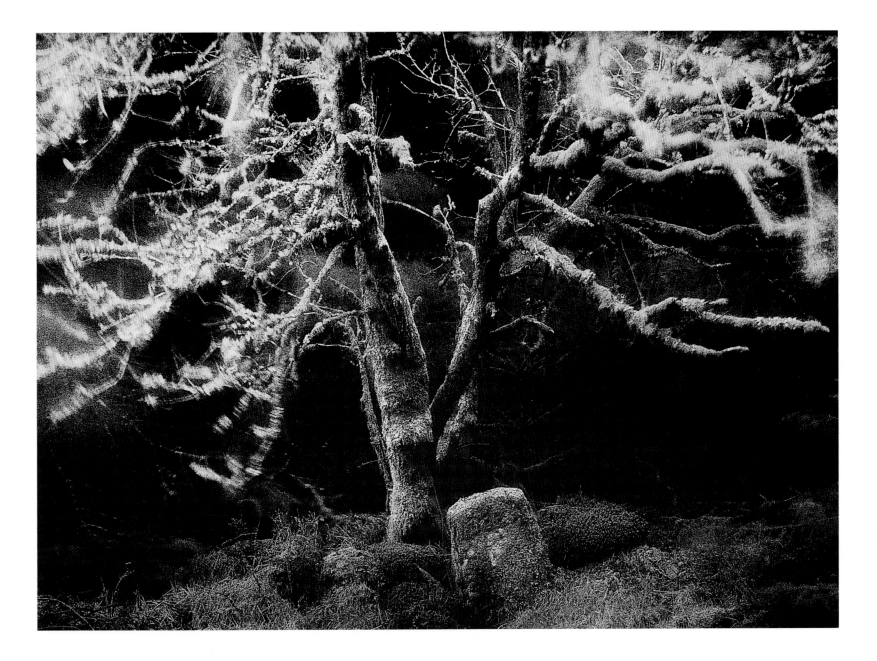

Image notes

Fernworthy Forest, on Dartmoor, is perhaps best known for its ancient stone circle. I had seen documentary photographs of this site in various local publications. From looking at these, and at an Ordnance Survey map of the area, I quickly formed an impression of how I would photograph the scene and at what time of day, to get the best angle of light.

But, as for **Trumpan Stone,** all this research still left me unprepared for the element of surprise. Yes, the stone circle was as I expected it to be, but the wind-fallen tree that lay in its midst hadn't been there in the photographs, unless someone like me had retouched it out!

No matter how many different viewpoints I tried, there wasn't one that was photographable. I gave up, not so much disappointed as slightly amused at my short-sightedness. Besides, I was pleased to have had the opportunity to visit this historic and atmospheric site.

It was on my walk back to the car that I came across the scene of this photograph. I had already noticed others like it, but none had such a completely blanketed backdrop of tightly woven dark green pinewood, against which the lichen and moss-covered branches of the tree stood out. I watched the scene for a while, waiting for each flurry of wind, to see how much the branches would move, wondering whether this movement would be visible on film. If so, then how could it be enhanced, for maximum effect?

The answer was to combine both creative camera and darkroom techniques. A slow shutter speed would capture the flow of the movement, whilst a little, subtle, camera diffusion would enhance the effect. Coupled to this, a yellow-green or green filter, that would further lighten the branches, and I figured I would be half way there. The rest, I thought, could be achieved through careful balancing of the print — the foreground of the picture was distractingly too bright — and then by multiple toning it, first in thiocarbamide, for a warm sepia tone, and then, briefly, in blue, for a green colour in the shadows.

I knew the hardest part would be to determine the duration of the blue tone, rather than to figure out the most appropriate length of camera exposure (bracketing would take care of that). Too little blue toning would fail to make the branches stand out. Too much would make the backdrop excessively blue, rather than green in colour.

As for the stone, its presence is coincidental, but compositionally helpful, which is more than can be said for the aforementioned fallen tree.

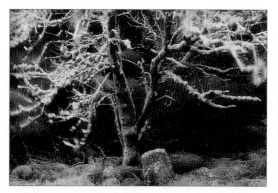

1. A black and white 20" x 16" proof print. The foreground has been burned in a little, but it is still too light. The top left is also too bright.

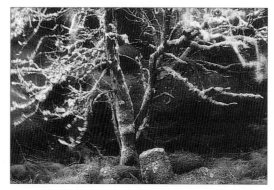

2. The top half of this proof almost looks right, but the bottom half is still too bright. Blue toner exaggerates this type of imbalance.

3. Sepia toned, in the modern, odourless (thiocarbamide) equivalent, the print is now ready for blue toning. Note how the contrast of the image picks up in the second toner.

4. Darkening the bright body of foreground detail allows attention to be drawn to the more subtle lines of the branches.

5. Some local burning-in, such as this small branch, results in a less punctuated, more continuous feeling of movement.

6. The top left of the image also needed burning in. Like the foreground, it was too bright and threw the print off-balance. Multiple toning would have exaggerated this effect.

Ilford Delta ISO400.

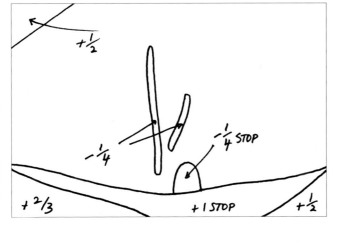

Grade 2¹/₂, for the basic print exposure, produced a print that was a little too flat. The blue toner compensated for this, but it also made obvious any exposure imbalances, so far unnoticed.

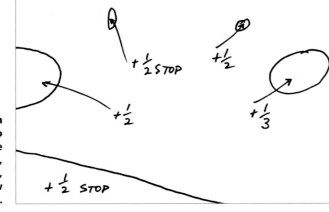

Changing to grade ¹/₂, with Multigrade, enabled me to print down some distracting bright areas, such as the foreground, without losing shadow detail.

Bleaching the edges of the tree trunks, with a fine, artist's brush, emphasised their rigid lines when compared to the wind-blurred forms of the branches.

1. Subject:

Photographing generic, universally understood landscapes, such as Rannoch Moor, has made up the bulk of my income for some time. So it is perhaps without surprise that I now find myself frequently photographing abstract, less obvious, patterns of nature, such as this image of Fernworthy Forest, or that of the essentially man-made scene of the Rance Estuary. Perhaps this is a reaction to producing too many popular-style landscapes? Or, maybe, its just that as one progresses in photography, so one looks for images that will provide greater intellectual stimulation of mind, rather than financial peace of mind. That said, if I worked out the time spent on any of my prints over the years, I should give up today. They are not cost effective to produce! But then where would the challenge be?

2. Camerawork:

A less immediately obvious subject merits attention to detail. So, I took particular care over my camera composition, making sure that the pre-visualised print I saw was what the camera and film also 'had in mind'. Scenes like this have a nasty habit of turning out as prints that show little except a natural (or is it man-made) chaotic state. By using a tripod I was able to step away from the camera, then back again, to refresh my view. The camera was a Nikon FM2, with 50mm lens and yellow-green filter.

3. Film processing:

Ilford LC29, diluted 1+29. By now it should be clear that given the restrictions of 36 exposures on a 35mm roll, I simply aim to get as good a negative as possible. If the negative is properly exposed, the rest I'll leave to printing.

4. Print exposure:

I was determined not to overwork this print. I didn't want to kill off its own natural sense of rhythm, yet I knew without some dodging, burning-in and local bleaching, it wouldn't stand up on its own, let alone lead the eye around the frame, as I intended. In its black and white, pre-toned state, the print looked good. Sepia toned it still looked good, but (in the small print here) I can say that maybe I overdid the blue toning. It has crept into the highlights. There again, the multiple tone is the right colour, so maybe it was my printing that was at fault. Perhaps I was a little too 'soft' on this print. Maybe I should have printed it bolder, rather like my grade 4 print of Epping Forest. I shall dwell on this thought for a while, before, perhaps, attempting a reprint. Although, I suspect that once I have come to a conclusion, I'll apply what I have learnt to a new image. Reprinting can become a purely technical exercise.

5. Print processing:

A standard developer again. I use warm or cold tone developers for chloro-bromide or bromide papers, as opposed to the neutral-tone bromo-chloride Multigrade FB. The print was hypo-cleared, then thoroughly washed before bleaching in formula 46, until the blacks were almost completely gone. After a thorough, ten minute rinse, the thiocarbamide toner was applied, made up with 2.5 parts A to 1 part B. A 1 hour wash followed, then partial blue toning in formula 51.

6. And finally:

One American magazine spoke of taking a length of rope on location, to tie back intrusive branches! Careful cropping may work better.

Route Napoleon

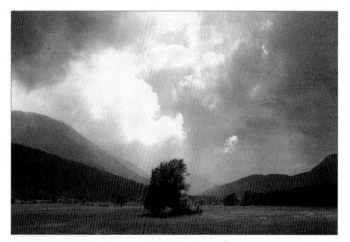

Above: straight exposure proof print.
Opposite: the final, thiocarbamide-toned print.

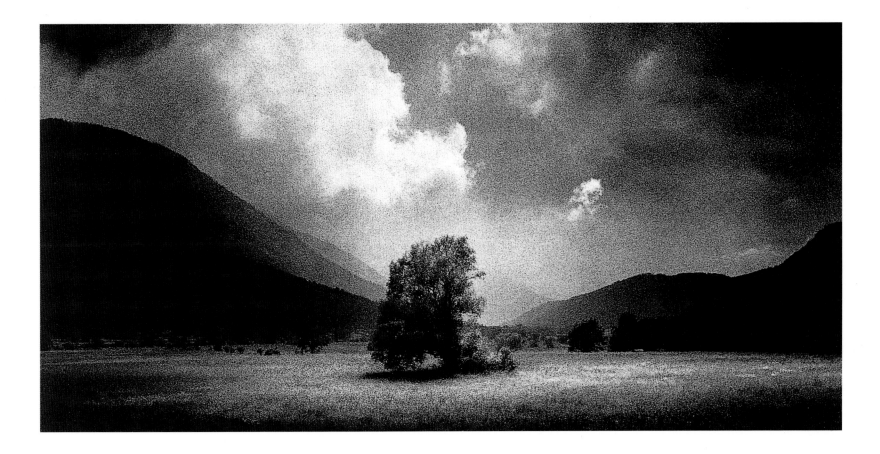

Image notes

Find a simple subject, apply (seemingly) complicated photographic processes to it and you get back to where you started — a simple image!

As yet, there are no short cuts in landscape photography. Prints still have to be crafted, using time-earned techniques and processes. More often than not, these are the very same methods, or chemical processes, that we used for our first attempt at processing or printing. Only, then, we didn't fully realise how they could radically, or subtlely, alter the appearance of a photograph. Like waiting for a cloud to pass over a tree before pressing the shutter release, given time and practice we will gradually become aware of when, and how, we should take control of these creative influences and processes, to put our own mark on the scene.

There was nothing complicated about the making of this print. It just took time. Several years, in fact! This was how long it took me to realise what local bleaching could do to a print. So, somewhat hesitantly, with brush in hand, I applied the Farmer's reducer 'chemical light' to the area around the tree. The result was a revelation. It worked! Just as it has worked for many others before me, and for many more to follow.

Since then, when I have been on location, I haven't only looked at what the natural elements have done, or are doing, to shape the landscape. I have also looked at what I could do to change, or to enhance the scene photographically.

Gradually understanding darkroom processes has brought with it a new way of seeing. So that, when it is appropriate, rather than wait for the 'right light', which may never appear, I often go ahead, and expose the film, illuminating the subject later, in the darkroom, with print exposure techniques and chemical processes, such as bleaching and toning.

I should imagine that, for all of us, there are at least a few old prints that mark similar 'emergence times' in each individual's personal photographic development. This is one such print. **Route Napoleon** may not be the best example of composition, but to this day, it still looks good. (At least to me it does!) Besides, even now, I still can't think of a better way of composing it.

Perhaps this represents a gradual, in fact very slow recognition, on my part, of the fact that we don't have to be clever with a camera — producing intricate or complex compositions — to make a good photograph.

Simplicity can work, and, what's more, we can make it work for us. What better short cut?

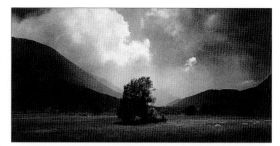

1. This is the scene a few moments before I made the final exposure. It is just possible to discern the makings of the cloud formation above and to the left of the tree.

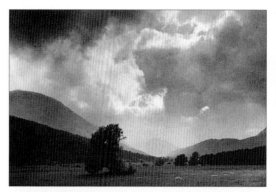

2. Literally a few moments later the cloud has almost dispersed. The compostion of the final print is deliberately simple. Changing it, by placing the tree off-centre, doesn't work.

3. A test-strip proof print like this, and for Trumpan Stone, provides almost all the basic exposure information needed to make a good, but by no means perfect, final print.

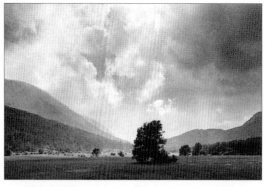

4. A black and white, 20" x 16" proof print, awaiting the application of bleach around the base of the tree. I decided to leave this print, as it was, for future reference.

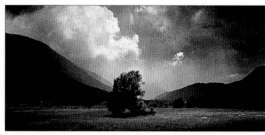

5. Toned, but unbleached in the foreground. It is too late to go back and work on this area. The bleach won't work very well and image colour will change.

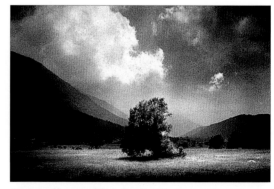

6. Locally overbleached with Farmer's reducer, prior to toning. There is a very noticeable change of toned image colour in the worked-on area of the print.

Kodak TMax ISO400.

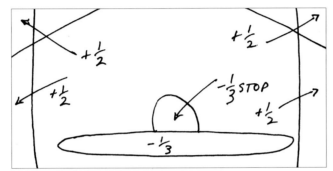

Grade 3 provided the right contrast for the mid-tone values of the print, but it left the highlights too bright and the shadows too dark. I lightened the latter with a 1" diameter black card dodger.

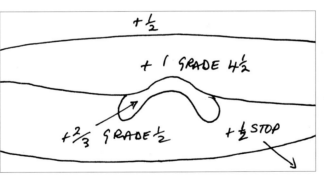

Burning in the sky at grade 4¹/₂, enhanced the cloud but left a visibly light area around the tree. This needed to be burned in at grade ¹/₂, to retain plenty of detail.

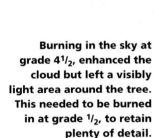

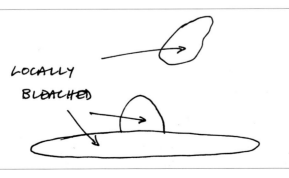

The tree only needed the very slightest application of bleach. The foreground tolerated more, but not too much — as I discovered with photograph 6 opposite.

1. Subject:
It is so easy to passover an opportunity like this, without realising the full potential of what is, albeit almost imperceptibly, present in the scene. Yet images with this type of lighting are very much there for the making, although merely 'taking' them will (most likely) yield an unsatisfactory print, rather like that of the straight exposure, unbleached and untoned proof. Developing the ability to pre-visualise a finished print enables the eye to detect a potential photographic opportunity and then quickly to establish — before the light has gone — whether the image can be made, given the supposed limitations of the 35mm format.

2. Camerawork:
35mm photography is full of theoretical hindrances. Grain is said to 'spoil' an image, exposing all 36 exposures to the same ISO setting won't produce the 'best' print quality, and so on. But, even purists can't deny the spontaneity of 35mm. Try exposing this type of quickly changing scene onto a large format, sheet film camera. It's possible, but will such a 'perfect' negative then be suitable for tampering with, at the printing stage? For example, might not local bleaching look out of order? 35mm is free of such photographic conventions. This image was happily exposed onto a basic 35mm Nikon FM2 camera, with a standard 50mm lens fitted with an orange filter.

3. Film processing:
Another film developed in Rodinal. It is cheap. If I had to choose an alternative developer, that produced finer grain, but very slightly less sharp negatives, it would almost certainly be Ilford ID11, diluted 1+2, or 1+3.

4. Print exposure;
Printing this type of picture can be really frustrating! Just when you think its balanced, you look at in the mirror and, guess what? It looks awful: out of balance and quite unlike any normal landscape. Wonderful! Yes, I do go on about viewing the print in a hand-held mirror, but who says it always has to look good viewed in reverse? If the movement of the cloud is from left to right, as here (and Pentire Point) then shouldn't we go along with our judgement of the print, based on how it looks when viewed the right way round? Listening to the advice of others may not help, although it is a good way of 'seeing' the scene in a different light. The print was made with a diffuser enlarger. A condenser might have lost subtle highlight detail in the cloud.

5. Print processing:
My standard print development — to completion. If made on a chloro-bromide paper, an even warmer effect to the thiocarbamide tone could be achieved by overexposing the print, then 'underdeveloping' it to a factor of x3. Farmer's reducer can be applied locally, using a wide variety of implements, in this case a brush, or a swab of cotton wool, dampened with bleach, will work well, provided the bleach is diluted for a slow, controllable effect. I test the speed of the bleach on a reject print, fixed and washed in the same way as the final print. This was another thiocarbamide toner job, at a 5:1, A to B ratio.

6. And finally:
Retouch the small white cloud (a third of the way in from the right), like that above the tree of Black Mount? No! Here it is vital to the balance of the print.

Equipment

Camera equipment

The 35mm format

All but two of the main, toned landscapes in this book have been made using a standard 35mm camera. Its use reflects the photographic practices and interests of the vast majority of today's black and white landscape photographers. But is it the best format for landscape work? Throughout the book I have tried to explain some of its pros and cons.

Aspect ratio

Different camera format, image-aspect ratios create various possibilities of composition, which will undoubtedly affect the subsequent balance, meaning and interpretation of our photographs. Some would argue that the 24mm x 36mm 'landscape' aspect ratio of 35mm is ideal for location work. Presumably because its shape generates eye movement that pans across the landscape from left to right and back, suggesting a sensation of dimension and space.

I have to admit that I often find its image-aspect ratio a drawback to composition. This is especially so if I want to make more abstract studies of natural patterns, whose rhythm and balance would be upset by anything other than the less ambiguous square format of some 120 cameras. For example, in the picture of **Fernworthy Forest** I was trying to capture the almost circular movement of the branches as they were blown in the wind. For this, I think a square format would have helped, within which the image could have moved as it wished. But, compare this with the silhouetted trees of **King's Tor**. It felt right composing this image with the 35mm camera's 2 x 3 aspect ratio, because I wanted to add the movement of the branch out to the left, in what would otherwise have been a very static scene. However, without care, the landscape format can very easily pull the picture in unwanted or unnatural directions, similar to the effect of panoramic cameras. A simple answer (if it ever can be simple) is to work with one camera format aspect ratio and to get to know it well, and, if need's be, crop the image later — as pre-visualised at the film exposure stage, of course!

Depth of field

35mm gives the most depth of field for a given aperture size when compared with larger format cameras — that is if those cameras don't have depth of field controlling lens and body movements. Good depth of field means everything can look sharp and, for 35mm cameras fitted with wide-angle to standard lenses, this can be achieved even at quite large apertures. I have found this makes low-light photography in the morning and evening much easier, as with **King's Tor**, when the light had virtually gone. Not having to stop the lens down too far also means shutter speeds can be kept relatively fast — important if you want sharp images on a windy day, or if you wish to freeze the movement of the elements.

A final word on depth of field. I always found some of the older books on photography slightly misleading when they advised us to stop down the lens as much as we could for landscape work, some even advocating f.64! Where this is stated you can be sure that it is for large-format camera users whose negatives are either contact printed to the same size, or enlarged just four times to get a 20" x 16" print, at which magnification any failings in lens performance are hardly noticeable. Magnify a 35mm negative x18 to get a 20" x 16" print and the same is not true.

Image sharpness

Larger-format negatives are undoubtedly capable of producing prints with less graininess. This should make the image look sharper, but if large-format camerawork isn't up to scratch, say the focus is even slightly out, or the camera's bellows have caught the wind during a typical lengthy large-format exposure, then the clarity of that negative will merely show up any such faults in technique!

You may laugh, but this is one of the reasons why I use the 35mm format, and usually with faster, inherently grainier — fault masking — film. For example, a print made from a highly magnified, granular 35mm negative will help to cover up any dust marks (usually caused by dirt attracted to the glass of the negative carrier), such as those I frequently experience. When these marks are visible, the grain pattern of the enlarged 35mm negative makes them easier to retouch.

Camera controls and facilities

Having chosen to use 35mm, I opted for purely manual, mechanical cameras. My choice? A Nikon FM2 and an old Nikon F2 as a backup, although, unfortunately, the latter no longer has its metered head. If you look at one of the illustrative camerawork photographs of **Wistman's Wood** you may be able to see why I prefer essentially non-electronic (more water-resistant) cameras: sheet rain is visible against the dark shadow of the rock. Rain, and the other harsher elements of nature make me think — most probably a little unfairly — that a mechanical camera, whose only battery operation is the meter, is best.

A depth of field preview facility and mirror lock-up — to reduce camera shake — are useful. Although with the FM2 the latter can only be activated by using the self-timer. However, with more modern, perhaps less 'clunky', cameras I should imagine mirror-shake is less of a problem. I like (and maybe need!) a simple, idiot-proof metering system: in the FM2's case it is centre-weighted which I have got to know well, to the point where I realise ('automatically') when to overexpose or underexpose the film, according to subjects of higher or lower light reflectance values. Even so, as a safeguard I always bracket my exposures (as described in CAMERAWORK) so that any element of risk is reduced, both in terms of possibly incorrect exposure readings or potential damage to vital negatives.

Shutter-speed control, that allows for long, timed exposures without battery drain, is a must. For example the **King's Tor** tree silhouette photograph required a 3-minute exposure in order to put what I consider to be sufficient printable detail into the area of the tree trunks. At this scene, I bracketed the camera exposures from 15 seconds (the camera meter's misleading backlit reading) up to 3 minutes, in half-stop increments. Although the print is essentially a silhouette, it has been made from the longest exposure negative to ensure good tonal separation around the diffused edges of the trees.

Whilst I like the FM2 I prefer a camera like the F2, which gives a more complete image in the viewfinder. The FM2 loses about 8% of the viewed scene, which makes slight cropping of the negative a common drawback. This reduced view also creates an urge to pull back a little from the subject

1. I used a transmisson step wedge like this to make the contact test prints in TONING. It can also be used to make prints on different paper types to objectively compare their qualities.

2. A dodger rarely needs to be more complicated or more expensive than this.

3. Holding the dodger at a different angle alters the shape of the lightened area.

matter to ensure that I'm getting everything in. With wider angle lenses, this has an unfortunately dramatic effect on the relative size and balance of the near-foreground to middle-distance elements of the photograph.

Because I had a problem with levelling horizons — my negatives invariably tilted to the right — I fitted a grid-screen in the camera viewfinder. However, even this did not completely solve the problem. Until, that is, I started composing pictures in camera, first using my right eye (which is the dominant but obviously 'crooked' one) and then levelling up the image with my left, which appears to see things 'straighter'. Tilting horizons can break or make an image: **Wistman's Wood** is a good example. Incidentally, hotshoe-mounted spirit-levels rarely seem to be accurate enough, although I do find the spirit-level on my tripod-head a help.

Another reason for using the grid-screen viewfinder is that it does not have a central focusing-spot or split-screen. For early morning, or late evening, low-light photography I find such focusing aids can in fact make focusing more difficult: the central spot is very distracting, especially when it darkens as the depth of field preview is used. Also, they do not work with some of my slower lenses, such as the 20mm, f.3.5 lens.

Lenses

I use a selection of prime lenses — 20mm, 28mm, 35mm, 50mm and 55m micro — purchased before zoom lenses could compete in terms of quality, although **King's Tor** was made with a borrowed zoom, set at 70mm. To cut down on the amount of equipment that I would have to carry, I chose only lenses that had the same 52mm filter thread size, even though, on a couple of occasions, this meant I missed out on buying faster, easier to focus lenses. The 35mm is a PC (perspective-control) lens, which is useful for correcting converging verticals.

Camera accessories

There are a number of accessories which I always take on location: a lens (blower-type) brush, lens cloths, spare camera meter battery, a good-length cable release, and a range of glass screw-in filters that includes: yellow, yellow-green, orange, red, neutral density, polariser and a couple of diffusers. I never use graduated filters to bring down the density of bright skies, since I find burning them in later produces a more controlled and natural effect.

Other essentials include a notepad, a waterproof pen, some sticky tape, a marked-up Ordnance Survey map of the area, which I keep in a waterproof map-sleeve, and a compass for any remote, off-road locations. For viewing work, I have a grey plastic viewer that is held at arms length to compose the image (see CAMERAWORK).

For landscape work I prefer to travel light, but usually I end up carrying a slightly oversized camera bag which, when loaded with equipment, accessories and film neatly tucked away, still leaves some room for hurried storage of equipment, for example when working in the rain. To add to this weight I have a heavy-duty, Manfrotto tripod which gives excellent elevation with good rigidity, but poor low-level performance. Look at the **Wistman's Wood** camera technique photograph and you'll see what I mean. Born out of frustration, I now have a clip-on bracket, that I attach to one of the tripod's legs, to which the tripod-head and camera can be fastened for low-level camerawork.

Finally, I almost always take a stepladder with me, to get away from the potential problem of distracting foreground detail arising from wide-angle lens photographs made closer to the ground. If it looks like it is going to rain I will also take a brolly, to protect the camera and keep water off the front lens element or filter. Although the stepladder is lightweight it is a little inconvenient to carry, which does detract somewhat from the general pleasure of being out there, unhindered, in the open. But then, what price a good landscape photograph?

Film processing equipment

Processing tanks

For 35mm and 120 rollfilms, I would always recommend small, daylight, manual processing hand tanks, rather than the deep tank (bulk film) or automated hand tank varieties.

Why this choice? There is no substitute for a good, evenly developed negative, free of processing faults. In my experience most tanks offer this potential, but only manually operated hand tanks also allow individual films to be processed in one-shot developers, and at different developer dilutions, and with different (perhaps very intermittent) agitation techniques to enhance the effects of negative development.

I have always tended to favour plastic, rather than metal, hand tanks. This applies to rollfilm and sheetfilm varieties, such as the Paterson and Jobo, or Combi-Plan (5" x 4"), tanks. Solution temperature control, in hot or very cold darkrooms, can be harder with thermally more sensitive, metal hand tanks. Such changes require careful monitoring and will necessitate some modification of development

times, to ensure negatives of consistent density and contrast. However, for all hand tanks, whether metal or plastic, I have always found that, to avoid an incorrect solution temperature reading, the thermometer should be brought up to approximate solution temperature before it is inserted into the low solution-volume neck of the tank.

All the plastic hand tanks I have ever used appear to have quicker solution drain and fill times than their metal counterparts. This gradual coverage of the film with processing chemistry should not cause uneven negative development with the more dilute, longer film development times of about 12 minutes, which I prefer. But it can be a problem with the more concentrated, shorter times, recommended by some developer manufacturers. For example, when I printed the **Pentire Point** triptych, each of the three negatives, which were all made with the same camera exposure, required quite different print exposure times. Balancing the density of each of the prints became extremely difficult, bearing in mind that all the negatives also required extra burning-in exposures, which all had to be modified.

These negatives were all processed some years back, in an eight-roll (!) hand tank — before I knew better. Now, for 35mm films, I always avoid using any hand tank that holds more than three spirals, because of the extra time it takes to fill, and also to reduce the likelihood of film processing marks, such as air bells, mottling and streaking around the film's sprockets. For 120 rollfilm, three rolls per tank is also my maximum.

I find the ratchet-type spirals of plastic hand tanks easier to load than the metal variety. But, like any spiral, they will only permit evenly processed negatives if they are kept clean of silver development by-products. Their ball-bearings also need to be regularly cleaned to ensure good, free, movement to avoid unwanted film tensioning during loading. A toothbrush is excellent for this job.

Unlike metal spirals, the plastic variety cannot be so easily bent, which also helps to avoid film loading problems and potential negative damage. But, take care! On more than one occasion I have heat-damaged plastic spirals, while drying them prior to loading, with similar consequences.

Film processing accessories

For loading film I have a cassette opener, a pair of scissors long enough to cut — rather than tear — 35mm and 120 rollfilm ends, and a pair of cotton gloves for sticky hands on hot days. A film-changing bag is a must for non-lightfast darkrooms.

For processing I would also suggest a good, consistent, thermometer that gives repeatable results, such as one of those described in the FORMULARY.

Various mixing vessels will also be needed, ranging in size from 300ml (enough for one roll of 35mm film) to about 2000ml. A mixing bucket is always useful, for making up powdered stock developers, such as the 5 litre or 13.5 litre packs of the ever popular Ilford ID11. A selection of small, accurate graduates, ranging from 25.00ml to 250.00ml is also essential for measuring small volumes of concentrated stock solutions.

I also have a few small syringes, ranging in size from 1.00ml to 25.00ml, for the very accurate measurement of highly concentrated solutions, such as Agfa Rodinal film developer. I use as little as 1.50ml (precisely measured) to process a 35mm roll of Kodak Technical Pan, for pictorial results, at a developer dilution of 1:200. I also use a small syringe to measure out wetting agent for the final rinse of the film. Syringes without needles are best, not just for safety's sake, but because the needles are too narrow to draw up viscous developers such as Kodak HC110.

A variety of storage containers is essential for keeping both stock and working-strength solutions fresh. The air in half-full, part-used solution containers can prematurely oxidise developers. This is visible as a brown solution discolouration, although some developers, such as HC110, are this colour to start with. My preferred system of solution storage involves the transfer of opened, part-used stock solutions to a number of smaller storage vessels, such as the 50.00ml to 500.00ml range of brown glass prescription bottles, available from chemists, of which only one needs to be opened to the air at any given time.

Rubber gloves are also extremely useful, for example to avoid skin contact with the inevitable leakages of tank chemistry from inversion agitation during film processing. Here, as for print processing work, my preference is for the washing-up, rather than disposable variety. They are easier both to put-on and to re-use with the occasional application of talcum powder. I also find that they leave hands far less clammy after long processing stints.

Film squeegees? I never use one after the final rinse, as explained in FILM PROCESSING. For drying roll film and sheetfilms, I use spiked plastic clips that securely grip the film. Weighted clips for the bottom of rollfilms limit curling while drying, thus reducing the risk of adjacent films sticking together permanently.

Heat-drying cabinets certainly speed up the film drying process and also filter-out any airborne particles which have a nasty tendency of sticking to the drying emulsion, where they can become permanently embedded, with a subsequent need for spotting prints. That said, I tend simply to air dry my films at room temperature, hanging them up in a draught-free and dust-free space. The drop in temperature associated with the possible opening of

heat-drying film cabinets, mid-way through drying, can leave irremovable tide-marks on negatives.

Enlarging equipment

Enlarger types

I have used very cheap enlargers to make exhibition quality, often complicated, multiple-exposure prints up to 20" x 16" in size. This process has sometimes been rather slow, but perhaps, all the more successful for it. Some examples of these prints are in this book. But, given the choice, what type of enlarger lightsource, and what design features would I look for?

On an overall design level, I would opt for an enlarger that offered the flexibility of interchangeable lightsources (as discussed below) for useful differences in both print sharpness and tonal range. In some cases, these system-based enlargers, such as the De Vere 504 I use, offer additional facilities, such as converting the enlarger into a print copy stand — a facility I often employ to copy toned black and white prints on to 5" x 4" and 35mm colour transparency film, for my portfolio.

The maximum height of the enlarger column is obviously important, since it will determine maximum print size and also the amount that a negative can be cropped without the enlarged print size being reduced. Inadequate enlarger head-height, when making bigger prints, either calls for the wall-mounting of the unit, or for projection of the image on to the wall or floor. In either case, the chosen set-up must keep the negative carrier, the lens panel and the easel all parallel to each other. If not, areas of the print may appear less sharp and the print's shape may change. If the image is less sharp, stopping down the lens will help, but for larger prints this may not be possible, since the amount of image-forming light reaching the easel may already be very low. Reciprocity failure may ensue, making highlights impossible to burn in.

In some instances I have found that it is not the maximum enlarger head-height that is a problem, but the distance of the head, and therefore the lens, from the column. If this distance is too small, it will prevent the correct alignment of the easel, especially with the wider-edged, larger print border, varieties. In this case, wall-mounting the enlarger may be the only way of bringing the head further out and also higher up. To do this, the column is usually taken off the baseboard, and attached to a simple-to-make, secure, wooden wall-bracket.

In this situation, I would also fasten the top of the column to the wall with two lengths of picture

framers'-type wire, each fixed at 45 degrees to the enlarger head, making sure they don't interfere with its movement. The length of these wires can be altered to make fine adjustments to the enlarger alignment. (Incidentally, they also provide greater enlarger rigidity. For this reason, avoid string, or any other fixing that might stretch.)

Adjusting the head-height of any enlarger, to make prints of different sizes, should be a simple matter, although with one enlarger I did have to wedge a clothes peg in between the head and the column, to stop the head rotating off its vertical axis as the head-lock was tightened. This overall head movement wasn't making the picture less sharp, in the same way that the easel can be tilted (to correct converging image verticals) without a loss of print sharpness, but as with the latter, it was causing a change in image shape. Like head-height adjustment, enlarger focusing should have a smooth operation, but not too fluid in motion as to allow the lens gradually to sag, and therefore image sharpness to fall off.

Ideally, the enlarger's negative carrier staging should be of a design that keeps the carrier, and therefore the negative, absolutely flat and parallel to the lens. If not, some minor adjustments may need to be made, as described in ENLARGING.

Moving on, the enlarger baseboard needs to be large enough to support an easel of a good size, and one that can be moved off-centre, should a negative need cropping. A minimum baseboard size, for making 20" x 16" prints is 24" x 20". Wall-mounting an enlarger means the dry bench conveniently becomes a large baseboard area.

Lightsources

How many publications and practitioners state that a particular type of enlarger lightsource is the right one for black and white? Too many. One school says condenser — "it's sharper", another says cold cathode — "it has a softer, more beautiful tonal range". I prefer diffuser!

In fact we can get a great-looking print from any type of enlarger lightsource, provided it gives sufficiently even — corner to corner — illumination that is of a predictable, consistent, output. More often than not, it is the quality of the enlarging lens, or the aperture at which it is used, that will most affect print quality, in particular print sharpness.

Without reading the technical data in the photo-spread section of this book, can anyone tell which of the prints has been made with which light-source? No! Only by comparing, side-by-side, two prints made from the same negative, but with different lightsources, can we begin to make such comparisons, and sometimes, depending on the type of image, these differences can be so subtle as to be hardly noticeable. Then again!

I divide lightsources into four categories, each of which is capable (at least in theory) of producing differences in print contrast, tonality and sharpness.

Cold-cathode

This produces the softest, lowest-contrast print for a given grade of paper. Its fluorescent tube produces light of an essentially blue nature which then passes through — and is scattered by — a diffusing sheet before reaching the negative.

Advantages of cold-cathode (in its favour it has been used by the likes of Ansel Adams and Edward Weston, so they must be good, although I never use one (!) — for reasons outlined below):
i) the printing speed of this blue lightsource should, theoretically, be fast, since most (graded) papers are primarily blue sensitive,
ii) the enlarger focus finder will only be focusing on that essentially blue part of the visible spectrum to which the (graded) paper is most sensitive,
iii) it produces prints with a beautiful, delicate tonal range, that also possess wonderful highlight detail,
iv) it minimises negative granularity,
v) it suppresses any scratches, blemishes and dust on the negative and,
vi) being quite cold in operation, it causes few of the problems, such as negative popping, associated with the heat of some other lightsources.
Disadvantages of cold-cathode:
i) print grading and exposure time problems can be experienced with VC papers, due to their wider spectral sensitivity,
ii) as a fluorescent lightsource it is not cheap to replace, and needs time to warm up to reach full power before print exposures can be made with consistency,
iii) once warmed, the light must be either left on, which makes timing print exposures a problem, or else a heavy-duty timer will be needed, with which the light is switched off momentarily as the paper is placed in the easel, before exposure commences,
iv) 5" x 4" is usually the smallest size in which it is made. This can create very long exposure times with highly magnified smaller format negatives,
v) power output tends to fall off with age, and
vi) only under-the-lens VC filters can be used if VC paper is employed, although this isn't a problem, provided the filters are kept clean.

Diffuser

Very similar in quality to the cold cathode, although producing slightly contrastier prints. This type of lightsource uses a tungsten bulb(s) for its illumination. The light usually passes into a white mixing box, before going through an opalised diffusing screen en route to the negative. Colour and VC enlargers are usually of this type, using a variety of above-the-negative, built-in filtration systems to change the colour of the enlarging light. (See VC FILTRATION chart for more information, including the merits of above or below the lens VC filters):
Advantages of a diffuser:
i) the availability of different sized light mixing boxes means print exposure times can be kept sensibly short for all formats,
ii) little heat from the bulb reaches the negative, usually because it is lost en route through the light mixing box,
iii) requires no bulb warm-up time to keep exposure times consistent,
iv) negative defects are kept to a minimum,
v) colour diffuser enlargers can be used for black and white and VC printing, and
vi) the broader spectral-range of its light-output makes it well suited for VC printing.
Disadvantages of a diffuser:
i) lightsources with more than one bulb may need checking for any colour and power imbalances, for example, if one bulb is replaced before another,
ii) the generally quite soft surface of the opalised, plastic diffuser can be easily scratched or damaged when interchanging light-mixing boxes for negatives of different formats, potentially causing marks on the print,
iii) maximum grade 5 print contrast may not be possible when using the dial-in filtration of some colour enlargers, and
iv) when focusing the image, the finder is seeing other wavelengths of light than those to which the paper is sensitive, however, in practice, and contrary to some theorists, this is not a problem for diffusers, condensers or pointsource lights.

Condenser

This produces sharper, higher-contrast prints than the diffuser and cold-cathode, although with Ilford XP2 dye film, prints should look the same. Traditionally, condensers were the black and white printer's choice, but I would say they are now less popular than the diffuser, or colour diffuser enlarger.

Their light, which usually comes from a single opal tungsten bulb, passes through one or two lenses above the negative, which collimate (condense) it so that it is projected through the negative, towards the centre of lens. Most condensers will focus the light just below the lens, so that it covers the entire lens element.
Advantages of a condenser:
i) potentially very sharp, higher-contrast prints, showing micro-level negative development effects, that improve sharpness, to their fullest and espe-

cially with more highly magnified 35mm images,

ii) different condensers, or adjustable condenser/bulb settings, are usually available for negatives of different formats, keeping exposure times short,

iii) the usual presence of a heat filter drawer above the negative carrier makes it possible to use either above or below the lens VC filters,

iv) they need no bulb warm-up time to keep print exposure times constant,

v) they keep print highlights 'bright' because the condensed, image-forming light is partially scattered by the (denser) negative highlights,

Disadvantages of a condenser:

i) if improperly set up, or perhaps with the wrong condensers fitted, the image-forming light may be focused above the lens, creating a potential, dark hot spot at the print's centre,

ii) even with a glass heat filter, negatives may pop during print exposure; this filter and the condensers must be kept clean, to prevent marks on the print,

iii) negatives may need time to warm up in the enlarger before exposure — to prevent further popping — by leaving the enlarger light on for a while,

iv) once the negative is focused, the light should ideally be left on in between exposures to prevent the negative de-popping,

v) the condensed nature of their light shows up negative defects, such as dust and scratches, and

vi) if the bulb, or condenser lens set-up, can't be adjusted to maintain an even coverage of light over the lens, recalculating exposure times for prints of different magnifications.

Pointsource

The very sharpest, most contrasty of all lightsources. Illumination comes from a single, clear, very small filament, tungsten bulb which, unlike the condenser, gives a 'point source' of light. Not a very common lightsource, although it has been used by a number of mainstream photographers to produce very distinctive, gritty results.

The pros and cons are the same as for the condenser. However, this light must, be accurately focused on the very centre of the lens which is then used wide open, at the largest aperture. To control print exposure times, the power output of the light is adjusted by means of a rheostat, whilst to ensure the light is focused on the centre of the lens, the bulb has to be moved up and down in accordance with changes in print size and variations in the bellows extension of the lens.

In its favour, it is noticeably much sharper and contrastier for a given grade of paper. However, sharpness comes at a price. Every spec of dust and damage on the negative, glass carrier, condensers, heat filter and bulb will show up on the print. Spotless cleanliness is therefore a must. Also, as expo-

sure time alterations are made with the rheostat, the colour temperature of the light will change and print contrast and speed will be affected.

So, if it's a gritty, ultra-sharp grain effect you want, then I would suggest making the print with a diffuser or condenser enlarger, slightly over-exposing it by about $1/4$ stop and, after fixing, bleaching it back very briefly in Farmer's reducer (formula??), as in the case of **Mis Tor**.

Negative carriers

I can't remember using a single enlarger whose negative carrier I haven't had to modify in some way or other, either to get the carrier absolutely parallel to the lens, or to prevent the negative from popping. Usually this change is simple to carry out, but with highly magnified 35mm negatives it is vital, if we want clearly visible corner-to-corner print sharpness.

For 35mm, my preferred carrier system (holding the negative completely flat) is to put an anti-Newton glass sheet in the top of the carrier and a normal (24mm x 36mm aperture) metal, glassless panel in the bottom. I use the glass from the medium format negative carrier and if the metal plate has any negative registration holes, I cover these with black masking tape, to prevent unwanted (image-degrading) light from reaching the lens. Any tape should be put on the underside of the lens, so that it won't interfere with the alignment of the negative.

To avoid extra spotting, I don't use a glass carrier in place of the metal bottom panel, since it presents another two surfaces on which dust can settle. Besides, the guiding principle behind the single glass-sheet set-up is that the negative will expand towards the heat of the bulb. Placing a glass carrier above the negative prevents this movement, whilst its textured surface prevents unsightly Newton's (oily-looking) rings on the print. Using this system, the negative won't need to be warmed before exposure and the enlarger can be switched on and off during burning-in work without fear of losing of image sharpness. This system works.

However, not all 35mm metal negative carrier plates give anywhere near the full 24mm x 36mm image size. If this is a problem, it can be overcome with the gentle use of a flat-edged metal file and, with care, the aperture can even be made slightly over-size, say 26mm x 38mm, to enable black print borders to be printed, as with **Walkham Valley** and **King's Tor**. However, if this aperture is made too large, an excessive amount of non image-forming light will work its way around the film's sprocket holes, to create dark patches on the print. Condenser and pointsource enlargers will show this up the most, in which case the blades below the

negative carrier can be used to cut down some of the unwanted light. These are best positioned with the lens temporarily stopped right down to its smallest aperture, so that their position is brought more clearly into focus. The lens should then be re-set to its working aperture for the exposure.

Lenses

There is nothing more visually distracting than looking at a print made from a highly magnified 35mm negative, whose grain is not sharp. For this reason alone, a really good enlarger lens is very important, although it will also help to provide maximum print contrast and the best tonal separation.

I am no expert when it comes to optics, but a few simple tests will tell you whether you have a good buy, or a not-to-buy lens. For this reason, I have often preferred to buy second-hand lenses so that, by putting down a deposit, I could test them first for a couple of days. By comparing the results made at different aperture settings with other lenses, it is possible to find the lens's best working aperture (ideally 2 to 3 stops down). Before buying a lens I also check for any unwanted focus shift as the lens is stopped down, by viewing the negative with the enlarger focus-finder as the aperture is changed.

It is also worth making a set of prints to check an enlarger lens; each change in aperture either up or down, should exactly represent a 1 stop decrease or increase in print exposure time. Often it won't, in which case an exposure modification factor will need to be worked out for any prints made at different apertures. Given the choice, I would opt for a lens with $1/2$ stop aperture 'click' changes, and one that illuminates the aperture setting.

Incidentally, I have often found that there is more of a difference between lenses of the same make and model, than between different makes. It's like buying a 'Friday car' or a 'Monday car'!

Focusing aids

A focuser is essential for 35mm work, and especially for large print, high-magnification work. One that swivels on its base to permit all round corner-to-corner negative viewing is great for checking all-over print sharpness, but a hand-held magnifying glass (or a spare condenser lens) will do the same job, at a fraction of the price.

I have tested expensive focusers with clip-on, blue-viewing filters, that supposedly help to create sharper prints by just seeing and focusing on the blue part of the image forming light to which (graded) papers are most sensitive. They do not appear to make any difference! For a start, all

papers see more than just blue light, especially VC papers. Besides, the blue filter cuts down the amount of viewing light by up to $1^1/_2$ stops, making the grain of the negative that much harder to see. What is more, a good, modern, colour-corrected enlarging lens will avoid the chromatic aberration that the blue filter attempts to overcome — provided the aperture of the lens is not excessively stopped down.

That said, a focuser with a glass, surface-coated mirror should give slightly better, sharper looking prints, than a cheaper, plastic-mirrored model. Although, of course, if the enlarging lens is no good, a focuser won't help much to get the sharpest print from a negative.

Timers

I am still amazed at the number of photographers who have cameras capable of highly accurate, consistent exposure times of as short as $^1/_{4000}$ of a second or less, but who will still 'time' their print exposures using often quite archaic and inconsistent methods. I have always found a print timer is essential (for example when making exacting prints, such as the **Pentire Point** triptych), though the simpler this unit is, the better — but it must provide adjustments in one tenths of a second, in seconds and in tens of seconds.

If the timer is capable of giving an audible signal every second then all the better, since this enables my pre-determined dodging and burning-in times to be counted without having to take my eyes off the easel during the exposure. An audible signal also creates a — repeatable — rhythm to dodging and burning-in exposure work, which means printing instructions can be accurately followed and repeated later, with other prints. I use a cheap metronome for other work, such as print bleaching, which needs to be timed for accurate repetition.

I use the enlarger timer with the F.STOP EXPOSURE TABLE to calculate changes in print exposure times, including dodging and burning-in times, as depicted in the printing diagrams in the main photospreads. This is a much cheaper option than buying a purpose-made, f.stop enlarger timer.

Easels

I have opted for a fairly conventional easel that gives up to 2″ print borders, adjustable in $^1/_4$″ increments, all the way round the image. Print borders are essential for handling the processed print, and for retaining the print under a presentation window-matte overlay.

When I purchased this unit I checked the absolute squareness of each blade at different print sizes, since cutting many print window-mattes for my work has shown me how inaccurate some easels can be and how crooked their 'straight' edges are, when the edge of the print is placed close against a neatly cut matte.

In its favour, this easel sits firmly on the enlarger baseboard; its non-slip base prevents accidental movement and image misalignment, whilst its spring-loaded action also firmly holds the paper retaining blades up, as large sheets of paper are inserted using both hands.

However, like many other units it does have its failings. The top and left-hand edges are inclined, and although they are painted matt-black, non-image-forming light bounces off them to fog those edges of the print. This is often the case when working with an oversize, 26mm x 38mm carrier, as explained above.

A clean, white-based easel is great for accurate set-up and alignment of the enlarged negative, but in some cases, with more translucent SW paper, it can be a problem. So, I insert a thin sheet of matt black paper (of about 200gsm in weight) under the printing paper. This absorbs unwanted, image-forming light that has passed through the printing paper, stopping it reflecting back into the image, and degrading print contrast.

Accessories

An enlarger timer footswitch is undoubtedly a help. It leaves hands totally free during print exposure work to dodge and burn-in. A meter can be useful, for example to measure the three **Pentire Point** negatives, but it is certainly not essential. Unlike camera exposure work (unless the camera has a Polaroid back), we can make test-strips and proof prints to determine print exposure times.

A contact printer that holds negative strips into place is sometimes useful, especially for thinner, polyester-based films, as discussed in IMAGE ASSESSMENT, otherwise I use a plain sheet of glass.

I use a rotary trimmer for cutting printing paper. It is not an essential item, but its use extends beyond the darkroom, for accurately cutting card for window-mattes.

For dodging, I have made a wide selection of dodgers from non-reflective matt black card, secured with matt black tape to thin florists' wire handles. Thicker, coat-hanger wire and bicycle spokes are not always suitable for this purpose, since they can cast shadows and reflect light onto the print. A little blob of Blu-tac on florists' wire, is excellent for dodging small, odd size shapes.

For burning in I use thin, 200gsm sheets of card, black on one side and white on the other. These cards are thin enough to be flexed for burning in, say, above curving skylines, as in **Walkham Valley**.

Their black undersides prevent light that bounces back up off the easel from reflecting back on to the print. I also have a selection of these cards with different shaped holes cut in the middle. One of these cards can be placed on top of another to make a variety of different sized, and various shaped, holes for burning in areas of the print. The white upper-side of these cards makes it easier specifically to locate often small and indistinct areas of the negative that are to be burned in, whilst holding these cards at various distances from the lens will create varying degrees of edge-sharpness to the burned-in area.

Diffusers can be useful for softening prints either overall or locally. I have made several, using old under-the-lens VC filter holders into which a piece of anti-Newton glass from a 60mm x 60mm transparency mount fits perfectly.

Safelights are covered in DARKROOM SET-UP and in TABLES AND CHARTS.

Print processing equipment

It is possible to process prints up to 20″ x 16″ in size with the bare minimum of equipment and without their quality suffering in any way.

I prefer to work with white as opposed to distracting coloured dishes. Ideally these should have troughs, rather than ridges, along the bottom. A thermometer can be laid in one of these during processing work, and unlike ridges, they don't locally raise the surface of the print, which can cause flow patterns. I label all dishes with a black permanent marker pen, to minimise the risk of chemical cross-contamination from interchanging them. Separate dishes are also best kept for toning and I use tongs and gloves to handle prints, as described in PRINT PROCESSING. I don't use a print processor for exhibition work. Quite simply I have found it lacks the necessary flexibility.

I use an old, audible timer for processing. Apart from lith development, I prefer to time-develop prints rather than the more haphazard method of inspection development, as demonstrated by the **Mis Tor** under red safelight photograph (page 125).

To wash RC prints I use either a Nova 20″ x 16″ Archival Washer, or a processing dish with an auto-tray syphon, such as the Kodak variety. I always use the archival washer for FB prints. It has 13 separate print compartments, each individually water-fed and drained. It is by no means essential: in the past I have used a 24″ x 20″ processing dish and an auto-tray syphon to good effect. The only drawback was that I was simply limited to washing six 20″ x 16″ prints at a time.

Darkroom set-up

Darkroom layout

Ventilation

Wherever the darkoom is located, and no matter how little use it sees, it should ideally have controlled ventilation, of which there are two types:

i) dilution ventilation, which is the gradual removal of unwanted airborne contaminants (such as processing fumes) that have dispersed into the darkroom, and

ii) local exhaust ventilation, which traps contaminants at source, before they can work their way into the darkroom's atmosphere.

(NB: air-conditioning, and portable air-conditioning units, will not provide proper darkroom ventilation.)

Dilution ventilation is good for general, low-contamination processing work, when developing and fixing. Local exhaust ventilation is better suited for more serious intermittent use, when mixing up solutions, or working with certain unpleasant-smelling toners, e.g. selenium, when a greater rate of air exchange will be required.

In both cases, we need an equal volume of fresh make-up air to replace the contaminated air when it is drawn out of the workspace. A lack of make-up air will create negative air pressure which will stop the extraction system from working. So, if we block out all unwanted outside light, are we inadvertently sealing up all sources of fresh air? If so, we'll need to make a lightproof, baffled air inlet.

Good ventilation relies on properly controlled changes in air pressure and for this we need to use an extractor fan, rather than relying on ambient air pressure conditions, such as opening a window — which can just as easily take the contaminated air back into, rather than away from, the workspace.

For one temporary darkroom, I mounted the end of the fan's ducting onto a lightweight, lightproof panel that simply pushed into a window frame, being held there with some self-adhesive Velcro tape. The window was opened during use.

What size of fan do we need? For dilution ventilation we should aim to get one that gives 10 complete air changes per hour. If you work out the air volume of your workspace (room width x length x height) and multiply this by ten, you will get a figure equal to the number of cubic metres of air that the fan will have to move in one hour. Conveniently, this is the same way that fan manufacturers

specify the strength of their units. If a contaminant trapping hood is fitted to the fan to improve its drawing power, then a unit of about the same power as for dilution ventilation will be right for local exhaust ventilation.

Too large a fan will create too much of a draught, causing problems of dust movement, heat loss and excessive chemical evaporation from uncovered dishes. Also — as I noticed too late on one occasion whilst loading film — too powerful a fan can draw in the blackout curtain of the darkroom door, making the room decidedly less than lightproof! Conversely, too weak a fan, such as the small toilet variety, is not recommended.

Where should the fan be situated? I would suggest it is best located just over, or just behind, the wet-processing and chemical-mixing area, where it will always draw the largest volume of most contaminated air away from us. If ducting is used, its outlet should be placed as close as possible to the fan to minimise surface-to-air friction. Therefore, long lengths of plastic, flexible, ribbed ducting or ducting that is too narrow in diameter, should be avoided. Incidentally, it is better to place the fan's outlet in as sheltered an external location as possible. If this outlet points into the direction of the prevailing wind, the fan's performance may be reduced on windy days. As for the location of the air inlet, it should be opposite and as far away as possible from the fan, so that air drawn through it into the darkroom will carry with it as much contamination as possible en route to the fan.

Dry, wet and chemical areas

I have always divided my darkrooms into dry, wet and chemical-mixing areas. In small workspaces the latter two have tended to double up as the same space. The dry area is for enlarging and cutting up paper, and, at its most basic, is simply a bench, which will give an enlarger easel height of about 30"-32". Under this, but off the potentially wet floor, I store my printing paper, leaving enough room on top of the bench for the enlarger timer and paper cutter. Enlarging tools, such as dodgers and burners, can be hung on the wall within easy reach during print exposure.

At its simplest, the wet area is a waterproof bench large enough to take three processing dishes. In extremely confined darkroom spaces, I

have improvised with a tiered, dish-stacking system: the developer sits on the top level, the stopbath on the middle shelf and the fixer on the bottom. In this way, any spilt chemistry will fall in to the next bath of the processing sequence, minimising solution contamination.

Where space has permitted, I have always built darkroom sinks to fit. These have usually been made of exterior grade plywood, simply coated with two-part epoxy or polyester resin. The internal edges of the sink can be filled with the same resin, but with an appropriate filler added, to create neatly filleted, easy to clean corners. I tend to cover the thin, uncomfortably hard edges of any sink with lengths of thick, clear hosepipe which also help to reduce the likelihood of damage to the sink edges, or processing dishes. To fit these, slit each pipe down one side, and then temporarily soften it in hot water so that it can be easily slid into place.

Flooring

When making fine-quality, exhibition prints, there is nothing worse, or more distracting, than aching feet. So, I have usually covered the 'dry area' of the darkroom floor with cheap carpet left-overs, or hessian or rubber mats. This really is better than working on a cold, hard concrete floor.

Blackout

The 'right' colour for darkroom walls always seems to raise some interesting, differing viewpoints. Some photographers advocate safelight-orange, or even black walls. I would always recommend white, with matt black emulsion paint around potentially less lightfast doorways and ventilation points. A white, rather than black, wallcovering gives a much less incarcerated feel to darkroom work. It also provides reflected, fill-in illumination from the safelights, allowing their power and number to be kept to a minimum.

The principle behind orange darkroom walls is that they will make 'safe' any stray light entering the darkroom or leaking out from badly sealed enlargers. This idea is fine in principle, but the colour can be very distracting when it comes to switching on the viewing lights and trying to evaluate print image colour.

1. Almost any space can be utilised for darkroom work. This old back-alley shower unit was my first 'proper' print washer. WASHING AND DRYING shows it in action.

2. It is important to have the right darkroom viewing light for assessing prints. The left-hand side of this print is illuminated by direct light, the right-hand side by indirect. Note how much contrastier and brighter the left half looks. In fact, the image should be reprinted lighter and at a harder grade setting, as the more realistic lighting of the right half suggests.

Blackout systems needn't be expensive or complex. Black bin-liners, stapled together and stretched over windows, make inexpensive blackouts, but if they absorb a lot of direct sunlight, they will release a lot of usually unwanted heat into the workspace. Lightweight card placed over windows works well, either held in place with double-sided tape or Velcro, whilst for open doorways I have always preferred blackout cloth. For very bright darkroom locations, I have found that up to three layers of cloth may be necessary, each one being at least one and a half times the width of the door opening, to allow for pleating. I tend to hold the edges of the curtain in place with Velcro, to prevent the fabric being sucked into the workspace when the fan is switched on.

Checking for the lightfastness of a darkroom is very simple, but most important. The method I use, is to close the door and then leave all the lights off for at least five minutes to allow my eyes fully to adjust. During this time I will check for any unwanted afterglow from electric illumination, as experienced with fluorescent tube lights. Then after the allotted time, I'll look around to check for incoming light, especially from around the door and ventilation points. Stray light, for example from cracks in walls and ceilings, can often be eradicated with black, self-adhesive, 2" wide, canvas Gaffa tape.

A very small amount of stray white light can be tolerated during printing work, such as that leaking from poorly fitting enlarger negative carrier drawers, provided it doesn't shine directly on to the easel — printing papers are fairly slow in speed and low in sensitivity. But, if it is difficult to eradicate all the light for film loading, especially when loading today's ultra-fast films such as Kodak TMax ISO 3200, then I would suggest using a film-changing bag, in which a small hand tank and spirals can easily be fitted. These bags are relatively cheap to buy and represent an effective, temporary system of blackout. In the absence of a truly lightproof darkroom, they are a much better alternative to loading film under the duvet — as once practised by a photographer friend of mine!

Electrics

Fortunately, most darkroom appliances draw little current. However, for safety's sake, I use a circuit breaker for my developer dish heater which is a 100W, submersible, fully isolated fish-tank heater, placed on the bottom of a 24" x 20" dish that is half-filled with water. In this water bath, I float my 20" x 16" developer dish. I try to keep all electrical darkroom plug sockets well above worksurface height, to reduce the risk from solution spillages. I also keep all safelights and viewing lights on bathroom-type, string pull switches, with cords

stretching the entire length of the darkroom. This way I can control the safelight and viewing light illumination from any point in the darkroom.

Illumination

I prefer to work with two levels of safelight illumination. The brighter safelight is left on for general processing work, whilst during print exposures, when I don't want any distracting shadows cast across the easel, I will just leave on one, very dim safelight. This gives sufficient background illumination to find printing tools during print exposure. Excessively strong safelighting (or its shadows) cast over the paper during print exposure can confuse dodging and burning-in exposures. Worse still, it may fog the paper, for example during the long exposure times of particularly complicated, multiple exposure prints, especially if the print is then lith processed. I prefer to locate the main, brighter safelight over the sink, and the second unit wherever it gives the workspace an open and comfortable feel. Safelights should conform to the paper manufacturers' recommendations.

Following many years of printing failures, I now use the most unflattering darkroom viewing light I can. It is a car inspection lamp, fitted with a clear bulb, clamped to the ceiling above the sink. Its use has significantly improved the quality of my prints, as described in PRINT ASSESSMENT.

Water supply

If possible, I like to have several water taps by the darkroom sink. I keep one plugged into the print washer, whilst another, fitted with a 1 metre length of ½" diameter garden hose, is used for general solution mixing work and for film washing (it fits perfectly into the ½" funnel opening of plastic film processing hand-tanks). The other — hot — tap is also fitted with a similar length of hose, and is there for mixing solutions and for adding warm water to the wash during colder winter months. Attaching hoses to the taps means water can be taken to the processing dish or chemical container, rather than the other way round — always a problem with large, flexible, plastic dishes.

Finally, a decent-sized sink splash back gives plenty of much needed space on which to stick wet (temporarily 'self-adhesive') prints and test-strips, in order to assess them for print quality. Above my present sink sits a shelf that casts a strong shadow over the sink splash back when the viewing light, described above, is switched on. Ultimate print quality can really be tested to the full in this dim, indirect and unflattering light.

Materials

Films

Colour sensitivity

Apart from the more obvious distinctions between, say, normal panchromatic film, and the orthochromatic or infra-red varieties, most panchromatic films will show a slight bias in their colour sensitivity that can make or break a landscape photograph. With this in mind, I test new films with a colour chart and different filters, bracketing the exposures to check their speed and contrast.

In particular, some panchromatic films show a slight blue bias. For landscape work this may require the use of a yellow, or even orange, filter to make particularly blue skies less dense in the negative and therefore easier to print. Others may have different colour biases, such as Kodak's Technical Pan, which has extended red sensitivity. Too much orange or red camera filtration with this film can produce an almost infra-red effect. I have found that Ilford XP2 needs much less filtration for landscape work than, say, Delta ISO400, or other ISO400 films.

Speed v quality

For landscape work I have used films ranging in speed from ISO25 to ISO3200. I like to exploit their inherently individual characteristics to (potentially!) good effect. For example, I used the very fine-grained ISO25 Kodak Technical Pan for **Pentire Point**, to resolve all the subtle cloud detail, whilst for **Epping Forest** I chose Kodak TMax 3200, partly because I knew the image would be made very early in the morning in quite heavily shaded woodland. I also wanted a faster, grainier film to mask a lot of unwanted foliage detail.

Slow speed films (ISO 5-50+/-) — are inherently fine grain, yet they are the most contrasty, because their smaller silver halide grains present a greater surface-to-volume ratio upon which the image-forming light, and later the developer, can act. For this reason, slower films often need to be developed in very low contrast developers. Such as Kodak's Technidol and Speedibrews POTA, or in a more dilute developer, such as Agfa Rodinal at 1:125-200, or developed for a shorter time. If not, image highlights may become unprintably dense

and tonally blocked up. Examples include: Agfapan APX25, Kodak Technical Pan and Ilford Pan F Plus.

Medium speed films (ISO100+/-) — offer the best compromise of grain, sharpness and controlled contrast. These films also tend to exhibit extremely good latitude, i.e. they can record subjects of extreme brightness range, maintaining detail in the very darkest shadow and tonal separation in the brightest highlight. A medium speed film like Ilford FP4 Plus is said to have a latitude of 7 stops. Compare this with the 3 stops latitude of a colour transparency film of the same speed. Examples include: Agfapan APX100, Kodak's TMax 100 and Plus-X 100, and Ilford's FP4 Plus and Delta 100.

Fast films (ISO400+/-) — exhibit fairly low inherent contrast. They can usefully record subjects of high contrast and be used in low-light level situations, but are more granular. Their thicker emulsions will tend to produce slightly less sharp images, so a surface-acting film developer, such as Paterson Acutol or Agfa Rodinal (producing a thinner — emulsion surface only — negative image) may well be beneficial. Examples include: Agfapan AP 400, Kodak's TMax 400 and Tri-X, Fuji Neopan 400, and Ilford's HP5 Plus, Delta 400 and XP2. Ultrafast films now include Fuji Neopan1600 and Kodak TMax 3200. Both are designed for very low-light work.

The faster the film and the more it is developed, the more base fog it will have, i.e. more unexposed, non-image forming silver will be developed out. In excess, this fog can begin visibly to interfere with the tonal separation of the thinner shadow values of the negative, in the same way that fogging a print will degrade the lighter highlight tones. Film that is overdeveloped, developed at too high a temperature, or processed in a developer that lacks an adequate amount of restrainer, will tend to exhibit higher levels of fog. For the same reasons, film, especially faster film, should be stored — before and after exposure — in a cool dry place.

Films of the same emulsion type, but of different formats, may sometimes exhibit different characteristics, as illustrated by the different development times published for 35mm and 120 roll film. There is also a school of thought that says film of one type, made for one particular market, may be different to the 'same' film made for another market. For example American Tri-X is said to be different to the European version, presumably because of international differences in taste?

New and old films

What is the difference between today's new films and those of yesteryear? Quite a lot. Apart from dramatic increases in film speed (it wasn't that long ago that ASA100 was the fastest film around!), the characteristic curves of most of today's films possess more abrupt toes and shoulders, giving the image's shadows and highlights a punchier feel.

Modern films also tend to have thinner emulsions which will, as a result, produce sharper negatives. Some older, thicker emulsions could even be physically abraded/reduced with metal polish to cut back dense highlights!

Modern T-grain technology has made big steps forward to reduce negative granularity, but its films respond less readily to the traditional development methods of changing developer dilution and altering agitation. In my opinion, these films have come under some quite unfair criticism, simply because their improved quality also depends on much tighter development controls. Older style films, such as Agfapan AP 400, are more forgiving: they allow for sloppier processing work.

And, of course, there is Ilford's XP2 (ISO400). A chromogenic film of exceptional latitude, which is processed in C41 (colour film chemistry) to produce very fine-grain negatives. I have found it ideal for recording subjects of extreme brightness range, producing negatives without blocked-up highlights. I used it for the black and white darkroom photographs in this book. It can also be over-exposed, by 1 or 2 stops, to produce even finer grain, albeit denser, negatives.

Testing films

I photograph the colour chart mentioned above using north facing daylight to simulate average (British!) landscape conditions (tungsten — warm — light is to be avoided for such tests). I try to expose these tests at around midday to get comparable results, bracketing the film exposures to enable me to check the film's speed later. I also make a series of exposures of this chart with different camera filters: usually yellow, yellow-green, orange and red. After processing the film, I study the negatives and contact sheets to ascertain the right film speed, the film's colour bias (if any) and appropriate filter settings.

1. Photographing a colour chart, such as this, is a useful way of seeing how different black and white films vary in their colour sensitivity. It is also a good way of learning how to see in monochrome.

2. Now lacking colour contrast, many of the squares appear quite similar in tone. This can be changed, to varying degrees, by the use of coloured camera filters.

Diagram of chart					
Dark Skin	Light Skin	Blue Sky	Foliage	Blue Flower	Bluish Green
Orange	Purplish Blue	Moderate Red	Purple	Yellow Green	Orange Yellow
Blue	Green	Red	Yellow	Magenta	Cyan
White (.05)*	Neutral 8 (.23)*	Neutral 6.5 (.44)*	Neutral 5 (.70)*	Neutral 3.5 (1.05)*	Black (1.50)*

ColorChecker is a trademark of Macbeth; a division of Kollmorgen Corporation. *Optical Density

3. The back of this particular colour chart contains useful reference information, including the reflection density values of the squares.

Note: some camera meters are colour biased, so I would always suggest metering the colour card, or landscape, with the filter detached from the lens, and then to apply the filter manufacturers' exposure modification factor to the reading. A filter factor of, say, x2 requires a doubling of the meter's unfiltered reading.

Testing films in this way, to see how they translate colours into various shades of grey, greatly helps the image pre-visualisation process, i.e. to see how an image will look in its finished black and white state.

Film storage

All film is best kept in its original wrapper to prevent ingress of emulsion-damaging humidity. Storage at lower temperatures will ensure the film maintains its speed, contrast and minimum base fog level up to, and beyond, the manufacturers' 'best-by' date, but always allow refrigerated film time to warm up before opening the packet, to prevent condensation on the emulsion. After exposure, the film should be kept in a dry, airtight container away from excessive fluctuations of heat and humidity, and it should be processed as soon as possible.

Printing papers

Which papers are best for landscape? A commonly heard reply might be: "the ones that are no longer available". I would disagree. Today's papers offer a wealth of creative opportunity that extends far beyond satisfying the needs of more traditional, or conventional, fine print making — as with fixed-grade papers. Just think of modern VC papers. They offer enormous scope for the most creative printer and are genuine exhibition quality material.

Support material

There are two basic types of paper:
Resin-Coated (RC) — the RC paper's emulsion is coated on to a waterproof base, made up of a layer of paper sandwiched between two sheets of non-absorbent plastic. RC papers are very quick to wash, because only the thin emulsion layer absorbs any processing chemistry. This makes them ideal for machine processing with dry-to-dry times of as little as 60 seconds. After processing, they automatically dry flat, unless they have been exposed to excessive heat drying. RC papers are suitable for all types of work, although early versions were thought to be archivally slightly less than stable. If overwashed,

they can curl irrevocably, while extended over-washing may also cause some delamination, or frilling around their edges.

Fibre-Based (FB) — the emulsion of these papers is coated on to an absorbent paper support that needs to be thoroughly washed to reach a satisfactory state of image stability. For this purpose, most FB papers need at least a minimum of one hour's wash, at 20°C. Because of their more tactile 'feel', they continue to be the preferred choice of exhibition printers; in particular, because they also respond better to different methods of development and toning.

FB's also work better than RC's for a wider variety of retouching methods. However, if handled incorrectly during processing, they can be creased and rarely, if ever, do they naturally dry flat.

Base coating

Both types of paper usually have a white, baryta layer, coated between the support medium and the emulsion layer. This improves the brightness of the paper's white. Some papers also contain added brighteners — rather like certain washing powders — for added optical effect. Whereas extended washing could once dull the look of a print, and sometimes discolour it, modern papers do not tend to suffer in this respect.

Base colour

Some different makes of paper have noticeably different base colours which cannot be changed through processing means, except by the overall application of a gelatin dye toner, or by fogging and then toning the print, as with **Epping Forest** and **King's Tor**. Examples of different base colour tints include: brilliant white, white, off-white, ivory and cream. As I see it, there are no hard and fast rules as to which is 'best'.

Emulsion type

Paper emulsions are made up of a mixture of silver salts (and other ingredients) that will determine an individual paper's particular image colour, printing speed, Dmax, contrast and tonality. Above a certain amount, the quantity of silver in an emulsion will make no difference to a paper's Dmax. However, I have found that it will affect the amount of developed silver that lies, unseen, 'beneath' the image, and therefore the print's ability to deal with certain toners that might otherwise cause an associated loss of print density and contrast. Papers that are richer in silver (usually FBs) will also respond better

to deliberate changes in print exposure and development, as outlined in FACTORAL DEVELOPMENT.

Bromide — produces the coldest-tone, highest-contrast image. However, used predominantly on its own, it will not yield the very densest of blacks, or the very best separation of tone. A Dmax of 2.0-2.1 is about the best that can be achieved with an untoned glossy print. Examples include: Agfa Brovira and Kentmere's Bromide, Document Art and Art Deluxe.

Bromo-chloride — a mixture of silver bromide and silver chloride, with bromide in predominance. It produces a neutral-tone image with both good blacks and good tonal separation. A Dmax of 2.1-2.2 is possible with some untoned makes of paper. Examples include: Ilford's Multigrade, Galerie, Ilfospeed and Merit, Kodak's Polymax and Elite and Agfa Multicontrast Premium.

Chloro-bromide — a mixture of silver chloride and silver bromide, with chloride in predominance. Papers of this type produce warm-tone images, the highest Dmax and best separation of tone. An untoned Dmax of 2.2 is possible with some makes. Examples include: Agfa's Record Rapid and Portriga Rapid, Kodak Ektalure, Kentmere's Kentona and Art Classic.

Chloride — very rarely used these days on its own as it tends to produce a slow-speed emulsion, with quite olive tones. Some examples can still be found in the old eastern bloc countries, but are hard to come by.

Graded and Variable Contrast (VC)

Graded papers still tend to have — only — marginally better tonal separation, perhaps noticeable in the shadows and highlights, although the difference is truly marginal and can be overcome by simply split-grading, or flashing a VC paper.

Grade spacings

Unlike the ISO settings for films, the numerical grade values given to papers are somewhat arbitrary. Whilst grade 0 denotes the softest (lowest contrast) setting and grade 5 the hardest (most contrasty), it is often the case that one manufacturer's grade 5 may not have the same contrast as another's. The same principle may apply for all the other grades as well.

The grade 0-5 contrast settings of a VC paper may also not equal the 0-5 contrast range of fixed grade papers. For example, grades 0-5 of Oriental Select FB VC paper only equate to the 0-4 settings of Ilford Multigrade, although the latter's 0-5 contrast range does equal the most contrasty 0-5 contrast range of some graded papers. In most cases, grade 2 is considered a paper's normal, best contrast grade.

Whilst VC papers offer useful, subtle, half-grade contrast settings, graded papers require changes in print exposure and development time, or changes in print developer type, to get the same effect. This is obviously not as convenient as using VCs.

Colour sensitivity

Graded papers tend to be predominantly blue sensitive, whilst VC papers are also sensitive to green light. As noted in the enlarger lightsource section, this can cause occasional print exposure time and contrast grading problems for VC's, and possible fogging associated with the incorrect use, or choice, of safelight. For specific safelighting requirements, check with the paper manufacturers' recommendations.

Weights

Airmail weight (AW) — the lightest of paper weights, Kentmere's Apograph may be the only paper available in this delicate, but most rapidly washed weight of FB paper.

Single weight (SW) — designed for shorter wash times than DW. This weight, and the AW, have been largely superseded by the very quickly washed medium weight RCs.

Medium weight (MW) — the usual weight for RC papers.

Double weight (DW) — most FB papers tend to be of this weight. It provides sufficient wet and dry strength to prevent the paper being easily damaged (as might be the case with AW or SW), whilst offering conveniently shorter wash times than TW papers.

Triple weight (TW) — Kodak Elite and Kentmere Art Classic are the two most readily available TW papers, designed for maximum physical (tactile) impact.

Surfaces

The list is almost endless: matt, semi-matt, lustre, stipple, gloss and so on. However, most individual makes of paper only come in two or three different surfaces — usually gloss and perhaps semi-matt.

Choosing the right paper surface for your landscape work is largely a matter of aesthetics. There are no rules, except your own. However, a different surface may require very different exposure methods and a different grade, since it affects the paper's Dmax and reflection density range. For example, printing a negative on matt, as opposed to gloss paper, usually requires going up one grade in paper contrast. Paper surface also noticeably affects print dry-down.

Despite the extra effort involved, I tend to opt for a matt finish largely because I like its less photographic appearance. This has always helped when selling prints to a public still slightly unsure about photography. Matt's lower reflection density range also ensures that the print's luminosity has been achieved by less obvious, more expressive means of printing, rather than relying on the greater contrast and luminosity of a glossier paper with brighter whites and blacker blacks.

Gloss FB papers will normally be less glossy than gloss RC's, unless they are glazed as they dry. For this purpose, the wet print is put emulsion-side down onto a clean sheet of polished metal or glass.

Miscellaneous papers

Developer-incorporated papers — a developing agent, such as the high contrast hydroquinone, is incorporated into the paper during manufacture. This promotes rapid development, gives maximum print contrast and good blacks with the shortest possible development times. RC papers intended for machine processing are often developer-incorporated. However, it is impossible to change print contrast with these papers by conventional methods of exposure time and development changes. Also, soft working developers won't lower their contrast.

Lith papers — designed for graphic, very high contrast results, although they can also be processed in heavily diluted lith developer for continuous-tone, pictorial results. This dilute 'lith process' gives a very warm-tone image with strong, neutral-tone blacks and very subtle mid-tone and highlight detail. Lith papers that work with this process include: Kodak Rapid RC, Kodak Transtar TP5 RC and Process Lith FB. A number of graded FB papers will also respond to this treatment, including (at the time of writing): Oriental Seagull, Sterling Premium F, Kentmere Art Classic and Kentmere Kentona.

Panchromatic papers — for printing colour negatives. Kodak Panalure Select RC is currently the only example.

A few words on densitometry

Various technical terms can be used to quantify, or objectively express, a paper's potential and actual performance. These go beyond individual opinions on the aesthetic values of a paper. Generally speaking, densitometric terms relate to measured units of film or print density plotted, as a graph,

against corresponding amounts of given exposure. We can use such terms, and their values, to help us make more objective considerations of paper choice and performance.

A densitometer is normally used to make these readings. It measures the amount of light reflected from the paper's surface, its readings being controlled by the amount of silver in the print and the paper's surface. You won't need such a unit, unless you plan to carry out involved tests of your own.

Terms:

Dmax — a measurement of the paper's maximum black. This figure is controlled by the amount of silver in the emulsion, the type of silver, the surface of the paper, the extent of print exposure and development, toning and the nature of the print viewing light. For a typical gloss paper the figure will be around 2.1, for semi-matt around 1.80 and 1.60 for matt. Selenium toning a glossy FB print, for example, will visibly increase Dmax, taking a 2.1 print density up to 2.2. In general, the higher the Dmax the better.

Characteristic curve — a graph, plotting increases in print density against corresponding increases of exposure. The graph is usually 'S' shaped, made up of a toe, a straight-line section and a shoulder. The shallower slope of both the toe and the shoulder illustrate that, at either end of the print's density range, detail becomes less well separated, i.e. differences in exposure will not be matched by corresponding increases in density. A steeper curve indicates a more contrasty paper and one with more limited exposure latitude, requiring more careful print exposure.

Reflection density range — the full range of print densities, going from the paper's base 'white' to its Dmax. It is controlled by the same factors as Dmax, but also by any colour-tint to the base of the paper, which will lower the range. A negative, printed onto a paper with a lower reflection density range (e.g. a matt-surface print), will show more compressed tonal values when compared to another print of the same grade, but made on a paper with a higher reflection density range (e.g. a gloss-surface print).

Old and new papers

Some of the older papers were certainly capable of producing a wider range of image colour tones, ranging from blue-black to warm-black by development means alone. Using today's papers, such methods of control are more limited: at the time of writing, Agfa Brovira and Kentmere Bromide are the only true, blue-black bromide papers generally available, whilst the warm tones of today's chloro-bromide papers, such as Agfa Record Rapid, Kodak Ektalure and Kentmere Art Classic, are not as strong as they used to be. This is mainly because emulsion additives, such as cadmium, are no longer permitted in manufacture — for health and safety reasons. However, by employing various methods of toning and redevelopment (see TONING) we can get today's papers to emulate, and even improve upon, those no longer available.

Most older papers also had a different, often straighter, characteristic curve, which gave them a more subtle but not necessarily 'better' tonal range. Although, in theory, the curve of many of today's papers may appear to lack this quality, they have been made very carefully to match the curves of modern films: for example Ilford's Multigrade and their range of ISO400 films. Besides, just imagine how many photographers working twenty years ago would have loved to use the VC papers we have now.

Storing paper

Papers will gradually change in contrast, speed and image colour as they age. They may also show a slight tendency to fog. Unlike films, there is no 'best-by' date for papers. To keep them fresh, I suggest a cool, dry storage place, avoiding fluctuations of temperature and humidity. I would not recommend storing papers in unventilated darkrooms used for regular toning work — especially sodium sulphide (traditional) sepia toning.

Paper can be kept refrigerated, but it must be slowly warmed up to room temperature before opening the (properly sealed) packet, or condensation on the paper's surface will be a problem. Papers likely to be phased out of production can be kept refrigerated or, better still, frozen for future use, but warm-tone varieties may still experience a cooling-off in their image colour associated with the ageing process.

Film developers

There are a multitude of brews currently available, each offering potentially different results, and more so, depending on how the film has been exposed and developed.

i) Single-bath — the most common type of developer, incorporating all the developer ingredients in one solution. Unlike ii) and iii) below, these allow good use of the development methods covered in FILM PROCESSING. After development, the film is stopped and fixed in separate solutions.

Examples include: Agfa's Atomal, Rodinal and Studional; Ilford's ID11, Ilfosol-S, LC29, Microphen and Perceptol; Kodak's D76, HC110, Microdol-X, Technidol and TMax; Speedibrews Celer-Stellar, POTA and 422; Tetenal's Neofin Blue, Neofin Doku, Neofin Red, Ultrafin and Ultrafin Plus and Paterson's Acutol, Aculux and Acuspeed.

ii) Two-bath — two separate solutions, the first containing the developing agents, the second the activator. Development only begins when the film is immersed in the second solution, in which the brighter, more heavily exposed areas of the image soon exhaust their stock of carried-over developing agents. This prevents an excessive build-up of contrast, it also permits the process to continue until the lesser exposed shadows are fully developed. Development is followed by a stopbath and then fixer.

Examples include: Speedibrews Resofine 2B and Tetenal Emofin.

iii) Monobath — a single solution which also contains the fixer, so that by the end of development the film merely needs to be washed. Monobath developers do not produce the very best quality, but they are convenient to use and fairly insensitive to the effects of processing temperature changes.

Examples include: Tetenal Monotenal.

My preference is usually for single-bath developers, used quite dilute and agitated less frequently than recommended, for maximum compensation and acutance effects. Although, with the recent reintroduction of the excellent Resofine 2B, I shall be exploiting the contrast controlling effects of two-bath development for subjects of higher than normal contrast work, such as **Wistman's Wood** and **Black Mount**.

Developer types

All of the above developers can be further categorised, although I would say that some proprietary solutions are rather optimistically labelled, laying claim to an extreme fineness of grain, for example, which is usually only possible with true 'extra-fine grain' developers such as Ilford Perceptol and Kodak Microdol-X. Most developers belong to several of the following categories.

Acutance — these enhance image sharpness, usually via chemical adjacency effects: exhausted developer migrates from more heavily exposed, denser areas of the negative to lesser exposed, less developed regions, locally inhibiting the development of the latter. At the same time, the largely unused developer of the lesser exposed areas migrates to the more heavily exposed adjacent areas, with the opposite effect. All this happens on a micro scale, creating 'lines' of negative density

change that enhance the overall sharpness of the image. Acutance effects can be enhanced by using the developer in a more dilute form, and with less frequent agitation.

Examples include: Agfa Rodinal, Ilford LC29, Tetenal's Neofin Red and Ultrafin, and Paterson Aculux.

High-acutance — as above, but to more noticeable effect. These developers are normally very energetic but are used at very weak dilutions. As such they also tend to be surface acting, compensating solutions, the effect of which is enhanced by not too frequent agitation.

Examples include: Agfa Rodinal and Paterson Acutol.

Compensating — formulated to maximise the build-up of shadow detail and also to restrict an excessive build-up of density in the negative highlights, as explained in two-bath developers above. Diluting a developer more, and agitating less, will create a more compensating effect.

Examples include: Tetenal Emofin and Speedibrews Resofine 2B.

Fine-grain — some developers contain a mild silver solvent, such as sodium sulphite when added in sufficient quantity, that partially dissolves the silver as it forms and then replates it onto the image. Examples include: Agfa Atomal, Ilford ID11 and Kodak D76.

Extra fine-grain — as above, but containing a much stronger silver solvent. Their stronger solvency effect usually requires some additional camera exposure, normally an extra $1/2$ to 1 stop. Examples include: Ilford Perceptol and Kodak Microdol X.

High-energy — formulated for subjects of extremely low brightness range, or for deliberately higher-contrast results. They should not be confused with the extremely energetic, very high-contrast lith developers, such as Champion Novolith, which are also heavily restrained to restrict the development of negative shadow detail, thus keeping contrast high.

Examples include: Kodak D19 and Tetenal Dokumol.

Lith — maximum-contrast developers for very graphic results, as with lith films like Agfa Ortho and Ilford Ortho.

Examples include: Champion Novolith, Speedibrews Speedlitho and Tetenal Dokulith.

Low-contrast — normally contain just a soft-working developing agent, such as metol or phenidone, and a weak activator, such as the preservative sodium sulphite. They are formulated for fine-grain films of inherently high contrast, such as Kodak Technical Pan and Agfapan APX25 and for subjects of extreme brightness range, although they will usually not produce adequate contrast with faster films. Examples include: Kodak

Technidol, Speedibrews POTA and Tetenal Doku.

One-shot — concentrated developers that are diluted immediately prior to development and used once, or maybe twice, immediately afterwards (with an extra 10% added development time). They are good for infrequent processing work when a smaller volume of unused stock concentrate developer will keep better than a larger volume of working strength solution diluted, ready for use.

Examples include: most developers (Ilford ID11 and Kodak D76) can be used, and re-used as stock concentrates, or diluted for one-shot use then discarded.

Speed-increasing — quite energetic solutions, supposed to enable the film to be used at a higher than normal (underexposed) ISO setting. In some cases an extra 2-3 stops in speed is claimed, but always at the expense of lost shadow detail, increased base fog and extra contrast.

Examples include: Ilford Microphen and Speedibrews 422.

Surface-acting — formulas that restrict development activity to the emulsion's surface, to produce 'thinner' (less 3-dimensional), sharper negatives. Their action also prevents the further development of silver in to the emulsion that may have also been exposed to image degrading irradiation and halation. Acutance and more highly diluted developers are usually more surface acting.

Examples include: Speedibrews POTA.

Stopbaths

At their working strength, these are normally 2-3% solutions of acetic acid, designed to immediately arrest development by neutralising the alkalinity (activity) of the developer. Their action enables the curtailment of development to be accurately timed and the life of an acid fixer to be prolonged.

Most proprietary solutions also contain a yellow-orange coloured indicator that changes to a purple colour when the solution contains too much carried-over alkali developer, i.e. when its pH has significantly changed from an initial value of about pH4 to pH6 or 7. At this point (and preferably before) the stopbath is discarded and not replenished.

Examples include: Ilford IN-1 Stopbath and Kodak Indicator Stopbath.

A regularly changed, plain-water stopbath can be used in between the developer and an acid stop, to prolong the life of the latter.

Fixers

Rapid — these contain the faster working ammonium thiosulphate fixing agent or a combina-

tion of sodium thiosulphate and ammonium chloride to achieve a similar, cheaper, but slightly slower effect. Typically, they fix most film in half the time of normal fixer solutions. Examples include: Agfa's Agefix and FX Universal, Ilford Hypam, and Kodak's Unifix Liquid and 3000 Fixer (part A).

Normal — contain the slightly slower working, more traditional sodium thiosulphate fixing agent. Examples include: Ilford Ilfofix and Kodak Unifix Powder.

(The old, but still used, term 'Hypo' can be ascribed to both types of fixing agent.)

Fixer types:

Acid — most of the above fixers are acidified, and some are chemically buffered as well, to counter alkali developer carry-over and to make the fixer compatible in pH with the acid stopbath.

Alkali — not that common, but gaining popularity as a means of preventing the bleaching of finely divided colloidal silver that gives chloro-bromide and lith prints their characteristic warm tone. Examples include: Speedibrews formula 26.

Plain — neither acidified or alkalinised, and used for the same reason as the alkali fixers above, e.g. for not interfering with the subsequent use of toners employed for changing print image colour. In its simplest form a plain fixer can be made by adding ammonium or sodium thiosulphate to water.

Examples include: Agfa Agefix and Speedibrews formula 25.

Hardening — a few fixers have a hardener incorporated in manufacture to prevent the emulsion softening and being damaged during processing and drying, such as with heated, canvas blanket driers. Some fixers can be 'hardened' by the addition of a separate agent.

Examples of hardening fixers include: Kodak's Unifix Liquid and Unifix Powder, and Ilford Ilfofix.

Examples of separate hardeners include: Ilford Rapid Hardener which can be added to Ilford Hypam and Agfa Aditan for Agfa Agefix.

Post-fixing solutions

Washing aids

Hypo (fixer)-clearing solutions will improve the removal of residual fixer, shorten wash times and improve the efficiency of lower temperature washing. They are used after fixing, usually following a brief rinse to remove most of the surplus fixer.

Examples include: Ilford's Galerie Washaid, Kodak Hypo-Clearing Agent and Tetenal Lavaquick.

Note: there is a clear distinction between hypo-eliminators and hypo-clearing solutions: the former chemically oxidise residual fixer, the by-

product is then easily washed out of the emulsion. From an archival viewpoint (see: ARCHIVAL PROCESSING), hypo-eliminators are not recommended.

Final rinse

Tap water is often unsuitable for the final rinse of films due to soluble and insoluble solids that will leave dirt embedded in the emulsion, or scratched along it if the film is squeegeed free of surface water prior to drying. A better, and cheaper solution than distilled water, is to use deionised water, such as car battery top-up water, available from car accessory shops in 1 and 5 litre bottles.

Wetting agent

A small, precisely measured amount, should always be added to the final rinse of films. These detergents break down the surface tension of the water to create a thin film that evaporates quickly and evenly, as the negatives dry. Their use prevents image degrading, ineradicable, water marks.

Examples include: Agfa Agepon, Ilford Ilfotol, Fotospeed Rinse Aid and Kodak Photoflo.

Toners

Films can be briefly selenium toned to improve their archival permanence without any change in density or contrast. Alternatively they can be toned for longer, or in a stronger solution, for intensification purposes, giving a maximum $1/2$ to 1 paper grade increase in contrast. Once toned, the film cannot be treated with another, stronger intensifier, such as the chromium variety. Neither can it be bleached in Farmer's reducer, or the like.

Examples include: Fotospeed Rapid Selenium Toner and Kodak Rapid Selenium Toner.

Intensifiers

A variety of intensifying solutions can be used to increase the contrast and, or, density of developed and washed negatives. Intensifiers can be divided into physical and optical varieties: the former bleaches the negative so that it can be redeveloped to form a denser and contrastier silver image. The latter changes the negative to a red-brown colour, rather like the old-fashioned tanning developer. This optically enhances the negative's contrast, by playing on the inherent blue sensitivity of black and white papers.

Examples include: Speedibrews Chromium Intensifier and Speedibrews Intense (optical intensifier).

Paper processing chemistry

Developers

There is a more limited range of developers for prints than for films. More limited because we view the print unmagnified and cannot, therefore, benefit from many of the subtle micro-level development effects that are made visible with negatives enlarged during printing.

Standard or universal — general purpose developers not intended to alter the inherent contrast or image colour of a paper.

Examples include: Ilford's PQ Universal, Bromophen, Ilfospeed and Multigrade, Agfa's Neutol BL and Multicontrast, and Kodak Dektol.

Low-contrast — soft-working solutions designed to lower print contrast. They can be used either on their own, to lower print contrast by a contrast grade, or as a part of a two-bath paper developer, i.e. juxtaposed with a dish of normal developer to create a more modest reduction in print contrast. Alternatively, they can be mixed with a standard developer to make a single bath, for a subtle contrast lowering effect.

Examples include: Agfa Adaptol, Kodak Selectol-Soft and Tetenal Centrabrom S.

High-contrast — will maximise the inherent contrast of a chosen grade of paper. However, the increase in contrast may only be marginally greater than that achieved by slightly underexposing a print and developing it to completion in a standard developer.

Examples include: Ilford Contrast FF and Champion Teknol.

Warm-tone — formulated to maximise the warmth of chloro-bromide papers. They have little if any effect on bromide and bromo-chloride papers. In simple terms, they work by restricting the growth in size of the print's individual silver grains. A standard or universal developer can be made slightly warmer in tone with a developer additive (see below).

Examples include: Agfa Neutol WA and Kodak's Selectol and D163.

Cold-tone — will produce the coldest tones with bromide papers. They will also neutralise the warmth of chloro-bromide papers, but will have little if any effect on bromo-chloride varieties.

Examples include: Agfa Neutol BL and Tetenal Eukobrom.

Lith — if heavily diluted they can be used to develop black and white paper for pictorial results (as mentioned in LITH PAPERS above). They are normally packaged as two solutions and mixed together just before use. These usually very alkaline developers can produce very warm tones (in a heavily diluted state) with certain Lith papers.

Examples include: Kodak's Kodalith RT and Champion Novolith.

Additives — can be used to enhance the image colour of standard, cold and warm-tone developers. For example, Benzotriazole, added in very small quantites, will cool print image colour (see formula 11), whilst the addition of potassium bromide can enhance its warmth. Both of these will also help prevent fogging with older or out of date papers.

Examples include: Rayco R42 Anti-Fog, which is a Benzotriazole-based solution.

Stopbaths

The same stopbath types can be used for paper and film, although a water stopbath may be preferred for FB prints developed for the warmest tones.

Examples have already been given in FILM PROCESSING CHEMISTRY.

Fixers

The same fixer types can be used for paper and film, although with the above stopbath considerations in mind. Separate working strength solutions of fixer should be made up for films and papers since used film fixer contains different fixed-out silver salt complexes that are easily absorbent FB papers.

Examples have already been given in FILM PROCESSING CHEMISTRY.

Washing aids

As for films, although hypo-clearing solutions are not needed with the easily washed RC papers. I would always recommend the use of these solutions with FB papers, but I do no go along with the old practice, popularised by Ansel Adams and the like, of combining hypo-clear and selenium toner. Kodak Selenium toner contains fixer! Besides, at working strength, hypo-clearing solutions have a shorter life than selenium.

Examples have already been given in FILM PROCESSING CHEMISTRY.

Toners

Virtually all papers can be toned using a number of proprietary or home made solutions.

Examples have been given in TONING and in the FORMULARY section.

Camerawork

Own system or Zone system?

So much has been written about camera technique and film exposure methods that I shall simply describe my own chosen methods and give reasons for their use. If, in some cases, these practices appear less than conventional, perhaps it is because I choose to work with the smaller format 35mm camera, inherently grainier ISO400 emulsions and matt printing paper. Definitely not the normal approach to fine printing, but it can work — just as the Zone system can work.

Pre-visualisation

Seeing the print in advance — pre-visualisation — should make the whole process of black and white landscape photography more successful and all the more enjoyable for it.

That said, we can't always anticipate how our chosen subject matter will look; it is affected by certain variables such as the weather and the season. But, whilst we may not be able to control these elements directly, if conditions aren't quite right we can always decide not to press the shutter release and to return when they are more suitable. Alternatively, we might decide to go ahead and expose the film, then control the image through creative methods of processing and printing in the darkroom, as in the **River Authie**.

In either case, successful pre-visualisation also depends upon an understanding of our equipment and materials. If we know how they 'see' we are half way towards being able to create our intended print. But, if this is starting to sound very controlled, don't discount the element of surprise! Were I to plan my work too carefully, I would miss out on some unexpected and wonderful opportunities. For example, don't forget to look for the less obvious images. **King's Tor** was made in a car park in Dartmoor! You can't always plan that type of photograph.

Finally, try letting the accident participate. I have learnt more by carrying mistakes through to their own logical conclusion than from trying to keep too much of a stranglehold on my work or my view of the landscape. Sometimes a mistake — the accidentally exposed image, the overexposed sheet of paper or the improperly toned print (to name just three of very many!) — might look 'better': one photographer's rejected image might be another's perfect print.

Planning and organisation

Even if we simply wanted to imitate the photographs of others we would still have to plan such work. For any trip or excursion I have a simple method of preparation.

First I gather together Ordnance Survey (OS) maps, tourist guide books and also postcards, all of which provide invaluable information for getting the best photograph, or most dramatic view of a local landscape. Where possible, let 'others' do the work.

For example, when making a recent set of photographs of Dartmoor, I scoured OS Landranger 1:50,000 maps (numbers 191 and 202) — grid square by grid square — looking for information on known and unexpected locations; they provided some interesting surprises. To their margins I stuck small, post-it labels for each intended location. On these I wrote map references for each subject and, after a brief reconnaissance trip, information on the most likely angle of view, taking into consideration which time of day would give both the best direction and the right quality of light. On these I drew a pencil outline sketch of each subject, so that by looking at the labels, and location marker stickers for them that I had placed on the map, I got an instant overview of the variety of pictures I might come away with, and also in which geographical sequence they ought to be made. I later added notes on subjects found whilst on location which merited a return trip.

Working in this way, as I usually do, I soon realised that certain locations might have to be eliminated from the list, perhaps because they were too far from the road, necessitating long walks in the dark to get the first or last light of the day. Judging the right amount of time that is needed to make such excursions isn't easy. As Minor White put it: "Often while travelling with camera we arrive just as the sun slips over the horizon of a moment, too late to expose film, only time to expose our hearts".

Like others, I have found that maps marked with scenic views sometimes provide a useful indication of what to expect — usually a crowd of other people. I tend to avoid these more obvious locations, unless I can be there very early in the morning; as with **Eileen Donan**, it is often the only way to get a landscape image free of people.

The weather

Reading, or listening to, the weather forecasts, coupled with a basic understanding of weather systems, permits some very useful pre-visualisation of possible lighting and cloud formations. It also warns of wind and rain, or cold, to come. Irrespective of the subject's inherent beauty or interest, any one of these natural elements can make or break the image — or the will to photograph it.

I have a cheap little battery-operated radio cassette that I use to record the early morning weather forecast so that I can play it back later — when I have woken up! More often than not I have found that passing frontal systems tend to produce the most varied and changeable weather. As such, they provide the opportunity to see the subject in a number of different climatic guises, all in a potentially short period of time. It is my favourite type of weather for black and white landscape work, although I have to admit that a good high pressure spell of clear blue skies does make camerawork more relaxed; there is less need to anticipate changes in cloud patterns, or patiently to wait for the most likely moment of sunlight. Besides, a high-pressure system usually means staying dry for a change.

Generally speaking, I tend to favour early morning rather than evening light. Rarely do I work in the middle of the day; I use that time to study known locations and look for new ones as well. Why do I prefer first light? Maybe it's just because I've actually got up early in the morning, and this, not the quality of light, hits my senses! But seriously, it is a wonderful time to photograph the landscape. I like the balance of the light first thing in the day. The light ratio, between the main directional light (the sun) and the fill-in light (reflected light), is such as to enhance the type of less detailed, simpler image I often like to make.

In summertime, in Scotland for example, it is light enough to photograph at four a.m. Too early for some of us, so a trip earlier or later in the year may be more rewarding and more relaxing.

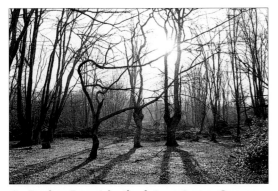

2. The same location but an alternative viewpoint looking in the opposite direction.

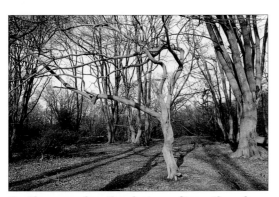

1. Epping Forest in the late autumn. Compare this colour view with the toned black and white photograph on page 73, which was made in the summer.

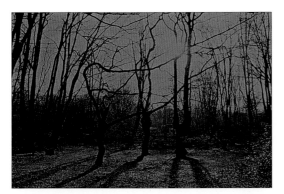

3. Pre-visualisation is a key element of black and white photography. Here the scene is viewed through a Wratten 90 monochrome viewing filter.

Camerawork

Viewpoint

To say: "This is where we should stand", or: "This is how we should compose the image", is no help. A viewpoint should be our own viewpoint. It is something that should not be dictated, since it relies on a fine balance of all the elements of photography, as discussed in the introduction, one of which is how we want to see the subject and therefore how we wish to communicate that statement. However, as a general rule, I would say that the photographs I like most are those in which the photographer has known when to break with conventional rules of composition or viewpoint. That takes confidence, born of considerable practice and ruthless editing of images. This process is also helped by looking at others' work with a constructively critical eye. Of all the many talks I have given, I can only remember one person — no, two — who ever really criticised my work, and one of them was me. Why only one other person? Perhaps it is because most of us are still needlessly a in awe of the very process of photography, and of the kind of black and white printing and toning processes illustrated in this book.

For me, the photograph of **Wistman's Wood** begins to fall (or should I say tilt?) into the less traditional landscape camerawork category. Its unconventional, quite severe cropping and the tilting of the horizon really make this image, unlike, say the image of **Black Mount** which relies more, perhaps, on the inherent splendour of the scene for its impact.

Viewing the scene

I use a viewer to help with the process of image visualisation and composition. It is simply a thin, flat, plastic template, cut out to the same aspect ratio as the camera's format, and designed to be held roughly at arm's length, depending on the focal length, and angle of view, of the camera lens.

I find this viewer much easier, and less fussy, to use than constantly having to hold the camera up to my eye. But for me, its real advantage is that, holding it at arm's length, I am viewing a framed image of the scene at the same distance I would normally view the framed and finished print.

Viewers are the poor-man's Polaroid. Like the print, they give a two-dimensional image. Compare this to looking through a 35mm camera viewfinder, albeit with just one eye, the image still has a considerable three-dimensional quality. There is a big difference between this view and that of a larger

format camera — and our viewer — where we look at it. 35mm connects us to the image, in my opinion much too intimately; the latter gives us an opportunity to stand back from the scene and therefore to be more objective about it.

Using my viewer, I am holding a 3.3" x 5" (35mm aspect ratio) image in my hand; looking through the 35mm camera viewfinder what size image do I see? Is it the 24mm x 36mm frame size or is it the actual size of the landscape in front of me? In my experience, if the 3.3" x 5" viewer image looks good, the 20" x 16" final print will look even better. The same is often not the case when I view the scene solely through the 24mm x 36mm camera viewfinder.

Consider also the viewfinder surround of the 35mm camera. It is jet black. I often find that its juxtaposition with the lighter tonal values of the viewed scene creates a distorted interpretation of their values.

You can buy viewers, although they tend to have black surrounds, are usually quite small and are most often fitted out with a Wratten 90 gel, whose effect is deliberately to flatten off the colour values of the scene. However, looking through this orange-brown coloured filter does not accurately reflect how the film sees the scene. Remember, if anything, our average panchromatic film often tends to be a little overly blue-sensitive, and thus the film will see the scene one way and the filter another. Our eyes will also see differently.

Simpler (and considerably cheaper), we can make a viewer using thin grey (waterproof) plastic (similar in density to an 18% reflection density card used to make handheld reflected light readings). A generous-sized viewer-surround effectively isolates the chosen subject, helping us compose our thoughts and thus compose the image. Above all, using it has taught me the importance of seeing the subject for myself, through my own eyes, rather than just through a camera.

Lens controls

The right focal length lens is obviously very important to give the composition we require, whilst the right f.stop (for cameras without lens or back movements) will determine the amount of depth of field we can have and how sharp the image can be made. For most of the images in this book, made with standard to wide-angle lenses, I have worked at around f.11, being sure to choose my point of focus carefully.

Incidentally, for corner to corner sharpness my 20mm f.3.5 wide-angle lens needs to be stopped down to f.11, but no more than f.16 if I want to retain good maximum sharpness with this lens. The overall quality of the image really begins to suffer

at f.16 and below. This restricted use of aperture setting can be very limiting when a particular speed may be required, perhaps to capture movement, as in **Monkstadt House**.

For landscapes, if I want everything in focus, I normally focus on a point $1/3$ of the way into the scene and stop down the lens to the required aperture, checking depth of field with the camera's preview facility. This 'fraction rule' follows the simple principle that $2/3$ of the available depth of field for a given lens aperture will be behind the point of focus and $1/3$ in front. A similar rule cannot be applied to close-up work. I always use the depth of field preview for viewing any landscape image, often finding the darker image of the temporarily stopped-down lens to be less detailed, and therefore easier to view, and to compose. I don't like any viewing screen focusing aids, such as split prisms, that interfere with this viewing process.

Filters

As mentioned in CAMERAWORK, I like to keep equipment to a minimum and this includes the number of filters I carry around. For this reason I chose camera lenses that all had the same 52mm thread. I always use glass, Hoya filters in preference to potentially poorer quality plastic varieties that are more easily scratched. I only employ a Cokin-type plastic filter holder for my diffusion filter.

I always meter the subject without the filter in place and then adjust the exposure reading according to the filter factor provided by the filter manufacturer. I then bracket my exposures to be sure I get the best negative. If there is time, and if I am unsure of exactly how the filtered scene will reproduce, I often make extra exposures using a selection of different filters listed in EQUIPMENT.

I use coloured filters to control contrast — for example a yellow filter will make blue skies less bright in the finished print. Just as often, I will use them to control the atmosphere of the picture — for example a blue filter enhances haze, or enhances the impression of haze, whilst a red filter will have a very strong, opposite, contrast increasing effect. In the case of **Fernworthy Forest**, I used both a light-green filter to lift the lichen-covered, light-green branches of the tree, and a diffuser to accentuate both this effect and the movement of the branches. Often, a coloured filter can be used for both effects, a yellow-green filter lightens foliage but also darkens blue skies, e.g. **Wistman's Wood**.

By photographing a colour chart (see MATERIALS), or similarly vari-coloured subject, we can get a much clearer visual indication of how filters will affect the black and white tonal values of the scene and that of our pre-visualised image.

Bodywork

I always use a tripod, especially if the shutter speed for my chosen aperture is approximately equal to, or below, the focal length figure of the lens when measured in millimetres: e.g. a 50mm lens shouldn't be handheld if the shutter speed is $1/60$ second or under, and a 28mm lens shouldn't be hand-held at $1/30$ second, and so on. Once set up, I make sure the tripod is weighted down with the camera bag for improved stability and, if possible, I try not to use it fully extended for the same reason.

For me, the tripod performs several very useful functions:
i) it ensures sharp images by keeping camera shake to a minimum, thus permitting the use of beneficial, very high definition film developers, which would show up camera shake or poor lens quality,
ii) it allows careful checking and rechecking of composition, by controlling the camera's position,
iii) it helps ensure level horizons if required — I have a tripod-head with built-in spirit-level,
iv) it permits bracketed exposures of identical compositions to be made with a second camera containing a different film, and
v) it slows down my camera work, enhancing the consideration I put into my photographs, with — I hope — obvious benefits.

To ensure image sharpness further, I expose the film with the camera mirror locked up, and use a cable release of at least one foot in length which is gently held so as not to pull on the camera. After winding on the film, I wait for several seconds for any vibration to die down, before making the next exposure. Sometimes I'll wait longer if exposures need to be made between gusts of wind.

Metering

For 35mm, with no interchangeable backs for difficult lighting situations that might require another film type or more suitable ISO setting/film development time, all we can hope for is to know the limitations of our film/developer combination and to work within these confines. But, if we also know what enlarger lightsource, paper and print processing techniques we are going to use, we'll have a clearer idea of how to expose the film — if at all!

I make my readings using the centre-weighted meter of the FM-2. For an average scene containing one-third sky and two-thirds foreground it's fine; it gives a generously exposed negative with plenty of shadow detail. A change of composition, for example to one-third foreground and two-thirds sky, and the meter will give a completely different reading. It isn't too hard to apply the knowledge inferred from this metering scenario to every scene and then bracket the exposures as outlined below.

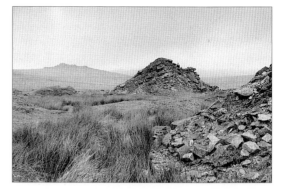

4. **A disused granite quarry on Dartmoor may seem an unpromising location, but a few hundred yards away lay some interesting remains.**

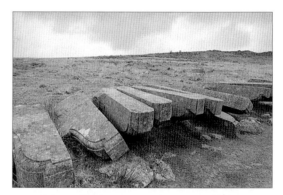

5. **These abandoned granite corbels were originally intended for use in the construction of the old London Bridge, now in America.**

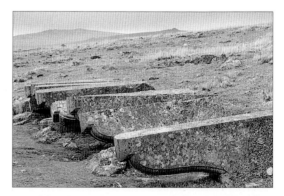

6. **This viewpoint was good for showing the carved shape of the stones. But it failed to put them into the context of their natural environment**

7. I opted for a higher viewpoint. Only full tripod extension and a lightweight step ladder made this possible.

8. The siting of these carved stones within a barren landscape appeared quite incongrous, rather like the barges at Bradwell.

9. An overview of Loch Ainort. This picture contains too much conflicting information. Moving in closer to get a lower angle of view makes the final image much stronger.

If you are looking for a general rule of exposure for black and white (not for colour transparency film) then the one I have always followed is simple: expose for the shadows and develop the film for the highlights (i.e. the right processing time to develop highlights to the most appropriate density). If your camera has a spot-meter facility it makes separate exposure readings of the shadows and highlights possible, but if it's a centre-weighted meter, like mine, you'll have to learn to interpret the meter's more general reading. But take note: if you have 36 exposures on one roll, and the subject of each is of a different brightness range, then you might be able to expose them all for the shadows, but you can't develop them all individually according to the luminance value of their highlights. For 35mm, unless you can cut the film up into individual frames (which can be done, but is not easy and is ill-advised!), you'll have to develop the whole film to one development time. Variations in individual negative's contrast will then have to be compensated for by using different paper grades, and various other printing techniques, such as dodging and burning in. If the film contains subjects of wildly differing brightness ranges I would recommend a developer with good compensating action, or better still, a two-bath compensating developer, such as Speedibrews Resofine 2B. Alternatively, try a film with good exposure latitude like Ilford's XP2.

Altering the film ISO

Rolls of film that are likely to be exposed in their entirety to subjects of lower or higher than normal brightness range can be rated, prior to exposure, at different ISO settings. As a general rule, downrating a film, for example setting an ISO 400 film at ISO 200, coupled with a decrease in film development time of about 20%, is an excellent way of controlling the contrast of harshly lit subjects. Conversely, films for flatly lit, low-contrast subjects can be uprated, say from ISO 400 to 800, and given 40% more film development to increase the contrast of their negatives. In both cases, such changes to film development time have less effect on the shadow values of the negative but a significantly greater effect on highlight density, and therefore on the overall contrast of the film. This further demonstrates the principle: expose for the shadows, develop for the highlights.

Film exposure

Film is the cheapest part of the process, so never skimp on bracketing or duplicating your exposures — it's certainly cheaper than returning to a scene to re-photograph it.

To bracket 35mm black and white film I first make two camera exposures at the normal meter setting, then one at $+1/2$ stop, $+1$, $+1^1/_2$, $-^1/_2$ and -1 stop. This bracket of exposures gives me a good range of negatives to choose from. As you can see from the negatives in the photospreads, I most often print with slightly over exposed ($+^1/_2$ stop) negatives, especially if I want to dodge part of the shadows, as in **Loch Ainort**. I usually find this type of slightly overexposed, but correctly developed negative is better: the shadow values are placed higher up the characteristic curve where they are better separated, and remain so, even when dodged. By working with matt paper, and printing on a harder grade, the remainder of the undodged shadows stay black, usually as I intended.

I would also recommend bracketing in case a single, valuable, irreplaceable negative gets damaged, or in case camera exposure readings were wrong, but also because we can learn so much about print quality from looking at all these differently exposed negatives, their contacts and enlarged proof prints. These images will show marked differences of tonality, tonal separation, image sharpness and graininess. We can then use this knowledge later to good, creative effect.

If you are totally unsure of your film exposure for a given roll of film, you might wish to carry out a film-clip test. It's simple. Working in the dark, use a film leader retriever to pull out roughly the first six exposed frames of the 35mm roll. Cut this length off, gently push the protruding film back into the cassette and then load, process and inspect the film clip. Yes, you'll probably loose one or two frames around the line of the cut, but at least you'll be sure of how to process the remainder of the roll.

Irrespective of what your camera meter might say, almost all black and white films suffer from reciprocity failure. As a general rule any film exposures that are longer than 1 second need to be increased by a factor of $1^1/_2$-2 stops of camera exposure, for example **King's Tor**. Consult the film manufacturers' recommendations, but be warned, reciprocity failure increases negative contrast and reduces the amount of printable shadow detail.

After exposing any film, I put the cassette back into the cannister and label it. Film left unprotected from the elements — light, heat and moisture — may experience a build up in shadow-degrading, base-fog density.

And finally, if you plan to change your printing paper or paper surface (for example from gloss to matt), or if you are thinking of toning prints, your film may benefit from changes in exposure and development times to provide the best, most suitable amount of negative contrast and density. If in doubt, test the film, making prints from differently exposed negatives to see which film speed is best.

Film processing

Equipment preparation

Before loading any film I lay out on the dry bench the tanks and spirals (all with their openings facing the same way round). I also put such easily misplaced items as the film, the film cassette opener, scissors and a pair of cotton gloves — in case of clammy hands — into a small open box. I also like to check that I have the necessary processing chemistry, as I don't like to leave loaded, unprocessed film in the tank for too long — it tends to be easily marked by absorption of any residual moisture.

Plastic, ratchet-type film processing spirals (as discussed in EQUIPMENT) must be totally free of surface moisture or else the film emulsion will stick to them during loading. Since the relative humidity of even a warm 'dry' darkroom is usually 60%, and frequently higher, surface 'dampness' will need to be removed from these spirals — just prior to loading — by a quick run-over with a small fan heater, such as a hair drier.

Some plastic and metal spirals can be loaded wet, but in my experience this can locally mark the film, as mentioned above.

Loading the film

After the lights are switched off I check for any stray light coming into the darkroom from around the blackout curtain-door.

I always fully open a 35mm film cassette to remove the film, rather than draw it out through the light trap, which can mark the emulsion. Next, I cut off the film leader between the sprocket holes, then run my finger over the film end to make sure it has a smooth edge for easy, jam-free loading.

Once the film leader is inserted into the spiral, rather than let go of the remainder — a 36 exposure roll is six feet long and can reach the (wet?) floor — I keep the film loosely coiled in one hand while it is being loaded. For ratchet-type spirals, I load the film with a fairly slow back and forth motion, just in case the film suddenly decides to stick. Once the film is loaded, I will then cut off, rather than tear off, the film spool. Tearing may create static sparks which can fog the film, especially faster, higher ISO films. It may also leave the sticky film-to-spool connecting tape attached to the film, from where it can come off during processing, with potentially disastrous results.

Film loading problems

Should the film stick as it is being loaded, I would suggest rapping the spiral a couple of times on the edge of the dry workbench. If this doesn't work, carefully remove the film — by gently pressing it together as it is slid out of the spiral — and reload it onto another spare, dry unit. Check the offending spiral afterwards.

Film that becomes badly jammed in plastic spirals, or that is squeezed too hard as it is loaded into a non ratchet-type metal reel, may suffer from tensioning or creasing. The result may be locally sensitised, developed-out marks on the negative.

Solution preparation

Mixing film developers

Some powdered developers such as the ever popular ID11 and D76 benefit from being made up a day or so prior to use. Films processed too soon in these solutions, even at the right temperature, often exhibit excessive contrast, as the freshly mixed stock developer needs a little time to settle down. An old lab trick is first to chuck some undeveloped 35mm film leaders into the fresh brew to take off its edge.

Other powdered developers, such as Speedi-brews POTA can — indeed should — be used straightaway once cool, whilst all one-shot developers made from stock concentrates should be used straightaway unless stated otherwise. If they are highly dilute, chances are they will oxidise very quickly. Always check with the manufacturers' instructions.

Water quality

Most stock developers can be mixed with tap water for use, although regional variations in water pH may necessitate some initial development time tests against the manufacturer's recommendations. Acid water may need longer development (and longer wash) times. For high-dilution, very sensitive developers, it may prove beneficial to mix the developer with deionised water, which has a neutral pH.

Solution volume

Most hand tanks need 300ml of working strength solution for each 35mm roll. Fortunately, most manufacturer-developer dilutions are worked out in simple fractions, or ratios of this amount. For example, Ilford LC29 at a recommended 1:29 dilution needs just 10ml of stock developer and 290ml of water for each 35mm, 300ml reel. Calculating film developer dilutions should be easy, but just in case, I have included a dilution table in TABLES AND CHARTS. The effect of diluting a developer at different ratios is outlined below.

Development

The process

We really only need to know a little about how developers work to get the very best from a particular solution (see MATERIALS) and, although all developers don't work in exactly the same way, we can make some basic assumptions.

Development time

In the early stages of film development — following the induction period and the emergence of the image — the shadow, midtone and highlight areas of the negative will develop at a similar rate. After a while, the development of the more heavily exposed midtones and highlights will begin to gather momentum and their density (but not that of the shadows), and the overall contrast of the image, will increase.

It should therefore be fairly clear that too little development of a correctly exposed film will yield a flat negative and too much development, in a typical one-bath developer, will yield an excessively contrasty one. Within certain limitations this needn't be a problem, since we can print such negatives on higher or lower contrast grades of paper. However, in either case, the print may not be as good (as fine in grain, or as tonally well separated) as one made from a properly developed negative whose qualities will best match that of the normal grade 2 paper.

1. This negative has been underexposed and normally developed. Overexposing it by one stop and cutting development by 20-30% would have produced a better negative with more shadow detail and less highlight density.

2. One stop more exposure and the same development time. The negative has more shadow detail but almost unprintably dense highlights.

3. A similar type of backlit scene. This time I correctly gave the film 1 stop more exposure and cut development by 20%. I also lith printed this negative to help me burn in the sky.

For example, a print made from a correctly exposed but underdeveloped flat negative, printed 'straight' onto a much harder grade of paper, will lack the subtle tonality of a good negative printed on normal grade two paper: shadows may appear blocked up, the highlights very washed out and the midtones will be gritty. Conversely, a print made from a correctly exposed but overdeveloped and contrasty negative, printed on the softest grade 0 paper, may have compressed shadow values, blocked up — yet visible — highlights and midtones that lack bite.

Densitometrically speaking, incorrect exposure, or incorrect development (or a combination of both) will alter the characteristic curve of the film away from its ideal shape so that it won't match that of the paper.

Incidentally, development is normally timed from the moment the tank is filled and is first agitated, to when it is completely drained and ready for the stopbath to be poured in. The length of time varies according to film type, ISO rating and according to the other means of control listed below.

Dilution

Manufacturer's recommended developer dilutions are calculated to keep development times practicably short. However, if we increase the developer dilution and extend development time accordingly, acutance and compensating effects will be enhanced.

Of course there is a limit to the amount a developer can be diluted before image contrast suffers, development times become too long and base fog starts visibly to interfere with subtle shadow detail. Look at the 'clear', unexposed rebate between two 35mm negatives with your enlarger focus finder and you will see what should be just a fine pattern of silver grains. This is base fog.

As a general rule, developers for slower, inherently contrastier films can be more diluted, and vice versa. For example, I often develop Kodak Technical Pan (ISO32) in Agfa Rodinal, diluted as much as 1:200 to get a grade 2 print from a scene of normal brightness range. The same scene exposed on a faster and inherently flatter ISO400 film, such as Ilford HP5+ of Kodak TMax 400, might require a dilution of 1:50 to get a negative of the same printing contrast. Rarely, if ever, do I use Rodinal diluted more than 1:50 for ISO400 films, especially when printing on a matt paper with a Mulitgrade diffuser head. If I did, I might end up on grade 5 paper with little room for more contrast if needed.

Some developers can be used diluted or undiluted. For example, the range of Ilford and Kodak powdered formulas, once mixed with water, can be used as a stock solution at full strength and replenished, to last a long time and to process many films, or they can be diluted just before development with 1 or 3 parts water and used (less economically) as one-shot developers, then discarded. Diluting these developers produces beautiful negatives with a longer, more delicate tonal range.

Agitation

During development, exhausted solution must be removed from the emulsion and replaced with fresh. This is done by carefully controlled agitation: too little and negatives may become unevenly developed and mottled in appearance, as well as lacking contrast, whilst too much creates developer flow patterns, usually adjacent to the sprocket holes of 35mm film where solution turbulence is greatest. Extra agitation also increases negative contrast and speeds up development.

To ensure uniformly developed negatives, agitation must begin immediately the tank is full. Normal practice is to invert the hand tank for the first 10-30 seconds and then for 10 seconds, or 4 inversions every $1/2$ minute thereafter. This routine may need to be varied, according to the inherent sensitivity of certain films and each individual's processing technique. My technique is to twist the tank as I invert it, turning it first to the left and then to the right; it breaks up what might be too regular flow patterns. Subjects of even tone will show up improper agitation most clearly. So, if you're unsure of your agitation technique, photograph a plain grey sheet of card, process the film and print the negatives 'straight' onto a hard grade of paper that will show up any such unevenness the most.

To remove developer-inhibiting air bells trapped on the surface of the film, I suggest you rap the film tank several times prior to and just after the first bout of agitation, and then following each subsequent phase of agitation. To protect the tank I use a small 8" x 8", $1/2$" thick, wooden 'rapping' board, placed in the sink on top of a $1/4$" thick sponge washing-up cloth. The shock of the tank hitting the board releases the air bells, whilst the absorption of the sponge protects the plastic tank from cracking.

Agitation brings other advantages and problems. Less agitation improves acutance and enhances developer compensation. I often agitate as little as once a minute and increase development time accordingly (on average by 10%) although carrying out your own development tests is the only way to find out what is right for you. Over-agitating makes some developers foam excessively, increasing the likelihood of air bells on the emulsion. This foam can also trap developer in the hand tank's funnel during inversion agitation. The top film will then be left partly uncovered by the

developer, to obvious effect. To counter this problem, which is most common with plastic tanks, I briefly open the snap-on (outer, non-lightproof) lid.

The volume of processing solution in a hand tank will play a significant role in the efficiency of agitation. Too little volume and the solution will flow too freely, whilst too much will be considerably impair the flow. For this reason, I fill plastic hand tanks up to the base of the funnel and no more, and certainly no less — even if the tank is holding fewer than its maximum capacity of films.

Push and pull processing

Film development times can be altered to compensate for changes in a film's ISO setting, perhaps to cater for subjects of unusually high or low brightness range, or for situations where there was too much or too little light to expose the whole film at its normal ISO setting.

For example, if the scene was too contrasty and the film has been down-rated by 1 stop (e.g. ISO400 to ISO200) the development time should normally be cut — pulled — by 20%. If the scene was too flat and the film has been uprated by 1 stop (e.g. ISO400 to 800) the time is increased — pushed — by 40%.

Pulling more than 20% will produce unevenly developed negatives and insufficient contrast, whilst pushing more than 1 stop in a standard developer may excessively increase negative contrast and base fog levels. Not all developers can be equally well pushed and pulled. More dilute one-shot developers, such as Agfa Rodinal, are rarely good candidates for pushing.

I am sceptical of any literature that says a film can be pushed more than 1 stop, in a standard developer, to handle very low-light level situations. Such literature also tells us to push the film — in the same way — to deal with subjects of low contrast. As already noted, an increase in development time won't significantly increase the density of the negative's shadows, it will only increase the density of the more exposed midtones and highlights. Under-rating and then pushing film will simply exaggerate this effect, whilst printing on a softer grade of paper to deal with the contrast will further decrease the separation of poorly separated and thin shadow detail.

Speed increasing developers may help, but are by no means an ideal alternative. Better to use a faster film at its recommended ISO setting. For example, Ilford Microphen and Fotospeed's FD30 won't genuinely increase the speed of a film by much more than 1 stop, although they will produce printable negatives of controlled contrast (but still lacking shadow detail) from film uprated and pushed by 2 or 3 stops.

Temperature

Temperature controls the activity and therefore the speed of development, as shown in the TIME-TEMPERATURE chart. However, not all developers respond in exactly the same way to changes of temperature. If the temperature of the developer is too high, then development times may become uncontrollably short, and the film may be unevenly processed. Most developers will also suffer badly at too low a temperature (14°C and below), failing to produce adequate contrast even with extended development time.

Also, film processed in solutions of widely differing temperature may suffer reticulation: physical emulsion damage that shows up on the print as mosaic-like pattern.

Stopbath

An uncomplicated, but vital, stage of film processing; it ensures accurately timed curtailment of development and prevents carried-over developer from contaminating the fixer. As we have already noted in MATERIALS, the choice is between a plain-water or acid stopbath. I normally work with both in succession.

Once the hand tank is completely drained of developer I fill it with water, at the same temperature as the developer, and up to the bottom of the funnel. I then rap the tank a couple of times to remove airbells (as explained in AGITATION), then agitate — inverting and twisting the tank several times over a 15 second period. I drain the tank and repeat the process with the acid stop, but over a longer 30 second period.

My reason for using both water and acid stopbaths is to gently introduce the developed, alkali saturated film to the acid environment of the stop and fixer. Sudden changes in pH, like sudden changes in temperature, can reticulate the emulsion and for this reason an overly strong acetic stopbath must be avoided. Clear, pinhole marks in the negative are a visible indication of too strong a stop. Acetic acid stopbaths should be around 2-3% in strength, e.g. formula number 21.

Since many modern films don't clear easily during fixing, an acid, rapid, ammonium thiosulphate fixer is normally best and therefore an acid stopbath is recommended to maintain the pH and therefore the level of activity of the fixer. Don't keep topping up a stopbath, or over use it; they are always best discarded earlier, rather than later, to reduce developer by-products being carried over into the fix.

Incidentally, you don't need to use a water stopbath, but judging by the fixer clearing problems some of us experience, the additional water-stop method should help to keep the fixer as fresh and as working as possible.

Fixing

The process

Our developed image is now made up of visible, metallic silver. However, until it is properly fixed, the emulsion also contains undeveloped and unstable, light-sensitive silver salts; removing these is the job of the fixer. It is a critical process.

Clearing time

Fixing comprises two stages; the first is visible, we can actually watch the film become clear of its undeveloped silver salts. Then, when clearing is complete and the film base is seemingly 'fixed', the fixer must also make soluble and take into solution these now invisible silver complexes. Failure to complete this second stage will make negatives very unstable, whilst over-fixing in a strong, acid fixer will begin to bleach the delicate shadow detail of the negative. Washing will not complete the second fixing phase, its job is to remove residual fixer from the absorbent emulsion.

Clearing time: the time it takes visibly to clear the film, is a highly important fixer indicator. When fresh, multiplying the clearing time by a factor of two gives us the total fixing time needed for that emulsion. When this time doubles, the fixer is overworked and should be discarded.

Different emulsions will have different clearing times; slower, finer grain emulsions clear quicker than faster coarser grain varieties. These individual clearing times should be carefully noted and regularly rechecked, by fixing an undeveloped 35mm film leader — of the same emulsion type. However, the dye sensitisers of some modern films take longer to clear, necessitating a good fresh fixer, although some of this 'colour', if it remains after fixing, will be removed by the wash.

Fixing times

If a film takes 30 seconds to clear it will need to be fixed for 1 minute. If, as the fixer ages, this clearing time becomes, say, 45 seconds, fix the film for the new time of 1 minute 30 seconds (i.e. 2 x 45 seconds). Once the clearing time reaches 1 minute, at which point it has doubled in time, discard the solution and make up fresh.

Ammonium thiosulphate rapid fixers will, on average, clear and fix films in half the time of more traditional sodium thiosulphate varieties. If a hardener is added to the fixer (to toughen up the emulsion in case of likely rough handling later), then the fixing time will usually need to be increased. Consult with manufacturers' recommended times.

I would suggest you don't expose the developed film to the light until it has completed its clearing stage.

Fixer type

First we must decide what fixer type we want to use, as discussed in MATERIALS. For most films, I would opt for the rapid, ammonium thiosulphate, non-hardening variety, since it keeps fixing times as short as possible with slower to clear, higher speed, modern emulsions.

One bath, or two?

A single fixing-bath has to perform both stages of the process. Initially this is no problem, but once a number of rolls have been fixed in this solution, it may contain too much of the dissolved silver complexes and therefore slow down, and possibly prevent, the complete fixing of subsequent films. At this point the fixer should be discarded; it has no further use. However, if we wish to maximise the capacity of a fixer and at the same time guarantee complete fixing, then a two-bath fixing system is definitely the preferred method, as explained in ARCHIVAL PROCESSING.

Agitation

Follow the same procedure as recommended for film development agitation and for largely the same reasons: good solution exchange, removal of air bells and complete fixing within the allocated time.

Fixer capacity

How much film can be fixed in a given volume of solution depends on several factors. If we want to achieve archival standards of processing we will need to replace the first bath when it has reached a silver level of 0.7grams/litre of working strength solution. And for general processing work, I would suggest you follow manufacturer's recommendations.

How do we measure these silver levels. Simply by dipping silver estimating papers into the fixer. They will give colour-coded readings, rather like pH papers, for different silver levels in solution. Alternatively, we can use a fixer testing solution like formula 33. Either way, keep a count of the number of rolls processed per litre. For archival purposes, with most normally exposed/developed emulsions we can process approximately 10, 36 exposure films/litre. Although this figure will depend on how much work the fixer has to do: the amount of unexposed and undeveloped silver it has to remove from the emulsion will vary greatly, according to film exposure and subject brightness.

Washing

This is covered in WASHING AND DRYING.

Final rinse

The final objective of film processing must be to produce negatives free from any dirt or scratches. To this end, I give the washed film a final rinse in completely dirt-free water, to which is added a little wetting agent.

The role of the wetting agent is to break down the surface tension of water left on the film when it is hung up to dry. This has two important effects:
i) the film dries much more quickly, since the agent creates a uniform surface layer of easily evaporated water, and as a consequence of this
ii) it eliminates water droplets which, as they dry, pull silver within that area in to a pattern that echoes the shape of the evaporating droplet. These drying marks cannot be removed — they are within the emulsion.

The surface tension won't be broken if too little wetting agent is added. Too much agent and the water tends to become slightly viscous, drying in rivulets that leave longitudinal drying marks within the emulsion and greasy-looking streaks on the film backing. The latter can be polished off — gently — with a cotton bud, or similar.

The final rinse method I use is simple, and unlike many others I have tried, it works. After the film has been washed in tap water, I put enough deionised water into another clean tank to easily cover one film spiral (350ml for 35mm film, 550ml for 120 rollfilm). To this I add exactly the right amount of wetting agent, using a small 1.00ml syringe for measuring perhaps more highly concentrated wetting agents such as Kodak's Photoflo, whose recommended dilution is 1.0 ml to 600.00ml water. However, from experience (too many badly dried films!) I know this amount is best reduced to a dilution of 1 part wetting agent to 1200 water , i.e. 0.25ml for 300.00ml of water, which is well under half the manufacturer's recommendations for final rinsing in ordinary tap water.

I stir in the wetting agent, but not so vigorously as to create a froth. Then I soak one spiral at a time in this solution, leaving each one in it for a minute at 20°C, with occasional agitation to dispel air bells. I then remove the spiral, shake off all the surplus final rinse solution, unroll the film and then hang it up, by its leader, to dry.

No squeegeeing? No final wipe? It isn't necessary, and certainly not worth the risk. Films that are final-rinsed in this way dry quickly at room temperature. I don't use drying cabinets, they can create more problems — notably, tide marks on the film if the cabinet is opened mid-way through drying and the temperature suddenly drops.

Post processing methods

Invariably, from time to time we will experience problem negatives that do not print up as well as we would like. For example, a murky looking negative may in fact be improperly fixed and may even visibly increase in overall density (fog) during enlargement. Resoak this film, as for the final rinse, then refix it in a plain, not too strong fixer. Wash the negative and final rinse it as above. If after this treatment the negative still looks fogged, it may benefit from treatment in a reducer.

Reduction

Negatives that are too dense, or too contrasty, can be chemically reduced. Much older, thicker emulsion films could be physically reduced overall, or locally, with metal polish!

Reduction of very dense negatives, using a formula like Farmers's (number 38), can shorten excessively long print exposure times, decrease negative granularity and reduce contrast. However, before treating any irreplaceable negative I would suggest that you make the best possible print from it, with plenty of good shadow and highlight detail, in case the negative treatment fails. Making an inter-negative of it, before treatment may also be a good idea, see INTER-NEGATIVES.

Intensification

Negatives that that are too low in contrast, or too thin, can be chemically, physically or optically increased in contrast. Optical intensification, such as with Speedibrews Speedintense, will improve the negative's printing quality without increasing its granularity As for reduction, I would make the best possible print of the negative before treatment.

Image assessment

Contact Prints

There is no short cut from the negative to the exhibition print — even if we have gained considerable photographic knowledge via a long, hard route. Careful study of contacts, proof prints and their negatives is an essential creative element in what will always be a gradual build-up to the making of the fine, exhibition-quality print.

Film preparation

Cutting up processed film correctly makes contact printing simpler, negative alignment in the enlarger carrier easier, and improves the efficiency of film storage and retrieval systems.

For 35mm film, first cut off both the rough-edged ends, then cut the film into groups of six frames, starting from its tail-end, and working back towards the leader. If exactly thirty-six exposures have been made then, good, you have six sensibly lengthed strips of film. Should there be an extra frame or two, then there is still the leader to provide a seventh, manageably sized strip. This will make the alignment of the individual negative that much easier than having to attach a length of thin tape to it so that it can be accurately located in the carrier. Lab processed XP2 negatives have a habit of coming back in short 4 frame strips — unsuitable for many enlargers. How you choose to cut 120 rollfilm depends on which format is used, but the same practical length principle still applies.

After the film is cut, it can be numbered and dated on the backing side (so that it reads correctly when contacted) using a fine Rotring-type — waterproof — black ink pen. A 0.25mm nib size is about right; any finer and the inkwork will probably disappear on more generously exposed contacts; any coarser and the ink will take too long to dry and the writing may become blocked up. Once the ink is dry, the film can be contact printed, or sleeved in a clear negative sheet and contacted through that. I prefer the latter technique — it protects the negatives — even if it does produce slightly less sharp contacts; absolute image sharpness should only be determined from looking at an enlarged proof, or from the negative itself. Besides, I tend to avoid paper-type, glassine negative sleeves, as they have a habit of sticking to accidentally wetted negatives.

Contact printing

I always use the same enlarger/lens set-up (and usually grade 0 paper) to expose my contacts. It makes the subsequent assessment of contact prints much simpler, by providing a known means of comparison with other contact sheets. This type of relative exposure and contrast grade information is then very useful when assessing negatives to make proof and final prints.

To expose the paper I always set the enlarger at the same head height, with the bellows fully racked up and a 50mm lens fitted as standard. The enlarger head should be sufficiently elevated to give greater coverage than the size of paper (normally 30.5cm x 24cm for a 36-exposure roll), whilst having the lens fully racked up throws the carrier out of focus, so that any dust that might be resting on its glass won't be projected.

I don't use a special contact printing frame, as I find their retaining strips can cover up vital information, although they can be useful for holding flat any thinner, polyester-based films, such as Kodak Technical Pan, that often seem to curl awkwardly. Instead, I simply use a sheet of clean, 6mm (quite heavy) glass with smooth, bevelled (not sharp) edges. It's slightly greater in size than the contact printing paper and keeps the negatives totally flat and therefore in register with the paper. Incidentally, if you want thin, smart white lines inside the black edges of your contacts, then use a slightly undersized glass sheet (say 28.5cm x 22cm); the image-forming light refracts at the edges of the glass.

On the centre of the white enlarger baseboard I lay a thin piece of 14" x 12" black card, and onto this I put the printing paper; it makes the edge of the white photographic paper clearly visible and therefore the alignment of the filmstrips that much simpler.

Contact print exposure and grade

If I am unsure of the right contact print exposure time and grade, I will first make a test-strip of one or two filmstrips that encompass the densest and the thinnest of the negatives. This strip is processed and assessed for grade and exposure settings and filed, and its exposure and grade details recorded for later use.

What makes a good contact? Not necessarily the sort that looks 'best'. I prefer denser, flatter contacts that show all the detail of both the negative's highlights and shadows. What use is a contact print that simply looks good, but which does not provide all the necessary visual information? Besides, when a negative is enlarged it will print quite a lot flatter, so if contacts are made on the hardest (grade 5) contrast setting, the final print will look disappointingly flatter.

A contact print should help us see what we can begin to do with our negatives. As mentioned, I prefer to print virtually all of mine very flat, at grade 0 on Ilford Multigrade RC gloss, giving them a generous exposure that will reveal all their densest highlight detail. If the film contains overexposed, or bracketed, negatives, I will make another contact with perhaps double the exposure time (i.e. + 1 stop of enlarger exposure). This is easier than dodging and burning individual frames on one contact sheet. The exposure times should be recorded, and the processing of the sheets kept consistent, with their exposure times geared towards full, rather than pulled, development.

Assessing contact prints

I have a slightly unusual method of viewing my dried contacts — by transmitted light on a light-table (or up against a window). Viewing them this way brings seemingly flat, grade 0 contacts to life: the quality of this light gives the images contrast — it makes dark shadow detail clearly visible and keeps highlights bright, rather as if looking at a scaled-down version of a luminous finished print. By playing with the balance of transmitted, versus ambient, room light, and by selectively placing a piece of dark card behind, say, the sky section of a contact print, it is possible to make the contacted images look very different. This can almost look as if we are making a number of experimental proof prints of different grade settings, with altered balance and various densities. Again, it is for this reason that I print my contacts flat and dark.

To help with contact assessment I use a variety of matt black card masks and, in particular, two black 'L' shapes to frame and isolate individual images. These can be moved in relation to each other, to check image cropping possibilities and to exclude the unseen extra image area not visible in

1. Although I liked the subject I wasn't too sure about my photograph of the granite corbels on page 109. A tighter crop has helped, but the image still lacks impact.

2. Reducing the basic print exposure time has made the foreground lighter, drawing more attention to the stones. Burning-in the sky for longer has added a little more drama.

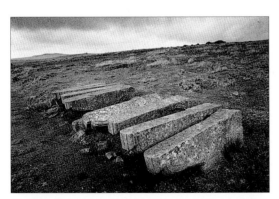

3. The final proof. Going up a grade, dodging the stones and burning-in all the edges have produced a better print. But, I am still not convinced the image works, when compared with a picture like Bradwell Barges.

my restricted 92% FM2 camera viewfinder. I look at contact sheets by eye and then with a magnifier (or with a standard 50mm camera lens).

Qualities to look for

What exactly am I looking for in a contact print? I certainly don't want to see just what I saw at the moment of camera exposure. I also look for what the camera and film — perhaps unexpectedly — saw. For example, I'll check the composition of the image, the balance of the elements, the quality of light and the effect of camera filtration. In fact, anything that might upset — or make — the final print.

In scenes where the pattern of light or the formation of the clouds has changed (for example **Mis Tor**), I will look at the contacts to see which frame fits in best with my pre-visualised image, although I'll spend as much time looking at the 'bad' images, trying to figure out what is wrong with them, for future reference. Often I am surprised by what I find; casually taken images often look better than carefully made ones. I'll ask myself why. For example, as in the **Wistman's Wood** photograph, do we always need horizontal horizons in our landscapes? Surely, by now we don't all need reminding the earth is flat!?

Incidentally, one of the biggest shocks I once had was discovering that by far the best image on one particular 36 exposure contact sheet was the first. It said everything about the scene: it showed the wind and rain, it depicted my reaction to this weather and it expressed these elements, and the scene, in a unified and clearly understood manner. It also happened to be an accident! This image was exposed as I was hurriedly winding on the film whilst simultaneously trying to mount the camera on the tripod and hold on to an umbrella to keep the rain off the lens. I looked at my other carefully composed images of the scene and, in comparison, they conveyed nothing!

Contact prints should also be used to check for more immediately obvious signs of negative damage, such as film loading and transport problems, or uneven processing and air bells. The negatives can then be checked against such discoveries. Quite often the mark is on the contacting glass. Too often it is not!

The right negative?

Having marked up the frames I want to proof print, I will then study the negatives over the light-table, on a clean sheet of polyester or glass. I always try to handle negatives with cotton gloves and check them for both their good and bad qualities. Is the image focused as sharply — or as unsharply — as required? How much depth of field is there? Will it be of the right amount when the negative is enlarged, say, up to 20" x 16"? Is the contrast suitable for the enlarger lightsource and paper type/surface? Is there sufficient detail and tonal separation to dodge shadows without them looking grey and washed out? Can highlights be printed-in without looking blocked up? Do I still like the image? Will others? Should they?

More often than not, I will choose negatives that are more generously exposed than the camera meter recommended, when set at the film's nominal ISO rating. The difference is usually about an extra half to one stop of camera exposure. Why this choice? Because I like to print on matt surface paper, even though it has a more restricted, lower density range than glossy paper. Also, if the negative is not generously exposed print tonal separation can suffer, especially in the shadow areas of the image, because 35mm ISO 400 negatives are inherently quite granular.

Printing on a matt surface usually requires printing on paper one grade harder, and then dodging the shadows and burning-in the print highlights. For dodging the shadows, I like a generously exposed negative that has well separated shadow values. Even slight dodging of a thin, poorly separated negative will give washed-out and weak looking print shadow values. This is to be avoided, especially if:
i) these shadow areas are to be locally bleached afterwards with Farmer's reducer (see **Loch Ainort**), and
ii) the print's colour is to be changed by toning.
Both processes will show up this undesirable quality.

For burning-in print highlights I don't like a too dense, or too contrasty, a negative, or one with blocked up highlight densities. For this reason I will normally process the film in a reasonably dilute developer, and not for too long, so that overexposed negatives won't become blocked up. A negative that is too dense or too contrasty will either need:
i) excessive burning-in of the highlights, giving a potentially badly balanced feel to the print,
ii) flashing, or
iii) a split-graded exposure (for VC papers only).

Either way, overly dense negative highlights will look grainier in the print than normal — unless we burn them in using a lower contrast VC filter setting. Also, if they are on the shoulder of the film's characteristic curve, they will start to look compressed and flat when burned-in, perhaps requiring a harder contrast grade for that part of the print's exposure, some local bleaching back with Farmer's reducer, or the use of a condenser enlarger. All these methods will separate out the

tonal values a little better, but they will also accentuate the graininess of the print.

The hinged lid of my light-table is painted matt black. If a good, printable negative is held up fairly near to this surface and viewed by reflected light it should still appear as a negative. However, if it turns positive, or some thinner parts of it look positive, then there is potentially insufficient density to make a tonally well-separated print with good detailed shadows.

Proof Prints

I always find it very helpful to make intermediary stage proof prints after I have carefully studied the contacts and negatives. I can look at these, as with the contacts, and be more objective about my work, before committing myself to making a final image. If I then leave them out of sight for a while, so that they become 'fresh' when I view them again, the delay usually reveals something that I didn't previously notice, perhaps regarding image quality or my style of work, and I can question whether the image is still successful.

Proof print size and type

Ideally, proof prints should be made on the same paper type and surface as the finished image since we want information on likely tonality and balance. 10" x 8" images are about right: they are big enough both to detect possible negative defects and to give us an impression of the greater sense of openness and scale we will discover when a landscape negative is finally enlarged to exhibition print size.

Exposure and grade

I tend to print my proof prints somewhat darker and flatter than the final image, almost as if I am making contacts prints and for the same reasons. However, I will dodge them and burn them in, if necessary, keeping a note of these exposure modifications in the form of a printing plan, such as those in the main photospreads. Usually I burn-in to pull in bright highlight information, so that I can see exactly what is there, and also to balance the print; imbalance in a proof print has often thrown me off the track towards a good final print.

I develop my proof prints to completion, i.e. two and half to three minutes depending on the print developer and paper type; I then stop, fix and wash them as per normal, after which I will flatten and spot them, for easier viewing.

Assessing proof prints

Once dry, I will view the proofs as objectively and as critically as I can. I like to print as many different images as possible and then to edit these ruthlessly, so that in any one year I will rarely print up more than about twenty different negatives to exhibition quality — they take time.

To edit the proofs I will look at them under different types and strengths of lighting, in particular to alter their mood: direct and indirect (diffused) viewing lights create remarkable differences in image quality, which gives some interesting clues as to how the images could look when they have been printed up to exhibition standard.

Likewise, tungsten and fluorescent lights give a very different print quality — images often look dull and lifeless under the latter, apart from experiencing a change in image colour, as illustrated in the King's Tor photographs in TONING. Of course, I also use the light-table to view my proofs, in the same way and for the same reasons discussed for contact prints. To check image balance, and to make my exposure printing plan for the final print, I will also look at the proofs upside down and then in a mirror to see them back to front.

Viewed in this way, a photograph looks remarkably different; it becomes simply an image of shapes and textures, devoid of personal comment, whose balance, or imbalance, becomes immediately apparent. It's like seeing a picture of ourselves. We are used to seeing our image reversed in a mirror.

Final image choice

After a while I will make a final selection of those proof prints whose negatives I want to print to exhibition quality. By this stage I will normally have a very clear idea of how I want to print these negatives, although whether their print turns out exactly as intended can be a little bit of a hit and miss affair if the print is to be multiple-toned, or heavily bleached back. Such chemical processes are far less predictable or controllable than methods of enlarger exposure control, which has often led me to understand why many photographers print their images straight black and white.

If I've had any sense, I will have allowed at least a couple of months to elapse between film processing and final exhibition print making. During this time I won't have lost sight of my pre-visualised image, but my memory of the unrecorded events associated with the moment of camera exposure will gradually (and rightfully) have taken second place to the photographic process: a medium that relies on visible, recorded expressions of communication.

4. A contact test-strip. The basic exposure was 5 seconds. Each of the darker strips were progressively given an extra $1/4$ stop of exposure. The +1 stop strip looked correct.

5. Printed on grade 2, the contrast of the contact sheet makes the images look good. But the print has been made on too hard a grade of paper to see the shadow detail.

6. Viewing the same contact print over a light-table, or up against a window, reveals most of the shadow detail. Alternatively, the contact sheet can be printed on a softer grade to show all the negatives' detail.

7. Frame 27 was my final choice from this contact sheet of Mis Tor. There is little difference between it and frame 26, except that the line of the right-hand cloud seems to make better contact with the tree. All the negatives on this roll were exposed over a fifteen to twenty minute period. Some would have benefited from more exposure and less development, and vice versa. A limitation of 35mm film.

Enlarging

Setting up

Checking the enlarger

Printing from small 35mm format negatives, as most of us do, means that negatives will often be considerably enlarged — approximately x18 for a 20" x 16" print. This has two basic implications: negative and enlarger qualities — both good and bad — will be highly magnified.

For example, the beneficial effects in sharpness of using a high acutance film developer with a 35mm film will become very apparent when this small format negative is greatly enlarged, but at the same time the use of such a developer will also show up any failings in the quality of the camera lens or in camera technique, such as imprecise focusing. In addition, if the enlarger is not set up correctly, this type of ultra-sharp negative may make the print appear locally very unsharp — when, for example, the lens carrier is not parallel with the enlarging lens and the crisp grain pattern is thrown out of focus.

Possible enlarger problems

Initially, I suggest we recognise the limits of our enlarging equipment. In this way we won't constantly be attempting to print the impossible.

However, that said, how many of us have ever allowed 'inferior' hardware to get in the way? For example, I've always believed that better images are always possible, and that they often lie just around the corner in our creative imagination — rather than in a 'better' enlarger. As I said in EQUIP-MENT: "I have used very cheap enlargers to make prints up to 20" x 16" in size, albeit rather slowly, but then, perhaps, all the more carefully and successfully for it." And, believe me, some of these enlargers were cheap!

But no matter how cheap or expensive the enlarger, it will benefit from a series of tests designed to eliminate basic practical, not creative, problems.

Such tests should be conducted with the enlarger set up for maximum print size, in order to show up any defect as clearly as possible.

When checking the enlarger, I would look first of all at the rigidity of the unit, in view of possible vibration and, in consequence, sharpness problems. However, a lack of rigidity in the column may in fact not necessarily be a problem, for example if the column moves around a little after focusing, provided the unit is given time to stabilise itself prior to making the print exposure. Simply check the projected image with the focus finder, looking at the magnified negative to see how many seconds it takes for the image to stop moving and to appear sharp after focusing it. Apply this exposure time-delay factor to future printing work.

If, however, the darkroom suffers badly from building vibration, you will need to isolate the set-up from this movement, perhaps by placing the enlarging bench on thick rubber feet (and away from the wall), and the enlarger on a heavy duty rubber mat — I have found that the footwell variety used in cars works well. Alternatively, it may prove better to allow the enlarger to vibrate at the same frequency as the source of the trouble — but making sure that the easel (and therefore the image) does exactly the same. To this effect, the top of the enlarger column will almost certainly benefit from being securely attached to the wall.

Bellows-sag, causing lens movement, is one other possible cause of poor image sharpness. To test this, focus the image and then leave it for five to ten minutes — the time it takes to expose and develop a test strip and print — leaving the light-source on, or off, depending on how you normally work. Afterwards recheck the focus. Make sure that any change is not caused by the carrier, such as the negative popping from the heat of the light-source (see EQUIPMENT). If the bellows and lens panel do move, some adjustment to them will need to be made, usually a simple tightening or servicing of the focus knob.

Image sharpness is affected in other ways. I've already looked at the focus finder and its use, and also discussed differences in enlarger lens quality, including the occasional problem of focus shift when a poor quality lens is stopped down. I also discussed the need to find the sharpest aperture. However, a few more additional lens checks won't go amiss.

Checking the lens

Quite regularly I take the lens out of the enlarger and look through it towards a reasonably bright light. Any scratches on the surface elements will now become visible, as will any fingerprints or dust. All these will lower image contrast and affect print sharpness to varying degrees. Carefully clean the lens if necessary and check it again, this time also via normal reflected light.

The next test would be to check for the exact alignment of the negative carrier and to look for possible negative popping, either before or during print exposure. The simplest way I have found, is to make a focusing aid for the negative carrier, using a black, exposed and developed 35mm film leader (see photograph 1 opposite). On mine, I have scratched a fine 24mm x 36mm grid pattern, using a sharp needle to make a set of lines on the emulsion side of the film. This gives a good, contrasty, very clearly visible target image, even when stopped down to the best working aperture. It enables us to see, either by eye or with a magnifier, any unsharp parts of the enlarged image. The grid pattern also shows up any barrel or pinhole distortion of the enlarger lens.

If all the edges of this projected target image are unsharp, either the lens is not up to it, or it has not been stopped down far enough. If it is due to the negative having popped in the carrier, then try using a glass over-carrier as described in EQUIP-MENT. If one corner or one side of the image is unsharp, then the negative carrier and the lens are not parallel to each other. Slowly alter the focus to see if the offending area can be pulled into focus, throwing the already sharp area out of focus. If this works, then gently move the offending corner, or side, of the carrier up and down, watching the projected image to see when it all comes into focus. Note the new elevation of that part of the carrier, slide the unit out and insert a thin plastic or metal shim of the appropriate thickness — this is something I have had to resort to on a number of occasions, even with supposedly good enlargers. Replace the carrier, refocus and see if the situation is now corrected. If so, you'll need to fix this shim in place — but not permanently so, in case it wears out and needs replacing.

Enlarger levelling

You can make a simple, provisional, enlarger levelling test with a small spirit-level. First align the enlarger baseboard, then check that the column is

1. A scratched film leader makes a useful enlarger focusing aid. Its high contrast makes it easy to detect any areas of the projected frame that are unsharp, due to poor focusing or improper negative carrier alignment.

2. A 20" x 6.5" test-strip of Pentire Point revealed that the sky needed an extra stop of exposure to put detail into all the clouds.

3. Even slightly blue toning the print increases contrast quite dramatically. Obviously this change needs to be anticipated prior to print making, so that the right paper grade is used.

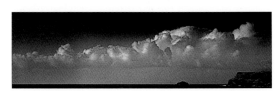

4. Extended blue toning increases print contrast by the equivalent of about 1½ grades in contrast. See TONING for more examples.

perpendicular to the base and see if both the lens panel and negative carrier stage are level, and therefore parallel, to the baseboard. I would check this in two planes: left to right, and front to back. If there are no purpose-made means of fine adjustment, then shims may have to be used to level everything up. More often than not, any such misalignment is due to the lens panel leaning forward under its own weight, at right angles to its fixing point on the column.

Illumination

Any unevenness of enlarger illumination will affect print balance and will require unnecessary burning-in of almost every image. To check the lightsource, focus the lens, set it at the normal working aperture and, without a negative in place, expose a sheet of paper to produce an overall, mid-grey tone print — check safelight fogging too, for the same reason. Develop this image fully, to completion, since we don't want any uneven development marks from poor processing to throw us off course Assess this print when it is dry, looking for:
i) local areas of unevenness, perhaps caused by greasy fingermarks/dirt on glass carriers, condensers and heat filters, or blemishes on opal diffuser sheets, and,
ii) general fall-off, or hotspotting, i.e. the centre of the image being significantly darker than the edge. (A slight fall-off is natural, and compensates for camera lens fall-off).

A general fall-off in light can be the result of:
i) an improper focal length enlarging lens,
ii) the wrong light-mixing box with diffuser enlargers, or the incorrect type or position of the lenses of condenser lightsources,
iii) the condenser's bulb may be too close, or too far from the lens,
iv) one of the enlarger's bulbs may have blown, and
v) a replacement bulb may be brighter, even if it is of the same — stated — wattage.

Cleaning the negative and carrier

Ideally, it shouldn't be necessary, but it always is — well, at least for me it is! No matter how scrupulously clean I have kept my techniques of film washing, drying, storage and retrieval, dust inevitably gets onto the negative or carrier as I put them into the enlarger's carrier drawer (see Black Mount retouching photographs in PRINT FINISHING). If I switch the lightsource on, dust will be clearly visible, circulating in the airspace of the illuminated carrier drawer, perhaps drawn there by the lightsource's fan. I have found there is little I can do

about this ambient dust, except to keep the workspace clean, and the enlarger covered when not in use.

However, dust on negatives can usually be carefully removed in a number of ways:
i) brushing the negative with an anti-static brush, a pure bristle (unused!) paint brush, a soft cotton natural fibre cloth, or lens tissues.
ii) blowing on the negative with a dust-off canister (hold onto the negative securely!) or lens blower brush.

Dirt ingrained into the emulsion side of the film may need to be removed by resoaking the negative in deionised water with some final-rinse wetting agent added to it, as described in PRINT FINISHING.

Focusing

Much of this has been covered above, and in EQUIPMENT. All that I would add now is the suggestion of focusing the enlarger's image with the safelights switched off, to cut down the amount of ambient, contrast-reducing, non image-forming light. Also, the much publicised idea of putting a sheet of paper under the focuser is not necessary; when we focus the negative we are primarily checking the lens-to-negative distance, and not the lens-to-easel distance. There will be more than enough depth of field at the easel to override the need for the paper sheet under the focuser. If we think about it, we can tilt the easel quite dramatically to correct verticals without losing sharpness, so why the need for a thin piece of paper?

Enlarger exposure controls

I have covered the pros and cons of different lightsources in EQUIPMENT.

The basic print exposure time

For most prints I suggest that it should not be shorter than eight seconds, for a variety of reasons:
i) it might be affected by the bulb warm-up time (see LIGHTSOURCES).
ii) the use of inaccurate timing methods will mean that even a-half second exposure error will make a proportionately greater difference to the overall print exposure time, visibly affecting its density,
iii) dodging manoeuvres will become too short to put into practice; with short basic exposure times, who can dodge to an accuracy of half a second?,

iv) shadows cast by the wire handles of dodgers, if held stationary for even half a second during their use, will create shadow marks on the print,

v) more than one dodging manoeuvre becomes impossible and,

vi) calculating any changes in the exposure time, for example when using the f.stop method of printing, becomes difficult and impracticable. This is especially true if we need to revise, or shorten, the basic exposure time, perhaps if the print is overexposed or if we want to make a smaller print off the same negative.

If the basic exposure time is too long, say over twenty seconds, then a number of problems may also arise:

i) burning-in exposure times, for dense highlights, will become very long, making the production of complicated, multiple burning-in exposure prints a very lengthy affair,

ii) lengthy burning-in exposures may suffer reciprocity failure, giving weaker print highlight densities than expected, and,

iii) safelight print fogging may become a problem, even with the correct safelight.

The right basic exposure time will be able to deal with the problems above. Personally, I prefer a time of about fifteen seconds. It gives me long enough to locate all the areas of the negative I have decided to dodge, and then time to dodge them rhythmically, with a one second sweeping movement, as explained in TIMERS. However, for uncomplicated proof prints and contacts, I will sometimes opt for a shorter basic exposure time, perhaps of about eight seconds or so.

The f.stop method

We all practice an f.stop method of exposure with our cameras and film, so why don't we logically carry this system through to completion with the enlarger and printing paper? The f.stop system makes sense, it is based on sense. Surely it is a far simpler and better way of expressing and controlling changes in exposure times, for both film and print, than any numerical 'counting' method?

I have included an f.stop exposure printing table in the TABLES AND CHARTS section at the back of this book. It is very easy to use — in fact just like reading a camera's exposure meter. If you study the **Black Mount** photographs in PRINT ASSESSMENT, you will see what happens to print densities when f.stop changes are made to the basic print exposure time.

Using the f.stop method, once the basic exposure time for the print has been established from a test-strip (the darkroom equivalent of the camera's sophisticated meter!), it is then a simple matter of making and studying a set of prints of different

(+ and -) basic exposure times. A calculation (rather than, perhaps, a guess) can then be made of the exposure modification times needed for dodging and burning in various parts of the print.

A set of such prints shows us what happens, say, when we add half a stop of exposure to a print, irrespective of the print's size. With numerical exposure 'systems' (one elephant, two elephant, three elephant...) adding, say, ten seconds of exposure to a print, perhaps to burn in the sky, is not the same as adding ten seconds of exposure to a print of a different size, yet adding half a stop of exposure is the same. How do we work out the new exposure time with simple numerical methods of enlarger exposure? Trial and error? More test strips? More time?

The rest should speak for itself, especially if you read PRINT ASSESSMENT, then study the printing diagrams I have included with the main photographs and tie in the information from both of these with the f.stop exposure table.

Dodging and burning

Also described as shading or shading in, and burning in or printing in. These idioms express deliberate local reductions of, or increases to, basic print exposure, in order to alter print density values selectively. Both these methods can be used as corrective or creative means of exposure modification. Few black and white prints are made 'straight' without them.

To dodge a print, we simply prevent light from reaching part of the paper for a fraction (f.stops again!) of the total exposure time. At its simplest, a dodger is a piece of black card taped to a length of thin wire, which is held between the easel and lens during the print exposure. Moving the dodger around will modify its action, by blurring (blending in) the edges of the dodged area with the remainder of the image, and by moving the dodger towards the lens we can also cover a larger area, and vice versa. A selection of different shapes and sizes of dodgers refines the job.

To burn in a print, we simply cover up areas of the paper that require none of the extra exposure. A sheet of card, or a sheet with a hole cut in it for localised areas of burning in, used like the dodger between lens and easel, will work well. And, yes!, a selection of different shapes and sizes of these burners will also refine this process.

A good negative?

How much we can, or should, dodge and burn a print depends on negative quality and personal values of print interpretation. A good negative with

5. Dodging Trumpan Stone by hand casts a shadow over the foreground. This would need to be burned in again.

6. For most work, a purpose-made dodger like this is not necessary. Here it is held about 2" above the easel for a soft-edged effect.

7. A small round dodger was quite suitable for lightening the side of Chapelle Gratemoine. Moving it around has blended in its effect.

7. Burning in the small bright area in the foreground of Trumpan Stone by hand leaves the sky unprotected from the exposure.

8. Two dodging cards with holes, one held over the other, can be used to form the right shaped hole for burning in areas of any size.

9. Burning in the foreground of Chapelle Gratemoine with a flexed, slightly curved card also protects the rest of the print.

excellent tonal separation makes extensive dodging and burning possible. When dodging with this sort of negative, we will not lose tonal separation, or any density of the blacks, and won't get blocked up highlights if they are burned in.

But then, perhaps, a good negative won't need this exposure modification treatment? Sometimes this is true, for example when printing on gloss paper with a fine-grain negative. But change to a matt surface and go up a grade to expand the paper's contracted tonal range and the situation is very much changed — more so if we print with a coarser-grained 35mm negative, whose granularity may block up denser, burned-in areas. When printing a grade harder on matt paper I expose the print for the mid-tones, dodge the shadows and burn in the highlights.

As a general rule, with a good negative we should be able to dodge the print for about $1/3$ of a stop for a tonally well-separated mid-tone area, and for about $1/4$ stop for less well-separated shadow values. Highlights are a different case, if we dodge them they may disappear from the print altogether.

To find out how much burning and dodging is necessary or possible with a particular negative, I suggest you make a set of completely straight prints: one at normal exposure, others at various plus and minus exposures, going up and down in $1/3$ stop increments, until you end up with a total of about eight differently exposed images. A composite scene can then be put together, as in the **Black Mount** photographs, and printing decisions made that are based on the information present.

Suggestions for dodging and burning in

Many photographers use their fingers and hands as dodgers and burners. For rough proof prints this works, but for fine printing I would always recommend a more precise, repeatable system; after all, can you make the same shaped shadow puppet two times in a row? Making a printing plan, and keeping dodging and burning notes, is a lot easier if we use dodgers and burners, especially when working with precise, perhaps very small, areas of the negative.

Incidentally, if hands are still damp from processing and then held under the lens to dodge or burn an image, water evaporating from them will condense on the front element of the lens if it is cold. This diffuses the image. Great, if you want that!.

I always dodge and burn with all the safelights switched off, except for one weak sidelight unit. Dodging and burning is all about casting shadows on the paper — I find safelight shadows don't help.

For me, a good rhythm to print exposure is essential. For this reason, I dodge and burn-in to the once-a-second sound of my enlarger timer/metronome. It makes exposure notes much easier to keep and simpler to follow later.

Poor burning-in work can leave a shadow line, demarcating the area of extra exposure. For example, the horizon of a landscape may look unnaturally dark where it meets a burned-in sky. This halo-effect is particularly common with graded papers which, unlike VC papers, cannot be burned in at a lower contrast setting to help soften this exposure edge impression. In this type of situation we either have to practice at our burning-in or learn to flash the print, or maybe just flash the sky of the print, to help us burn in the area more easily. We also have to learn when the negative simply is not up to the job!

Printing masks

For precise dodging and burning-in work I sometimes make printing masks, for example to burn in the sky of **Monkstadt House**. I make these from old FB prints, tracing onto the back of them the outline of the image, which I then cut out to the required shape.

For precise work I keep the mask close to the easel, moving it very slightly during exposure, gently to soften its edges. For less precise areas, the mask can be held nearer the lens to give a hazy-edged effect. However, the same size mask cannot be used for both situations, since a smaller mask will be needed if it is to be held nearer the lens.

Burning in with VC papers

When printing with VC papers I often switch grades to burn in certain areas. This can create a much more natural gradation of tones, avoiding the halo-effect I mentioned above.

For example, we can burn in denser, and therefore grainier, skies of landscape negatives using a softer grade setting of paper to suppress their graininess, as in the case of **Black Mount**. Alternatively, we may want to burn in a sky using a harder grade to accentuate cloud separation. For that print I also exposed the middle distance area of the landscape, up to the skyline, at a softer grade setting, to blend the ground and sky areas together and to create a more natural quality of light with lower contrast.

The process isn't difficult, provided we work logically up to the final print: for example, I always ask myself exactly how I want the final print to look and also whether the negative is up to it. Then, if I'm still not sure, I'll make a set of differently

exposed prints, and at different grade settings (as already described), to see how the image can be pieced together.

Split-grading with VC papers

We can divide the basic print exposure time into two, so as to expose the print at different grade settings. Depending on which two grades are chosen, we can either subtly or dramatically alter the tonal range of the print. For example, a short exposure at, say, grade 4, will enhance shadow separation, whilst making the rest of the exposure at a softer grade, perhaps grade 1, will give the midtones and highlights extra subtlety.

Densitometrically speaking, with split-grading we can change the shape of the paper's characteristic curve. In this way we can get the curve of a VC paper to match that of a graded one (provided their surfaces, and therefore their reflection density ranges are similar). Split-grading can make the toes and shoulders of the curve more or less steep, i.e. enhance or suppress shadow and highlight separation and, if we combined this with flashing, for example, we can go further still.

There are two methods of split-grading

i) Make the basic exposure at one grade setting, then burn in the highlights at a different grade. With this method we can also dodge the shadows during the basic exposure and burn in these afterwards with another grade.
ii) Divide the basic exposure into two, each part being made at a different grade setting. We can then burn-in at different grade settings. How we divide the basic exposure time, and what grades we use will significantly alter the look of the print.

In either case, the effect can be dramatic. It can transform a mediocre print into — perhaps — the photograph it always deserved to be. It can make a good print even better, and, what's more, it can salvage very difficult negatives, which might not have been printable with conventional papers. Try it. But, if you do split-grade a print, remember to modify your basic exposure times if you use the grade 4-5 VC filter settings, which need longer exposures.

Flashing

So far I've mentioned some of its uses, but not all of them, nor how to do it. Like split-grading, it can be applied to either the whole print, or part of it, as in **Monkstadt House,** and in varying amounts as in the upper left and upper right hand corners of the same print

Flashing gives the exposed print an additional exposure, but simply to 'white' light and without the negative in the enlarger. Its effect is to give the less exposed highlights, that wouldn't otherwise develop out, sufficient additional light to move them over the exposure-development threshold. And, of course, with VC paper we can flash with different filter settings. Carried out properly, flashing won't fog — degrade — the paper, although fogging, too, can be usefully employed (see below).

Flashing gives a wonderful delicacy to highlight detail and, by retaining this information, it also allows prints to be made bolder, on a harder grade of paper, making the shadows and midtones even more open. It is perhaps surprising that it doesn't affect the separation of shadow and lower midtone values. Why not? The flashing exposure is so weak that it has little added effect on the already heavily exposed shadows and midtones. However, its cumulative effect on the lightly exposed highlights is proportionately much greater, and visibly so.

To work the system successfully (yes, another printing system!) we need to find out how much flashing exposure the paper needs, and then find out by how much, if at all, we need to reduce our basic print exposure time to compensate for this extra exposure.

First of all we need to decide what equipment we are going to use to provide a consistently timed, even source of illumination, of sufficient coverage for flashing bigger prints. The choice is:
i) to use the enlarger and its timer, taking the negative out after exposing the print and then making the flash exposure,
ii) to have a separate enlarger and timer, set up for flashing (and also for making contact prints) or,
iii) to have a separate flashing light, such as a small 15W safelight without its filter, set up above the bench to provide a uniform coverage of light to the paper.

Method i) has certain disadvantages: the negative has to be removed, replaced and refocused between prints. I use method ii) as I am lucky enough to have a spare, old enlarger with a timer. If I didn't, I would choose method iii), since I don't like to handle negatives more than I need to, an unfortunate necessity with the first method.

To flash a print, stop the enlarger lens right down to f22 or less. Put an unexposed sheet of paper in the easel — making sure its borders are covered — after processing they will act as unexposed, unfogged, paper-white reference-strips — and then start to expose. An initial basic time of 2 seconds should be about right, then expose the paper going up in $1/4$ stop increments, as if making a test-strip, marking the edge of all these differently exposed steps with a pencil as you go (see **Epping Forest** and **Wistman's Wood**). Process and dry the strip as normal.

The point in this sheet where a slight grey tone is just visible, represents fogging. The preceding (invisible) pencil-marked strip represents the maximum time of flashing exposure possible without fogging the paper.

It isn't always necessary to use the maximum amount of flashing exposure, since a $1/2$ or $1/4$ stop of the maximum flash time may provide a more subtle contrast controlling effect.

Either way, tests clearly show that any amount of flashing exposure up to the maximum flash time requires a $1/4$ stop decrease in the basic print exposure time. Flashing also necessitates a $1/4$ stop less exposure to all burning-in exposures. Incidentally, a sensibly lengthed maximum flash exposure time is important, for the reasons explained in BASIC PRINT EXPOSURE above.

Local flashing

We can locally flash a print, for example to tone down distracting highlights that might otherwise throw the print out of balance. However, as there is no negative in the enlarger to locate the area to be exposed, I will often make a registration mask to hold over the print, through which I flash (and sometimes even fog) the relevant areas. This can be used like a printing mask when burning in, i.e. moving it during the flashing exposure softens the edge of the flashed area. (see **River Authie**.)

Fogging

Why go above the maximum flash time if it fogs the print and degrades the image highlights?

I have often found the process useful, for example if I deliberately want to alter or perhaps compress the tonal range of the print (see **Epping Forest** or **River Authie**), or if I want to replace possibly distracting background print tones, such as broken-up sky detail, with a more uniform shade of grey which I can later tone, e.g. the silhouetted trees of **King's Tor**.

Using this fogging and toning technique it is possible to mimic lith process printing, as in **Rance Estuary**. It is also a good way of appearing to alter the inherent base colour of a paper.

The amount of fogging exposure needed is largely a subjective decision, although if it is being used to provide an overall grey veil of silver for the toner, then it must be of sufficient density to remain visible after toning. Any toner that slightly bleaches the lightest print values must therefore be used with care if the highlights are not to look

white and bleached out, as in the reject toned prints of **Epping Forest** in PRINT ASSESSMENT.

Diffusion

We can diffuse the negative in printing to suppress unwanted detail, scratches, blemishes and excessive graininess, so as to make retouching easier. Alternatively, diffusion can be used to add atmosphere to the print. Unlike camera diffusion it is the darker, rather than lighter, areas that will diffuse out, for example the dark shapes of both the trees of **King's Tor** and the stones of **Walkham Valley**.

Diffusers of different strengths can be used for a variety of printing effects. We can also diffuse the print for part or all of the basic enlarger exposure time. In all cases of diffusion it is necessary to modify the undiffused basic print exposure time according to the diffuser's exposure factor (just like film exposure times need to be altered when camera filters and diffusers are used).

I use two different glass diffusers, whose exposure factors I have worked out to be $+^1/_4$ stop and $+^3/_4$ stop respectively. So, if the basic print exposure time without diffusion is 10.0 seconds, by referring to the exposure table at the back, we can see it will need to be increased to 11.9 seconds or 16.8 seconds respectively.

If I only want to diffuse for half the print exposure time, so as to keep some clearly defined detail, then for a basic exposure time of 10 seconds, I will expose the print for 5.0 seconds without diffusion and then 6.0 seconds (i.e. 5.0 seconds plus a quarter stop more exposure) with the 1.25 diffuser.

Local diffusion enables certain areas to be played down, for example the bottom left hand corner of **Fernworthy Forest** might have benefited from this treatment, to de-emphasise the detail there. Alternatively, it can be used to enhance specific, darker subject areas of the print. For this job, I tend to use a burning-in card with the diffuser laid over its hole, or temporarily placed under the lens. Many photographers use black stockings as diffusers. To avoid the denier pattern showing up on the print the stockings need to be moved during the print exposure, which I find less convenient than mounting a glass diffuser under the lens in the VC paper filter holder.

Black borders

These were once a popular part of 35mm photography, giving its images a clearly identified 2 x 3 format. There are times when they can be useful, mainly to hold in bright print corners and edges that are hard to burn in. However, I normally prefer to work on these areas, burning-in, flashing or fog-

ging them for what is usually a better, more natural effect. Imagine how different the final print of **Wistman's Wood** might have been had I printed black borders round it rather than fogged in the sky. But the same cannot be said of **King's Tor** or **Walkham Valley**. Both of these prints had clearly definable edges — without the use of black borders — and yet I felt the former image, in particular, really needed all the branches and the tree trunks that touched the edge of the frame, connected by a diffused black border.

Borders can be simply printed using an oversize carrier, as in the case of the above mentioned prints. But, if the negative is cropped this will not be possible, so the method I adopt is to cover all the print with a sheet of black card, leaving one thin uncovered edge. This edge can be exposed, and then the next edge and so on. Black template cards can be made to print all four edges at once, for prints of a specific size.

Lith printing

Properly controlled, this process is capable of producing prints with contrasty, strong blacks and compressed, yet delicately rendered, midtones and highlights. Typically, the print will also have a strong duotone colour: neutral blacks and peachy-brown highlights. However, only a limited number of papers will work, including several lith (reprographic) papers and most of the warm-tone graded papers. Variable contrast and most neutral tone bromo-chloride papers tend not to work, although the graded, neutral tone, Oriental Seagull paper is a notable exception.

Suitable developers include Champion Novolith or Kodak Kodalith RT. The former comes as a liquid, rather than powder, stock concentrate. Both keep well if their parts A and B are kept separate before use.

The contrast and colour characteristics of this process rely on a number of factors:
i) the chemical composition of the lith developer; it contains a large amount of the energetic and warm working developing agent hydroquinone, and is normally highly caustic,
ii) the dilution of the developer, which is usually made up at least four times weaker than normal; any stronger and development time will be uncontrollably quick, more dilute and image colour gets warmer, but development times may become excessively long,
iii) the process of infectious development, which is typical of lith developers (more below), and which gives strong blacks before the highlights begin to develop too far, at which point they would lose their colour and the print would become too dark (by two stops — see iv) below),

iv) overexposure of the print; on average, two stops more than for the same print developed in a standard paper developer (developed to completion) for normal results,
v) the grade of the paper: it may need to be harder than normal to compensate for the tone compressing effect of overexposure and,
vi) very careful control of development; we develop the print by inspection.

Other factors to bear in mind include the age of the developer — lith solutions, especially highly dilute varieties, go off quickly, sometimes in an hour or so. Also, the temperature of the developer is fairly critical — keep it at 20°C if possible.

As for warm tone print development, the colour of the process relies on finely divided silver to give the image its colour. This is achieved by the extra exposure and restrained (highly dilute) developer, the former provides enough exposed silver to give the print the necessary highlight density, whilst the latter stops the individual grains from becoming too large, producing a cooler and darker image.

What stops the print from looking two stops overexposed? The effect of the highly dilute lith developer. It slows development down to the point where we can judge when the process of infectious development has done its job in building up the shadows and before it sets to work on the midtones and highlights. A typical lith development time may be as long as five to ten minutes, whilst completion (a print that is visibly two stops too dark) will happen almost immediately afterwards.

When should the process be used? Typically, if we want to change print image colour without the extra process of toning. Also, when we want to make a print from a difficult negative, whose highlight detail is perhaps hard to burn in and which will now be included in the lith print, by virtue of the fact that it has been given two stops of extra (self burning-in) exposure.

A very similar effect can be achieved with conventional printing paper/developer combinations. For example, print the negative about two grades harder than normal, expose it for the shadows, then fog the print to pull in and compress the highlights, as in **Epping Forest**. Some modification of the print's basic exposure time will be needed, to offset the extra fogging exposure, as described in FLASHING.

Fine tuning

Once a satisfactory exposure/development time has been found, we can then change the image colour even more, or less, by either altering the exposure time — longer exposures will give a warmer image colour, or by increasing the dilution of the developer — more dilution gives warmer tones.

Print processing

Development

Methods

I outlined the different types of print developers, explaining their purpose, in MATERIALS; here, I shall attempt to explain their use, both in normal and modified form.

We have the option to use almost all print developers in a number of ways, to control or alter the density, contrast and tonal range of the print:
i) normally, i.e. as a single-bath solution, prior to the stop and fix baths,
ii) as one of two separate baths, used in succession, usually to lower print contrast and extend tonal range, followed by the stop and fix, or,
iii) as a single-bath solution, but used inconjunction with a separate plain-water bath, as for ii) above, followed by the stop and fix.

For method ii), one of the dishes contains a normal contrast developer, the other a low contrast developer. The print is normally developed in each dish for half the total development time. Whichever developer is used first will have the greatest effect on the image's contrast. For subtler effects, the print can spend two thirds of the development time in one dish, and one third in the other, and vice versa. This technique only has the capability of lowering a paper's contrast; to increase it significantly, a harder grade of paper or a contrastier enlarger lightsource, such as a condenser or point source, must be used. For maximum lowering of a print's contrast just one single-bath soft working developer should be used.

For method iii), one of the dishes contains a normal contrast developer, the other has plain water at processing temperature. The paper is developed in the first until it has emerged, then transferred to the water bath, where it is left to sit — without agitation — for about thirty seconds, until all the developer absorbed into the emulsion has exhausted. The print is then transferred back to the developer dish for about fifteen seconds, and then back to the water bath and left as before. The process is repeated until there is sufficient detail in the shadows and highlights. This process works in a similar way to compensating film development.

Note: developer-incorporated papers will not respond well to method ii) or iii), whilst premium quality FB papers will respond better than RC's.

Dilution

Most print developers have a recommended dilution for their use which, for most papers, is usually calculated to give practical development times of between 1-2 minutes. This dilution and period of time should be sufficient to produce a print of good density and contrast. However, I frequently find it beneficial to develop FB prints for longer, perhaps for a total of 3 minutes or more.

We can increase the dilution of the developer for a number of reasons:
i) simply to slow down the development process if it is inconveniently fast, as with lith processing,
ii) to improve developer compensation effects, in a similar way to development method iii) above, or
iii) to enhance the warmth of chloro-bromide and lith printing papers, provided they are given enough extra exposure to give good print density, when developed to a factor of x3 (see FACTORAL DEVELOPMENT). Excessive print developer dilution may lead to both chemical and safelight fogging.

We can decrease the dilution of the developer:
i) to speed up development,
ii) to increase print contrast slightly, and
iii) to increase the warmth of chloro-bromide papers, provided that the development time is reduced to keep it to a factor of about x3.

Temperature

The higher the developer temperature, the shorter the emergence time, and vice versa. Developer temperature can also affect image contrast — below 14°C both contrast and density will be badly affected. The image colour of chloro-bromide and lith-printing papers will also become cooler.

A developer temperature above 20°C (the norm) can enhance image warmth, but may increase chemical fogging and shorten developer dish-life. If developed at too high a temperature the emulsion may become very easily damaged. For general work, try to keep all solutions at the same temperature of 20°C — including the wash.

There are various methods of keeping the developer up to temperature: photo dish heaters, in-built dish heaters, or, in my case, an oversized (24" x 20") dish, half full of water, in which the 20" x 16" developing dish sits. It is kept at the right temperature with a (cheap) fully submersible, thermo

statically controlled fish tank heater. I keep an eye on developer temperature with a thermometer, placed in one of the dish's troughs.

The darkroom temperature itself plays an important role in maintaining solutions at the right temperature. For working I find the most comfortable room temperature is about 18°C, which requires little additional effort to keep the developer at 20°C.

Handling the paper

Inserting the print smoothly and evenly into the developer will prevent development marks. Careful handling will then ensure that more delicate, larger FB papers won't be creased or damaged.

I always make prints with good-sized white borders for handling, so that finger prints, or glove and tong marks, won't show up on the image area. This border also provides a captive flap for window mounting the print later. It is also an area of the print where fixing tests (formulary numbers 35 and 36) can be applied if thought necessary.

I tend to handle prints with rubber-tipped bamboo tongs, or with washing-up gloves. Metal or plastic tongs, with no rubber tips, can damage the print physically, and if rubbed over the image area they may sensitise the paper, causing black marks when processed.

Agitation

Agitation for prints should be continuous, unless the water-bath method is used, because we usually want the maximum density from a paper/developer combination and because we can't see the micro development effects of briefly agitating films.

Assuming dish development, there are number of ways of agitating a print:
i) rock the dish by first lifting one side, then the opposite, and then the other sides, reversing the sequence to ensure good developer movement over all the print. The efficiency of this method is affected by dish size and the volume of the developer in the dish. Or,
ii) circulate the developer, stirring it by hand, but preferably without touching, and therefore potentially damaging, the emulsion.

Over-agitation won't harm the print, but it will oxidise the developer much more quickly. Excessive

1. It is very easy to misjudge the density of a print if it is developed by inspection under a safelight.

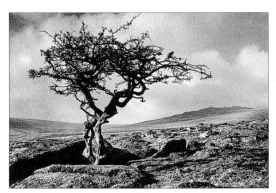

2. This is the same, identically exposed and developed print as above, but viewed under normal lighting conditions.

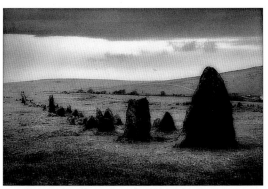

3. This print was locally bleached too much with Farmer's reducer, before toning, as described in Walkham Valley IMAGE NOTES.

agitation will also create more evaporation, and therefore increase the need for good ventilation. Deep-tank print processors are good in this respect, because they have very small surface-to-air ratios, but they do not provide good agitation control.

Dish size and solution volumes

Some attention needs to paid to the amount of solution in the dish. Too great a volume and we won't be able to agitate the print enough, using method i) above, without developer spilling out.

A dish one size up from the print, filled with the minimum amount of solution, will ensure good development, by allowing a rapid flow of solution over the print, as agitation takes place. I fill 12" x 10" dishes with about 500ml of developer, 16" x 12" dishes with 1000ml and 20" x 16" dishes with 1500-2000ml. The right volume is essential for good agitation when developing images for a short x3 factor (see FACTORAL DEVELOPMENT).

Emergence and completion time

The time it takes for the image to appear in the developer will vary with different types of papers and developers. It may range from a few seconds with some developer-incorporated RC papers, to about 15 seconds with warm-tone chloro-bromide papers, about 30 seconds for most neutral-tone papers, and to about 1 minute with lith prints.

For a start, knowing the emergence time for a typical paper and developer combination enables us to see if the developer is slowing down (perhaps because it is getting old, or too cold). We can then adjust the total development time using the FACTORAL DEVELOPMENT CHART.

A print is said to be developed to completion when further development will not significantly increase Dmax or highlight detail. For more information, see the notes with the factoral chart.

Changing print image colour

Warm-tone print image colour is largely dictated by the size of the paper's metallic silver particles. The smaller they are, the warmer the image.

Methods to warm image colour:

i) Give a warm-tone chloro-bromide print more exposure than normal and then process it in a warm-tone developer, more diluted than normal,

but not to completion. The extra exposure ensures enough silver is exposed to produce both good blacks and the necessary highlight detail, whilst curtailed (x3 factor) development keeps the silver particles smaller in size. For this reason warm tone prints should not be developed to completion,

ii) give the print more exposure and reduce its development time, for the same reason as i) above,

iii) use a warm tone developer additive (formula 16), or

iv) alternatively, tone the print or redevelop it in formula 58.

Lith processing

Properly controlled, this process is capable of producing prints like those of **Rance Estuary**, i.e. strong blacks and quite delicate, compressed mid-tone and highlight detail. A typical lith print will have a strong duotone colour: neutral blacks with peachy-brown highlights. However, only a limited number of papers work, among them several lith and most of the warm-tone chloro-bromides. Variable-contrast and neutral-tone bromo-chlorides tend not to work, although Oriental Seagull does.

When should the process be used? Typically, if a considerable change in print image colour is desired without toning. It is also very useful for making a print from a difficult negative, whose highlight detail is hard to burn-in. By virtue of the +2 stops of extra exposure given to a lith print, this detail will be automatically burned-in.

However, I have found that a very similar effect to lith processing can be achieved with conventional printing paper and toner combinations. For example **Epping Forest**, which I slightly fogged and then toned to create a split-toned colour, with tonally compressed, lith-type highlights.

The contrast and colour characteristics of the lith process rely on a number of factors:

i) the chemical composition of lith developer, which usually contains large amounts of both the energetic, warm-working developing agent, hydro-quinone, and the restrainer, potassium bromide. Most developers are also very caustic, about pH13,

ii) the dilution of the lith developer, which must be greater than for normal high-contrast black and white (non split-toned) lith work. I make up Champion Novolith developer with 1 part A, 1 part B and 24 parts water. If the developer is too concentrated, the process will be uncontrollably fast and it will be harder to get such warm tones,

iii) the chemical process of infectious development, characteristic of lith developers, which suddenly gives the print blacks their strength of tone, usually after about 5 minutes development with the above developer dilution,

iv) overexposure of the print, which on average

should be +2 stops more than for a print on the same paper, developed in a standard developer,

v) the grade of paper, which should preferably be quite hard so as to compensate for the over-exposed nature of the print and the typically small, x3, development factor, and

vi) very careful development, which has to be carried out by inspection to determine the point at which the print has to be hurriedly pulled from the solution before infectious development really starts to work rapidly on the midtones and highlights (see the **Rance Estuary** illustrative photographs).

Other determining factors to bear in mind include the age of the lith developer which, used highly dilute, tends to go off very quickly — sometimes within an hour or so after mixing. Also, the process is fairly temperature sensitive. Keep it at 20°C if possible.

As for warm-tone print development, the colour of the lith image relies on the finely divided nature of the silver image. This is achieved by the +2 stops of print over-exposure coupled with the very dilute, restrained nature of the developer. What stops the print from looking too dark if it is a couple of stops overexposed? Taking the print out of the developer after a development factor of about x3.

If the lith developer is not sufficiently diluted, the process of infectious development will be too rapid to accurately judge when to remove the print from the developer. A correctly diluted developer slows down development to the point where development can be accurately monitored. A typical development time may be between 5-10 minutes. I would not recommend shorter, or longer.

Once a good lith print exposure/development time combination has been worked out, the colour of the print can be subtly altered by increasing the developer dilution and revising the total development time, yet still keeping to the normal x3 development factor.

Lith processing guidelines:

i) the developer dish should not be overfull, to ensure good agitation and even development of the 'pulled' (under-developed) image,

ii) the developer temperature should be 20°C,

iii) the print must be inserted smoothly and evenly into the developer,

iv) agitation must be continuous and thorough,

v) the emergence time of the print should be carefully noted as the dilute lith developer ages and slows down very soon after mixing,

vi) after emergence, the image will continue to lack contrast and good blacks for about another three to four minutes. Up to this stage, don't be fooled into thinking you have under-exposed the print, since its warm orange colour will make the image

look very weak under the similar colour of the safe-light, and

vi) the print should be removed from the developer fractionally before the blacks are judged to be dense enough. At this point infectious development of the shadows takes place very suddenly. The skill is to pull the print out of the developer at the right moment, before the midtones and highlights become too dense.

Methods to cool image colour:

The image colour of some papers can be cooled, simply through the use of cold tone developers. But, as for warmer tones above, it is possible to employ various methods of development, including additives, for enhanced effects. These methods work for cold tone and standard print developers.

i) extend development time to completion,

ii) use an acid stopbath and acid fixer, they will slightly bleach the finest silver of the print, or

iii) use a cold tone developer additive, such as the benzotriazole formula 11.

Developer capacity

The capacity and dish-life of a heavily diluted lith developer are not large or long, and will decrease rapidly the more dilute the developer is used. When you replace the lith developer (perhaps after as little as one hour), if you want added warmth for the fresh solution, try making up half the required total amount and then add an equivalent volume of the exhausted developer. The same technique can be applied to warm-tone print developers, when used with chloro-bromide papers.

The capacity and dish-life of conventional print developers is much greater than for lith. On average, 1 litre of working strength developer will process 30 10" x 8" prints without any significant change in the emergence time. Thereafter, as the emergence time slows down, print Dmax and highlight detail will begin to fall off if the development time is not revised according to factorial development. At this point I tend to discard the developer, especially if it looks yellowish in colour. If, however, the developer is still good after a printing session, I will store it in an airtight container and use it later for contacts and proof prints.

Stopbath

The various choices have been covered in MATERIALS. However, there are a few other points regarding their use that I should mention here.

Prints should be thoroughly drained of developer before entering the stop. I drain RC and FB prints for a minimum of 10 seconds, and for up to 20 seconds for larger FB prints. Too much developer carried over into the stop, for example, with absorbent FB papers, will significantly reduce the capacity of the stopbath. Holding the print from one corner, before it is stopped, will encourage the developer to drain off the paper's bottom edge more quickly. However, lith prints may need to be immersed into the stop without draining, depending on the speed of infectious development.

In every case, all prints should be smoothly immersed and then properly agitated — don't leave prints stacked up in the stop. Also, don't replenish the stopbath: for the indicator variety, discard it once it begins to change in colour; for non-indicator, acid varieties, check their acidity with pH papers. It will normally be about pH 4-5. Too acid a solution will inhibit washing and toning, and may chemically damage the emulsion. The temperature of the stop should be the same as that of the developer.

Drain the stopped print thoroughly before putting it into the fixer, in the way described above. Too much carry-over of a yellow indicator stopbath discolours the fixer and temporarily stains the whites of the paper. Until the print has been thoroughly rinsed, this makes print viewing and assessment after fixing significantly harder.

Plain water stopbath

In FILM PROCESSING I outlined the reasons for using a plain water stopbath. They should be used at the same temperature as the developer and should be changed after each print or two, to prevent developer carry-over into the fixer.

Failure to use a stopbath after development may quickly lead to a badly contaminated fixer, improper fixing and possible dichroic fogging of the print (usually a mottled pink in colour).

Fixing

Fixer types and processing choices have been covered in FILM PROCESSING and ARCHIVAL PROCESSING. Included here are some additional guidelines, irrespective of whether a one or two-bath fixing system is used. Previous processing guidelines in this chapter, regarding dish solution volume, print immersion, agitation and handling techniques, also apply to fixing, whilst specific archival fixing information can be found in ARCHIVAL PROCESSING.

We cannot see the action of the fixer clearing the print's emulsion in the same way that we see it

clearing a film. Therefore, it is imperative that we keep a check of the number of prints fixed in a given volume of fixer. A check should also be kept on the fixer's pH and silver levels. Otherwise, the process will be incomplete and image decay quite rapid, with the possible result of fading and brown print discoloration. In a tray, a working-strength fixer will keep for a few days at most, and a couple of weeks in a stoppered, airtight bottle.

Recommended fixing times apply to individual prints fixed in a dish with good agitation. Prints stacked up in the fix will most probably not get properly fixed, unless they are continuously rotated from top to bottom — in which case more delicate FB prints may become damaged.

Once the print is in the fixer, the lights can be switched on after about 15 seconds for rapid ammonium thiosulphate fixers, and after about 30 seconds for the slower, sodium thiosulphate varieties. However, don't take the print out of the fixer to view it until fixing is complete and the image has been rinsed, or else staining and bleaching may result. Over or under-fixing are never recommended for reasons outlined in ARCHIVAL PROCESSING.

Rinsing the print

The print should always be thoroughly rinsed after fixing, prior to viewing: rinsing times for RC and FB papers are, respectively, about fifteen seconds and two minutes. After this I lay the image on a flat sheet of plastic and remove the surplus water with a soft, rubber, wiper blade.

How I then make my assessment of print highlight and shadow density, contrast, tonality and balance is explained in PRINT ASSESSMENT.

Care should be taken not to view prints for too long in this partially washed state. At most, I try not to keep them out of the wash for longer than a minute or two.

Print reduction

If the print looks too dense overall, or contains areas that are specifically too dark, we can either expose another sheet differently, as outlined in ENLARGING, or we can bleach the image with Farmer's reducer, after fixing, as in **Mis Tor**.

This process of reduction is also known as bleaching back, cutting-back or ferrying (the reducer is potassium ferricyanide, see formula 38.)

Reduction can also be used to salvage prints made from very flat negatives, which still lack contrast when printed on the hardest available grade. For this, the print should be overexposed by about a $1/4$ of a stop (i.e. made a little too dark) and then

bleached back, after fixing and a good rinse, in a dish using a subtractive reducer, such as Farmer's, formula number 38.

I often locally bleach the shadows of a print to lift the detail and contrast, often in conjunction with some dodging of that area, provided there is enough shadow detail in the negative. For example **Loch Ainort** and **Walkham Valley** were locally treated in this way. The latter somewhat disastrously, as shown on page 125, where the bleached area has become clearly visible in the thiocarbamide and gold-toned print.

Bleaching can be creatively used in other ways, for instance, to give added life to cloud scenes. For this type of situation I tend to overexpose the print by about a $1/3$ stop more than normal and print on $1/2$ grade softer paper — in order to retain the shadow detail. After fixing, the whole print can be gently bleached in a dilute solution of Farmer's, to lift the highlights values. The effect can be subtle or quite dramatic, depending on the dilution and bleaching time. If the dilution is right, bleaching time should be about thirty seconds or more. Any less and the process will become very hard to control.

Whichever reduction method is used (i.e. local or overall), the print must first be properly fixed and thoroughly rinsed, since any residual fixer would accelerate the action of bleach (which already has fixer added to it). Bleaching works with both RC and FB papers, but for local reduction I find the more absorbent FB papers easier to control.

Overall reduction

The bleach can be used as a single-bath reducer containing both ferricyanide and fixer, or as a two-bath reducer, one dish containing the 'ferry' and the other the fix.

The single bath version produces a "what you see, is what you get" effect, whereas the separate fixer of the two-bath version tends to reduce the image back still further. For all types of bleaching work, the solutions must be made up to working strength just prior to use, according to the formula's instructions.

I prefer to work slowly, with a fairly dilute, and therefore more controllable, bleach. It will appear to start working after about 15-20 seconds at 20°C, when the highlights will just begin to lose some density. Then, just before the desired amount of reduction is achieved, I'll remove the print and rinse it in cold water to arrest the process. Hot water will momentarily accelerate the process before the bleach is washed out. After bleaching the print should be washed as normal.

Some books recommend refixing prints reduced with method i). If the bleach has been made up

correctly, this shouldn't be necessary, but if fixed again, be sure to rinse the bleached print thoroughly first, or else further reduction will take place.

Local reduction

Lay the fixed and rinsed print on a sheet of flat plastic, or on a flat dish. Gently wipe off the surplus water and locally apply the combined (one-bath) ferricyanide/fixer bleach to the relevant area. Depending on the size of the area to be bleached, one of several means of application can be employed:
i) a very fine brush for delicate detail, and for removing small black pin marks,
ii) a cotton bud or larger brush for intermediary sized areas, or
iii) a swab of cotton wool for larger areas.

For finer detail, when the bleach's effect must be confined, I work with a brush or cotton bud that is slightly dampened (not soaked) with bleach.

To see exactly what is going on during bleaching, I work with a bright, angled viewing light, with which the glistening damp area of applied bleach can be seen on the paper. Once the bleach is applied I tend to rinse it off almost immediately with cold water, and then wipe the print dry to assess progress, repeating the process as necessary.

Overbleaching with Farmer's reducer will gradually create a brown tone, as in the print of Hound Tor in TONING. This is not a stain, but a visibly noticeable reduction in the size of the bleached silver particles, similar to that described in the section on warm-tone print development. This process can be used creatively. For instance, I have made prints like **Eileen Donan** which have been deliberately overexposed by about two stops, processed normally, and then slowly bleached back with Farmer's reducer to 'normal' density. For this effect, extra dilution of the bleach is essential to avoid losing all the blacks of the print. However this dilution will make the process slow, often up to 10 minutes or more in duration, after which the bleach will need to be changed. Incidentally, this process also accentuates print graininess and texture.

Print intensification

Unlike for films, this process is rarely very productive. Making a new print at a harder grade setting, perhaps with a contrastier lightsource, or intensifying the negative, or slightly overexposing the print and slightly bleaching it back, will work much better. However, selenium toning a print will intensify the blacks a little, raising Dmax for glossy FB papers from an average value of 2.1 to about 2.2.

Print assessment

Like many of us, I have spent a long time, quite literally 'in the dark', making many, many prints in an attempt to find out how best to express my response to the kind of questions landscape photography can pose. I first studied what I believed to be the most creative tool of the process, that of using different papers and processes. I also tested innumerable different toners and toner combinations. In the end I saw the light. Assuming I had a good negative, I realised that all these other variables were of secondary importance; I should have been expressing myself through often quite simple means of planned enlarger exposures. As I became better at printing, I found out that print balance and harmony would always say more than dressing the image in a different make of paper, or presenting it with an alternative process.

Now, as a consequence, I almost always print on just one type of paper — Ilford Multigrade matt, FB, VC. The use of only one paper may sound restrictive, yet the more I work with this kind of 'limited' approach, the more I realise how much there is to discover about printing and I learn that I can't blame my failed images on what was a sheet of blank paper. I have learnt how to expose this make of paper in the best way, and then discovered what variations of enlarger exposure and what different grade settings could do to a print — my print. I also experimented with flashing, fogging and split-grading, to see how they could be used to control fine print balance. Only after this did I go back to testing Multigrade with different toners and toning methods.

The test-strip

Having chosen my negative I will make a print exposure test-strip from it, usually about 20" x 3" in size, if I am making a 20" x 16" final exhibition print. This strip should cover the vital highlight and shadow areas of the image, and at least two opposite corners — to check edge to edge sharpness. I develop the test-strip for exactly the same length of time as the subsequent print, so that it provides accurate comparative exposure information. After the fix, I will rinse it for two minutes (or 15 seconds if it is RC paper) and then wipe off the excess water with a wiper blade.

For really accurate exposure assessments I quickly dry the test-strip either with a hot air drier or, for FB paper, on an old flatbed drier (used solely for this purpose to prevent fixer contamination of finished prints). I will then assess the dried-down image under several different types of viewing light, looking for various types of information, asking myself a number of questions:
i) is the print sharp, from corner to corner?,
ii) what is the right exposure time?,
iii) have I used the right grade?, and
iv) how will the print look once it has been toned — will it look too dark or too light, or perhaps too flat or too contrasty? For this purpose I will compare it with step wedge toning tests that I have made, such as those in TONING.

I will then put the test-strip back in the wash, to remove any residual fixer, as I like to keep it for future reference when making other prints from the same negative.

The right print exposure time

The best exposure time is obviously the one that gives the print the correct density when it has dried, but it is also the length of exposure with which it will be easiest to work, and that depends on how much dodging and burning in will be necessary.

Usually, for a 20" x 16" print, I will aim for a basic print exposure time of about 15 seconds. When the enlarger light comes on, this length of exposure gives me long enough to register what I am supposed to be doing(!) and exactly where I have to dodge. It should give the time to carry out at least two or three separate dodging manoeuvres during this basic exposure time if the need arises. Should I be one second out with any of my dodging, then the percentage error this represents is minimal compared with a shorter basic exposure. For example, a similar one second dodging error during a shorter basic exposure time of, say, seven seconds represents a very noticeable 15% error — it is 6% in the former case, which is much less noticeable a mistake.

Too short a basic print exposure time, with correspondingly shorter dodging times, can leave clearly visible shadows on the print cast from any dodger that isn't moved quickly enough. Also, the edges of burned-in areas, if the burning in card isn't moved enough, may appear too clearly defined, with locally poor gradation of tones.

However, a basic exposure time of more than 20 seconds may create uncomfortably long burning in times. For example, if we need to give an extra +2 stops of exposure to the print, to burn in an area of sky, it will require an additional exposure of 40 seconds. If this +2 stops has to be given at a harder grade setting, for example grade 4 or above with VC paper, then remember this time will need to be doubled, to 80 seconds, (unless you have a multi-grade-type enlarger head). Arms soon get tired with careful moving of burning in cards during such very long exposures.

Opening up the lens to shorten burning in times is something I try to avoid. The image may become less sharp around the edges, since we may no longer be working at the optimum lens aperture. Adjusting the lens aperture half way through the making of a print may also move the lens, and therefore the image, slightly out of place, creating a blurred image and double grain pattern.

Test prints

Assuming the test-strip was good I will next make a complete print at the right basic exposure time (without any dodging or burning in), processing this print as for the test-strip. If areas of the print are likely to need dodging and burning in, and I am not exactly sure of how much exposure to give these parts, I will then make several other straight exposure prints, or test-strips, at a variety of different exposure times, to show me exactly how much possible dodging and burning in particular areas need. For a grade 2 paper, with a good negative I tend to make one print at $-1/4$ stop, then several others at $+1/2$, +1 and +2 stops, in the same way as the **Black Mount** series, on page 133.

Sometimes I will make several additional prints at different grade settings and at different exposure times (as above), to show me, for instance, how the sky of a landscape will look if it is burned in at a harder grade setting, or how better to separate cloud detail, or how to suppress grain with a lower contrast setting, or maybe how to create a more even, perhaps less distracting body of tone, as in the sepia toned prints of the **River Authie**.

If I think flashing, or fogging of the print is necessary, as in **Epping Forest**, I will also make test-strips that include this extra exposure. For flashing and fogging I tend to decrease the basic print

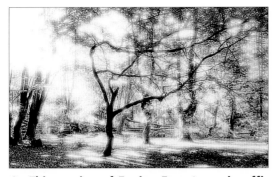

1. This version of Epping Forest was insufficiently fogged. The sky to the top left lacks detail and throws the print right off balance.

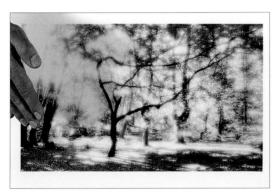

2. Playing shadows over the print, it is possible to get a good idea of how much better it might look if locally darkened.

3. Subtle changes in print exposure can then be simulated by varying the ratio of direct-to-indirect print viewing light.

exposure time by about $^1/_4$ stop. Any dodging and burning in also needs to be modified by $-^1/_4$ stop.

Once they are processed, briefly rinsed and dried, I will lay out all these prints, or test-strips, so that I can visually piece together their relevant areas of print exposure information, mentally constructing a nicely balanced composite image from which I can make my final, exhibition print exposure plan. As I said in IMAGE ASSESSMENT, "there is no short cut to a good print."! But working this way provides predictable print exposure information, even if making several test prints does produce only one or two really good final prints from a 10 sheet packet of 20" x 16" paper. Surely that's better than 10 potentially mediocre prints.

Sometimes, with an easier to print negative, all these preliminary test stages aren't necessary. For example, when making a fairly small print from a good negative. But, if I am making an exhibition print, irrespective of how good the negative is, I always go through the above tests. Remember, there is a big difference of scale, and relative tonal values, between, say, a 35mm contact, or a 10" x 8" proof print and a 20" x 16" final print. There is also an even bigger difference between a glossy contact and my matt surface final print.

Making a printing plan

An exposure plan is a diagrammatic version of the exposures required to produce the correct balance of our final and perhaps toned print.
Making an exposure plan is simple, provided:
i) we know how we want our print to look,
ii) that the negative is up to it, and
iii) that we can anticipate the way that the paper will respond to a) our print exposure methods and b) all our processing techniques.

After I have studied my test-strips and test prints, I will map out on paper the relevant exposure details for the various different parts of the print, in f.stops and fractions of f.stops. I will make separate plans for exposures at different grade settings. For example, my first diagram usually details the basic print exposure time, including dodging instructions. The second diagram will show the burning in, and the third will show burning in at different grade settings, or perhaps flashing details.

Incidentally, recording the exposure information in f.stops, not seconds, means any changes of basic print exposure time (brought about through subsequent changes of paper batch or type, or through alterations of print size) won't require lengthy recalculation of all the other dodging and burning in exposure times.

However — and this is an important point worth noting — if we make another print from the same negative but at another contrast grade setting, our printing plan information will almost certainly need modifying. This is because different grades of every make of paper have different exposure latitudes. For example, a $+^1/_2$ stop increase of print exposure, for instance, makes a significantly greater difference to print density for a grade 5 print than for one made on grade 2. This difference in exposure latitude also happens to be one of the reasons for avoiding thin, flat negatives that need to be printed on hard papers: trying to balance them is more difficult, and we have to be that much more precise at our dodging and burning in. Imagine trying to print the **Pentire Point** triptych on grade 5, if the negatives were all too thin. No thank you!

On my printing plans, apart from recording the print exposure information, I will record details of the enlarger: its lightsource, the lens, the lens aperture and the height above the baseboard of the enlarger head. I will also note the paper batch number, the date of printing, the negative frame and roll number and will detail the processing solutions: their types, dilutions, temperatures, and times. Keeping a record of any processing modifications — such as continuous, rather than intermittent agitation of trays — is a must.

A good printing plan must take into account all the variables of the darkroom process, i.e. anything — and everything — that might alter print contrast, tonality and density, whether optically or physically, expectedly or unexpectedly. It must also be easily understood and clearly visible for use in the darkroom (avoid red ink, it's invisible under the safelight) and for making subsequent reprints, perhaps months, or even years, later.

Dry-down

What is that makes black and white prints look so different when they have dried, often leaving them flat, dark and lifeless — even boring!

The novelty factor

Certainly, by the time the print is dry, the novelty factor of seeing it freshly processed will have begun to wear off, and this may account for taking a little (sometimes all!) of the 'sparkle' out of a newly made print. But there are other more objective reasons for this dry-down effect.

Emulsion swelling

When wet, the gelatin of the print's emulsion is swollen with liquid. In this expanded state the silver grains that make up the image are less compact.

What this means is that the lighter print highlights, where the quantity of silver is least, reflect proportionately more of the print viewing light back out. In practical terms of what we see, this makes the highlights look brighter and the print that much contrastier.

The amount a particular emulsion swells will depend, in part, on the type of processing sequence to which it is subjected. Extended print development, especially in highly alkali developers used with lith printing (pH13), will expand the emulsion the most. In such conditions, it is possible to feel how slippery the emulsion has become, in this, its very swollen state.

Wet print surface

If the print is viewed wet, and it has a glistening surface, this will exaggerate the dry-down effect: the surface water, like a glazed print, will diffuse less of the print viewing light, increasing print Dmax and decreasing the density of the paper's white base. To overcome this problem, when viewing a wet print, I always — carefully — wipe off the surplus water from its surface with an old (soft) car windscreen wiper blade. However, once toned, I would never recommend wiping dry, or touching the surface of the print, since it can be marked very easily.

Emulsion type and surface finish

Those emulsions that swell more during processing — such as FBs as opposed to RCs — will suffer dry-down the most. Warmer-tone, chloro-bromide emulsions which tend to be softer, are also more of a problem, as are non-glossy, textured or matt print surfaces. The base colour of a paper will also play a significant role; off-white colours accentuate dry-down the most. Many papers have built-in brighteners, rather like washing powders. At one time, extended washing certainly removed some of these, dulling (and discolouring) the print, but improvements in paper manufacture make this much less of a problem today.

Dry-down exposure modifcation factors vary between about 2-5% for RCs and 5-15% for FBs.

Dry-down summary

i) never judge a print in the developer, stopbath or fixer. Immersed in solution, and under dim, coloured safelighting conditions, the print will appear contrastier and brighter (see page 125),
ii) in safelight conditions our eyes will try to compensate for the lack of illumination by 'opening up', but (rather like film reciprocity failure with dimly lit subjects) this bigger 'aperture' may not be large enough to raise dark shadow values to a visible level, although it will be enough to brighten the lighter highlights significantly,
iii) the right viewing light, (see TONING),
iv) knowing the type of final viewing light, and
v) will the print eventually be framed under glass, or stored in a polyester-type print sleeve? (both will darken the print).

How to compensate for dry-down

A number of methods exist. The simplest, and most effective, is quickly to dry a test-strip or proof print (of the same print exposure time and grade) as already explained. Alternatively, prior to this stage, I usually employ a 'comparator' strip. This is a contact print of a film step wedge, such as Agfa's Transmission Step Wedge, made on the same type and surface of paper, that has been previously printed, processed and dried. To use the comparator, cut it in half and put one piece in the wash, keeping the other half dry. By comparing the density values of the wet print with corresponding density values on both the wet and dry halves of the comparator we can see how much darker the print will become when it has dried down. Because each of the stepped wedges of density of the comparator represents half a stop difference in print exposure, it is a fairly simple process to calculate changes in print exposure times, in fractions of f.stops.

Print viewing light and conditions

A darkroom print viewing light that is dimmer than the final print viewing light is, in my experience, absolutely essential to help compensate for dry-down. The quality of this light is also extremely important — it must not flatter the print in any way, in the belief that if the print looks good under this bad light it will look good anywhere. I use a car inspection lamp fitted with a clear tungsten 60W bulb, of the artist's 5400°K variety, that throws light off in all directions. Better, I have found, to view the print under this type of distracting light, which illuminates the whole darkroom, making prints compete for my attention, rather than view them under a spotlight set at 45° to the sink splash back, which will unrealistically improve their quality.

Under this light, I view the processed print on a flat plastic sheet which I stand up in the sink. I then look at the image from various distances — and always sitting down on the darkroom stool, so that I can relax and concentrate properly. After I have looked at the print under this direct light, I will

4. **Wet print densities can be compared with the wet and dry densities of a printed-out step wedge. This is a more advanced way of estimating print dry-down.**

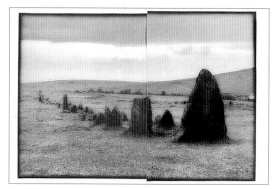

5 **Comparing a wet and a dry half of the same print, it is possible to see the darkening and flattening-off effects of print dry-down.**

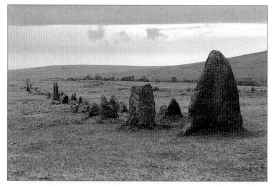

6. **Another viewpoint of Walkham Valley. The line of the cloud is so clean-cut it could easily be mistaken for clumsy burning in of the print. I chose another negative from a series of bracketed film exposures.**

7. This proof of Loch Ainort was made from an undiffused negative. The telegraph wire would need retouching with a scalpel.

8. A black and white 20" x 16" proof. This version still needs to be locally bleached, according to the print diagrams in Loch Ainort. The sky is also a little too light.

9. Too dark and lacking shadow detail. This earlier, toned version was assessed with too bright a print viewing light, as described in Loch Ainort IMAGE NOTES. The final dodged, burned in and bleached print is clearly better.

move it back against the sink splashback where it sits in a shadow cast by the shelf above. Under this dim light, if the print still looks good, then I know it will look good anywhere — whether exhibited in a well-lit gallery, or if seen in a poorly-lit viewing space. I have exhibited prints in restaurants, where the proprietor usually wants to keep the lights turned well down!

My sink splashback-viewing area is light to middle grey in density. Were it any darker, it would make any print placed against it look relatively too bright, which would certainly not help dry-down calculations. Viewing the print against a white background, such as a print processing dish, will make our eyes 'close down' a little — rather as if the print had dried down. This is another useful means of dry-down estimation.

Making the final print

Working with the printing plan

Once I have worked out my basic print exposure time for the final enlarged print, I will convert all the f.stop exposure notes on my printing plan into seconds using the f.stop table at the back of book. I then make sure I have all the necessary dodgers and burning in cards/tools to hand.

With the paper in the easel, and all but one weak safelight switched off — the same conditions as for the test-strip exposures — I will make the basic print exposure carrying out any dodging in a rhythmic style which can be easily repeated with any future prints. I then expose the rest of the print according to my printing plan: printing by numbers, as it were.

Once the print has been exposed, processed and thoroughly rinsed (I wouldn't recommend viewing it too soon, or else in its fixer-laden state the high-lights may start to bleach out and the image begin to stain), I will view it as already mentioned. Next I will view it upside-down, and then in reverse by looking at it in a small, hand-held mirror.

This process enables me to check for any imbalance in the print that I may not have already noticed. If some modification is needed, I will amend my exposure plan and make another print. If that image looks good, I will make a few extra copies, some at slightly different exposures, to provide me with a selection of prints which I can tone to differing degrees, if needs be. I always try to keep one good, spare, untoned print for future reference. I also number all the prints with pencil, in their margins, to make the subsequent identification of the ones to be toned that much easier when they are in the wash.

Final print balance

What gives the print its balance? Camera composition is obviously crucial, as is the quality and direction of the light at the time of film exposure, but when it comes to printing we have to decide where and how we want to cast the enlarger's image-forming (and balance-altering/controlling) light. The process at this point becomes extremely subjective: only practice, and constant comparison between prints with which you are both happy and disappointed, will teach you to see and understand what works well for your prints. However there are a few useful pointers I can make. Where possible, I have also included such information alongside my toned landscapes.

As a general rule, I like to see clearly defined edges to all the sides of my prints; they hold the image in place, and help prevent the viewers' attention wandering out of the image. If we think back to when we composed the image in camera or with our viewer, we saw black or clearly defined image margins that isolated the view from its surroundings, holding it in place. To me, it only seems logical that if we pre-visualised the image this way, we should print it similarly. However, I will never print heavy black borders around a print to hold in the image; they tend to make the blacks of the print look weak.

In almost all cases, I will give each side of the print an extra $1/8$ -$1/4$ stop of gently graded-in exposure. This gives each corner a cumulative exposure increase of $1/4$ -$1/2$ stop. Without this extra exposure, the lighter sky tones of a landscape print may blend in too easily with the card of a window matte overlay — even if this card is white. I therefore have a reject window matte that I keep for laying over test and final prints to check the edges of the print are dark enough.

To check this aspect of print balance thoroughly, I will look at the centre of the print from the normal viewing distance, without moving my eyes away from this point of focus, I will 'see' if corners, edges, or any other areas of the print disappear from view. If they do, then, for the next print, I will usually burn in these areas for an appropriate extra length of time.

I should reiterate that viewing the print's reflection in a mirror really does help to assess image balance. If in doubt, try it, but don't get stuck always trying to get the print to look 'correct' when it is viewed in reverse. Some images are meant to read left to right (**Route Napoleon**), or right to left (**Bradwell Barges**), and looking at them in the mirror will reverse the effect, perhaps to the detriment of the image.

Images, when toned, may experience a shift in tonal value and therefore in image balance. For example, I burned in the sky of **Walkham Valley**

much more than initially appeared necessary, simply because I knew from my toning tests that the sky's grey print values would look optically and physically brighter when toned to a warmer orange-brown colour.

Print size also affects balance. A 10" x 8" proof print may need very little burning in to achieve good balance, but if enlarged up to 20" x 16" you can be sure the more open feel of the new image will require considerably more burning in of other areas to retain the same balance (see **Rance Estuary** printing diagram notes). Also, at the larger print size, you may find that a harder grade will be needed and that this will require some changes to burning in and dodging, as already explained.

Finally

I firmly believe in experimentation, so don't be afraid of using several sheets of paper, or many more, to — gradually — build up to the final print. If this means you can get the desired, pre-visualised result, it has to be worth the expense. That said, I don't believe in the idea of throwing vast quantities of the stuff at the enlarger easel in the mistaken belief that quantity will eventually produce something of quality.

If I make mistakes with my prints, I don't throw them away. I keep them and carry them through to their own natural conclusion; it is surprising what I have learned in this way. Above all, try to keep print exposure, processing and toning records — they should help to point out where mistakes have been made, and will provide objective, quantifiable, reasons for successes, or failures.

Once successfully printed, I will usually make a limited edition of prints from a negative. Sometimes this may simply be the largest number I can make in one session, sometimes as few as two or three prints. I don't like going back to print an image later, once I am happy with it, because from that point on I feel it will just become a repetitive, or technical, exercise. I think of a print as a visual diary: it depicts how and what I felt at the time and date of both camera exposure and darkroom work. To reprint it, perhaps years later, and perhaps when I know how to improve upon it, is akin to rewriting an entry in a diary. Better, surely, to think ahead, expose some more film and to print from those negatives instead. That is unless we are afraid that these 'good', old images represent the best of times, and the best we can hope to achieve. Finally, a good, well-framed print (like any art object) should not necessarily force itself upon the viewer — it should be visible, stimulating and challenging when you want it to be, and harmonious with the surrounding environment when your concentration is wanted elsewhere.

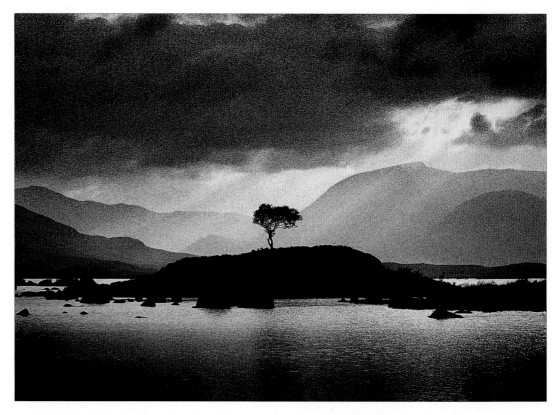

The final print of Black Mount, above, was made after I had produced a set of proof prints of different exposures and grade settings. These prints, opposite, showed me exactly what dodging and burning-in times, and what various grade settings, would be needed to produce the print that I visualised. After I had made them, I drew up a series of printing diagram plans of how I would make the final print, as depicted in the Technical Data page of Black Mount.

This whole process is obviously not necessary for every exhibition print, but, even performed just once, it provides invaluable information as to the mechanics of print exposure. A simpler option is to make test-strip prints, like those of Route Napoleon and of Trumpan Stone, and of Pentire Point (in ENLARGING).

When making a print with VC paper, using several different filter settings, it is important to remember that different contrast grades have different exposure latitudes. For example, +1 stop exposure at grade 4 will darken the print considerably more than +1 stop at grade 2.

Likewise, dodging the print at grade 4 has more noticeable an effect than dodging it at grade 2. Also, different grade settings will affect print graininess. A hard grade setting will accentuate it the most.

Top row, left to right:
1. Grade 2, but at -$^1/_4$ stop off the basic exposure. This print showed how much I could dodge either side of the island, to separate it better form the middle-distance.
2. This print, made on grade 2, represents the basic exposure time.
3. Grade 2, but at +1 stop. This print showed how much burning either side needed.

Middle row, left to right:
1. Grade 2, but at +1$^1/_2$ stops exposure to see how much burning in the foreground needed.
2. Grade 2, basic exposure and then + 1 stop at grade 4, to see how much extra exposure was needed for the bottom part of the sky — just above the skyline.
3. Grade 2 basic exposure and then + 2$^1/_2$ stops grade 4 exposure, to see how much extra exposure the top of the sky needed.

Bottom row, left to right:
1. Grade 2 basic exposure and then + 1$^1/_2$ stops at grade $^1/_2$ to see how much extra exposure was needed for behind the tree.
2. As for print 2, middle row, but with +1 stop at grade $^1/_2$ to see how much extra exposure was needed for the main bright cloud.
3. Grade 2 basic exposure and then +3$^1/_2$ stops grade 4 to see how much exposure the very top edge needed.

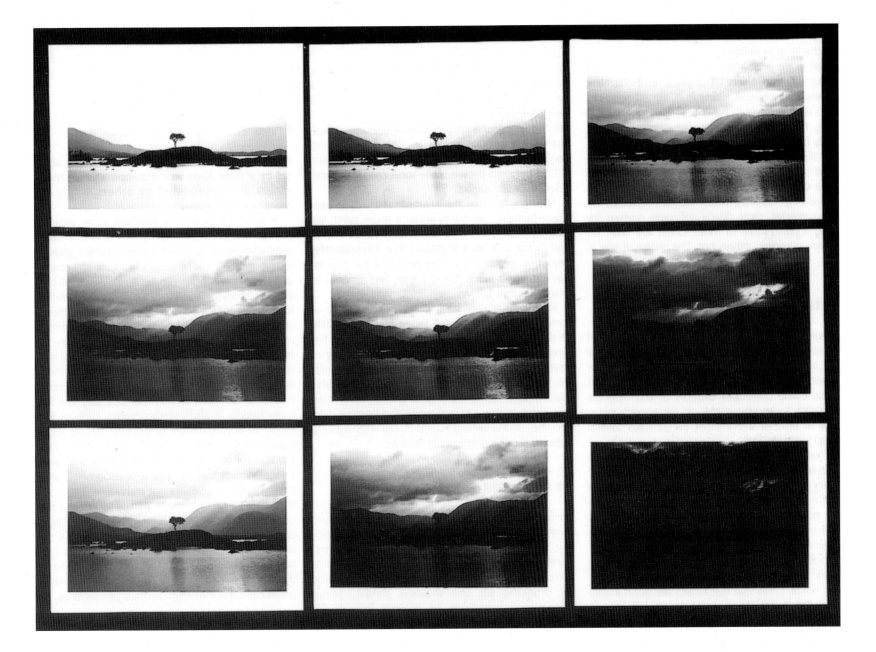

Toning

I use the term to define any chemical process that is applied to the print after it has been fixed and partly washed, that alters its physical and chemical composition, whether visibly (e.g. strong selenium toner) or invisibly (e.g. weak selenium toner). Post-fixing, hypo-clearing baths, for example, which merely help the wash process, are not toners.

In the text accompanying each of the main, toned landscapes I have detailed my personal choice of toner(s), how I toned the image and the reasons why. Outlined below are what I see as the three universal, most clearly definable reasons for toning a print; some of these toners will cater for all three purposes, others not. The choice, if any, is yours.

To change image colour

Perhaps we don't like the inherent image colour of a particular paper and we can't get the colour we want, either through changes in developer type or developer additives, or through variations of print exposure and developer dilution. In this case we can switch to another paper or, for a much wider range of effects, use a toner (or perhaps several toners) in succession.

If we want to alter the base colour of a particular paper, this can be achieved through 'dye' toners that work on the gelatin of the entire emulsion and not just the silver image. Fogging a print and then toning it, as for **Epping Forest**, is often my preferred method of changing the base colour of a paper, such as Ilford Multigrade, without having to use dye toners and without having to mask the print margins in order to keep them white. I find that dye toners are often a little too electric in colour.

Some toners are capable of a variety of effects, such as the thiocarbamide, variable-colour solutions capable of producing purple, brown and warm-yellow tones. Others, like the two-bath, thiocarbamide toner can also produce split-toned prints, i.e. whose image colour is divided into two, simply by partially bleaching the print (in the toner's bleach) prior to toning. On the other hand, a single-bath, direct toner such as selenium can also produce a split-tone effect of purple-brown shadows with neutral grey midtones and highlights, but only when used in a fairly concentrated form with a warm-tone, chloro-bromide paper.

Conversely, lith development alone, without toning, can produce a very strong, warm, peachy-brown split-tone image colour. However, if I want to get rid of this strong colour, but keep the high contrast lith effect, as with **Rance Estuary**, I will briefly tone the print in a weak solution of selenium toner until its colour is cooled and almost neutralised. Toning it for longer would then create a stronger, red-brown, split-tone colour as with chloro-bromide papers.

Multiple toning, for example with blue over thiocarbamide, can create either a green print, like **Northern France**, or a print with warm brown highlights and blue shadows like **Fernworthy Forest** — depending on the colour of the thiocarbamide toned print, and the type and amount of blue toner that follows.

Note: rather confusingly, the image colour of some black and white and toned black and white photographs, in various magazines and books, has been produced not by photographic means of development and toning, but by the four-colour, ink reproduction process! This process can also make a poor, rather flat original photographic print look much better, i.e. contrastier and brighter, but, likewise, in the wrong hands it can also make a wonderful original look quite terrible.

To alter contrast and or Dmax

Some toners will do both, for example selenium toner which can raise a glossy print's Dmax from, say, 2.1 to 2.2., visibly increasing its density and contrast. Other toners, like the blue variety (formula 51) can increase contrast, but not necessarily Dmax, by blocking up the shadow detail. Some copper toning solutions, for example formula 54, may even decrease contrast and Dmax, whereas thiocarbamide, variable-colour toners used at their weakest dilutions — to create a yellow-brown effect — will reduce contrast, but not so when made up with more of the activator for brown or purple-brown effects.

Some toners, through their change of image colour, may make a print's contrast or density look 'optically' different, when, in fact, densitometric readings show no 'physical' density change. A split-tone print with warm-coloured highlights, such as **Rannoch Moor**, always looks livelier and brighter, whereas a cold, purple-brown toned print usually looks moodier and darker. Virtually all toners will suffer a loss of density in the highlights if the print is improperly fixed or washed prior to toning.

For archival permanence

All untoned prints will gradually decay; this action can be slowed down with the application of certain toners and accelerated by others, or by bad processing techniques.

A brief immersion in selenium toner may not change image colour, but it will improve image permanence. Suggested archival toners include: selenium, gold, thiocarbamide, sodium and potassium sulphide. Copper can be quite good, but, for archival permanence, I avoid the copper red-chalk formula 54 which visibly reduces print density and contrast and — invisibly — has done what with the remainder? Multiple toning an image may not necessarily be archival, even if it does employ an archival toner — for example, blue over archival selenium. The literature accompanying blue toners may describe them as lightfast, but they will fade quite rapidly in alkali environments, such as even mildly alkali wash-water, in window mounts whose card is often alkali buffered, or if subsequently multiple toned in an alkali toner such as the caustic thiocarbamide variety. The redevelopment toners (formulas 57 and 58) are not archival toners, in that they don't improve image permanence, but they certainly do it no harm. They merely redevelop the original silver image to a different colour. Dye toners are not archival, since they may often be quite light sensitive. Important: no matter how archival the toner, only properly fixed and correctly washed prints can offer maximum archival permanence.

Methods of toning

Direct toners

A single-bath solution that may incorporate a bleach, such as potassium ferricyanide. Also known as direct or monobath toners. Examples include: selenium, gold; copper and blue. Traditional sodium sulphide sepia toner, potassium sulphide and thiocarbamide toners can all be made up as either one-bath (direct) or two-bath (indirect)

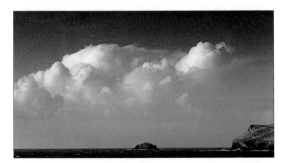

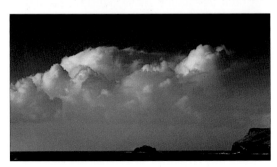

This sequence shows the print in solution at various stages of blue toning. The first print has been toned for 30 seconds, the last for 180.

toners; the two-bath variety offers more colour control and greater flexibility.

Indirect toners

Two (or more) separate baths, the first is usually a bleaching solution — most commonly potassium ferricyanide and potassium bromide — and the second is the toner. Indirect thiocarbamide toners usually consist of three separate stock solutions: a bleach, a toner and an activator. The toner and activator keep better when stored separately; they are mixed together just before use. Prints do not need to be bleached all the way back in the first bath. A slight bleach that lightens just the highlights of the prints without affecting the blacks will give a subtle,lovely split-tone effect when toned, as with **Rannoch Moor**.

Examples include: sepia toners, thiocarbamide toners and redevelopment toners.

Multiple toning

Two or more separate toners (either direct or indirect) used one after the other, and usually with a thorough intermediary wash. Alternatively, a toned print can then be hand-coloured for multiple effect.

Multiple toning techniques:

i) selenium toning a thiocarbamide or traditional sodium sulphide, sepia-toned print will create a warmer tone than thiocarbamide or sodium sulphide alone. Gold toning a thiocarbamide or sodium sulphide sepia print will produce an even redder, more salmon pink effect than selenium toner. A briefer period in the second toner will restrict the colour shift to the highlights. Gold toning a warm, orange-brown sepia print can create orange highlights on warm green blacks, as in **Walkham Valley**.

ii) blue over selenium toned prints can produce a blue-purple effect, partly dependent on the paper emulsion type. Chloro-bromide papers, split selenium toned first, work better in this respect.

iii) blue over thiocarbamide or sodium sulphide toned prints produces a variety of green effects, depending on the warmth of the sepia-toned print before it is blue toned. A brief blue tone will shift the colour of the blacks, without affecting the warmer highlights, as with **Fernworthy Forest**. A longer blue tone will make the print an overall green, as in **Northern France**.

iv) a blue-toned print, briefly washed till the yellow toner stain has gone, then placed in a print developer, briefly washed and retoned, will create a significantly intensified blue tone.

v) copper toning a blue-toned print can produce a range of purple-blue effects.

vi) print developer added to sodium sulphide toner, or thiocarbamide toner, produces colder toned results.

Other methods of toning or altering an image's colour not covered in this book include gelatin dye toners, mordant and chromogenic toners, hand colouring with dyes, watercolour pigments and photo oils. Pigments and oils should be archivally permanent, but the other methods less so.

Proprietary or home-made solutions?

With the exception of selenium toner I make up all my own solutions. Your decision should be based on how much toning you are likely to do, the possible cost-savings this might make, and whether you have the facilities and a suitable, sensibly ventilated workspace.

Proprietary, pre-packaged toners are undoubtedly more convenient to use, and reduce any possible health-risk from improper handling of raw chemicals — for example, if mixing-up in a badly ventilated workspace, or temporary kitchen or bathroom-type darkroom. I don't mix my own selenium toner for safety reasons (it's toxic), but for all other preparations, as long as an organised and safe approach is adopted towards all chemistry, there should be no problems.

Undoubtedly, home-made toners offer greater flexibility and control. We know exactly what they contain, and we can change this, if needs be, for more subtle or more pronounced effect. For example, I often add more potassium bromide to the bleach solution of thiocarbamide toners in order to enhance the warmth of the print when the toner is used at the yellow tone 5:1 thiocarbamide to activator ratio.

With proprietary pre-packaged solutions we are paying for guaranteed, accurate solution formulation and absolute consistency, albeit with a mark-up for packaging, distribution and necessary safety information. On the other hand, proprietary toners only list their potentially hazardous ingredients. Because they are formulated with a good shop-shelf life in mind, we don't know what other ingredients, if any, they may contain, to the detriment of their maximum potential.

Above all, home-made toners can usually be produced at a fraction of the cost of their proprietory equivalent, for example formula 51 costs about 25 pence per litre for us to make, so we shouldn't feel obliged to squeeze every last (and incompletely toned) print out of the solution.

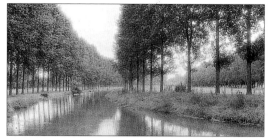

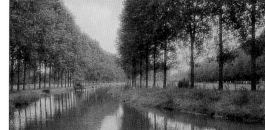

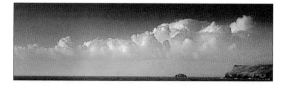

14. Very vivid blues can be achieved with most proprietary toners if they are used at full strength. Diluting them will produce less vibrant results, but the print will need to be washed for longer to remove the toner's stain.

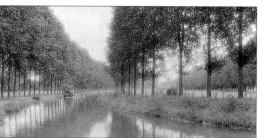

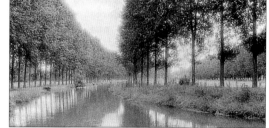

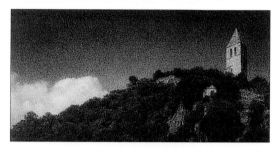

15. Bathing a blue-toned print in a very weak alkali bath will produce a more navy-blue result. This treatment should be brief, or the print will rapidly begin to lose its colour.

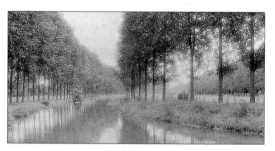

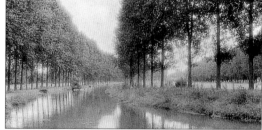

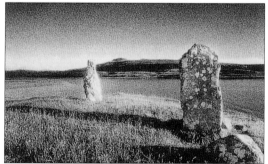

River Authie on page 65 was multiple toned, first with thiocarbamide, formula 50 and then with blue, formula 51. It was fully bleached-back in the toner-bleach formula 46, prior to thiocarbamide toning. My idea was to create a subtle, almost duotone, layering of colour. This effect is not possible with a one-bath — more monochromatic — green toner.

7. I wanted an all-over green tone, so this early proof print, which lacks density in the sky, was not suitable. Blue toner only takes where there is a silver image.

8. This proof print has a little more overall density after I increased the print fogging exposure time. However, the highlights are still a little too light.

9. Just right! The print may look flat but the blue toner will add contrast. To compensate for this, the black and white print should be made about one grade softer than normal.

10. The same print as 13, above, but blue-toned too long, or in too strong a blue toner. Washing this print for longer, to try to lighten

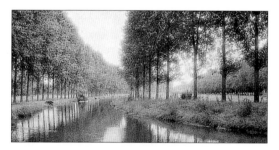

the blue tone, will lead to bleaching of the highlights, as in photograph 16.

11. Blue toners can exhaust quickly. If so, shadows will tone first, becoming very strong in colour, before the highlights begin to change. Also, after washing, the toned print will almost certainly have a toner stain.

12. Overwashed after blue toning, this print has lost its colour and some highlight density.

13. One-bath, proprietary green toners can produce good results and they don't increase print contrast.

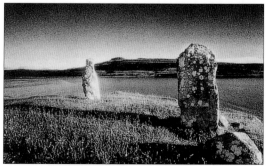

16-17. Altering the ratio of thiocarbamide toner activator will dramatically change print image colour. More toner has produced a warmer, livelier print with a more pronounced feeling of late evening light.

18. Hound Tor, Dartmoor. This print was first overexposed and then bleached-back with Farmer's reducer, in a similar way to Eileen Donan. Selenium toning, in Kodak Selenium Toner at a dilution of 1 to 5, has then enhanced the warmth of the print.

19. Differently exposed, but similarly toned, to photograph 23. The print was carelessly handled during selenium toning and the temporarily softened emulsion clearly marked. A final rinse in formula 59 would have helped.

20. Bleaching a print with Farmer's reducer, whether locally, as in Loch Ainort, or overall, as in Mis Tor, will create a brown-toned image if the bleaching is taken too far, as with this print. This colour is permanent provided the bleach contains fixer and, if it does, density cannot be replaced.

Toning Test Prints

All the toning test prints on pages 140 and 141 have been made on Ilford Multigrade FB matt paper. They been identically exposed to an Agfa Transmission step wedge that was contact printed onto the paper, in the same way a negative contact print is made. This piece of film, which measures about 5" x 1" in size, contains nineteen incremental steps of density, with each step up the scale representing an extra half stop of print exposure.

By comparing toned and untoned step wedge prints it is possible to see how particular toners will affect print density, contrast and colour, provided all the step wedges were first developed similarly. So, for example, if a toned, step wedge print loses one step of density in its highlights, a print toned in the same solution will need to be overexposed by half a stop (the equivalent of one step) to compensate for this loss. Rather than making toning test prints with a favourite negative, step wedge print-outs are an excellent way of objectively evaluating the performance of different papers and toners.

1. **Red chalk toner formula 54. Fully toned for 3 minutes.**
2. **Red chalk toner formula 54. Toned for 3 minutes, then intensified in formula 56.**
3. **Red chalk toner formula 54. Partially toned for 1 minute 15 seconds.**
4. **Red chalk toner formula 54. Partially toned for 1 minute, then gold toned for 6 minutes in Tetenal's gold toner.**
5. **Red chalk toner formula 54. Partially toned for 30 seconds.**
6. **Copper toner formula 53. Partially toned for 1 minute 45 seconds.**
7. **Blue toner formula 51. Partially toned for 1 minute.**
8. **Blue toner formula 51. Partially toned for 1 minute, then copper toned in formula 53 for 1 minute.**
9. **Blue toner formula 51. Partially toned for 25 seconds, then copper toned in formula 53 for 40 seconds.**
10. **Blue toner formula 51. Partially toned for 40 seconds, then copper toned in formula 53 for 40 seconds.**
11. **Thiocarbamide toner formula 50, 2.5 parts A, 1 part B. Partially blue toned in formula 51 for 1 minute 30 seconds.**
12. **As for 11 above, but blue toned for 4 minutes and then overwashed.**
13. **As for 11 above, but blue toned in formula 51 at a 1:1 dilution, for 1 minute.**
14. **As for 11 above, but blue toned in formula 51 undiluted, for 3 minutes.**
15. **Untoned grade 2 Multigrade FB matt.**
16. **Copper toner formula 53. Toned for 3 minutes, then blue toned in formula 51 for 3 minutes.**
17. **Blue toner formula 51. Toned for 2 minutes, then fully toned in copper toner 53.**
18. **Blue toner formula 51. Toned for 2 minutes.**
19. **Blue toner formula 51. Fully toned, but slightly overwashed.**
20. **Blue toner formula 51. Fully toned, redeveloped, improper wash and retoned.**

21. **Untoned grade 2 Multigrade FB matt. Half stop more exposure than print 15.**
22. **Standard toner bleach formula 46. Fully bleached and as yet untoned .**
23. **Standard toner bleach formula 46. Partially bleached and as yet untoned, with processing marks.**
24. **Standard toner bleach formula 46. Partially bleached.**
25. **As for 21 above.**
26. **Copper toner formula 53. Partially toned for 1 minute 15 seconds.**
27. **Thiocarbamide toner formula 50. 2.5 parts A, 1 part B.**
28. **Thiocarbamide toner formula 50. 1 part A, 1 part B.**
29. **Thiocarbamide toner formula 50. Improperly washed before toner bleach formula 46 applied, with a I stop loss of density.**
30. **Thiocarbamide toner formula 50. Warmer tone bleach formula 48, then toned in 3 parts A to 1 part B.**
31. **Blue toner formula 51. Fully toned.**
32. **Blue toner formula 51. Fully toned and redeveloped for higher contrast, as for 20 above.**
33. **Blue toner formula 51. Fully toned, then a very brief, weak, alkali rinse bath for a more navy-blue effect.**
34. **Blue toner formula 51. Not quite fully toned.**
35. **Thiocarbamide toner formula 50. 2.5 parts A, 1 part B.**
36. **As for 35, but partially selenium toned.**
37. **As for 35, but partial selenium, then partial gold tone.**
38. **As for 35, but fully selenium toned, then fully gold toned.**
39. **As for 35, but partially gold toned for 1 minute 40 seconds.**
40. **As for 35, but fully gold toned for 7 minutes.**

Residual staining of the paper's base is visible with some of these toning tests, usually the result of improper washing prior to toning.

Toning test prints. See page 139 for full caption details. Top row: numbers 1-10 (inclusive). Bottom row: numbers 11-20 (inclusive).

Toning test prints continued. Top row: numbers 21-30 (inclusive). Bottom row: numbers 31-40 (inclusive).

Washing and drying

Function of the wash

The role of the wash is to remove residual chemistry from the image — both from the emulsion and its support medium — that might interfere with any subsequent processes, such as toning, or which could reduce the anticipated life-span of the image.

How does the wash process work?

Residual processing chemistry will gradually diffuse from the image into the wash water until a balance is reached between the two. So, provided this water is removed and then replaced by an adequate supply of fresh, the diffusion process should go on unchecked until a satisfactory residual chemistry level is deemed to have been reached.

As an example, $0.01g/m^2$ is the archivally accepted level for residual thiosulphate ion (fixer) within FB paper. For double weight prints this figure should be attainable after about one hour's wash in water at 20°C — depending on the other controlling factors outlined below— whilst for RC papers the same level can be reached in just a matter of minutes.

For absolute assurance, residual thiosulphate levels can be checked, as mentioned in ARCHIVAL PROCESSING and in the FORMULARY, and the wash continued if needs be. But, provided recommended wash times and procedures are followed, such tests should not be necessary except, perhaps, when first working with a new washing system, or if working in another part of the country where the water may have a quite different pH value.

Unfortunately, similar residual chemistry tests have not been devised for checking toner chemistry levels in the print (there are too many variables) so, although these solutions will normally wash out of the print much easier than fixer, it is still very important to follow recommended minimum wash times and if possible to extend these times, provided the toned print will come to no harm. In my experience some suggested wash times for toned prints are over-optimistically short. For example, prints that are to be thiocarbamide toned really do need more than a 'minimum' wash time, if sufficient residual fixer is to be removed, to prevent permanent reduction of the print's highlights in the toner's bleaching bath. Similarly, selenium-toned prints need to be properly washed after toning, as the toner itself contains fixer. For FB papers, if a hypo-clearing bath is not used after selenium toning, then the print will require a further one hour's wash if the water is at 20°C.

Controlling factors

As a gradual process of chemical diffusion, the speed of the wash cannot be accelerated simply by increasing the flow of fresh water. If anything, vast torrents will only serve to physically damage the film or print. To this effect, I remember reading one American magazine in which the author spoke of cutting a print in two and washing one half in his darkroom and the other in a fast flowing stream at the bottom of his garden. The results conclusively proved there was no benefit to be had from the faster flowing method! However, wash time and its efficiency do vary — greatly — according to a number of other factors.

These include:

Emulsion and base support

As a general rule, the less absorbent the photographic material the better. For example, how many of us have the time to multiple tone FB prints, when their minimum total wash may take as long as two hours? Add to this the time it takes to expose and develop the print in the first place and we're talking about a very long printing session. This may require the setting aside of an entire evening (or more usually a whole night!) for the making of one 20" x 16" exhibition quality print.

So, whilst I would advocate FB papers for the ultimate in black and white, I would only seriously recommend their use if you have the required time to wash them properly. If not then stick to RC.

Film and RC paper — their non-absorbent bases need little washing but their very thin, chemically absorbent emulsions require a little longer.

FB paper — their absorbent paper support requires the longest wash, with triple weight papers requiring the greatest length of time.

See: WASHING TIMES on page 145.

Emulsion type should have little effect on the speed and efficiency of the wash, but its thickness will play a significant role, so will the way it has been processed. For example, if a hardening fixer has been used, the emulsion will be physically altered — contracted — in condition which will significantly inhibit the diffusion process.

Fixing

Proper fixing will keep wash times as short as possible. For obvious reasons underfixing should be avoided, but for perhaps less obvious reasons over-fixing is not a good 'play it safe' technique. First, it may start to bleach the more delicate, finely divided image silver and, second, it gives the fixer longer to penetrate the absorbent base of FB paper, from where, unlike other processing solutions, it is not so easily removed. Hardening fixers, or hardening agents added to fixers, also necessitate longer than normal fixing times for full hardening effect. This in itself will require a longer wash time to remove the fixer, as will their emulsion toughening effect, as mentioned above.

An overworked fixer should also be avoided as it will contain an excessive amount of soluble silver complexes which, with the longer fixing time required, will have more chance to penetrate the paper's base. This is the basis of Ilford's fixing sequence, outlined below. Worse still is to fix prints in used film fixer, as this too contains soluble silver complexes that are very hard to remove from FB paper.

In excess, such silver complexes will make extended washing quite useless, although the detrimental effects may not be immediately noticeable.

So, as a general rule, I will regularly test the fixer with silver estimating papers and especially if processing FB prints — not just to keep an eye on the efficiency of the fixing process itself, but to make sure it won't unduly affect the wash or the toner. I've made too many failed prints even to begin to think about overusing a fixer!

If you stick to recommended levels of soluble silver within fixers, and use either Ilford's rapid single-bath technique or the two-bath fixing method (see ARCHIVAL PROCESSING), you should have few problems. Ilford's shorter fixing time technique is not underfixing, it simply uses a stronger fix to shorten the process.

1. Staining of the paper's base after toning indicates either improper washing prior to toning, or the use of an exhausted toner.

2. A slightly exaggerated case of overwashing! In fact, this FB print was in the wash for just a day and a half before the emulsion came off.

3. My first print washer in action, as described in DARKROOM SET-UP.

Hypo-clearing

The use of a hypo-clearing bath after fixing, and preceeded by a short wash, will greatly reduce wash times. With the exception of selenium toner (it contains fixer), I hypo-clear and then wash my FB prints for the stated time before toning. Hypo-eliminators, which chemically eliminate (oxidise) all traces of residual thiosulphate, are no longer recommended. From an archival point of view, it is nowadays agreed that some minute traces of residual thiosulphate (as after normal washing) will, in fact, help to protect an image; like a brief archival selenium tone, they will combine with the silver to form a more stable (but invisible) compound of silver, in this case silver sulphide, as opposed to silver selenide.

Toning

Most residual toner is easily washed out of the image, but I would suggest their use should be preceeded by a full wash (and a hypo-clear for FBs) to prevent non-reversible reduction of the print in the toner's bleach (e.g formula 46). After toning, I give selenium toned prints a brief rinse, then hypo-clear them, followed by washing for the normal time. Blue- toned prints must not be overwashed or they will lose their colour. This also applies to prints like **Fernworthy Forest** that have been multiple-toned, with blue as the second toner.

Water temperature

It plays a critical role. Ideally, the temperature of the wash should be kept at 20°C, i.e. the same as for other black and white processing solutions. This helps to prevent physical damage, such as reticulation of negatives. However, warmer water can be used to accelerate the wash, but this temperature change should be initiated gradually. I would certainly not recommend water above 25°C if heat drying prints in canvas, blanket-type driers: the emulsion of some papers, such as the warmer-tone chloro-bromides, may stick to the blanket.

However, I do sometimes increase the temperature of the wash to about 30°C, to speed up the removal of the yellow ferricyanide-ferric ammonium citrate stain of blue-toned prints. before the blue tone itself has time to be washed out. Generally speaking, hotter water should be avoided for its temporary emulsion-softening effect, as depicted in the Hound Tor photograph in TONING (besides, if you're into archivalling, such radical changes should be avoided). In this case, hot water, at about 40°C, was used briefly to rinse the print after selenium toning, solely to improve the colour of the toned image. I have found that a stronger red-brown tone can be achieved in this way. I will sometimes use the same technique to bring back the full density of thiocarbamide-toned prints, as outlined in TONING, whilst the same treatment will make blue-toned prints much more vivid, even cyan, in colour.

Colder water will slow the wash process and should the temperature fall below below 8°-10°C, no amount of washing will remove enough residual fixer from FB prints to reach archival standards and predictable toning requirements, unless a hypo-clear has been used.

In winter, tap water may average just a couple of degrees centigrade above freezing, whilst in summer it usually rises to a convenient 18°-20°C. In colder months we either need some form of in-line water heater, preferably thermostatically controlled to avoid very sudden fluctuations in temperature (usually caused by changes in water pressure), or we must manually wash important images in 'baths' of warmed water. (see WASHING METHODS below).

The TIME-TEMPERATURE chart provides a useful, rough guide for altering wash times according to variations in water temperature.

Water pH

A neutral pH water supply is best; it won't interfere with any chemically sensitive toned images and it can be used to mix chemistry, such as highly dilute film developers, without fear of altering their performance.

Mildly acidic water, below pH7, (or an overly strong or prolonged acid fix), will slow the wash process, so I would recommend a hypo-clear for all FB prints, whether they are to be toned or not. More alkaline water, above pH7, will improve wash efficiency but may soften the emulsion until it has dried, so take care when handling prints — don't touch their image surface.

Tap water contains varying amounts of soluble and insoluble solids. These can leave precipitated scum-type deposits on film and paper, hence my use of deionised water for the final rinse of all film. Any tiny, water-borne iron particles may lead to small dark pin marks on some toned prints. An in-line water filter or, perhaps simpler, a manual, hand-held filter (for final rinses) may prove invaluable.

For fine control, I suggest testing the wash water with pH papers and, if this varies greatly from the norm, to apply residual thiosulphate tests to the white print margin at various stages during the wash, to establish a 'normal' wash time for your own individual set-up. These residual test formulas can be found in the formulary.

Washing methods

Water exchange

For chemical diffusion to take place, there must always be a supply of fresh water adjacent to both the emulsion and support medium of each image. For this purpose, a special wash unit may sometimes be wanted, such as an archival print washer, that performs this task automatically. Alternatively, a cheaper, manual washing system, such as rotating prints in a dish by hand, may have to be settled for. Either way, it is a good idea to test the efficiency of your intended washer or washing system using the indicator method, formula34.

FIlm

Rollfilms developed in plastic or metal handtanks are easily washed without the need for a special wash unit. Their design, and that of their spirals, is such as to permit good processing solution exchange (to both the emulsion and its support medium) so we can safely assume this includes the wash. Special archival film washers are available for those seriously intent on the ultimate in film processing. I haven't found them necessary.

The method I use to wash rollfilms, like many others, simply involves inserting a $1/2$" hose into the plastic hand tank funnel and then letting the flow of the water do the rest. If sufficiently tight fitting, this hose should force the water down through the central column, so that on its way out it takes with it the heavier, fixer laden water from the bottom of the tank. However, as a precaution, I will occasionally empty the tank by inversion, perhaps three or four times during the wash, to ensure that all fixer contaminated water is removed. I'll also agiate the tank every couple of minutes to remove air bells clinging to the emulsion surface — as described in FILM PROCESSING.

This method works well provided there is a constant supply of water at the right temperature, but in the winter, if warm water is in short supply, a drain and fill method may have to be adopted.

This manual method is just as effective, it's just more labour intensive. Once the film is fixed the tank is filled with water, warmed to 20°C, agitated for a minute or so and then drained. It is then refilled and the process is repeated. After the second emptying, the tank can be refilled at three minute intervals until a total wash time of twenty minutes has been reached. All that is required for this method is a source of hot water — a kettle will more than suffice — and a mixing vessel for the water. It is a good idea to rinse out the kettle first.

Paper

Archival print washers make washing as easy and as effective as films washed in handtanks. Their individually water-fed, chambered design keeps each print free from chemical cross contamination, such as from freshly fixed or toned prints added to the wash later. This is particulary important for prints waiting to be toned.

However, they are relatively expensive and in my experience they don't do it all on their own, especially if warm water is scarce, when a modified, more manual method of washing will be needed.

The archival washer that I use is a Nova 20" x 16" model. I have slightly modified its use, in that I have attached a 3 foot hose to the outlet which then feeds a 20" x 16" processing dish. This acts as a pre-rinse tray, for freshly fixed images.

Once the first print of the session has been rinsed in this dish for a few minutes, I hypo-clear it and then put it into the nearest washer compartment. When the second print is rinsed and hypo-cleared, I'll move the first one along to the next chamber and replace it with the second print, and so on. On the assumption that it takes me at least five minutes, and usually ten, to process each print, by the time the first print has reached the last chamber it will be archivally washed, without the need for gallons of water flowing through the unit to flush out fixer-contaminated water.

Working this way cuts down the amount of warm water required; I simply switch the washer tap on every five minutes to flush the water through completely and to agitate the prints. Residual fixer tests show the sytem works.

I wash toned prints in the same manner, but with added care to make sure their often quite soft emulsion doesn't get damaged between chambers.

Manual print washing methods

Washing prints without an archival washer is no less efficient. It is capable of producing an archivally washed photograph provided the residual processing chemistry is given a chance to diffuse out. At its simplest, this means rotating the prints top to bottom in a tray of water and replacing this water at five minute intervals, over a one hour period, rather like the drain and fill film tank method.

This method may be more labour intensive than using a purpose-built archival washer, but it is considerably cheaper and given the appropriate number of water changes, a double weight FB print will be archivally washed provided no other prints are added to the dish during this time. If they are, then the process will need to be continued for another hour. For 20" x 16" images, I would say six prints to a dish is the maximum for this method.

4. Draining prints, before they are screen-dried, speeds up drying times. Tilting the print, at an angle on the plastic sheet, ensures the water drains freely from the bottom edge of the paper. Here, an acrylic sheet divider from an archival washer is being used.

5. Untoned prints can be wiped free of surplus water with a soft-edged wiper blade. Apart from reducing drying time, removing water from the print's surface also helps to avoid potential water droplet drying marks.

6. Back-to-back drying leaves FB prints almost completely flat. But care should be taken with larger, heavier prints they do not slip from the line. Wooden, rather than plastic pegs, are better.

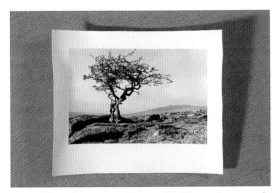

7. Drying times are short with fibre-glass mesh (mosquitoe netting) drying screens. They allow air to get to both sides of a print. These non-absorbent screens are easily washed free of any unwanted chemical contamination.

8. I use this canvas-covered, flatbed drier for quickly drying test-strips and rough proof prints, that have been briefly washed, as the stained blanket indicates.

Dish washing, with a clip-on, photo-tray syphon, is a good halfway house; prints still need to be rotated top to bottom, but the syphon will do the job of changing the water.

So, personally, I would avoid any washer where the water simply flows out from the top, as with some tiered washers. Remember, fixer is heavier than water. It sinks and needs either to be flushed out, as with an archival washer, or syphoned out, as with a clip-on photo-tray syphon washer.

Washing times

MATERIAL		TIME	NEW TIME
Film		20 mins	10 mins
RC paper		3 mins	n/a
FB paper	SW	40 mins	20 mins
	DW	60 mins	30 mins
	TW	80 mins	40 mins

* Washing tIme is based on the efficient removal and replacement of water throughout the wash period. The above times are for untoned prints.
* The 'new time' is for images that have been hypo-cleared. See TONING and FORMULARY for more nformation on wash times for toned prints.
* FB washing times are for prints that have been fixed using the two-bath method. Ilford's one bath method, coupled to the use of their Galerie Washaid, can reduce times further. (Consult Ilford's literature for full details.)

Drying

Film

After the FINAL RINSE, I shake the spiral free of water and simply hang my film up in a dust-free and draught-free place and let it dry naturally. The use of deionised water, and the right amount of wetting agent, for the final rinse, keeps the drying time quite short and by using this method I tend to avoid any problems sometimes associated with heated drying cabinets, such as 'tide marks'.

Paper

I air dry, rather than heat dry, any important RC prints, giving them a final rinse, with a little wetting agent added, so that when they are hung up on a line they drip-dry, simply and quickly. I reserve the use of heat driers for proof prints and contacts, largely because I am never sure whether the heat drier may have been used for any hurriedly processed or improperly washed rough prints.

To air-dry RC prints, I hang them up by one corner, or if they are larger than 12" x 10", I attach a clothes peg to both top corners and then let them drip-dry.

For FB paper there are several drying methods:

i) photographic blotters — prints are first drained of surplus water then placed in between the (photographic quality) blotters which are then stacked into a pile. After an hour or so, the prints are transferred one by one to another set of dry blotters and the stacking process is repeated, perhaps several times over a several-hour period, until the prints are 'dry'. After drying, prints should retain no more than a little surplus humidity, or else they will curl, and will need to be flattened off later. Blotters are fine, archivally, provided they are of 'photographic quality' and have definitely not been used for any improperly processed or badly washed prints.

ii) fibre-glass mesh drying screens — washed and drained prints are laid on these, either face down, provided the emulsion has not been softened too much during processing (perhaps through toning), in which case it may pick up a pattern from the absorbent, fibre-glass screen, or face up, in which case they will curl more, especially if dried quickly in a warm room.

Alternatively, to prevent almost all curling, another layer of mesh can be stretched over the prints as they are dried. These non-absorbent screens are easily washed and are ideal for archival work. Their use is the method I prefer, and if I have to dry a lot of RC prints, rather than hang them up on a line, I quickly lay them out on a screen.

iii) back to back — two prints can be hung, back to back, from a line with clothes pegs at both their top and bottom corners. As the prints dry, their emulsions contract and as each paper starts to curl outwards, the opposing pull of the other print keeps them both flat.

This method is ideal for archival work, since the only point of physical contact is between the pegs and the non-image area of the print margin. It is much easier to align the two prints whilst they are in the wash: by turning one over and then floating the other on top.

Whatever the method of air drying, whether for films and papers, try to avoid locations that come into close proximity with sources of processing chemistry, or harmful fumes. Incidentally, I would not recommend heat drying FB prints in canvas, blanket-type heat driers or glazers. Like photographic blotters, their absorbent canvas drying cover will pick up — and retain — any unwanted processing chemistry from poorly washed prints.

Archival processing

What is it?

All photographic images will decay. The speed of this process is determined by the inherent qualities of the material, how it is processed and the way in which it is subsequently looked after. Archival processing is therefore an ongoing process, continuing beyond the darkroom. It includes retouching, image presentation and storage — in fact, anything that might affect, or prolong, the potential lifespan of an image.

Why archivally process?

It is a personal decision. There are no rules (yet!) as to how we should process our prints. For some of us, the pleasure of photography may be derived purely from the very act of image making, in which case archival processing may never be on the agenda. For others, it might be the very process of photography itself, including archivalling, that is of interest.

Either way, the fact that all photographic image makers decide to fix their images (or think they have!) is an admission that they want to go beyond the pure act of image making. To then take a further step towards archivalling is simple — maybe nothing more than keeping a more careful eye on processing techniques: fixing and washing in particular — which requires little, if any, creative compromise. And, to go that little bit further? In some cases, it may require no additional effort at all.

Chances are, everyone has archivally processed films and prints without even realising it. For example, in the simplest archivalling scenario of the largely chemically non-absorbent RC print, the process just requires proper fixing of the print (i.e. for the recommended time, with agitation) in a fixer that is not in any way overworked. The image should then be properly washed, say, for 5 minutes in a fresh, fixer-uncontaminated supply of water, followed by air-drying.

Agents of decay

Strange though it may seem, fixing, or more correctly, improper fixing, is probably the photographic image's worst enemy; that and insufficient, or improper washing.

Underfixing — caused by too little time in a fresh fixer, or fixing for the 'normal' time in an overworked, slowed down fixer leaves an archivally unstable image.

Overfixing — caused by too long a time in a fresh or overworked fixer, will necessitate a longer than anticipated wash, but even an extended wash of an over fixed image, or one that has been fixed in an overworked fixer, will not reduce fixing silver by-product levels to archival standards.

Fixing by-products — most importantly residual thiosulphate (fixer) and silver complexes (dissolved, unexposed silver) from the emulsion, or from previously fixed emulsions held in the fixer. These will enter the emulsion, especially the paper base of FB paper, and, if not washed out, can cause premature image decay, most noticeably in the form of brown staining and fading.

In conventional black and white (untoned) work, the job of the wash, as I have mentioned in WASHING AND DRYING is to remove residual thiosulphate and silver complexes from the emulsion and support medium. For this to be possible, the soluble silver content of the fixer should not exceed 0.7g/litre of working strength fixer solution, whilst after washing, residual thiosulphate-ion levels in a processed and washed print should not exceed 0.01g/m^2.

To test for:

i) Levels of silver in the fixer:
a) keep a count of the number of prints fixed per litre of working strength fixer; for FB paper I would recommend that the number should not exceed twenty 10" x 8" prints (of average image density) per litre, when working with the two-bath fixing method,
b) use silver estimating papers, checking the colour of the test paper (after it has been dipped into the fixer) against its colour chart under artificial tungsten light, not flourescent light, or daylight.
c) use the fixer testing formula number 33.

ii) Residual thiosulphate (hypo) levels in the image:
a) apply Kodak HT2 test (formula35) to the white print margin and check the stain, if any, under tungsten light, comparing it with Kodak's Hypo Estimator colour chart. It should be lighter than the first cream-coloured patch.
b) apply selenium toner (formula 36) to the margin

as for a) above and note any stain once blotted off.

In either of these tests, anything more than a pale cream stain requires longer washing to reduce thiosulphate levels to the 0.01g/m2 level. Daylight should not be used to check the colour of these tests, as it may 'artificially' darken any stain.

The best materials for archivalling

Film — all films, if properly processed, washed and dried, will conform to archival standards of processing. However, the finer silver grain of slower speed films is somewhat more susceptible to improper processing, especially over fixing which will begin to bleach delicate shadow detail.

RC and FB paper — in the past, RCs were not considered as permanent as the FB variety. This was because of the physically more unstable nature of their construction: a piece of paper, laminated between two waterproof sheets, with the emulsion 'stuck' on top.

Nowadays, advances in paper manufacturing have ensured that a properly processed RC print will last almost as long, if not as long, as a properly processed FB. And, it is worth bearing in mind, that it is easier to process archivally, and in particular to wash properly, an essentially non-absorbent (quick and easy to wash) RC print as opposed to a chemically more absorbent FB paper, especially if washing facilities are limited.

The archival process

A consistent approach is essential — simply to ensure that solution capacities and processing times/temperatures are kept within known tolerances and manufacturers' recommendations.

Development

The developer plays an important role, albeit indirectly. Finer grain development of films and prints (warmer tones) will create images that are more susceptible to overfixing and subsequent decay, perhaps through insufficient washing. A brief seleneium tone of such images will certainly help to protect their intended lifespan.

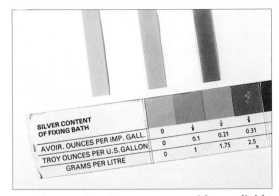

1. Silver estimating papers provide a reliable means of checking the silver content of used fixer. The left-hand strip is unused, the middle strip indicates a fixer that is quite fresh and the right hand one shows a fixer that is no longer suitable for archival processing.

2. Kodak's Hypo Estimator chart is designed for use with their HT2 testing solution (formula 35). It provides a visual indication of residual fixer within the print.

3. The undiluted activator of thiocarbamide toner is pH 13 (blue), undiluted acetic acid stopbath is pH 1 (red) and diluted acid fixer is pH 5 (orange).

Stopbath

A fresh, regularly changed stopbath (either the plain water or acid variety) is essential. It ensures the fixer remains as free as possible of developer contamination, so that it can do its job — completely — in the recommended time.

Fixing

There are two recommended methods of fixing:

i) Ilford one-bath method
Use an acid stopbath, then fix the print in Ilford Hypam rapid fixer at a dilution of 1+4, and at 20°C for exactly 60 seconds, with constant agitation. Once ten 10" x 8" prints (or their equivalent), of average density, have been fixed in a litre of this working-strength fixer, replace the bath with fresh. The used fixer can then be kept for archivally less important images, such as RC contacts and proof prints which will tolerate a higher silver level of between 1.5-2.0g/m^2.

ii) Traditional, two-bath fixing method
Make up two fixing baths, of either the rapid ammonium or the slower, more traditional, sodium, thiosulphate fixer, with both dishes at the same working strength (don't mix the two types of fixer). Fix the print in each bath for half the total recommended time, agitating constantly. Once the first bath reaches its 0.7g/litre level of soluble silver, replace it with the second and make up a fresh second bath. The process can only be repeated a maximum of four times before both baths should be replaced with fresh.

The main benefit of Ilford's system is that with such rapid fixing there is very little time for the fixing agents of decay to penetrate the paper base of FB prints. However, the process must be very accurately timed and, because of the strength of the fixer, it may affect the delicate silver highlight detail of prints developed to a very warm tone.

The main benefit of the two-bath method is that a greater amount of paper can be processed per litre of working strength fixer. This is because the first bath does the bulk of the work, and because the print is removed from it half way through the total fixing time, it doesn't have long enough to absorb much of the fixer and silver by-products held in the first fixing solution.

For archival processing I would never recommend hardening fixers or the addition of a separate hardening agent to the fixer, they require prolonged fixing for full hardening effect and they inhibit washing, as discussed in WASHING AND DRYING. If it is necessary to use a hardening bath,

for example if heat drying FB prints with a canvas, blanket-type drier, then it is better to make up a separate bath, such as the plain acetic acid variety (formula 59) and to use this once the print has been washed for at least half the total wash time.

Hypo clearing

For archival purposes I would recommend the use of hypo-clearing baths for FB prints and films. Not because their use is essential, rather that they ensure better washing at lower temperatures and they reduce wash times. Attention needs to be paid to the instructions that accompany specific brands, in particular the clearing time: for example 10 minutes for Ilford Galerie Washaid and 4 minutes for Kodak Hypo Clearing Agent.

I tend to pre-rinse my films and prints before using such a clearing bath, simply to maximise the capacity of the solution. The practice of combining hypo-clear and selenium toner into one bath is no longer recommended: a) the toner outlasts the hypo-clear and b) selenium toners contain fixer.

Toning

A number of toners can be used as part of an archival processing sequence. Some can be used to improve permanence whilst others: selenium, gold, thiocarbamide and traditional sodium sulphide sepia in particular, will significantly improve image permanence. Some toners will have little effect on image permanence — one way or the other. For example the redevelopment toners, formula?? Others can have quite a detrimental effect, whilst none will be of any benefit if the toned image is not properly washed afterwards. See TONING for more detailed information.

Washing

I have covered most of this this in WASHING AND DRYING and I have also listed various archival washing tests in the formulary.

Drying

For prints and films I would always recommend 'contactless' air-drying methods as outlined in WASHING AND DRYING.

For film, a heated air drying cabinet is archivally quite acceptable provided it is not too hot — I would recommend a maximum temperature of 35°C, although I still prefer simply to air dry my films at room temperature.

Print finishing

I can't think of a single FB toned print in this book that hasn't needed to be flattened or retouched in some way. Usually, this retouching work has involved the simple spotting out of small white marks on the print. More often than not, these are the result of minute specs of dust on the glass over-panel of the negative carrier, but they can also be caused by improper processing, handling or storage of negatives.

Almost all the prints in the main photospreads have also been 'improved' by some additional retouching work, such as the removal of unwanted distracting detail. For example, just look at the before and after retouching photographs of **Rannoch Moor** and **Black Mount**. I can think of nothing more satisfying than being able to run my eye uninterruptedly over a properly retouched print, whose seamless, totally smooth tone should create a desire to touch its surface rather than an urge to pick at it.

For this purpose I will often spend half an hour or more retouching a 20" x 16" exhibition quality print that has been made from a highly magnified 35mm negative.

Flattening prints

I retouch my FB prints after they have been flattened, but before they are window mounted, as this makes them easier to rewash if retouching dyes have been applied too heavy-handedly.

RC prints — if properly processed should dry perfectly flat. If not, then chances are, they have been washed for too long, or subjected to excessive heat during drying. Either way it is almost impossible to reverse this curl, so making another print may be the only remedy.

FB prints — almost always need some flattening after air drying, even if they have been dried back-to-back or on a fibre-glass screen with an additional mesh covering layer pulled over them as they dry. Even heat-dried FB prints may need to be flattened, especially if the canvas drying cloth isn't evenly tensioned or lacks sufficient pressure.

There are a number of flattening methods to choose from. The one that I prefer is the heat press method i), although in the absence of a press I would opt to spray the back of the dried print with water, method ii).

i) Heat press — a dry mounting press can be used to gently heat flatten FB prints. The method I use is to place a print in between two sheets of clean, uncontaminated museum board and then to insert this sandwich into the press, which should be no hotter than 90°C. Gently apply pressure and heat the print briefly, for 15 seconds, so that it becomes warm — but not hot. Take the print out, lay it face down on a clean surface, under a weight as it cools, so that it will eventually lie flat. Repeat the process for the next print, and so on. Prints must be dry prior to heat flattening, or they will stick to the boards with irreversible consequences.

For the same reason, the boards must be pre-heated for each flattening session. Place them in the press for about 2 minutes once it has reached operating temperature. This should be long enough to drive out all ambient moisture; the boards will steam slightly when removed, so repeat if necessary, until they feel completely dry. Before flattening the print, check that there are no dirt particles stuck to the board, print or the press that might indent the image under pressure.

NB: only one print at a time should be dried in this way and if allowed to overheat, the emulsion may appear locally glazed. Therefore the press should never be used without the protective boards, although heavyweight paper, of about 200gsm (minimum) will work well. Personally speaking, I would never use heat press silicone release papers for the same purpose, since on occasion I have found they can mark the print.

ii) Spraying the print — a fine, plant-mister can be used to spray the back of FB prints very lightly with water until they become just damp, and very slightly limp. Each print is then placed in between clean dry photographic blotters and then left under a weight until dry.

iii) Cold press — dry prints can be flattened, albeit fairly slowly, in a pile in between two boards and under a heavy weight, such as a stack of books. The full flattening effect may take several days and to prevent any marking of the prints make sure that they are of the same overall size.

Whilst on the subject of flattening, it is worth pointing out that all flat FB prints will tend to curl if they are moved between environments of differing humidity and temperature. For example, taking air 'dried' prints from a humid basement darkroom to a less humid, possibly centrally heated upstairs viewing area will cause almost immediate curling.

To prevent this, prints should not be left face up on their own. Instead, keep them under a weight as they acclimatise to the change

Before measuring heat-flattened prints for window mounting, or before hinging them to a window-mount backing board, give them an hour or so to reabsorb atmospheric moisture so that they have time to expand back to their true size. I once window mounted a whole exhibition of photographs, measuring the prints as soon as they had come from the heat press. The mattes were subsequently all a couple of millimetres too small!

Retouching

Both RC and FB prints can be retouched, although only FB's can be gently etched with a scalpel to remove small black specs, caused by dust on the film prior to camera exposure, as in **Bradwell Barges**, or to lighten catchlights as in **Glen Coe**.

If a print is likely to need spotting with a brush, for example if the negative is particularly dirty or damaged, then I always opt to make the image on FB paper. Its more absorbent emulsion takes retouching dyes and pigments much better.

As a general rule non-gloss, matt, semi-matt and stipple surfaces are best for retouching. Their surfaces mask such work, whilst their lower Dmax makes easier any building up of density with dyes.

Cleaning film

In particularly bad cases, rewashing a dirty negative may be necessary, especially if the print is to be made with a condenser enlarger that will show up almost every spec of dirt and dust. Negatives can be easily rewashed, by first soaking them in water at 20°C for about ten minutes, after which they should be immersed in filtered or deionised water containing wetting agent, at the right dilution — as for the FINAL RINSE. After a minute or so gently wipe the negative with a swab of cotton wool that has been immersed in the same solution of water and wetting agent. Then put the negative back into the solution for half a minute, shake off the surplus and hang it up to dry in a dust-free environment. On no account would I recommend squeegeeing such negatives, in case all the dirt has not been removed. Incidentally, strips of 35mm negatives can

1. Retouching the distracting straight line of this dried-out watercourse helps to draw attention to the more natural, flowing shape of the stream.

2. Carefully etching the ridge line of the house, with a pointed scalpel blade, has given the building much needed, added dimension.

3. Dust on the film prior to exposure has left a clearly visible short dark line in the middle of the print. Often this sort of unwanted detail will go unnoticed, but in an area of uniform grey tone it needs to be etched out.

be safely handled by inserting a plastic paper clip through one of the film's sprocket holes.

If this treatment doesn't work, then you'll have to resort to retouching the print, perhaps diffusing the image and printing it with a softer lightsource, as mentioned below.

Spotting

For spotting non-glossy matt, or semi-matt papers I prefer to use artists' quality watercolour pigments. These are inert, lightfast and easily removed from the print, with a damp (not wet) cotton bud if the retouching has gone wrong — for example, if the colour does not match the toned image or if the retouching is too heavy. They are also very permanent when dry but with the added advantage that, because they sit on the print's surface, they can be worked on locally with the tip of a very sharp scalpel blade without damaging the print surface. This is a particularly useful trick for removing any surplus pigment, or to locally lighten retouching work without having to lift all the pigment off with a cotton bud and start again.

I have also retouched matt papers with retouching dyes and artists' watercolour dyes. However, if a mistake is made they are less easily removed from the emulsion in which they sit, requiring a print rewash which is time consuming and which may not suit wash-sensitive images, such as blue-toned prints (for example **Pentire Point**).

Applying watercolour pigment is very easy. If the photograph is toned, I first test the pigment on a spare print to check its colour matches that of the print. Then, making sure the brush is merely damp and not wet with pigment (that would leave a drying mark), I will gradually apply the medium, building up the required density in stages. Generally speaking, when the brush is freshly charged I will start by retouching those marks in the darker areas of the print and then, as the brush becomes progressively drier, I will move to the lighter parts of the print where the retouching has to be the most delicate.

For larger areas I first lay down a lighter 'wash' and, if the image is quite grainy, I will add the remaining density with a grain pattern, created by dabbing the very tip of the brush onto the paper in a random manner. For this stage the brush is charged with darker pigment.

If you look at the top edge of **Black Mount** in some of the proof prints, you'll be able to see a very bright area about a third of the way in from the right. This area is very dense in the negative and if I had wanted to burn it in I would have most probably resorted to fogging the paper locally as well. Although fogging alone would have done the job, it might have left a rather distracting grain-free area. Easier, I thought, to retouch it, as I have done for the main toned print. To keep this retouching

neat I laid a piece of paper along the print margin to act as a ruler.

I retouch all gloss papers with photo-dyes (since the dull matt finish of watercolour pigments shows up). I will start on the darker areas first, just as for pigment work, but owing to the rather translucent nature of photo-dyes, it is usually necessary to apply the dye in several stages, letting it dry in between each to prevent dull-looking drying marks. Again, the brush should only be just damp for such work. How lightfast these dyes are is difficult to say, although if they do fade in years to come it is a fairly easy matter of applying some more.

Any pigment or dye should be mixed with tap or deionised water and not saliva, i.e. don't lick your spotting brush, even though this does give it a nice fine point! Salivary enzymes are designed to break down animal products, and will attack the gelatin of the emulsion. Cotton gloves can be worn when retouching, to protect the print from dirty or greasy hands, although I usually prefer to do without and to lay a clean sheet of paper between the print and my bare hand, as in the **Bradwell Barges** retouching photograph.

Removing scratches

Scratches on the film backing, giving white lines on the print, can be dealt with in a number of ways:
i) if using a condenser enlarger, I would switch to a softer lightsource, such as a diffuser or cold cathode. This will drastically reduce the visible extent of any dust or damage and it will also soften the edges of scratch lines, making them much easier to blend in when retouching,
ii) part diffuse the image during print exposure, although care must be taken not to overdo this if you don't want a diffused looking print. I would give a maximum of half the total basic print exposure time using my anti-Newton glass diffuser (or similar). You'll have to test your diffusers to see how much diffusion is acceptable,
iii) wipe a little grease from the side of your nose across the scratch and then make the enlargement,
iv) apply a little glycerine across the scratch and then make the enlargement. Glycerine can be purchased from the chemist or supermarket. It's cheap and totally safe to use.
v) apply a little proprietary scratch solution such as Tetenal's Repolisan, allowing it dry before making the enlargement, or
vi) retouch the dry print with a spotting brush and retouching dyes or artists' pigments.

Methods iii), iv) and v) work on the principle that the scratch is filled with a substance of approximately the same refractive index as the film's backing material. Glycerine and nose grease can be removed by a brief rinse in water with

added wetting agent. Tetenal make a solvent for thinning and removing Repolisan.

Scratches on the film emulsion, giving black lines on the print, can also be dealt with in a number of ways:
i) switch to a softer lightsource, but don't diffuse the image since this will exacerbate the effect,
ii) apply a little brown or black shoe polish across the scratch and make the print, spotting any trace of a white line on the print where the scratch has been overfilled. It is easier to spot out white lines than to etch black ones with a scalpel, so don't worry if the scratch is overfilled with polish, or
iii) print the negative as normal and knife the dry print, using a very sharp finely-pointed scalpel.

Knifing prints

FB prints can be etched with a scalpel to remove small dark marks or lines. Usually these are the result of dust on the film before it was exposed, as in the **Bradwell Barges** photograph. However, a scalpel can also be used creatively to add local 'catchlights'. For example, **Glen Coe** was knifed to accentuate the ridge line of the roof. And, occasionally, I have found it necessary to etch the print where the usually neatly broken up, random grain pattern of the image has become locally blocked up, causing a small 'worm-like' pattern.

Knifing seems to be a much underestimated craft. Perhaps the idea of literally shaving the surface off the paper is enough to deter most people, yet the process is actually quite simple and very effective — although it is imperative that the right type of blade is used and it must be very sharp. For fine detail I use a pointed blade, whilst for larger areas a more rounded one is definitely better. You'll also need a steady hand and a good viewing light.

Rather than lay the dry print completely flat on a hard surface, as some books advise, I prefer to bow the paper a little so that the area to be etched actually sits slightly raised; putting a weight on either edge of the paper will then hold it in place. Working in this way, you'll be able to hear the scalpel 'sing' as it is carefully drawn across the paper and should you press too hard, the paper will be able to give under the extra pressure, rather than the blade dig deep into the emulsion.

The skill is to work gradually, shaving the very surface of the emulsion off — little by little. If the blade is not absolutely sharp it will hop across the paper picking at its surface, creating a line of white spec marks. Properly exercised, no brush work should be needed once the mark has been lightened to an acceptable degree, although for glossy surfaces the sheen of the paper will have

gone so you may want to apply a little artists' gelatin size locally with a fine spotting type brush. The size is available in small quantities, as a liquid, from most good art stores. Alternatively, gelatin granules can be bought from most supermarkets. Add about 20-40grams to 500ml of cold water and leave for 20 minutes to swell before use.

Inter-negatives

In extreme cases of negative damage I tend to make an enlarged inter-negative from the original, using Kodak Direct Duplicating 5" x 4" film. This larger (easier to work on) negative can then be retouched using a fine artists' brush, very lightly dampened with retouching dye.

Making an inter-negative is very easy — it's just like making a print. Put the original negative in the enlarger carrier as normal, set the easel blades to give a least a quarter inch border all round and then size-up and focus the image. Before exposing the film I suggest you lay a piece of thin, clean, matt black paper on the easel, under the film, to prevent image-forming light reflecting back into the film during the exposure. The right inter-negative exposure time is best determined by making a test-strip as if making a print, which is helped by the fact that this film has approximately the same speed as most black and white papers. After exposure, the film can be dish processed in standard paper developer at the normal, or double the normal, dilution. Development time, with constant agitation in a dish that is not too full, should be no less than about 2 minutes for even results. After which stop, fix and wash the film as normal.

Direct Duplicating film is orthochromatic, so it can be used under a red safelight. Unlike other films it has an almost clear backing, so can be exposed through the emulsion — for example if contact printing negatives on to it, in which case put the film emulsion-side down on the easel. Otherwise it should be laid on the easel emulsion-side up. As a direct reversal film, it is important to remember that extra exposure will make the inter-negative lighter (as for transparency film) whilst extra development will make the blacks denser.

Inter-negatives can be printed as normal, although if your enlarger can only take up to 120 roll film formats, you'll need to make an inter-negative to fit.

I would not suggest retouching original negatives, especially if they are small 35mm or 120 format images, if you do, make the best print possible from these negatives before retouching them. At least this way, you'll have a good master print, that is best made with plenty of shadow and highlight detail, from which a copy negative and prints can be produced.

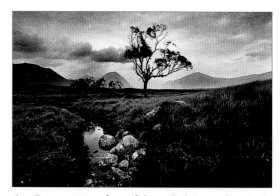

4. Even reproduced in miniature here, it should still be possible to see most of the very distracting dust marks and unwanted detail that I subsequently retouched.

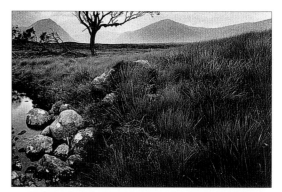

5. This close-up shows why I decided to burn in the bottom right of the print and to retouch it later as well. In its present form it contributes little to the photograph.

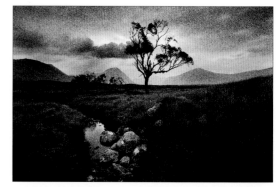

6. The finished, retouched print has a much smoother, uninterrupted tonal quality. The lower resolution of 35mm often makes it necessary to retouch more poorly defined detail, as in the Black Mount photos opposite.

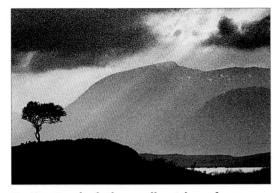

7. Unretouched, the small patches of snow on the hillside look disarmingly like dust marks. As such they make no valuable contribution to the photograph.

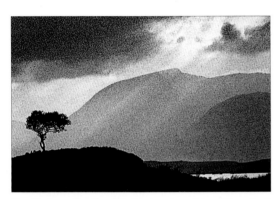

8. Not content with just retouching the dust marks and the patches of snow, I also removed the small bright spec of a cloud that sits above the tree.

9. Viewing the print upside down makes the image less easily readable and is a good way of identifying any other areas that might still need spotting. This was how I first noticed the bright cloud of photograph 8, above.

Print presentation

There are quite a number of options for the presentation and storage of black and white prints. Once flattened and retouched I like to window mount mine with white museum-quality board, and, when they are not being viewed, to store them in clamshell-design archival storage boxes. For exhibitions I will frame these window-matted images under standard 2mm picture glass and normally in simple, plain, dark grey or black-stained wooden frames.

In my opinion, good presentation performs a number of useful roles. First, it should protect the print from physical and chemical damage, such as creasing and greasy fingers. It should also hold the print flat so that it can be viewed without distraction. Finally, it should show the print's tonal values as they were intended.

I have seen many black and white or toned prints ruined by being mounted under quite inappropriately dark, or even coloured, card: if you remember, in CAMERAWORK I talked about how the black viewfinder of 35mm cameras can easily distort the interpretation of a scene's tonal values — in my opinion the 'wrong' type of card can do the same. I have also discovered that window mounts are often best cut to leave at least a 5mm gap between the edges of the print and card itself. This gap means the edge of the image can be clearly seen, so that any delicate tonal values and light highlight densities around the edge of the print don't blend in with that of the card over-matte. If no such space is left, careful exposure balancing of the print, to hold in the sides of the image (as in the **Walkham Valley** print exposure photograph), may be wasted. Conversely, a window matte of the same aperture size as the print can also be usefully employed to 'frame' a print that has poorly defined edges, in the same way that black print borders can be printed to hold in an image.

I use a small, relatively inexpensive, handheld Maped window mount cutter. It is attached to a guide ruler, giving accurately cut straight edges. When cutting, I also leave a larger 15mm gap between the bottom of the print and the matte overlay, which provides sufficient space in which to write the caption to the image and to sign, date and number it — if a limited edition has been made. Anyone buying a print will therefore be able to see that the photograph is signed by the photographer, which undoubtedly makes a difference to its value. Also, if the print rather than the mountboard is signed, should the board need to be replaced, then the value of the image won't be affected and whilst most of us may think our work has little value at present, at least this method does look towards the future, with hope!

Mounting prints

I usually attach exhibition prints to the backing board of the window matte with paper hinging tape along the print's top edge. This method is simple and unlike some alternatives, such as heat dry mounting, it is fully reversible — an important consideration for anyone interested in the archival implications of photographic presentation and storage. Attached in this way, should the mount-board become damaged, the print can be removed — without harm — by just cutting the tape.

Instead of hinging tape I have sometimes used self-adhesive polyester print corners into which the print is slotted, in the style of some old photo albums. For smaller prints I found these worked very well, but for larger images they didn't seem to allow for print expansion or contraction, caused by changes in humidity and temperature. Hinging tape allows the print to hang, and therefore 'float' freely, behind the window matte.

My suggestion would be to hinge-mount FB prints (especially those larger than 16" x 12") onto reasonably heavyweight card: 4ply, or 1650 micron, is about right, any lighter, such as the 2ply 1100 micron weight and the card may warp or buckle and distort the picture. Besides, a heavier board also acts as a more effective barrier between the print and what is often chemically impure picture frame hardboard backing. So, for additional protection, you may want to put an impermeable interleaf between the mountboard and the hardboard. I find old polyester print sleeves, cut down to size, are particularly good for this purpose.

To attach a print with hinging tape, first centre the image on the board and then lay a heavy weight on it so that it won't move as the water activated tape is laid over the edge of the print and pressed down onto the board. After a minute or two the bond is quite strong and reaches full strength as the tape dries. However, for the most accurate alignment of the print, I would recommend that this join is made after the backing board has been attached to the overmatte board.

A few final words on print presentation. If you're planning on putting prints in protective polyester type sleeves, you may need to make the print a little brighter and contrastier to compensate for their print darkening effect. You may also find that some sleeves will slightly alter the image colour of the print, most commonly towards a slightly warmer-yellow hue. The same kind of problem can be encountered when framing images under glass, some batches of which I have found to have a slight green cast which will noticeably affect the print. And, if you're going to mount a print under glass, don't let them touch — the surface of the print will almost certainly gradually become glazed, even in moderately humid environments.

Formulary

Formulation notes

My selection

In this formulary, I have included a variety of processing solutions that I use on a regular basis. Some of these offer enormous creative potential (such as the popular, two-bath, thiocarbamide, variable-colour sepia toner) whilst others are equally useful for perhaps less immediately obvious, preventative reasons. Very simple fixers, for example, ensure less bleached, warmer tones with chloro-bromide papers and also guarantee more predictable results when toning. I have also added a couple of corrective solutions, like the Farmer's reducer (number 38) and the chromium negative intensifier (number 40), although both of these can also be used for creative effect, as in the bleached (reduced) print of Hound Tor in TONING.

My criteria for selection are also based on leaving out those solutions too complex or too subtle for us to mix (e.g. modern T-grain film developers) and those that are cheaper (such as Agfa Rodinal), or safer to buy as pre-packed proprietary solutions (such as Kodak Selenium toner). All of the formulas listed below should be cheaper than proprietary equivalents, where they exist, and in some cases, the cost-saving is quite dramatic.

Safety

Above all, I would describe these formulas as perfectly safe to mix and use provided (like all photographic solutions) they are mixed in the stated order and handled intelligently.

Strong acids or alkalis should always be added slowly to water and never the other way round, for example when making up the sodium hydroxide activator of the thiocarbamide toner (formula number 50). Therefore, before mixing chemicals for the first time, I would suggest you refer back to the section on DARKROOM SET-UP, paying particular attention to the benefits of having separate wet, dry and chemical areas. In that section I have also discussed the importance of having good darkroom ventilation, preferably of the local exhaust variety, that draws air, any fumes and possible chemical dust, away from the chemical mixing area in a controlled way.

Mixing chemicals

All the formulas are written up, with their chemicals listed in the same way. I would suggest that before you make up a particular solution, you lay out the necessary chemical containers in the order listed in the formulary, i.e. the order they are to be added to the initial, stated volume of water — the recommended temperature of which should be closely adhered to.

Once the first chemical is added, stir the solution, but not so vigorously that it introduces an excessive amount of free oxygen into the solution. Keep stirring until it is fully dissolved, then add the second chemical, and so on. Once all the chemicals have been mixed, add enough cold water 'to make' the solution up to the final required volume. Failure to mix the chemicals in the right order, or not to dissolve them fully before the next one is added, may lead to a change, or even a failure, in the solution's performance.

In the whole formulary there is only one instance in which you need to break with the stated chemical mixing order and that concerns the developing agent metol which is insoluble in strong solutions of sodium sulphite, the developer preservative (anti-oxidant) normally added to the water first. Therefore, for any formula containing metol and sodium sulphite, first add to the water just a pinch of the sulphite (from the formula's measured amount) which is then sufficient to prevent immediate oxidation of the metol when it is added. Once all the metol is dissolved, the remaining sodium sulphite preservative can be added.

Incidentally, all the formulas can be made up under normal tungsten lighting, unless stated otherwise.

Chemistry

For a long time I avoided mixing my own photographic solutions because of a fear of chemistry. In fact we don't need to understand it. At that time I also experienced some considerable confusion with photographic chemical names, since most of my sources of information were old, photographic almanacs using, what I later found to be, out-of-date or foreign terminology. This made some formulations unnecessarily difficult to follow and their chemicals hard to track down, even though they were readily available. For example, in these source books, I found what I later discovered to be the soft working developing agent metol listed under other names, such as Elon, Monazol, Monol, Planetol, Rhodol and Scalol — all trade names — and even under its chemical name of mono-methyl-paraminophenol! All the chemicals here are listed by their most common name and all of them are stocked by any really good black and white photographic supplier.

However, whilst on the subject of nomenclature I should point out that there is a difference between some chemical spellings; it took me a while to realise that sulfate and sulphate were one and the same chemical (USA and UK spellings), but that sulphate and sulphite were definitely not.

Incidentally, I have included a weights and measures conversion chart in TABLES AND CHARTS, in case you have one or two old source books, containing some interesting looking formulas, which are perhaps worth a try. These older books usually contain various, anachronistic measuring systems, but you'll be relieved to hear that this book faithfully adheres to decimal grams and millilitres.

Equipment

We need surprisingly little hardware. The most important is a set of scales, accurate to within a quarter of a gram; varieties include the pan balance, the fisherman's spring-balance and the digital version, which are all easy to find and relatively cheap to buy. You will also need a funnel, several plastic mixing vessels of various sizes and some graduates and syringes for measuring very small solution volumes, vital when working with, for example, Benzotriazole, the cold-tone developer additive in formula number 11.

A consistent, accurate thermometer is a must; spirit, mercury or digital versions are all to be recommended, whilst, for accuracy reasons, the metal-dial variety are not. These items aside, you'll need some papers for weighing out chemicals (I use cheap 5" x 4" glassine negative bags — one on each of the scale's weighing pans), and a selection of storage bottles including old photo-chemistry containers, concertina bottles and the small, brown glass bottles which are available (very cheaply) from chemists. All of these are airtight and lightproof and should be labelled with information concerning

the contents, the dilution and the date of mixing.

Not only does labelling ensure the right solution is used, but when it comes to the disposal of any unused, or old, chemistry, we know what we are dealing with.

I would suggest storing chemicals and made-up solutions in a safe place, that is also out of reach of children, with preferably a fairly constant temperature of around 20°C, so that solutions will always be ready for use.

Water quality

Tap water should be perfectly adequate to make up most of these formulas, unless stated otherwise, in which case deionised or distilled water may be required. Deionised is cheaper than distilled and can be bought very cheaply in 1 or 5 litre containers from car accessory shops. It is used for topping up batteries.

Testing your tap water with pH papers will help determine the likely efficiency of your wash. Acid wash water will slow down the process of residual fixer removal from film and paper, whilst even slightly alkaline wash water will bleach out the colour of iron, blue-toned prints, usually before the yellow-green chemical toning stain can be washed out. Also, manufacturer's recommended film development times may need to be adjusted according to regional tap water pH values.

If water-borne solids are a problem — for example tiny, almost invisible iron particles can locally mark toned prints — then you may find an in-line, or (cheaper) hand-held water filter is essential.

It's easy!

All said and done, don't be put off. Some other books and practitioners may doubt the need for, or benefits of, home formulation, but, believe me, the results — and very often the cost saving — can definitely be worth the effort, as I hope is evident from the toned photographs shown in the preceding pages. Many of the effects that I have illustrated could not have been achieved so easily with proprietary solutions, or by following their often rigid instructions — written to protect any less than careful practitioners from doing anything 'wrong'. For example, the **Pentire Point** triptych was toned in formula 51, which gives a much subtler colour, after a brief tone, than any of the proprietary blue toners. If you are still in doubt about the benefits, start by mixing up the thiocarbamide, variable-colour sepia toner, formula 50. Its effects are very apparent and it's cheap and easy to make. Then, if you feel more ambitious, try multiple toning, perhaps with formula 51.

Standard paper developers

These conventional formulas will work with any printing paper: FB or RC, graded or variable-contrast. Development times are based on constant agitation and they can be altered, if necessary, for potential improvement in print quality, as outlined in PRINT PROCESSING. For any developers containing metol see the formulation notes above.

1. Standard developer — Ilford ID20

Water at 40°C	750.00ml
Metol	3.00g
Sodium sulphite, anhydrous	50.00g
Hydroquinone	12.00g
Sodium carbonate, anhydrous	60.00g
Potassium bromide	4.00g
Water to make	1000.00ml

● For use, dilute 1 part developer with 3 parts water.
● Development time at 20°C is about 2 minutes.

2. Standard developer — Kodak D72

Water at 50°C	750.00ml
Metol	3.00g
Sodium sulphite, anhydrous	45.00g
Hydroquinone	12.00g
Sodium carbonate, monohydrate	80.00g
Potassium bromide	2.00g
Water to make	1000.00ml

● For use, dilute 1 part developer with 2 parts water.
● Development time at 20°C is 1-2 minutes.

3. Standard developer — Kodak D158

Water at 50°C	750.00ml
Metol	3.20g
Sodium sulphite, anhydrous	50.00g
Hydroquinone	13.30g
Sodium carbonate, anhydrous	69.00g
Potassium bromide	0.90g
Water to make	1000.00ml

● For use, dilute 1 part developer with 2 parts water.
● Development time at 20°C is 1-2 minutes.

4. Standard/high-contrast developer — Ilford Universal

For paper and film

Water at 50°C	750.00ml
Sodium sulphite, anhydrous	110.00g
Hydroquinone	31.00g
Potassium carbonate, anhydrous	100.00g
Phenidone	1.28g
Potassium bromide	2.00g
Water to make	1000.00ml

● For use, dilute 1 part developer with 9 parts water.
● Development time at 20°C is 2 minutes.
● For films, dilute 1 part developer with 19 parts water and test for your correct development time. If necessary, dilution and development time can then be further modified.

Soft-working paper developer

This soft-working formula can be used with any paper, provided it does not have a developer incorporated emulsion, formulated for both rapid processing and also maximum print contrast.

5. Soft-working developer — Kodak D165

Water at 50°C	750.00ml
Metol	6.00g
Sodium sulphite, anhydrous	25.00g
Sodium carbonate, anhydrous	37.00g
Potassium bromide	1.00g
Water to make	1000.00ml

● For use, dilute 1 part developer with 3 parts water.
● Development time at 20°C is about 2 minutes.

High-contrast paper developers

These formulas will work with any paper, producing the highest possible contrast for each grade setting. Maximum contrast is achieved by working at no less than 18°C.

6. High-contrast developer

Water at 50°C	750.00ml
Sodium sulphite, anhydrous	72.00g
Sodium carbonate, anhydrous	50.00g
Hydroquinone	8.80g
Phenidone	0.22g
Potassium bromide	4.00g
Benzotriazole	0.10g
Water to make	1000.00ml

● Use undiluted.
● Development time at 20°C is about 2 minutes.

7. High-contrast developer

Water at 50°C	750.00ml
Sodium sulphite, anhydrous	150.00g
Potassium carbonate, anhydrous	100.00g
Hydroquinone	50.00g
Phenidone	1.10g
Caustic soda	10.00g
Potassium bromide	16.00g
Benzotriazole	1.10g
Water to make	1000.00ml

- For use, dilute 1 part developer with 1 part water.
- Development time at 20°C is 2 minutes.

8. High-contrast developer — Kodak D8

Water at 50°C	750.00ml
Sodium sulphite, anhydrous	90.00g
Hydroquinone	45.50g
Caustic soda	36.50g
Potassium bromide	30.00g
Water to make	1000.00ml

- For use, dilute 2 parts developer with 1 part water.
- Development time at 20°C is 2 minutes.
- Dish life may be as short as a couple of hours.

Lith paper developers

This formula will produce the warm, split-tone, high-contrast effect with any of the papers suitable for lith printing.

9. High-contrast lith — Ilford ID13

Solution A

Water at 50°C	750.00ml
Hydroquinone	25.00g
Potassium metabisulphite	25.00g
Potassium bromide	25.00g
Water to make	1000.00ml

Solution B

Water at 30°C	750.00ml
Potassium hydroxide	50.00g
Water to make	750.00ml

- Add the potassium hydroxide slowly to the water.
- For conventional black and white, high-contrast development that won't create a warm, split-tone colour, add 1 part A to 1 part B and use undiluted.
- Development time at 20°C is 2 minutes.
- For split-tone lith printing of papers, add 1 part A, to 1 part B and dilute with 4 parts water. More water can be added, if necessary.
- Development time at 20°C at this dilution is usually 5 minutes or more. If any faster, development will be too rapid to control the split-tone effect, in which case dilute with more water.

Cold-tone paper developers

These formulas are normally used for cold-tone bromide papers, although they can also be used to neutralise, or considerably cool-off the warm tone of chloro-bromide papers, such as Agfa Record Rapid and Kentmere Art Classic.

10. Cold-tone developer — Agfa 115

Water at 40°C	750.00ml
Metol	2.00g
Sodium sulphite, anhydrous	25.00g
Hydroquinone	6.00g
Sodium carbonate, anhydrous	33.00g
Potassium bromide	0.50g
Water to make	100.00ml

- For use, dilute 1 part developer with 1 part water.
- Development time at 20°C is 2 minutes.

11. Cold-tone developer additive — 1

Water at 40°C	750.00ml
Sodium carbonate, anhydrous	10.00g
Benzotriazole	10.00g
Water to make	1000.00ml

- For use, add 10.00ml of solution to 1 litre of working strength developer and increase to 20.00ml if necessary.

12. Cold-tone developer additive — 2

Water at 40°C	750.00ml
Potassium thiocyanate	5.00g
Water to make	1000.00ml

- For use, add 8.00ml of solution to 1 litre of working strength developer and increase to 15.00ml if necessary.

Warm-tone paper developers

These formulas are for chloro-bromide, warm-tone, emulsion papers. For maximum image warmth, it is important not to let the temperature of the working strength developer fall below 18°C. Read PRINT PROCESSING for further information on the principles of warm-tone print development.

13. Warm-tone developer

Water at 40°C	750.00ml
Chloro-hydroquinone	3.40g
Hydroquinone	3.40g
Sodium sulphite, anhydrous	31.25g
Sodium carbonate, anhydrous	23.00g
Potassium bromide	0.35g
Water to make	1000.00ml

- A variety of image colours can be achieved with warm-tone chloro-bromide papers. Working from i) to v) (below) will produce prints that become progressively warmer in tone but which are lower in contrast, and which may possess a weaker Dmax. Toning may prove a more practical alternative.
i) Warm brown = normal print exposure, undiluted developer, 1.5 minutes development at 20°C.

ii) Sepia brown = 3x normal print exposure, dilute 1 part developer with 10 parts water, add 1.00ml of a 10% solution of potassium bromide to the working strength developer, 5 minutes development at 20°C.

iii) Brown sepia = 5x normal exposure, dilute 1 part developer with 15 parts water, add 3.00ml of a 10% solution of potassium bromide, 10 minutes development at 20°C.

iv) Red brown = 6x normal exposure, dilute I part developer with 25 parts water, add 5.00ml of a 10% solution of potassium bromide, 15 minutes development at 20°C.

v) Bright red = 7x normal exposure, dilute 1 part developer with 30 parts water, add 5.00ml of a 10% solution of potassium bromide, 15 minutes development at 20°C.

14. Warm-tone developer — Agfa 124

Water at 40°C	750.00ml
Metol	0.80g
Sodium sulphite, anhydrous	15.00g
Hydroquinone	4.00g
Sodium carbonate, anhydrous	9.00g
Potassium bromide	8.00g
Water to make	1000.00ml

- A variety of tones can be achieved by varying print exposure times and developer dilutions, coupled to alterations in development time, similar to that outlined in formula 13.
- Dilute 1 part developer with between 2-5 parts water, and increase print exposure time anything up to 5 times more than normal.
- Development at 20°C may be up to 6-7 minutes.

15. Warm-tone developer — Kodak D163

Water at 40°C	750.00ml
Metol	2.20g
Sodium sulphite, anhydrous	75.00g
Hydroquinone	17.00g
Sodium carbonate, anhydrous	65.00g
Potassium bromide	2.80g
Water to make	1000.00ml

- For use, dilute 1 part developer with 3 parts water.
- Development time at 20°C is 1.5 minutes.

16. Warm-tone developer additive — 1

- Add 1 part well-used (exhausted), warm-tone developer to 1 part fresh, warm-tone developer.
- Print exposure time will need to be increased by an appropriate amount — determined by exposure test-strips.
- For maximum warmth, development at 20°C should be kept to the same time (a factor of x3 is about right) as for the fresh developer without the additive.

17. Warm-tone developer additive — 2

Water 30°C	250.00ml
Potassium bromide	2.50g

● Add 10.00ml of solution to 1 litre of working-strength developer. This amount can be increased quite significantly, but with a corresponding increase in print exposure time.

● For maximum warmth, development at 20°C should be kept to the same time as for the fresh developer without the additive.

Variable-contrast paper developer

Such formulas are capable of producing varying, subtle degrees of print contrast; the lowest-contrast mixture of 8 parts A, 0 parts B and 8 parts water equates to the contrast of the soft-working developer D165 (number 5) above, whilst the contrastiest mixture of 2 parts A and 14 parts B equates to the Ilford Universal high-contrast formula, number 4 above.

18. Variable-contrast developer

This formula was originally created for graded, rather than VC papers. Although it will work well with VC's, their half-grade contrast changing potential will be capable of producing the changes in print contrast that are possible with this developer. Papers with developer-incorporated emulsions will not normally respond well to the lower contrast mixtures of this formula.

Solution A	
Water at 50°C	750.00ml
Metol	8.00g
Sodium sulphite, anhydrous	23.00g
Potassium carbonate, anhydrous	20.00g
Potassium bromide	1.10g
Water to make	1000.00ml

Solution B	
Water at 50°C	750.00ml
Hydroquinone	8.00g
Sodium sulphite, anhydrous	23.00g
Potassium carbonate, anhydrous	27.00g
Potassium bromide	2.20g
Water to make	1000.00ml

Low contrast					High contrast		
A	8	7	6	5	4	3	2
B	0	1	2	3	4	5	14
Water	8	8	8	8	8	8	0
Total	16	16	16	16	16	16	16

● Print image colour may change, most notably with chloro-bromide papers, as the ratio of developer A to developer B is altered.

● Solution B is the contrasty developer.

● As an alternative, substitute the above with varying mixture-ratios of soft, low-contrast and high-contrast paper developers.

Paper restorers

These formulas can be used for old and out-of-date paper which, upon normal development, might otherwise fog. Print exposure times may need to be increased to compensate for the restraining effect the restorers have upon development and to enable development times to be kept as short as possible — further to reduce the risk of fogging. Upon development, ageing chloro-bromide paper will normally have a much cooler image colour, especially if the Benzotriazole restorer number 11 is used. All old papers will tend to show a marked loss in speed and contrast.

19. Restorer

Water at 40°C	750.00ml
Potassium bromide	100.00g
Water to make	1000.00ml

● Add 10ml of this 10% solution to 1 litre of working strength developer. This can be increased up to 20.00ml, or more.

● Development at 20°C should be kept as short as possible to prevent chemical fogging.
Alternatively:

● Immerse the exposed, but unprocessed paper in the above solution for 1 minute before it is developed.

● Drain the print and develop for as short a time as possible.

20. Restorer

Water at 30°C	250.00ml
Benzotriazole	2.50g

● Add 5.00ml of this solution to 1 litre of working strength developer. This amount can be increased to a maximum of 15.00ml.

● Print exposure time shouldn't need to be modified.

● Benzotriazole restorers will cool print image colour far more than potassium bromide solutions (see cold tone developer additive — 1, formula number 11 above).

Stopbaths

The simplest stopbath is a dish of plain water. It is recommended for use with all non-acidic and alkali fixers listed below, to prevent their gradual acidification, due to chemical carry-over, were a normal acid

stopbath, such as formula 21, employed. Frequent changing of a plain water stopbath is essential to arrest development and to prevent alkalinisation of the fixer from developer carry-over.

21. Plain acid stopbath

For film and paper

Water at 20°C	1000.00ml
Acetic acid, glacial	20.00ml

● Acetic acid is often sold in different percentage strengths. For example, 30.00ml of 60% stock acetic acid solution would need to be added to 1000.00ml of water to make approximately the same strength stopbath as above.

● Never make acetic acid stopbaths too strong or emulsion damage may occur.

22. Plain acid stopbath

For film and paper

Water at 30°C	500.00ml
Potassium metabisulphite	20.00g
Water to make	1000.00ml

● This is a simple alternative to formula 21.

23. Plain acid stopbath

For film and paper

Water at 20°C	1000.00ml
Citric acid	10.00g

● This may be a preferred formula for some photographers, as it does not give off the unpleasant and potentially irritating smell associated with the two-acid formula, above.

Fixers

Plain, or alkali, fixers may be preferred to the more commonly used acid variety as they will interfere less with toning processes used to change print image colour. Also, they will be less likely to bleach the delicate, finely divided silver that gives chloro-bromide papers and lith prints their characteristically warm image tone.

There are two types of fixing agent: the more rapid working ammonium thiosulphate and the traditional, slower working sodium thiosulphate. The former will clear film and paper in about half the time of the latter. Modern films, with their extensive use of dye couplers, may need a longer fixer clearing time and for this reason they usually benefit from the use of a rapid fixer.

Note: to prevent potential toning problems and improper washing, separate working strength solutions of fixer should be used for prints and films. Used film fixer contains silver complexes that bind strongly with the paper base of FB papers.

24. Plain fixer

For film and paper

Water at 40°C	750.00ml
Sodium thiosulphate, crystals	200.00g
or 120.00g of the anhydrous salt	
Water to make	1000.00ml

● Use undiluted.
● Fixing times at 20°C are 5-10 minutes for film and 5 minutes for paper.

25. Plain fixer — Speedibrews

For film and paper

Water at 40°C	750.00ml
Sodium thiosulphate, crystals	250.00g
or 150.00g of the anhydrous salt	
Sodium sulphite, anhydrous	10.00g
Water to make	1000.00ml

● Use undiluted.
● Fixing times at 20°C are 5-10 minutes for film and 5 minutes for paper.

26. Alkali fixer — Speedibrews

For paper

Water at 40°C	750.00ml
Sodium thiosulphate, crystals	60.00g
Sodium carbonate, anhydrous	3.00g
Water to make	1000.00ml

● Use undiluted.
● Fixing time at 20°C is 5-10 minutes.
● This formula is especially good for wam tone papers.

27. Acid fixer — Kodak F24

For film and paper

Water at 50°C	600.00ml
Sodium thiosulphate, crystals	240.00g
Sodium sulphite, anhydrous	10.00g
Sodium metabisulphide	25.00g
Water to make	1000.00ml

● Use undiluted.
● Fixing times at 20°C are 5-10 minutes for film and 5 minutes for paper.

28. Rapid fixer — Speedibrews

For film and paper

Water at 40°C	800.00ml
Sodium sulphite, anhydrous	10.00g
Ammonium thiosulphate	150.00g
Water to make	1000.00ml

● Make 24 hours before use, to allow reaction by-products to settle. Decant before use.
● Use undiluted.
● Fixing times at 20°C are 3-5 minutes for film and 2-3 minutes for paper.

29. Rapid fixer — Speedibrews

For film and paper

Water at 40°C	750.00ml
Sodium sulphite, anhydrous	10.00g
Ammonium sulphate	25.00g
Sodium thiosulphate, anhydrous	180.00g
Water to make	1000.00ml

● Use undiluted.
● Fixing times at 20°C are 4-5 minutes for film and 2-3 minutes for paper.
● This is a cheaper version of the other rapid fixer above.

30. Rapid acid fixer — Agfa 304

For film and paper

Water at 50°C	750.00ml
Sodium thiosulphate, crystals	200.00g
Ammonium chloride	50.00g
Potassium metabisulphite	20.00g
Water to make	1000.00ml

● Use undiluted.
● Fixing times at 20°C are 4-5 minutes for film and 2-3 minutes for paper.

To prevent the possible formation of unwanted precipitates in hard water, Speedibrews recommend the addition of 1.00g of Calgon (sodium hexametaphosphate) to each litre of their fixer formula.

Hypo-clearing solutions

Hypo is the old term for fixer, i.e. sodium or ammonium thiosulphate. These clearing solutions speed up the wash and improve its efficiency, especially at lower temperatures. Even extended washing in water alone may not guarantee predictable toning results and will not remove sufficient amounts of residual thiosulphate to conform with archival standards of processing. In most cases these hypo-clearing solutions will reduce the wash time by approximately one half. RC papers do not benefit from treatment in these solutions.

31. Clearing bath — Agfa 320

For film and paper

Water at 30°C	750.00ml
Sodium carbonate, anhydrous	10.00g
or, sodium hydrogen carbonate	10.00g
Water to make	1000.00ml

● Rinse the image after fixing, prior to treatment.
● Clearing time at 20°C in this formula is 2-3 minutes with regular agitation.
● Wash the image for half the normal time after clearing.

32. Clearing bath

For film and paper

Water at 30°C	750.00ml
Sodium sulphite, anhydrous	20.00g
Water to make	1000.00ml

● Rinse the image after fixing, prior to treatment.
● Clearing time at 20°C in this formula is 2-3 minutes with regular agitation.
● Wash the image for half the normal time after clearing.

Fixer tests

As the fixer is used, or simply ages, it undergoes certain changes which require monitoring to guarantee a properly fixed and stable image. Unlike developers, the action of the fix is largely invisible; these tests make the fixer's condition visible.

33. Fixer exhaustion test

For film and paper fixer

Potassium iodide	2.50g
Distilled or deionised water	50.00ml

● Put 1.00ml of this solution into a clean, glass vessel containing 25.00ml of the working strength fixer.
● If the fixer turns cloudy, and does not clear even upon shaking, the fixer contains too much silver and should be discarded.
● The use of silver estimating papers may be a preferred method to this test.

34. Wash-water fixer test

Distilled or deionised water	1000.00ml
Potassium permanganate	1.00g
Sodium carbonate, anhydrous	1.00g

● Put a few drops of wash water into a clean glass vessel and the same quantity of water, straight from the tap, into another.
● Add one drop of the formula to both of these vessels.
● Both solutions should clear at the same rate, but if washing is incomplete, i.e. the wash water still contains residual thiosulphate, this vessel will clear more quickly and the wash should be continued.

35. Film and paper residual fixer test — Kodak HT2

Distilled or deionised water	350.00ml
Acetic acid, 10% solution	175.00ml
Silver nitrate	3.75g
Deionised water to make	500.00ml

● Remove surplus water from the washed image.
● Place a drop of the solution on the clear film rebate or white print margin.

- Leave for 2-3 minutes, then rinse and blot dry.
- No more than just a very slight cream stain is acceptable.
- For more accurate assessment, use this test with Kodak's Hypo Estimator colour chart.
- Store the solution in a brown glass bottle away from the light.

36. Film and paper residual fixer test

Kodak Selenium toner	10.00ml
Water	90.00ml

- Remove surplus water from the washed image.
- Place a drop of the solution on the clear film rebate or white print margin.
- Leave for 2 minutes, then rinse and blot dry.
- No more than just a very slight cream stain is acceptable.

37. Washer efficiency test

For film and paper washers

Potassium permanganate	2.00g
Distilled or deionised water	100.00ml

- Add enough of the solution into the washer to create an even, light-purple mixture.
- Turn the washer on and note the time for the solution to clear, i.e. to be completely replaced by fresh water.
- Ideally this should be 5 minutes or less; enough to give 12 complete water changes in one hour's wash.

Reducers

Fixed and washed images that are too dense or too contrasty, overall or just locally, can often be bleached (reduced). The first of the three reducers, 38.i, gives a more subtractive result, i.e., the most delicate detail will be bleached first. 38.ii is more proportional in effect, i.e. image tones of different density will be bleached more uniformly.

These formulas will not work with dye images, such as Ilford's chromogenic XP2 film, or with prints that have already been toned, for example in protective selenium toner.

38. Farmer's reducer

For film and prints

Solution A

Water at 30°C	75.00ml
Potassium ferricyanide	10.00g
Water to make	100.00ml

Solution B

Water at 40°C	750.00ml
Sodium thiosulphate, crystals	200.00g
Water to make	1000.00ml

- Store both solutions in brown glass, lightproof bottles.

38.i (for subtractive reduction):

- For use, mix 1-2 parts A with 5 parts B, immediately prior to use.
- Rinse the image and then bleach it in the combined solution, at 20°C, until just before the desired effect has been achieved. Bleaching time varies, so test first.
- Rinse in cool water (about 15°C) — to arrest the action — and then wash the image normally at 20°C, for the usual recommended time, or bleach further if required and refix again. The process can be repeated until the desired result is achieved, but overbleaching will leave a brown silver stain.
- The combined A and B solution has a very short working life, sometimes of as little as 5 minutes. and it should certainly be discarded once it has changed from its original bright yellow colour towards blue-green.
- Solution B can be replaced with an approximately equal volume of unused working strength proprietary fixer.

38.ii (for proportional reduction):

- Reduce the properly washed image in just solution A, at 20°C. Not much will appear to happen, but then rinse thoroughly and fix in solution B, when the reduction will appear to take place.
- Repeat, if necessary, washing in between to remove residual traces of solution B.
- Failure to fix bleached images in solution B will result in very impermanent results.
- Any brown, residual image colour after reduction and thorough washing is not a stain, but simply a product of overly extended reduction and therefore too great a change in the nature and size of the image's silver particles. This does not affect the permanency of the image.
- Dry prints can be locally reduced with solution 38.i) by using a fine brush. They should then be washed for the normal time.

39. Reducer

For film and paper

Water at 40°C	75.00ml
Iodine	2.00g
Thiocarbamide	4.00g
Water to make	100.00ml

- Use this reducer immediately, it does not keep well.
- Images should be properly washed first.
- At 20°C, bleaching time is approximately 2 minutes.
- Unlike the Farmer's reducer, this solution will completely reduce the image without any residual brown silver stain.

Intensifiers

Fixed and washed silver images, that are too thin or too flat, can often be intensified to a more acceptable level. Listed below are two formulas. The first is not recommended for use on prints, since making another print is a much better and far simpler alternative.

40. Intensifier

For film

Water at 40°C	750.00ml
Potassium dichromate	10.00g
Hydrochloric acid, concentrated	5.00ml
Water to make	1000.00ml

- Store in a lightproof, brown glass bottle.
- For use, pour a small amount of the solution into a clean, preferably clear glass vessel.
- Immerse the washed negative, agitate and bleach for about 2-3 minutes at 20°C.
- Wash for 5-10 minutes and then redevelop the image in a standard paper developer at 20°C.
- Wash and repeat if necessary, then rinse and refix.
- All work can be carried out under normal lighting.
- To be on the safe side, make tests first with a negative of the same emulsion type and if negative reticulation is experienced, harden the negative before treatment in an acid hardening fixer.

41. Intensifier

For film and paper

Water at 20°C	900.00ml
Kodak Selenium toner	100.00ml

- Use undiluted at 20°C for properly fixed and washed images.
- The degree of intensification will be much less than for the previous formula and once applied, the protective nature of the selenium process will prevent subsequent treatment.

Tray cleaners

Processing vessels, especially plastic ones, will inevitably become impregnated with residual chemistry. This can contaminate subsequent solutions, or, worse still, cross-contaminate solutions if dishes are used for a variety of different processes. To reduce this risk, label dishes for specific processes and clean as needed, with 42 or 43 below.

42. Tray cleaner

Water at 40°C	750.00ml
Citric acid	50.00g
Water to make	1000.00ml

- Rinse the vessel first to remove any surface chemistry.
- Fill with the cleaner at 20°C and leave overnight.
- Drain and wash thoroughly.

43. Tray cleaner

Water at 40°C	750.00ml
Potassium dichromate	60.00g
Sulphuric acid, 10% solution	100.00ml
Water to make	1000.00ml

- Rinse the vessel first to remove any surface chemistry.
- Fill with the cleaner at 20°C and leave for a few minutes.
- Drain and wash thoroughly.
- Both of the above solutions can be used to clean film-spirals of built-up silver, a tooth brush being used to gently remove stubborn deposits. Wash the spirals very thoroughly afterwards to remove even the slightest trace of residual cleaner which could contaminate film developers, especially the highly dilute high acutance varieties.

Toners

I have included a variety of the traditional sodium sulphide (smells of bad eggs) and modern, odourless, thiocarbamide sepia formulas, for a variety of image colours ranging from very cold purple-brown through to yellow-brown. The formulas are divided into one and two bath varieties, the latter employ a separate bleaching bath prior to the toner and are capable of producing a wider range of colours.
Note: unless otherwise stated, tone the print at 20°C, with continuous agitation.

One Bath Sepia Toners

Prints should be thoroughly washed prior to toning. Due to their extended toning time, a hardening fixer, or post toning hardening bath (formula 59) may be needed to avoid chalky looking scum marks on the dried print.

44. Neutral brown tones

Solution A	
Water at 40°C	750.00ml
Potassium ferricyanide	35.00g
Potassium bromide	11.00g
Water to make	1000.00ml

Solution B	
Water at 40°C	750.00ml
Sodium sulphide	25.00g
Water to make	1000.00ml

- Mix solution B in a properly ventilated space and — to avoid fogging — away from unexposed materials.
- For use, mix one part A and one part B just before toning.
- Toning time may be as long as 15 minutes, but shorter with higher temperatures up to a maximum of 30°C.
- Discard toner after use.

45. Cool purple-brown tones — Kodak T8

Water at 40°C	750.00ml
Potassium sulphide	7.50g
Sodium carbonate	2.50g
Water to make	1000.00ml

- Use undiluted.
- Toning time will be 15-20 minutes. This can be reduced to 3-4 minutes by increasing the temperature to 35°C.
- After toning, rinse and immerse in a 3% solution of sodium metabisulphite for one minute. (30.00g in 1000.00ml of water).
- Mix and use in a well-ventilated space.

Two Bath Sepia Toners

Fixed and washed prints are bleached and then thoroughly rinsed before toning. Depending on the type of bleach, the extent of bleaching and the formulation of the toner, a wide yet incredibly subtle range of colours can be achieved. (All bleaching and toning work of fixed prints can be carried out with the lights on.)

Note: for permanent results, images bleached in one of the following formulas must be fully toned afterwards. If only partially toned, they must then be rinsed and refixed. Most toner bleaches, at working strength, have a very limited life. Discard after use.

46. Standard toner bleach

Water at 40°C	750.00ml
Potassium ferricyanide	100.00g
Potassium bromide	100.00g
Water to make	1000.00ml

- For use, dilute 1 part bleach with 9 parts water. The concentration of this solution can be increased, if bleaching is too slow.
- Evenly immerse the properly washed print into the solution. Agitate continuously.
- Bleach the print back until the desired reduction is achieved, then rinse thoroughly until all the residual yellow bleach stain has gone. Tone with formula 49 or 50.
- For colder image tones, halve the amount of

potassium bromide, for warmer effects increase the amount to 150.00g, or more.
- Store in a lightproof container.

47. Colder tone bleach

Water at 40°C	750.00ml
Ammonium bromide	11.00g
Potassium ferricyanide	35.00g
Water to make	1000.00ml

Alternatively,

Water at 40°C	750.00ml
Potassium ferricyanide	6.00g
Ammonia, 10% solution	15.00ml
Water to make	1000.00ml

- Use either of the above, undiluted.
- Bleach the print until the desired effect has been achieved, then rinse thoroughly to remove all residual yellow bleach stain.
- Tone with formula 49 or 50.
- Store in a lightproof container.

48. Warmer tone bleach

Water at 40°C	750.00ml
Sodium chloride	6.60g
Potassium ferricyanide	35.00g
Water to make	1000.00ml

- Bleach the print until the desired effect has been achieved, then rinse thoroughly until all the yellow bleach stain has gone.
- Tone with formula 49 or 50.

49. Sodium sulphide sepia toner

This should be made up and used in a properly ventilated space to avoid fogging unexposed materials.

Water at 40°C	750.00ml
Sodium sulphide	50.00g
Water to make	1000.00ml

- Tone the bleached and rinsed print until full image density has returned — if not, rinse the print and refix.
- Wash the print for the usual time.
- Discard the toner after use.

For colder tones:
- Immerse the washed print in the sulphide toning solutions for five minutes before bleaching, rinsing and toning as normal.

Alternatively:
- Add print developer to the sodium sulphide toning solution.
- Start by adding 200.00ml of working strength developer to 1000.00ml of toner solution. Increase, or decrease, as necessary. This method can also be used for thiocarbamide sepia toning solutions.

50. Thiocarbamide toner

Solution A

Water at 40°C	750.00ml
Thiocarbamide	100.00g
Water to make	1000.00ml

Solution B

Water at 30°C	750.00ml
Sodium hydroxide	100.00g
Water to make	1000.00ml

● Add the sodium hydroxide slowly to the water. A variety of image colours can be achieved by toning the bleached print in one of several different ratios of toner solutions A and B, see table:

SOL A	SOL B	WATER	IMAGE TONE
10.00ml	50.00ml	500.00ml	purple-brown
20.00	40.00	500.00	cold-brown
30.00	30.00	500.00	brown
40.00	20.00	500.00	warm-brown
50.00	10.00	500.00	yellow-brown

● Tone the image until full image density has returned. Toning time may take up to several minutes with the yellow-brown dilution.
● To ensure full image density is obtained with the higher-dilution, warmer-tone solutions, make sure the toner is at about 25°C and, if the print has been previously washed in cold water, warm it in a dish of water at 25°C prior to toning.
● Any print that fails to achieve full image density after toning can be immersed in a dish of warm water at 35°C, for half a minute. Full density should then return. This method may usefully alter image colour, to warmer effect.
● If full density fails to return, rinse and then refix the print, followed by a brief rinse, hypo-clear and a full wash.
● An even wider variety of colour effects can be achieved by experimenting with the different bleaching solutions listed above, or by following the instructions for colder sepia tones, as explained in formula 49.
● Working strength thiocarbamide toner has a limited life, discard once it begins to develop a slight cloudy sediment.
● Stored separately, stock toner solutions keep well.

One Bath Blue Toners

51. Blue toner

Solution A

Water at 40°C	750.00ml
Potassium ferricyanide	2.00g
Sulphuric acid, 10%	40.00ml
Water to make	1000.00ml

Solution B

Water at 40°C	750.00ml
Ferric ammonium citrate	2.00g
Sulphuric acid, 10%	4.00ml
Water to make	1000.00ml

● Mix one part A and one part B just before use.
● Agitate prints continuously.
● Toning time will be about 1 minute at 20°C, but can be varied depending on the intensity of colour required.
● Wash the print in neutral to slightly acid water until all traces of residual yellow ferricyanide stain have gone. Then dry the print.
● Wash water can be acidified by the addition of a little plain acetic or citric acid, or similar.
● To get softer blue-grey tones with the above formula, bathe the toned print in 0.05% solution of sodium carbonate (0.5g in 1000.00ml of water).
● Over-washing blue toned prints may lead to bleached and slightly brown looking highlights.
● At its working strength, a blue toner doesn't keep for long. An old toner will permanently stain the paper yellow-green in colour.

52. Gold blue toner

Solution A

Water at 40°C	200.00ml
Gold chloride	1.00g
Calcium carbonate	3.00g
Water to make	250.00ml

Solution B

Water at 40°C	200.00ml
Thiocarbamide	20.00g
Sodium thiosulphate, crystals	20.00g
Potassium metabisulphite	5.00g
Water to make	250.00ml

● Mix solutions 24 hours before use.
● For use, add one part A to one part B.
● Toning time takes about 5 minutes.
● Wash the prints for the usual time.

One Bath Copper Tones

53. Warm-black to red tones

Solution A

Water at 40°C	750.00ml
Copper sulphate	25.00g
Potassium citrate, neutral	100.00g
Water to make	1000.00ml

Solution B

Water at 40°C	750.00ml
Potassium ferricyanide	20.00g
Potassium citrate, neutral	110.00g
Water to make	1000.00ml

● For use, mix one part A with one part B immediately prior to toning.
● Tone with continuous agitation until the desired effect has been achieved and wash for the usual time.
● Any pink stain can be cleared by immersing the print in a 5% solution of ammonia.

54. For red-chalk tones

Water at 40°C	750.00ml
Ammonium carbonate	100.00g
Copper sulphate	11.00g
Potassium ferricyanide	22.00g
Water to make	1000.00ml

● Toning time will be about 3 minutes, or until the desired effect is achieved.
● Any pink stain in the highlights can be cleared as for the above formula.
● Wash the print as normal.

55. Red sepia tones

Water at	750.00ml
Sodium sulphide	10.00g
Glacial acetic acid	20.00ml
Water to make	1000.00ml

● Immerse the fully copper-toned print in the above solution at 20°C.
● Tone until the desired result is achieved.
● Wash the print as normal.

56. Copper-toned print intensifier

Water at 40°C	750.00ml
Copper sulphate	50.00g
Potassium bromide	20.00g
Glacial acetic acid	10.00ml
Water to make	1000.00ml

● Immerse the rinsed, copper-toned print in the solution for 30-60 seconds at 20°C.
● Wash the print as normal.

Two Bath Redevelopment 'Toners'

Changing the image colour of any neutral-toned bromo-chloride paper, such as Ilford Multigrade, is not, as with chloro-bromide papers, normally possible by development alone. However, once such prints are fixed and washed they can be bleached, as for two bath sepia toning, and then redeveloped to produce a range of subtle, stable image colours.

57. Bleaches

Solution A

Water at 40°C	750.00ml
Potassium ferricyanide	40.00g
Water to make	1000.00ml

Column 1

Solution B

Water at 40°C	750.00ml
Copper sulphate	50.00g
Sulphuric acid, 10%	65.00ml
Sodium chloride	50.00g
Water to make	1000.00ml

Solution C

Water at 40°C	750.00ml
Potassium dichromate	20.00g
Sulphuric acid, 10%	50.00ml
Sodium chloride	100.00g
Water to make	1000.00ml

58. Redevelopers

Solution 1

Water at 40°C	750.00ml
Metol	10.00g
Sodium sulphite, anhydrous	33.00g
Sodium carbonate, anhydrous	33.00g
Water to make	1000.00ml

Solution 2

Water at 40°C	750.00ml
Hydroquinone	33.00g
potassium metabisulphite	16.00g
Water to make	1000.00ml

Solution 3

Water at 40°C	750.00ml
Ammonium carbonate	100.00g
Water to make	1000.00ml

BLEACH	REDEVELOPER	IMAGE COLOUR
A	1 part 1	
	1 part 2	
	2 parts water	purple-brown
B	1 part 1	blue-black
C	4 parts 2	
	6 parts 3	
	2 parts water	brown
C	1 part 2	
	1 part3	
	1 part water	sepia-brown
C	2 parts 2	
	1 part 3	
	2 parts water	bright-brown

● Prints must be properly washed before bleaching.

● Bleaching times at 20°C will vary for the different solutions A, B and C.

● Rinse bleached prints thoroughly prior to redevelopment.

● Redevelop the print with continuous agitation until the full image colour returns.

● Wash the print for the usual time.

Column 2

Post-Toning Solutions

Films and prints sometimes exhibit some surface scum deposits upon drying, especially those images washed in hard water areas or those which have been toned with selenium or thiocarbamide solutions.

59. Scum remover
For film and paper

Acetic acid, glacial	20.00ml
Water	1000.00ml

● Rinse the image thoroughly first.
● For use, immerse the image in solution at 20°C for 1-2 minutes.
● Wash afterwards for the usual time.
● Treat the image in formula 60.

60. Scum remover
For film and paper

Deionised, or filtered tap water	1000.00ml
Wetting agent, at normal strength	

● Rinse the image thoroughly first.
● Immerse the image for 1-2 minutes and, if necessary, very gently wipe any marks with a cotton wool swab.

Conversion Tables

Milli-Litres	UK fl.oz	US fl.oz
1.00	0.04	0.03
2.00	0.07	0.06
3.00	0.11	0.10
4.00	0.14	0.14
5.00	0.18	0.17
6.00	0.21	0.20
7.00	0.24	0.24
8.00	0.28	0.27
9.00	0.32	0.30
10.00	0.35	0.34
15.00	0.53	0.51
20.00	0.70	0.68
25.00	0.88	0.85
50.00	1.76	1.69
100.00	3.52	3.38
250.00	8.80	8.45
500.00	17.60	16.90
1000.00	35.20	33.80

● To calculate fluid ounces from milli-litres multiply the volume in litres by 0.0352 for UK fl.oz and by 0.0338 for US fl.oz.
● To calculate milli-litres from UK fl.oz multiply the volume in UK fl.oz by 28.4 and by 29.6 for US fl.oz.

Column 3

Litres	UK Galls	US Galls
1.00	0.22	0.264
2.00	0.44	0.528
3.00	0.66	0.793
4.00	0.88	1.06
5.00	1.10	1.32
6.00	1.32	1.59
7.00	1.54	1.85
8.00	1.76	2.11
9.00	1.98	2.38
10.00	2.20	2.64
15.00	3.30	3.96
20.00	4.40	5.28
25.00	5.50	6.60
50.00	11.00	13.20
100,00	22.00	26.40
250.00	55.00	66.00
500.00	110.00	132.00
1000.00	220.00	264.00

● To calculate gallons from litres multiply the volume in litres by 0.22 for UK gallons and by 0.264 for US gallons.
● To calculate litres from gallons multiply the volume in gallons by 4.55 for UK gallons and by 3.79 for US gallons.

Grams	Grains	Ounces
1.00	15.4	0.035
2.00	30.9	0.071
3.00	46.3	0.106
4.00	61.7	0.141
5.00	77.2	0.176
6.00	92.6	0.212
7.00	108.0	0.247
8.00	123.0	0.282
9.00	139.0	0.317
10.00	154.0	0.353
15.00	231.0	0.53
20.00	309.0	0.71
25.00	386.0	0.88
50.00	772.0	1.76
75.00	1157.0	2.65
100.00	1534.0	3.54
250.00	3858.0	8.85
500.00	7716.0	17.60
1000.00	15432.0	35.40

● To calculate grains from grams multiply the amount in grams by 15.432. To calculate the amount of ounces from grams multiply the amount in grams by 0.0354.
● To calculate grams from grains multiply the amount in grains by 0.0685. To calculate grams from ounces multiply the amount in ounces by 28.35.

Enlarger and safelight filter values

Safelight filters

MANUFACTURERS SAFELIGHT CODINGS AND RECOMMENDATIONS

AGFA - ENCAPSULITE
Amber Non-orthochromatic materials, black and white papers.
Green Panchromatic materials.
Red 'S' Slow orthochromatic materials.
Red 'D' Fast orthochromatic materials.

ILFORD
902 Light Brown - blue sensitive materials, Ilfobrom Galerie, Ilfospeed, Merit, Ilfospeed Multigrade DeLuxe, Multigrade FB.
904 Dark Brown - fast Blue sensitive materials, Line films.
906 Dark Red - orthochromatic (blue-green sensitive) materials.
907 Dark Green - very slow Panchromatic materials.
908 Very Dark Green - all Panchromatic materials, Colour papers.
914 Sepia - X-ray films.
915 Light Red - orthochromatic graphic arts materials.
916 Green - Ilford red sensitive Holographic plates.

KODAK
00 Light Yellow - slow contact speed blue sensitive materials.
0A Green Yellow - fast contact and projection sped blue materials.
0C Light Amber - Kodabrome Print Rc Paper.
1 Red - slow orthochromatic and fast blue sensitive materials.
1A Light Red - Kodalith materials.
2 Dark Red - fast orthochromatic materials (indirect illumination).

PATERSON
Red Blue sensitive and orthochromatic materials.
Orange Non-orthochromatic materials, printing papers.

- Orthochromatic = Blue-Green sensitive.
- Panchromatic = Sensitive to all wavelengths.

Variable-contrast paper filter settings

With some enlargers it is possible, by using combinations of yellow and magenta filtration, to keep the exposure time constant when changing contrast. The table below gives a guide to dual filtration settings.

Dual filtration settings:

ILFORD MULTIGRADE filters	Kodak values		Durst		Paterson Electronics PCS 2500	
0	150Y	25M	92Y	16M	offB	35G
½	110Y	33M	74Y	22M	180B	35G
1	85Y	42M	56Y	28M	120B	40G
1½	70Y	55M	46Y	37M	85B	45G
2	55Y	70M	36Y	46M	55B	55G
2½	42Y	80M	28Y	53M	30B	65G
3	30Y	90M	26Y	60M	20B	85G
3½	18Y	112M	12Y	75M	15B	120G
4	06Y	135M	04Y	90M	10B	160G
4½	00Y	195M	00Y	130M	05B	210G
5	*	*	*	*	00B	offG

* Maximum contrast is not available with this colour head

Enlargers using Kodak values include Beseler, Chromega, Dunco, Jobo, Kaiser, LPL, Paterson, Simmard and Vivitar enlargers. Leitz values are ⅔ those of Kodak, for example 10 Leitz = 15 Kodak. Meopta values are ½ those of Kodak, for example 10 Meopta = 20 Kodak.

Above and below-the-lens VC filters

If a colour enlarger is not available for printing with VC papers, there remains the choice of above or below-the-lens filters. In my experience, for single grade exposure work, neither will adversely affect print quality. For example, below-the-lens filters will not affect print sharpness or contrast, provided they are not damaged, e.g. scratched, or marked by greasy fingers.

However, my preference is for the below-the-lens variety, especially when making multiple-exposure prints, and if several different filter settings are required, such as **Black Mount**. In these situations, compared to opening the enlarger's heat-filter drawer to change a filter, it is much easier to change filters that (simply) slide into a holder below the lens. The former can very easily cause enlarger movement and a double image area, where each subsequent exposure is made.

Using either system, print exposure times still need to be doubled for any exposures made at grade 4 and above.

F.stop exposure table

Initial exposure	Less exposure (f.stops)			NORMAL	+0.33	Extra exposure (f.stops)			
	- 0.75	- 0.50	- 0.25	NORMAL	+0.33	+0.66	+1.00	+1.33	+1.50
1.00	0.59	0.70	0.84	1.00	1.26	1.59	2.00	2.52	2.83
2.00	1.18	1.41	1.68	2.00	2.52	3.17	4.00	5.04	5.66
3.00	1.78	2.12	2.52	3.00	3.78	4.76	6.00	7.56	8.49
4.00	2.37	2.82	3.36	4.00	5.04	6.35	8.00	10.08	11.31
5.00	2.97	3.53	4.20	5.00	6.30	7.94	10.00	12.60	14.14
6.00	3.56	4.24	5.04	6.00	7.56	9.52	12.00	15.12	16.97
7.00	4.16	4.94	5.88	7.00	8.82	11.11	14.00	17.64	19.80
8.00	4.75	5.65	6.72	8.00	10.08	12.70	16.00	20.16	22.63
9.00	5.35	6.36	7.56	9.00	11.34	14.29	18.00	22.68	25.46
10.00	5.94	7.07	8.40	10.00	12.60	15.87	20.00	25.20	28.28
11.00	6.54	7.77	9.24	11.00	13.86	17.46	22.00	27.72	31.11
12.00	7.13	8.48	10.09	12.00	15.12	19.05	24.00	30.24	33.94
13.00	7.72	9.19	10.93	13.00	16.38	20.63	26.00	32.76	36.77
14.00	8.32	9.89	11.77	14.00	17.64	22.22	28.00	35.28	39.60
15.00	8.91	10.60	12.61	15.00	18.90	23.81	30.00	37.80	42.43
16.00	9.51	11.31	13.45	16.00	20.16	25.40	32.00	40.32	45.25
17.00	10.10	12.02	14.29	17.00	21.42	26.98	34.00	42.84	48.08
18.00	10.70	12.72	15.13	18.00	22.68	28.57	36.00	45.36	50.91
19.00	11.29	13.43	15.97	19.00	23.94	30.16	38.00	47.88	53.74
20.00	11.89	14.14	16.81	20.00	25.20	31.75	40.00	50.40	56.57
21.00	12.48	14.84	17.65	21.00	26.46	33.33	42.00	52.92	59.40
22.00	13.08	15.55	18.49	22.00	27.72	34.92	44.00	55.44	62.22
23.00	13.67	16.26	19.34	23.00	28.98	36.51	46.00	57.96	65.05
24.00	14.27	16.97	20.18	24.00	30.24	38.10	48.00	60.48	67.88
25.00	14.86	17.67	21.02	25.00	31.50	39.68	50.00	62.63	70.71
26.00	15.45	18.38	21.86	26.00	32.76	41.27	52.00	65.51	73.54
27.00	16.05	19.09	22.70	27.00	34.02	42.86	54.00	68.03	76.37
28.00	16.64	19.79	23.54	28.00	35.28	44.44	56.00	70.55	79.20
29.00	17.24	20.50	24.38	29.00	36.54	46.03	58.00	73.07	82.02
30.00	17.83	21.21	25.22	30.00	37.80	47.62	60.00	75.59	84.85
31.00	18.43	21.92	26.06	31.00	39.06	49.21	62.00	78.11	87.68
32.00	19.02	22.62	26.90	32.00	40.32	50.79	64.00	80.63	90.51
33.00	19.62	23.33	27.74	33.00	41.58	52.58	66.00	83.15	93.34
34.00	20.21	24.04	28.59	34.00	42.84	53.97	68.00	85.67	96.17
35.00	20.81	24.74	29.43	35.00	44.10	55.56	70.00	88.19	98.99
36.00	21.40	25.45	30.27	36.00	45.36	57.14	72.00	90.71	101.82
37.00	22.00	26.16	31.11	37.00	46.62	58.73	74.00	93.23	104.65
38.00	22.59	26.86	31.95	38.00	47.88	60.32	76.00	95.75	107.48
39.00	23.18	27.57	32.79	39.00	49.14	61.90	78.00	98.27	110.31
40.00	23.78	28.28	33.63	40.00	50.40	63.49	80.00	100.79	113.14
45.00	26.75	31.81	37.84	45.00	56.70	71.43	90.00	113.39	127.28
50.00	29.73	35.35	42.04	50.00	63.00	79.37	100.00	125.99	141.42
55.00	32.70	38.89	46.24	55.00	69.29	87.30	110.00	138.59	155.56
60.00	35.67	42.42	50.45	60.00	75.59	95.24	120.00	151.19	169.70

Using the f.stop exposure table.
From a test-strip or trial print you should already have found the basic print exposure time.
1) Find this basic time in the first "Initial exposure" column.
2) Look up the amount of extra, or less, exposure you want (in stops, or fractions of stops) from the top row.

| | | | | Extra exposure (f.stops) | | | | Initial |
+1.67	**+2.00**	**+2.50**	**+3.00**	**+3.50**	**+4.00**	**+4.50**	**+5.00**	**Exposure**
3.18	4.00	5.66	8.00	11.31	16.00	22.63	32.00	1.00
6.35	8.00	11.31	16.00	22.62	32.00	45.26	64.00	2.00
9.53	12.00	16.97	24.00	33.93	48.00	67.89	96.00	3.00
12.70	16.00	22.63	32.00	45.25	64.00	90.52	128.00	4.00
15.88	20.00	28.29	40.00	56.56	80.00	113.15	160.00	5.00
19.05	24.00	33.94	48.00	67.87	96.00	135.78	192.00	6.00
22.23	28.00	39.60	56.00	79.19	112.00	158.41	224.00	7.0
25.40	32.00	45.25	64.00	90.50	128.00	181.04	256.00	8.00
28.58	36.00	50.91	72.00	101.81	144.00	203.67	288.00	9.00
31.76	40.00	56.57	80.00	113.13	160.00	226.30	320.00	10.00
34.93	44.00	62.23	88.00	124.44	176.00	248.93	352.00	11.00
38.11	48.00	67.88	96.00	135.75	192.00	271.56	384.00	12.00
41.28	52.00	73.54	104.00	147.06	208.00	294.19	416.00	13.00
44.46	56.00	79.20	112.00	158.38	224.00	316.82	448.00	14.00
47.63	60.00	84.86	120.00	169.69	240.00	339.45	480.00	15.00
50.81	64.00	90.51	128.00	181.00	256.00	362.08	512.00	16.00
53.98	68.00	96.17	136.00	192.32	272.00	384.71	544.00	17.00
57.16	72.00	101.83	144.00	203.63	288.00	407.34	576.00	18.00
60.33	76.00	107.48	152.00	214.94	304.00	429.97	608.00	19.00
63.51	80.00	113.14	160.00	226.26	320.00	452.60	640.00	20.00
66.69	84.00	118.80	168.00	237.57	336.00	475.23	672.00	21.00
69.86	88.00	124.45	176.00	248.88	352.00	497.86	704.00	22.00
73.04	92.00	130.11	184.00	260.19	368.00	520.49	736.00	23.00
76.21	96.00	135.77	192.00	271.51	384.00	543.12	768.00	24.00
79.39	100.00	141.43	200.00	282.82	400.00	565.75	800.00	25.00
82.56	104.00	147.08	208.00	294.13	416.00	588.38	832.00	26.00
85.74	108.00	152.74	216.00	305.45	432.00	611.00	864.00	27.00
88.91	112.00	158.40	224.00	316.76	448.00	633.64	896.00	28.00
92.10	116.00	164.05	232.00	328.07	464.00	656.27	928.00	29.00
95.27	120.00	169.71	240.00	339.39	480.00	678.90	960.00	30.00
98.44	124.00	175.37	248.00	350.70	496.00	701.53	992.00	31.00
101.62	128.00	181.02	256.00	362.01	512.00	724.16	1024.00	32.00
104.79	132.00	186.68	264.00	373.32	528.00	746.79	1056.00	33.00
107.97	136.00	192.34	272.00	384.64	544.00	769.42	1088.00	34.00
111.14	140.00	198.00	280.00	395.95	560.00	792.05	1120.00	35.00
114.32	144.00	203.65	288.00	407.26	576.00	814.68	1152.00	36.00
117.49	148.00	209.31	296.00	418.58	592.00	837.31	1184.00	37.00
120.67	152.00	214.97	304.00	429.89	608.00	859.94	1216.00	38.00
123.84	156.00	220.62	312.00	441.20	624.00	882.57	1248.00	39.00
127.02	160.00	226.28	320.00	452.52	640.00	905.20	1280.00	40.00
142.90	180.00	254.57	360.00	509.08	720.00	1018.35	1440.00	45.00
158.78	200.00	282.85	400.00	565.65	800.00	1131.50	1600.00	50.00
174.65	220.00	311.14	440.00	622.21	880.00	1244.65	1760.00	55.00
190.53	**240.00**	**339.42**	**480.00**	**678.78**	**960.00**	**1357.80**	**1920.00**	**60.00**

3) Now read down the column from this figure in the top row.
4) Next, read off the number where this column coincides with the row that you first chose (the basic "Initial exposure" print time).
5) This is the new exposure time. But, for burning-in, rememeber to subtract the basic exposure time from the new figure.
E.g. if the basic exposure time is 10 seconds, and the print is to be burned in for $+^2/_3$ stop (+0.66), the burning in exposure is 15.87 - 10.00 = 5.87 seconds.

Print magnification exposure table

Old \ New	130	140	150	160	170	180	190	200	210	220	230	240	250	260	270	280	290	300
120	1.17	1.36	1.56	1.78	2.01	2.25	2.51	2.78	3.06	3.36	3.67	4.00	4.34	4.69	5.06	5.44	5.84	6.25
130	1.00	1.16	1.33	1.51	1.71	1.92	2.14	2.37	2.61	2.86	3.13	3.41	3.70	4.00	4.31	4.64	4.98	5.33
140	0.86	1.00	1.15	1.31	1.47	1.65	1.84	2.04	2.25	2.47	2.70	2.94	3.19	3.45	3.72	4.00	4.29	4.59
150	0.75	0.87	1.00	1.14	1.28	1.44	1.60	1.78	1.96	2.15	2.35	2.56	2.78	3.00	3.24	3.48	3.74	4.00
160	0.66	0.77	0.88	1.00	1.13	1.27	1.41	1.56	1.72	1.89	2.07	2.25	2.44	2.64	2.85	3.06	3.29	3.52
170	0.58	0.68	0.78	0.89	1.00	1.12	1.25	1.38	1.53	1.67	1.83	1.99	2.16	2.34	2.52	2.71	2.91	3.11
180	0.52	0.60	0.69	0.79	0.89	1.00	1.11	1.23	1.36	1.49	1.63	1.78	1.93	2.09	2.25	2.42	2.60	2.78
190	0.47	0.54	0.62	0.71	0.80	0.90	1.00	1.11	1.22	1.34	1.47	1.60	1.73	1.87	2.02	2.17	2.33	2.49
200	0.42	0.49	0.56	0.64	0.72	0.81	0.90	1.00	1.10	1.21	1.32	1.44	1.56	1.69	1.82	1.96	2.10	2.25
210	0.38	0.44	0.51	0.58	0.66	0.73	0.82	0.91	1.00	1.10	1.20	1.31	1.42	1.53	1.65	1.78	1.91	2.04
220	0.35	0.40	0.46	0.58	0.60	0.67	0.75	0.83	0.91	1.00	1.09	1.19	1.29	1.40	1.51	1.62	1.74	1.86
230	0.32	0.37	0.43	0.48	0.55	0.61	0.68	0.76	0.83	0.91	1.00	1.09	1.18	1.28	1.38	1.48	1.59	1.70
240	0.29	0.34	0.39	0.44	0.50	0.56	0.63	0.69	0.77	0.84	0.92	1.00	1.09	1.17	1.27	1.36	1.46	1.56
250	0.27	0.31	0.36	0.41	0.46	0.52	0.58	0.64	0.71	0.77	0.85	0.92	1.00	1.08	1.17	1.25	1.35	1.44
260	0.25	0.29	0.33	0.38	0.43	0.48	0.53	0.59	0.65	0.72	0.78	0.85	0.92	1.00	1.08	1.16	1.24	1.33
270	0.23	0.27	0.31	0.35	0.40	0.44	0.50	0.55	0.60	0.66	0.73	0.79	0.86	0.93	1.00	1.08	1.15	1.23
280	0.22	0.25	0.29	0.33	0.37	0.41	0.46	0.51	0.56	0.62	0.67	0.73	0.80	0.86	0.93	1.00	1.07	1.15
290	0.20	0.23	0.27	0.30	0.34	0.39	0.43	0.48	0.52	0.58	0.63	0.68	0.74	0.80	0.87	0.93	1.00	1.07
300	0.19	0.22	0.25	0.28	0.32	0.36	0.40	0.44	0.49	0.54	0.59	0.64	0.69	0.75	0.81	0.87	0.93	1.00
310	0.18	0.20	0.23	0.27	0.30	0.34	0.38	0.42	0.46	0.50	0.55	0.60	0.65	0.70	0.76	0.82	0.88	0.94
320	0.17	0.19	0.22	0.25	0.28	0.32	0.35	0.39	0.43	0.47	0.52	0.56	0.61	0.66	0.71	0.77	0.82	0.88
330	0.16	0.18	0.21	0.24	0.27	0.30	0.33	0.37	0.40	0.44	0.49	0.53	0.57	0.62	0.67	0.72	0.77	0.83
340	0.15	0.17	0.19	0.22	0.25	0.28	0.31	0.35	0.38	0.42	0.46	0.50	0.54	0.58	0.63	0.68	0.73	0.78
350	0.14	0.16	0.18	0.21	0.24	0.26	0.29	0.33	0.36	0.40	0.43	0.47	0.51	0.55	0.60	0.64	0.69	0.73
360	0.13	0.15	0.17	0.20	0.22	0.25	0.28	0.31	0.34	0.37	0.41	0.44	0.48	0.52	0.56	0.60	0.65	0.69
370	0.12	0.14	0.16	0.19	0.21	0.24	0.26	0.29	0.32	0.35	0.39	0.42	0.46	0.49	0.53	0.57	0.61	0.66
380	0.12	0.14	0.16	0.18	0.20	0.22	0.25	0.28	0.31	0.34	0.37	0.40	0.43	0.47	0.50	0.54	0.58	0.62
390	0.11	0.13	0.15	0.17	0.19	0.21	0.24	0.26	0.29	0.32	0.35	0.38	0.41	0.44	0.48	0.52	0.55	0.59
400	0.11	0.12	0.14	0.16	0.18	0.20	0.23	0.25	0.28	0.30	0.33	0.36	0.39	0.42	0.46	0.49	0.53	0.56
410	0.10	0.12	0.13	0.15	0.17	0.19	0.21	0.24	0.28	0.29	0.31	0.34	0.37	0.40	0.43	0.47	0.50	0.54
420	0.10	0.11	0.13	0.15	0.16	0.18	0.20	0.23	0.25	0.27	0.30	0.33	0.35	0.38	0.41	0.44	0.48	0.51
430	0.09	0.11	0.12	0.14	0.16	0.18	0.20	0.22	0.24	0.26	0.29	0.31	0.34	0.37	0.39	0.42	0.45	0.49
440	0.09	0.10	0.12	0.13	0.15	0.17	0.19	0.21	0.23	0.25	0.27	0.30	0.32	0.35	0.38	0.40	0.43	0.46
450	0.08	0.10	0.11	0.13	0.14	0.16	0.18	0.20	0.22	0.24	0.26	0.28	0.31	0.33	0.36	0.39	0.42	0.44
460	0.08	0.09	0.11	0.12	0.14	0.15	0.17	0.19	0.21	0.23	0.25	0.27	0.30	0.32	0.34	0.37	0.40	0.43
470	0.08	0.09	0.10	0.12	0.13	0.15	0.16	0.18	0.20	0.22	0.24	0.26	0.28	0.31	0.33	0.35	0.38	0.41
480	0.07	0.09	0.10	0.11	0.13	0.14	0.16	0.17	0.19	0.21	0.23	0.25	0.27	0.29	0.32	0.34	0.37	0.39
490	0.07	0.08	0.09	0.11	0.12	0.13	0.15	0.17	0.18	0.20	0.22	0.24	0.26	0.28	0.30	0.33	0.35	0.37
500	0.07	0.08	0.09	0.10	0.12	0.13	0.14	0.16	0.18	0.19	0.21	0.23	0.25	0.27	0.29	0.31	0.34	0.36

Changes in print exposure times, due to alterations of print size, are easily calculated using this exposure table. First, measure the length of the original print and find this value on the left-hand "Old" column. Now, find the "New" length on the top row. An exposure factor can now be found where their two lines of figures intersect.

310	320	330	340	350	360	370	380	390	400	410	420	430	440	450	460	470	480	490	500
6.67	7.11	7.56	8.03	8.61	9.00	9.51	10.03	10.58	11.11	11.67	12.25	12.84	13.44	14.06	14.69	15.34	16.00	16.67	17.36
5.69	6.06	6.44	6.84	7.25	7.67	8.10	8.54	9.00	9.47	9.95	10.44	10.94	11.46	11.98	12.52	13.07	13.63	14.21	14.79
4.90	5.22	5.56	5.90	6.25	6.61	6.98	7.37	7.76	8.16	8.58	9.00	9.43	9.88	10.33	10.80	11.27	11.76	12.25	12.76
4.27	4.55	4.84	5.14	5.44	5.76	6.06	6.42	6.76	7.11	7.47	7.84	8.22	8.60	9.00	9.40	9.82	10.24	10.67	11.11
3.75	4.00	4.25	4.52	4.79	5.06	5.35	5.64	5.94	6.25	6.57	6.89	7.22	7.56	7.91	8.27	8.63	9.00	9.38	9.77
3.33	3.54	3.77	4.00	4.24	4.48	4.74	5.00	5.26	5.54	5.82	6.10	6.40	6.70	7.01	7.32	7.64	7.97	8.31	8.65
2.97	3.16	3.36	3.57	3.78	4.00	4.23	4.46	4.69	4.94	5.19	5.44	5.71	5.98	6.25	6.53	6.82	7.11	7.41	7.72
2.66	2.84	3.02	3.20	3.39	3.59	3.79	4.00	4.21	4.43	4.66	4.89	5.12	5.36	5.61	5.86	6.12	6.38	6.65	6.93
2.40	2.56	2.72	2.89	3.06	3.24	3.42	3.61	3.80	4.00	4.20	4.41	4.62	4.84	5.06	5.29	5.52	5.76	6.00	6.25
2.18	2.32	2.47	2.62	2.78	2.94	3.10	3.27	3.45	3.63	3.81	4.00	4.19	4.39	4.59	4.80	5.01	5.22	5.44	5.67
1.99	2.12	2.25	2.39	2.53	2.68	2.83	2.98	3.14	3.31	3.47	3.64	3.82	4.00	4.18	4.37	4.56	4.76	4.96	5.17
1.82	1.94	2.06	2.19	2.32	2.45	2.59	2.73	2.88	3.02	3.18	3.33	3.50	3.66	3.83	4.00	4.18	4.36	4.54	4.73
1.67	1.78	1.89	2.01	2.13	2.25	2.38	2.51	2.64	2.78	2.92	3.06	3.21	3.36	3.52	3.67	3.84	4.00	4.17	4.34
1.54	1.64	1.74	1.85	1.96	2.07	2.19	2.31	2.43	2.56	2.69	2.82	2.98	3.10	3.24	3.39	3.53	3.69	3.84	4.00
1.42	1.51	1.61	1.71	1.81	1.92	2.03	2.14	2.25	2.37	2.49	2.61	2.74	2.86	3.00	3.13	3.27	3.41	3.55	3.70
1.32	1.40	1.49	1.59	1.68	1.78	1.88	1.98	2.09	2.19	2.31	2.42	2.54	2.66	2.78	2.90	3.03	3.16	3.29	3.43
1.23	1.31	1.39	1.47	1.56	1.65	1.75	1.84	1.94	2.04	2.14	2.25	2.36	2.47	2.58	2.70	2.82	2.94	3.06	3.19
1.14	1.22	1.29	1.37	1.46	1.54	1.63	1.72	1.81	1.90	2.00	2.10	2.20	2.30	2.41	2.52	2.63	2.74	2.85	2.97
1.07	1.14	1.21	1.28	1.36	1.44	1.52	1.60	1.69	1.78	1.87	1.96	2.05	2.15	2.25	2.35	2.45	2.56	2.67	2.78
1.00	1.07	1.13	1.20	1.27	1.35	1.42	1.50	1.58	1.66	1.75	1.84	1.92	2.01	2.11	2.20	2.30	2.40	2.50	2.60
0.94	1.00	1.06	1.13	1.20	1.27	1.34	1.41	1.49	1.56	1.64	1.72	1.81	1.89	1.98	2.07	2.16	2.25	2.34	2.44
0.88	0.94	1.00	1.06	1.12	1.19	1.26	1.33	1.40	1.47	1.54	1.62	1.70	1.78	1.86	1.94	2.03	2.12	2.20	2.30
0.83	0.89	0.94	1.00	1.06	1.12	1.18	1.25	1.32	1.38	1.45	1.53	1.60	1.67	1.75	1.83	1.91	1.99	2.08	2.16
0.78	0.84	0.89	0.94	1.00	1.06	1.12	1.18	1.24	1.31	1.37	1.44	1.51	1.58	1.65	1.73	1.80	1.88	1.96	2.04
0.74	0.79	0.84	0.89	0.95	1.00	1.06	1.11	1.17	1.23	1.30	1.36	1.43	1.49	1.56	1.63	1.70	1.78	1.85	1.93
0.70	0.75	0.80	0.84	0.89	0.95	1.00	1.05	1.11	1.17	1.23	1.29	1.35	1.41	1.48	1.55	1.61	1.68	1.75	1.83
0.67	0.71	0.75	0.80	0.85	0.90	0.95	1.00	1.05	1.11	1.16	1.22	1.28	1.34	1.40	1.47	1.53	1.60	1.66	1.73
0.63	0.67	0.72	0.76	0.81	0.85	0.90	0.95	1.00	1.05	1.11	1.16	1.22	1.27	1.33	1.39	1.45	1.51	1.58	1.64
0.60	0.64	0.68	0.72	0.77	0.81	0.86	0.90	0.95	1.00	1.05	1.10	1.16	1.21	1.27	1.32	1.38	1.44	1.50	1.56
0.57	0.61	0.65	0.69	0.73	0.77	0.81	0.86	0.90	0.95	1.00	1.05	1.10	1.15	1.20	1.26	1.31	1.37	1.43	1.49
0.54	0.58	0.62	0.66	0.69	0.73	0.78	0.82	0.86	0.91	0.95	1.00	1.05	1.10	1.15	1.20	1.25	1.31	1.36	1.42
0.52	0.55	0.59	0.63	0.66	0.70	0.74	0.78	0.82	0.87	0.91	0.95	1.00	1.05	1.10	1.14	1.19	1.25	1.30	1.35
0.50	0.53	0.56	0.60	0.63	0.67	0.71	0.75	0.79	0.83	0.87	0.91	0.96	1.00	1.05	1.09	1.14	1.19	1.24	1.29
0.47	0.51	0.54	0.57	0.60	0.64	0.68	0.71	0.75	0.79	0.83	0.87	0.91	0.96	1.00	1.04	1.09	1.14	1.19	1.23
0.45	0.48	0.51	0.55	0.58	0.61	0.65	0.68	0.72	0.76	0.79	0.83	0.87	0.91	0.96	1.00	1.04	1.09	1.13	1.18
0.44	0.46	0.49	0.52	0.55	0.59	0.62	0.65	0.69	0.72	0.76	0.80	0.84	0.88	0.92	0.96	1.00	1.04	1.09	1.13
0.42	0.44	0.47	0.50	0.53	0.56	0.59	0.63	0.66	0.69	0.73	0.77	0.80	0.84	0.88	0.92	0.96	1.00	1.04	1.09
0.40	0.43	0.45	0.48	0.51	0.54	0.57	0.60	0.63	0.67	0.70	0.73	0.77	0.81	0.84	0.88	0.92	0.96	1.00	1.04
0.38	0.41	0.44	0.46	0.49	0.52	0.55	0.58	0.61	0.64	0.67	0.71	0.74	0.77	0.81	0.85	0.88	0.92	0.96	1.00

For example, an exposure time of 10 seconds for a print 200mm in length, is now 14.4 seconds (10 x 1.44) for a print with a new length of 240mm.
Note: this table will not work for some condenser enlargers, for example, whose lightsource cannot be adjusted to give the same area of coverage over the lens as print size (and lens/bellows extension) changes.

Conversion charts

Percentage Solutions

Dilution Ratio	Final Vol. Required	Vol. of Stock Sol	Vol. of Water
1+1	1000.00ml	500.00ml	500.00ml
1+2	1000.00	333.33	666.66
1+3	1000.00	250.00	750.00
1+4	1000.00	200.00	800.00
1+5	1000.00	166.67	833.33
1+6	1000.00	142.86	857.14
1+7	1000.00	125.00	875.00
1+8	1000.00	111.11	888.89
1+9	1000.00	100.00	900.00
1+10	1000.00	90.91	909.09
1+11	1000.00	83.33	916.67
1+12	1000.00	76.92	923.00
1+13	1000.00	71.43	928.57
1+14	1000.00	66.67	933.33
1+15	1000.00	62.50	937.50
1+16	1000.00	58.82	941.18
1+17	1000.00	55.56	944.44
1+18	1000.00	52.63	947.37
1+19	1000.00	50.00	950.00
1+20	1000.00	47.62	952.38
1+30	1000.00	32.26	967.74
1+40	1000.00	24.39	975.61
1+50	1000.00	19.61	980.39
1+75	1000.00	13.16	986.84
1+100	1000.00	9.90	990.10
1+125	1000.00	7.94	992.06
1+150	1000.00	6.62	993.38
1+200	1000.00	4.98	995.02
1+250	1000.00	3.98	996.02
1+500	1000.00	2.00	998.00

Time-temperature chart

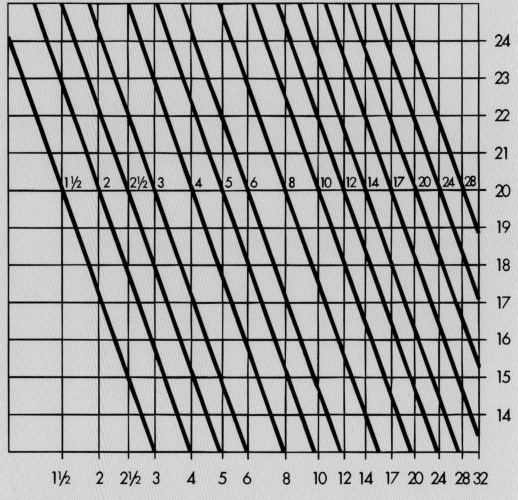

For example, if 4 minutes processing or washing time at 20°C is recommended, the time at 23°C will be 3 minutes and the time at 16°C will be 6 minutes. Processing and washing times below 14°C are not recommended. However, archival washing is possible down to 10°C provided a hypo-clearing bath is used.

Factoral development chart

If, for example, at the start of a printing session, a print takes 30 seconds to emerge in the developer and we develop it for 2 minutes (120 seconds) then it has had a development factor of x4 (4x30 = 120). If this emergence time changes later in the session, e.g. to 40 seconds, multiplying this figure by the same factor of x4 provides a new development time of 160 seconds.

Different papers, developers, developer dilutions, additives, temperatures and age, all create different emergence times. By noting these times, and using this factoral system, it is possible to calculate the right development time for each.

For example, to maintain warm image tones with a chloro-bromide paper, I would develop the print for a factor of x3, and no more than x4. So, if the paper takes 15 seconds to emerge, I would aim for a print exposure time that gives a print of the right density after just 45 seconds development. Similarly, for warm-tone lith processing, like the untoned image of the **Rance Estuary**, I would also go for a factor of about x3.

For more neutral bromo-chloride papers I tend to develop the print for a factor of about x5, so that if they take about 30 seconds to emerge, I will develop them for 150 seconds. This larger factor ensures good blacks and a completely, evenly developed image. For example, I develop Ilford Multigrade FB for longer than the manufacturer's recommended x4 factor. This extra development doesn't visibly improve the density of the blacks (conversely a factor of x3 with a warm-tone chloro-bromide paper, like Record Rapid, shouldn't weaken them) but it does ensure the maximum amount of silver is developed-out. This is useful to combat any toners that might reduce print contrast or density. Try viewing a processed print by transmitted light. You'll see how much more detail there is in the shadows. Also, when viewed in this way, you will notice any unevenness of development in the print, if it exists.

Development factors of less than x3 tend to produce weak-looking prints that may appear unevenly developed. If these images are later toned, such development irregularities will show up much more. Factors of x7, or more, produce little benefit; in fact, prints may begin to fog, either chemically, or from too much safelight exposure.

The development of developer-incorporated papers cannot be easily controlled by factoral development, whilst FB papers, rather than RC, will respond the best.

Factor	x2	x3	x4	x5	x6	x7	x8
Development Time/Seconds							
5	10	15	20	25	30	35	40
10	20	30	40	50	60	70	80
15	30	45	60	75	92	105	120
20	40	60	80	100	120	140	160
25	50	75	100	125	150	175	200
30	60	90	120	150	180	210	240
35	70	105	140	175	210	245	280
40	80	120	160	200	240	280	320
45	90	135	180	225	270	315	360
50	100	150	200	250	300	350	400
55	110	165	220	275	330	385	440
60	120	180	240	300	360	420	480
65	130	195	260	325	390	455	520
70	140	210	280	350	420	490	560
75	150	225	300	375	450	525	600
80	160	240	320	400	480	560	640
85	170	255	340	425	510	595	680
90	180	270	360	450	540	630	720
95	190	285	380	475	570	665	760
100	200	300	400	500	600	700	800
105	210	315	420	525	630	735	840
110	220	330	440	550	660	770	880
115	230	345	460	575	690	805	920
120	240	360	480	600	720	840	960
125	250	375	500	625	750	875	1000
130	260	390	520	650	780	910	1040
135	270	405	540	675	810	945	1080
140	280	420	560	700	840	980	1120
145	290	435	580	725	870	101	1160
150	300	450	600	750	900	1050	1200
155	310	465	620	775	930	1085	1240
160	320	480	640	800	960	1120	1280
165	330	495	660	825	990	1155	1320
170	340	510	680	850	1020	1190	1360
175	350	525	700	875	1050	1225	1400
180	360	540	720	900	1080	1260	1440

Factoral development can be used to subtly alter the contrast of graded papers, similar to that which is possible with the half grade filter settings of VC papers. Increasing print exposure and decreasing print development time reduces contrast and vice versa. Therefore, a print that is to be developed to a smaller factor of x3, for warm tone development, also requires more print exposure. You'll need to make some test-strips for your own printing set-up, to find out by how much exposure times need to be altered.

Technical section index